HOLLYWOOD
A JOURNEY
THROUGH
THE STARS

BOB WILLOUGHBY
A PHOTOGRAPHIC
AUTOBIOGRAPHY

D1344547

Photographs © Bob Willoughby, 2001
© 2001 Assouline Publishing, Inc.
601 West 26th Street
18th floor
New York, NY 10001
USA
Tel: 212-989-6810. Fax: 212-647-0005
www.assouline.com

ISBN: 2 84323 261 9

Printed in Italy

HOLLYWOOD
A JOURNEY
THROUGH
THE STARS

✳

BOB WILLOUGHBY
A PHOTOGRAPHIC
AUTOBIOGRAPHY

ASSOULINE

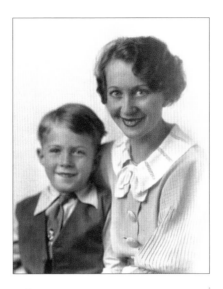

The Journey Begins

"Bobby..." I was being gently awakened on a morning, long ago. "Get up, there's something that you must see." Through one eye, I could see my mother smiling down on me. Half asleep, I tumbled out of bed, and she bundled me into my bathrobe, led me through the kitchen and out the back door. Standing outside in the cold my eyes opened wide, for I could see tiny white flakes falling from the sky, decorating the garden. It was magical. I stood there, truly amazed, for the world that I knew was being transformed before my eyes.

My mother told me that it was snow, a rare sight in Los Angeles. It was January 1932. We lived right across from the Hoover Street School, and I was four. It is one of my earliest memories, and perhaps this snowy vision kindled something inside of me, effecting the way that I see things, that has lasted throughout my life.

There are other early memories that I remember now—dancing around that living room, the overstuffed couch, the sun streaming through the front windows, the radio playing, as I sang: "little Bobby Willoughby, always into mischief!" There were Easter egg hunts, and a rooster hidden behind the hall door, with a spring for a neck, which bobbed up and down and made me laugh. Running for my life, down a hill, being chased by a mad dog that I thought would eat me if I ever stopped.

An unusually clear memory is the day my mother took me to that same Hoover Street School to enroll me in kindergarten. She had cautioned me to be on my best behavior. We were sitting alone in the principal's office, and Mother had been given forms to fill out. Finding the room dark, mother asked me to go and put on the light.

I went over to the switch by the door, pushed it, and all hell broke loose. Bells rang, the doors of the classrooms banged open, and the entire school noisily emptied out; teachers were clucking and directing the children onto the playground. My mother and I, frozen in our seats, all alone, wondered if little Bobby was ever going to be accepted into kindergarten after pushing the school's fire alarm.

I remember other things that seemed important at the time, but so often I think of a specific photograph, and wonder if each of us remembers the past the same way. My feeling is that photographs have become a second memory-bank for us all. They remind us of all of the people we have loved and every detail of their appearance. That long-ago landscape can trigger a flood of memories and emotions. Our dear friends that are gone stay with us. Sunny days when we were young, and the vision of youth preserved.

Bob and Nettie Willoughby, 1931.

When I was twelve, my mother planned a train trip for the two of us, back to Detroit where she was born, and then as a special treat, a side trip to Niagara Falls.

My mother and father were divorced before I was born, so I rarely saw my father, but for my birthday he gave me a technological marvel of a camera—an Argus C-3!

No "point and shoot" as we have today. This mechanism had mind-numbing demands like f-stops and shutter speeds, and, even more daunting, an extinction light meter.

I probably drove my mother half crazy, keeping my head in the "simple" instruction book, written for practicing engineers, and in the process missing all of the scenery on that train ride of a lifetime.

Without realizing it then, taking pictures turned out to be the key to my future. One of the reasons that I applied myself was that I had to pay for the film and processing out of my weekly allowance, and, in my very frugal way, I wanted to see 36 exposures on every roll. So I did learn about shutter speeds and f-stops (never really conquering the extinction light meter), and unknowingly began my journey.

Mother moved us to a flat on Orange Drive in Los Angeles, and I started at Cathedral Chapel School. She hoped that the nuns would hold my natural exuberance down a mite, and parochial school was a necessary step. She was away all day working, and I was on my own most of the time. Usually, I found myself knee-deep in one drama after another.

One of my classes had a free period, and I was drawing the plant on the desk. Our teacher leaned over me, and quietly showed me how to make my flowerpot seem round by shading it. I must have been starved for input at the time and absorbed it like a wet sponge. Here was something the teacher did in a chance moment, but it was directed to me personally. It was the right thing at the right time.

It awakened an interest in me to learn more, and I started then and there to look at art and to learn from what others had done. My interest has never flagged to this day. One really never knows how a chance gift (like the camera my father gave me), a meeting, a conversation or momentary kindness can influence an entire life.

When I finished at CCS, I went to nearby John Burroughs Jr. High School. This was a real graduation, since I was now with the big kids, in a different world. Up till then I hadn't given girls much thought, but in this new school with a new curriculum, I found myself awash in my math class. I can clearly remember asking the girl who sat behind me to explain the problem marked so clearly on the blackboard. I just didn't get it.

Memorably, I was touched once again, this time by a gentle blonde named Peggy McDonald. She was so encouraging and patient with me, I had a grateful crush on her. I did manage to squeak through the math class, but not without her helping hand, smoothing the way for this pilgrim.

Another awakening was in store for me. Rena Cortella was one of the older and very popular girls in school. Shubert Byers and I were doing a magic act in the school's yearly variety show, and Rena and another girl sang "Who Will Buy My White Gardenias." They were dressed in those off-the-shoulder, white peasant blouses, and I'm sure there was not a boy in the audience that wouldn't have bought all their flowers.

As I was leaning out the stage window after rehearsal one day, I saw Rena below, surrounded by her usual coterie of admiring boys. From my vantage point, I could see right down her open blouse. For the first time in my life, I was seeing a girl's bare breast. Something happened inside me. It was beautiful and wonderful. It blew me away. It was as if I had been introduced into another and higher order of things. I was twelve, and just awake to the idea that girls were really something special.

To raise money for my camera expenses, I started baby-sitting on Saturday nights. Harry and Lillian Hoffman lived in the apartment below us on Orange Drive, and I used to sit with their new baby Dusty and his older brother Ronald. I was introduced to him again at Paramount Studios, 27 years later, on his first film, when we made *The Graduate* together.

We moved to Marvin Avenue in 1941, and I transferred to Louis Pasteur Jr. High. This school had a terrific program, and they introduced every boy to different shops, which continued throughout high school as well. I learned a little about printing, woodworking and electricity. I even built my own "cat's-whiskers" radio.

In retrospect, it seems that I retained most of what I learned in those practical shop courses, and was able to apply them throughout my life. Of course, I was still taking pictures all of the time, because it was a great way to meet girls, a project to which I had now become dedicated.

One of our neighbors was a real photographer, who worked in an aircraft factory. We made a great deal: baby-sitting for the use of his darkroom. So by the time I got to Alexander Hamilton High School, I was able to develop and print my own photographs.

Louis Pasteur Jr. High School, and my first camera (center), c. 1942.

At Alexander Hamilton High School, there was a photographic course taught by Lois Vinette, a truly dedicated teacher. I know I annoyed her for fooling around in the darkroom too much, but she introduced me to contemporary photography, taught me to use large format cameras. The class became another step on the road that I didn't know I was taking.

I always had it in mind that I would do something in the arts. I even took costume design as one of my electives. I was the only boy in the class, which might have been one of my incentives, but I seemed drawn to that world.

Graduating from high school was one of my happiest days. It had felt like I was in prison, and the teachers were the wardens. I just didn't seem to fit into that format of study. As it turned out, after graduation, I never read so much in my life. I literally devoured information. I read in every room —on philosophy, theology, art history and archeology. What I discovered later is that the way I read, a chapter on art in the kitchen, then in the bedroom a bit of theology, something else in another room, created a different synthesis than if I had read the books individually. This different way of learning altered my perspective for the rest of my life. The year was 1946. I was 18. The war had passed me by.

I had to earn a living to help support my mother, who had a stroke when I was still in junior high. This was not an easy time for either of us, but we struggled through. I had given up the idea of art as my chosen field, because I realized I just wasn't good enough.

One of my high school friends, Gene Dennis, was a male model, and he convinced me to try and get some jobs. We did a few things, but it was not where my head was. I found I was more interested in the other side of the camera, and started to apprentice with some of the photographers in town.

John Engstead was a known Hollywood photographer who did a lot of the California fashions at the time. I convinced my friends to pose for me, traded free prints with new models for letting me build up a portfolio to show around, and started to try my luck.

I went to work at the same time for Wallace Seawell, a society and glamour photographer. He would probably hate me to describe him as such, but he taught me a lot. Wally paid me $5 a week, enough to have lunch, but not in Beverly Hills, where the Martine Studio was. He taught me to spot (coloring the dust spots on the photographic print with dyes), and he honed my eye to recognize a good print. Most important was his advice: "People pay me $1000 for a photograph, and they put it in a prominent place in their home. Since they paid that much for it, they wish to show it to their friends. They say, 'Wally Seawell took that photograph!' If they had paid $100 to someone else, it would never be mentioned." If you make them pay, the photograph will then be appreciated. It turned out to be good advice, especially working in Hollywood.

(left) In cap and gown with Carl Lindner, June 1946.
(right) Dancing at my senior prom with Bonnie Geiselman.

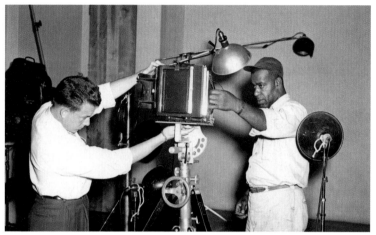

(left) One of my first fashion photographs made in my garage studio with a roll of white paper and a few reflectors. Model: Rosalie Calvert, 1949.

(above) Setting up the camera with Horace for photographer Paul Hesse, 1949.

Wally moved into Paul Hesse's large studios on Sunset Blvd. Paul was probably the biggest advertising photographer on the West Coast. Glenn Embre was also working out of Paul's, so whenever they needed an extra hand, they would call. They were producing the big ads for Rhinegold beer, cigarettes, soap, and all the advertisements one would see in magazines, especially involving film personalities. It was a great photographic apprenticeship, watching how they worked and solved technical problems.

I learned how Paul liked to light his photographs. He called me, told me what time to be ready, and I loaded the film in the 8 x 10 holders, set the lights, then he came in and charmed the people. And charming and handsome he was. During this period, I was also going to night school to learn printing production as well as design with Saul Bass at the Khan Institute of Art, and to the University of Southern California Cinema Department, whenever I could.

At USC, I studied with Slavko Vorkapich and William Cameron Menzies, the great production designer. Many others came to lecture, including Jean Renoir. It was a special time for me, to learn new disciplines. One of the other students was Bill Cartwright, who was aghast at my lack of knowledge of his favorite artists. "You mean you don't know Redon? You can't be serious!" "Rennie MacIntosh, and Mrs Cranston's tea room? Where have you been?" He led me into so many hidden corners of art history, that without his insistence or, rather, bulldozing me with his enthusiasm, I would have missed out on a lifetime of discoveries.

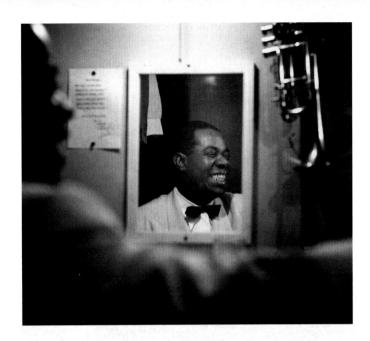

Louis Armstrong in his dressing room, backstage at the Bal Tabarn in downtown Los Angeles. This was published in Fleur Cowles' spectacularly interesting experimental magazine Flair, *November 1950.*

I had to use the garage-turned-darkroom at night because the sun would leak in during the day. With the radio blasting and tuned into the best jazz stations, I printed and processed my film into the early morning hours. They advertised what was happening on the local jazz scene, and it just seemed logical to go and record some of those terrific talents.

Good neighbors on the next street, Cyril and Martha McGeein, had two daughters, Celine and Theresa. Theresa was a dancer, and I took some photographs of her, and then of some of her dancer friends, and from there it all seemed to snowball. One contact led to another, and eventually I found myself on the masthead of *Dance* magazine.

Martha McGeein was dynamite, and she latched onto me, involving me in all sorts of her pet projects. She was truly indomitable. She had muscular dystrophy, and while she couldn't physically move, she moved mountains from her home, managing all of the MD programs from her stationary spot in her sunny dining room on Curson Street.

I was taken on various field trips and picnics. We went to see the Mission in Santa Barbara, and her daughter Celine was often my guide. (She later became my secretary.) I was only one of Martha's disciples, for she could see how limited so many young people's horizons were. She was one of the special people who helped me on this journey.

Alice Cavers, photographed at
the Eugene Loring Dance Studio, Hollywood.

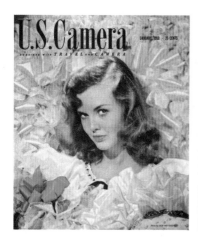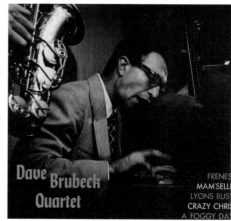

My first national magazine cover came in January 1950 for *US Camera*, with my photograph of Ann Baker, and then *Popular Photography* used my montage of dancer George Zorich, also in January of that year, which was encouraging (above, left and center).

While working in my darkroom late at night, I used to get a program from San Francisco, featuring the Dave Brubeck Quartet. I thought they were sensational, and when I read that they were coming to The Haig, in Los Angeles, I made arrangements with Dick Bock to photograph Dave and his group.

I sent Dave some of my pictures as I normally did, and one morning I received a telephone call from Sol Weiss at Fantasy Records in San Francisco. He had seen the photograph (above right) and wanted to use it as their first photographic cover. He and his brother Max Weiss were coming to L.A. and wanted to meet with me.

Meeting the Weiss brothers was an event like no other. They were great and special characters, and we became the best of friends. They promised to send me a copy of every record in their catalogue, if I agreed to let them use the shot of Dave.

That didn't sound like too bad a deal, so I agreed, and in due time the albums arrived in a large box with dozens of records. What they hadn't told me was that Fantasy pressed Chinese stories for one of their clients in San Francisco, and I found myself in possession of a fine collection of Chinese soap operas! Of course they had other artists that I did enjoy, but it wasn't the last time the doorbell would ring, and there would be an unusual present from Sol or Max.

I enjoyed photographing musicians, and I thought I could take my photographs and hear a concert at the same time. That didn't turn out to be the case. On the first concert that I covered backstage, I realized, as I was driving home, that I hadn't heard any of it. While I can often do two things at once, the concentration when I am photographing excludes everything else.

Coleman Hawkins backstage at the Shrine Auditorium,
after one of Gene Norman's "Just Jazz" concerts, Los Angeles, 1950.

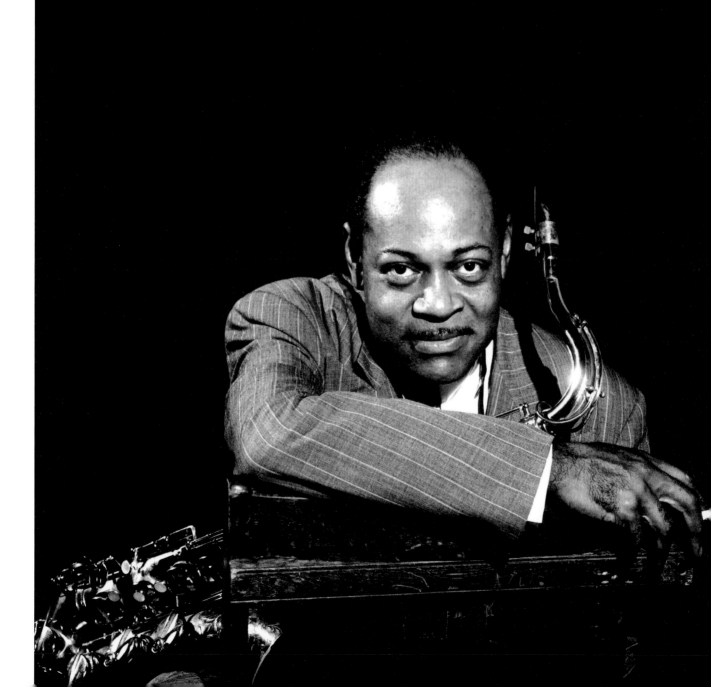

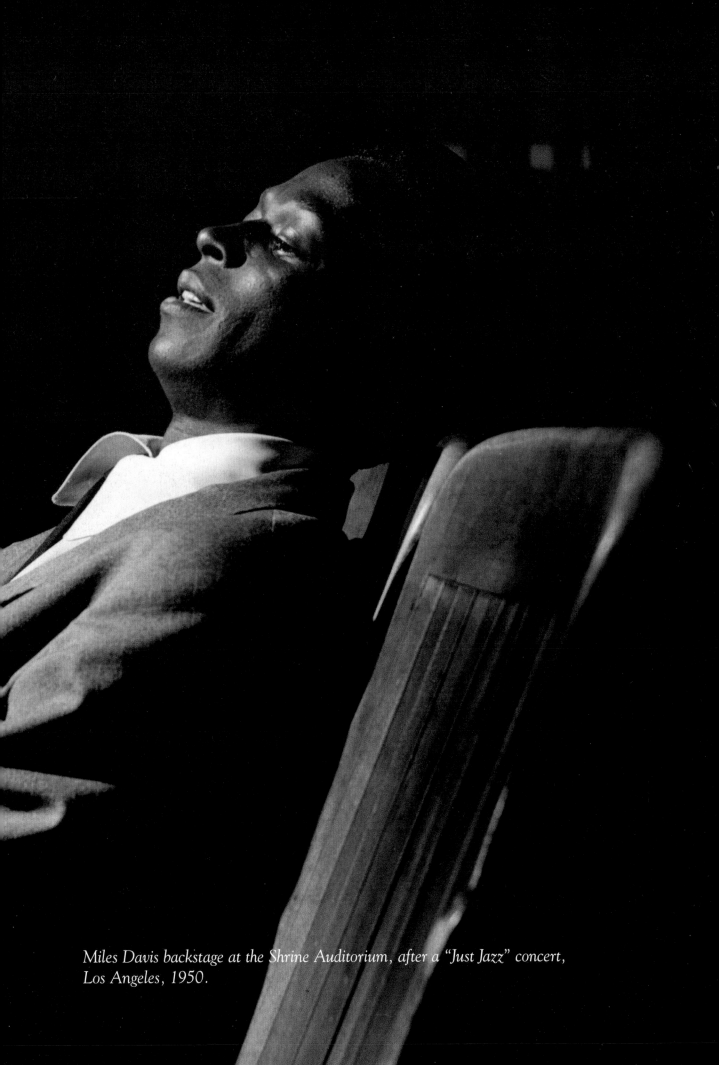

Miles Davis backstage at the Shrine Auditorium, after a "Just Jazz" concert, Los Angeles, 1950.

The Cornet Theatre on La Cienga Blvd. was the best place to see all the foreign and experimental films, and I went there often. I held my first exhibition there in 1951, and it became a turning point in my career. Igor Stravinsky, who lived in L.A. at the time, visited the theatre one night and made a special point to tell the manager how much he liked the exhibit, which was thrilling to me. More important to my career, Globe Photos' west coast director Charles Block saw the exhibit, and asked me if I would like to join their agency.

He personally took my work back to New York and showed it to Alexey Brodovitch, the great art director at *Harper's Bazaar*. When he told me that Brodovitch had liked my work and they had given me my first assignment, I almost cried. It had been five years since graduating high school, and I had worked and studied so hard and seemed to be going nowhere fast, and now finally a breakthrough.

It was about this time that I started haunting the used magazine shops in Hollywood. I spent every free night I could, going through years of back issues, occasionally buying some (otherwise they would have thrown me out), and discovered that almost every magazine had its own look—a look that their readers were comfortable with, from type-face and page layout to the photographic style. This was consistent. *Collier's* didn't want to look like *The Saturday Evening Post*. Likewise for *Life* and *Look*, *Harper's Bazaar* and *Vogue*. Being familiar with these individual styles was the key to my success when I started working for the studios. They never could figure out how I sold my pictures to the magazines, when they couldn't give theirs away, and I never told them my secret.

(left) Wardell Gray and his combo backed Billie Holiday, and was like a fresh blast of oxygen after Billie had sung her melancholy songs. Tiffany Club, Los Angeles, 1951.

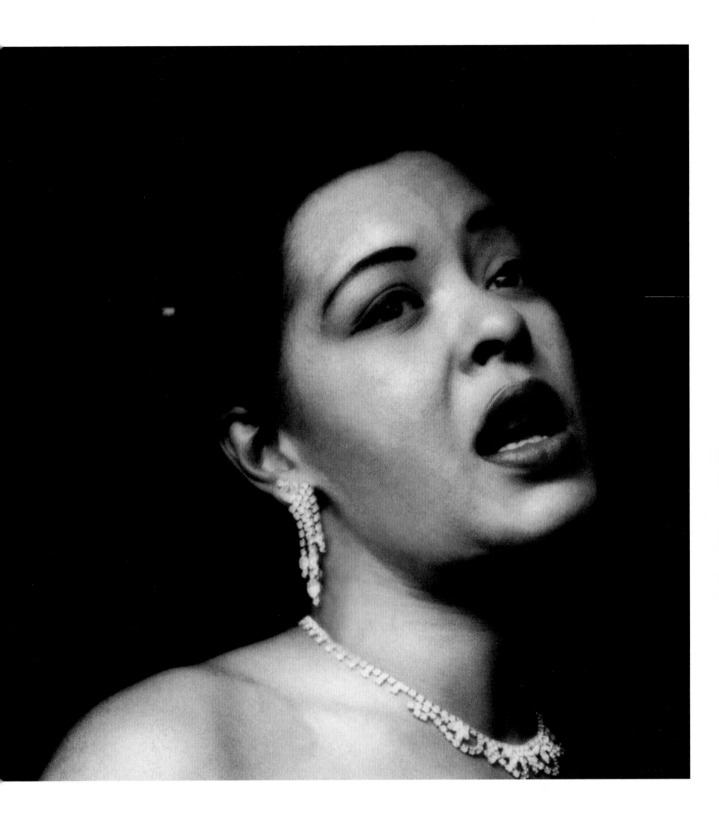

To me, Billie Holiday was magical, for she touched one like some remembered sorrow when she sang. When I read that she was coming to Los Angeles, I made arrangements to take photographs. She was no disappointment. It still sends shivers up my spine to think back on those plaintive, wistful songs she sang. After the set, she invited me back to her apartment and asked me to take photographs of her wearing some of her favorite hats.

How could I refuse "Lady Day" anything? She was gentle and sweet, but overwhelmingly sad.

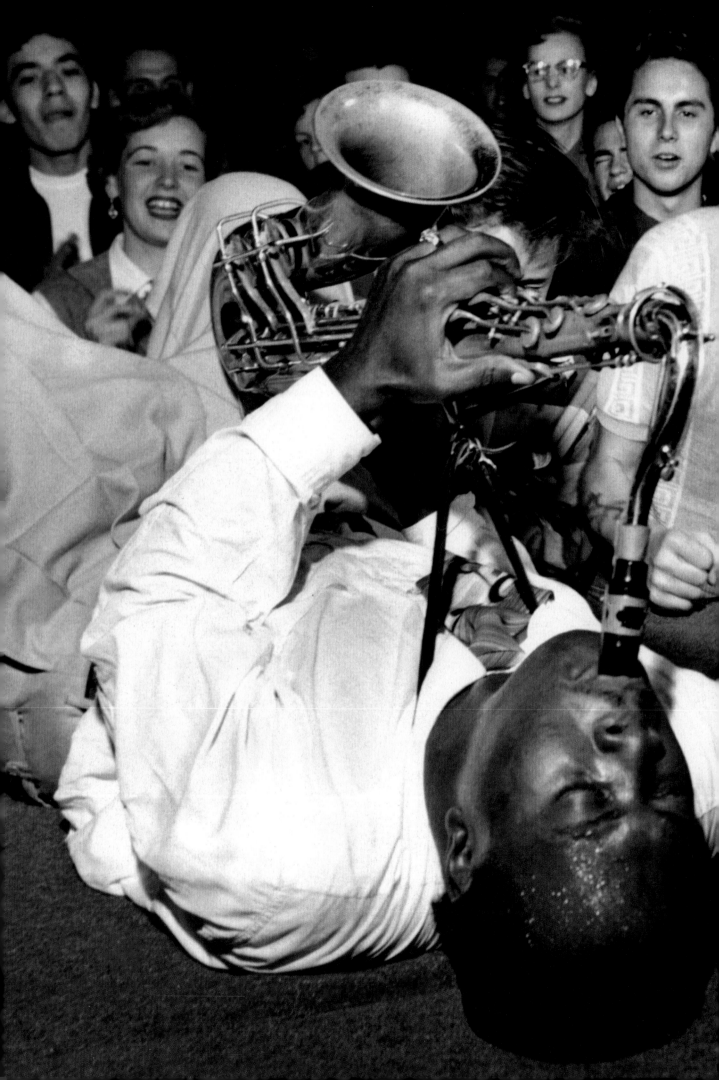

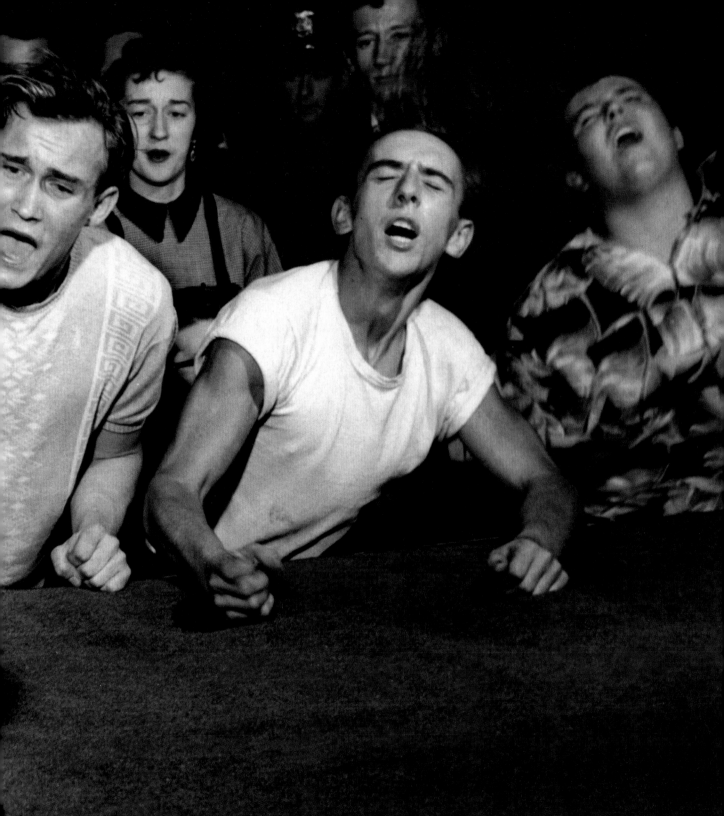

In one of his marathon numbers, Big Jay McNeely is seen here driving his fans absolutely wild as they scream "GO! GO! GO!" Sometimes playing 45 minutes at a stretch, Big Jay became soaking wet. At one venue in San Diego, he led the entire audience out of the auditorium and around the block, much to the dismay of the local police. You see him here honking away at a late night concert put on by a local Los Angeles disk jockey, Hunter Hancock. Notice the badge on one of the policemen's hats (top right) who were patrolling the concert. Olympic Auditorium, 1951. (This set became part of the exhibition in NYC's Museum of Modern Art: "Always the Young Stranger." 1953.)

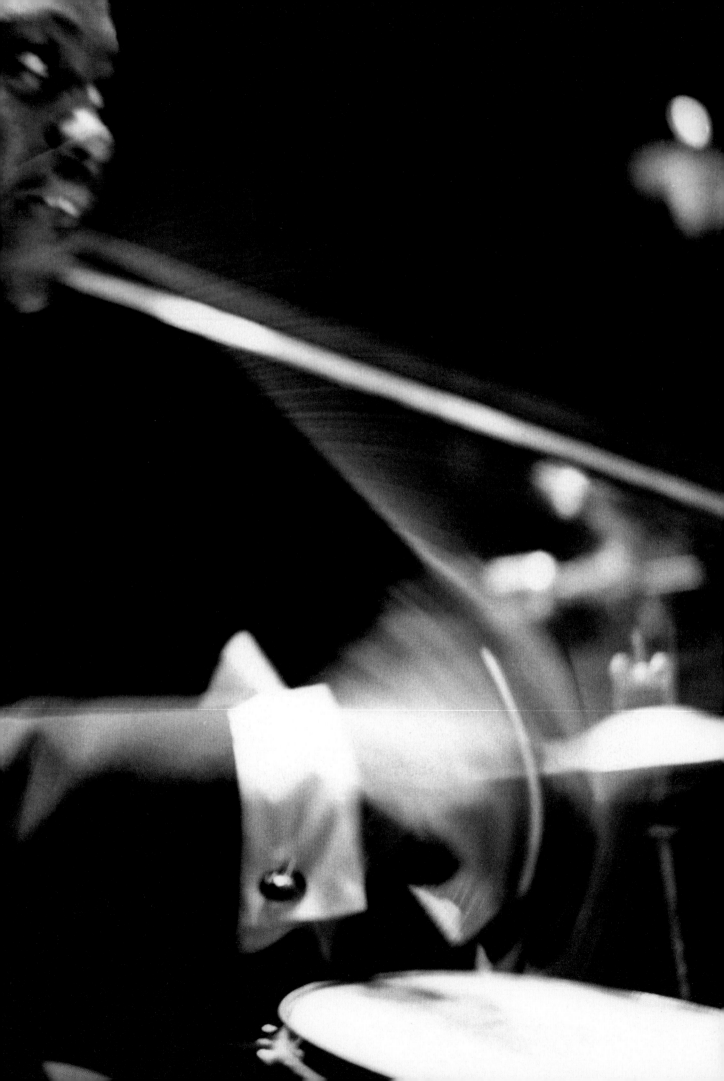

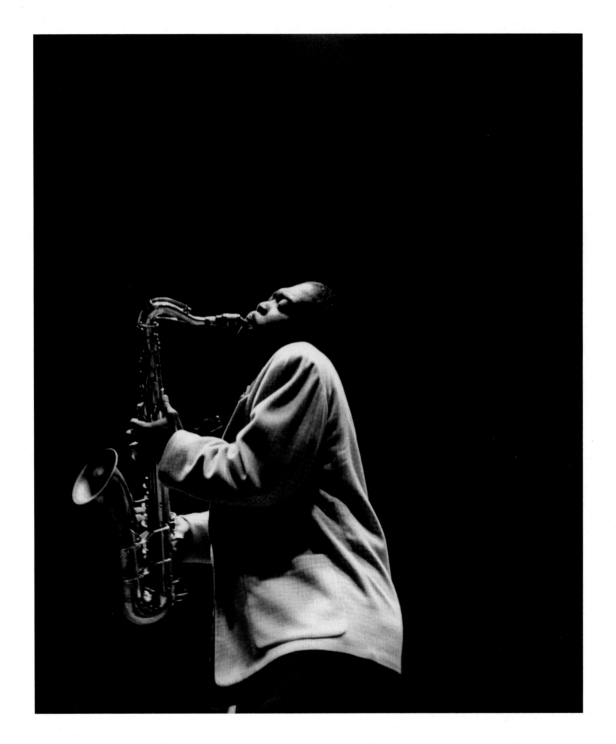

I had heard about these late night concerts, but nothing prepared me for what I saw and heard. When I arrived, I thought there was an earthquake. The place was literally rocking. I cannot describe it. This building, normally used for prize fights, was actually moving. It was truly fantastic.

I was so excited by what I saw that I jumped up on the stage where Big Jay McNeely (above) was playing, and got these amazing images of the crowd's reactions to his music. On the facing page is his drummer Al Bartee, who kept the explosive atmosphere at truly seismic levels. (Olympic Auditorium, Los Angeles, 1951.)

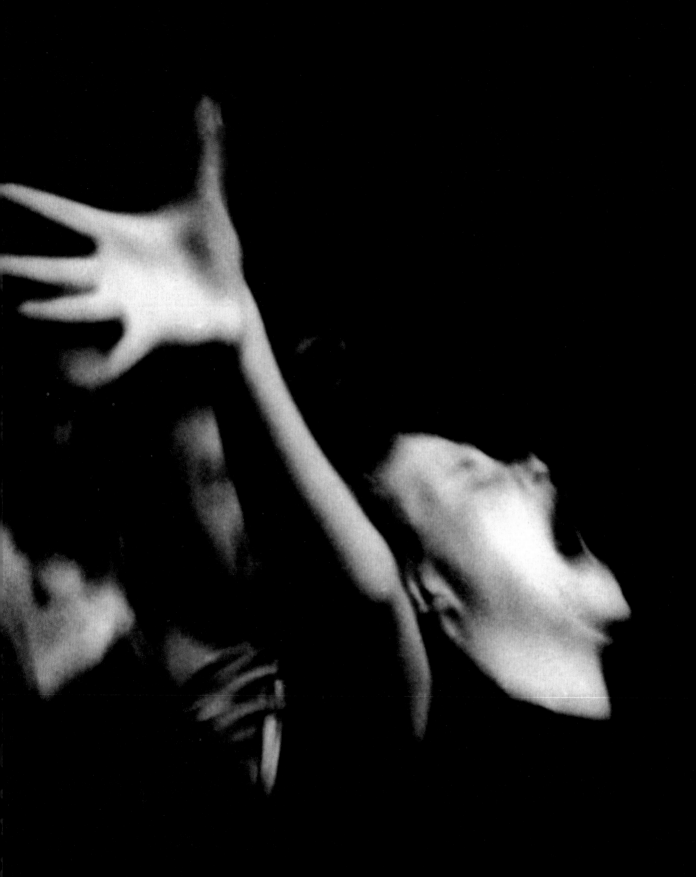

The crowd reaction was mind-blowing. These girls were orgasmic with Big Jay's constant rhythmic repetition. It was mad and wonderfully exciting. Los Angeles, 1951. (This image became part of the Museum of Modern Art's famous exhibition "The Family of Man," which traveled all over the world in 1954.)

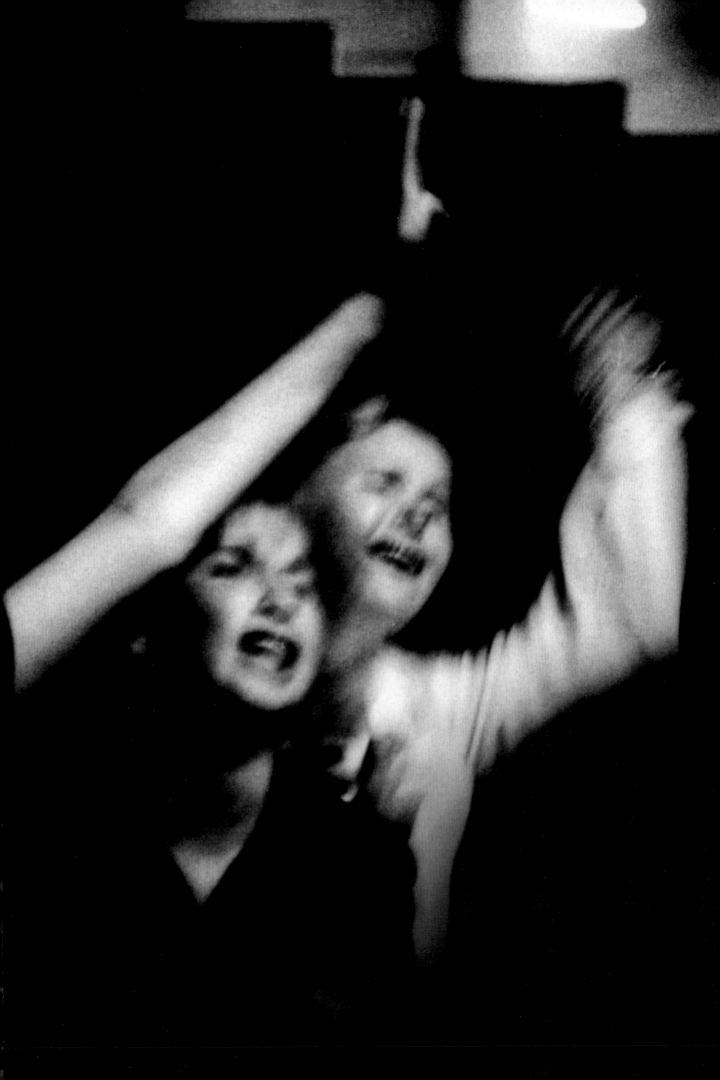

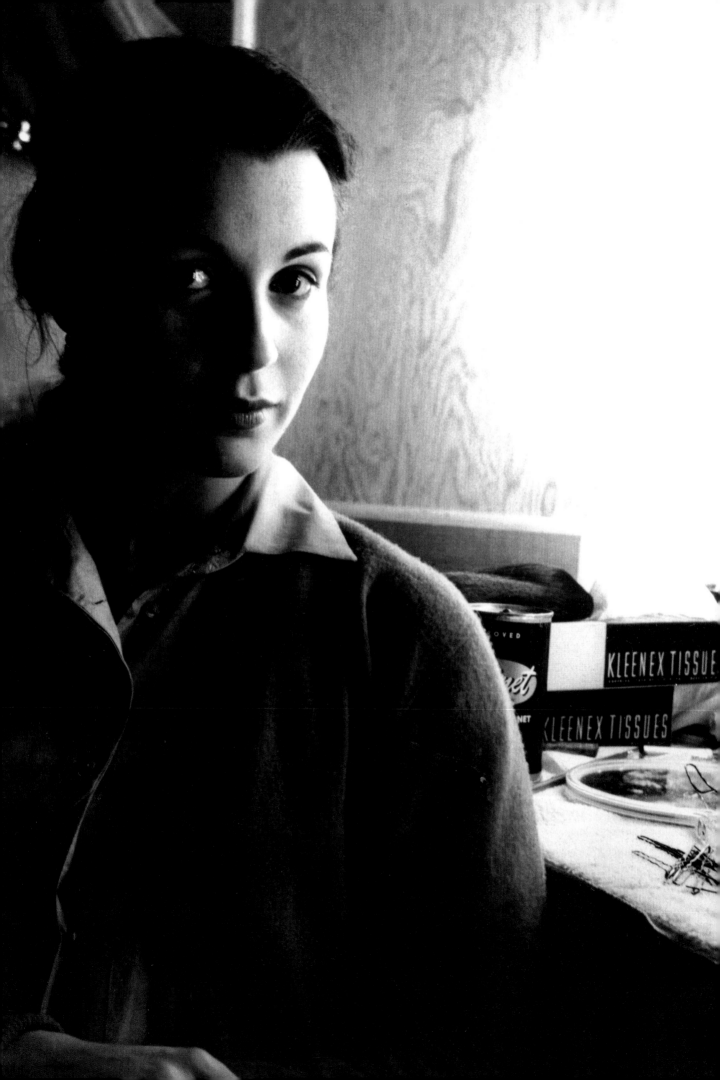

I found some massive war-surplus aerial photography scrapbooks with black pages. When I brought my magazines home, I tore out my favorite images and pasted them into the book in sections, as portraits, fashion, advertisements and so on. I kept another of these huge books for painting and sculpture. When I found a new photograph that I liked better than a previous one… out it would go. In this way, I constantly kept editing and (I hoped at the time) improving my eye. Recently, when I went back to Ireland to visit my daughter Catherine and her husband Rob, I discovered these books were still under their bed after all these years.

Three photographers seemed to be selected more often than any others—Henri Cartier-Bresson, W. Eugene Smith and Irving Penn—quite a diversity of style, and I learned from each of them. Cartier-Bresson has an amazing eye for composition, and his use of space is unique. Edgar Degas, the painter, had influenced my composition, by the unique way he placed the weight of the images on his canvas. I find Cartier-Bresson's photographic images have this same tension.

W. Eugene Smith touched me emotionally where Cartier-Bresson did not. Gene Smith obviously felt things very deeply, and sought the human element in his images. The things that Gene did for *Life* have still, to my mind, never been topped by any photojournalist. Photojournalism is now a thing of the past, so Gene will keep his place at the top of the heap. I only crossed paths with him once, when I watched him photographing Charlie Chaplin for *Life*, on *Limelight*. *Life* had the exclusive, so I was not allowed to take pictures on the set, but I sat in the audience and watched Chaplin and Buster Keaton work out a comedy routine with a piano, and it was a memorable occasion. *Harper's Bazaar*, on one of my first assignments for them, asked me to photograph the young Claire Bloom, so I had to work around the master.

Irving Penn has a wonderful style all to himself, and he taught me the value of seeing the figure as sculpture. He refined his elements down, in elegant style. I think he is also unique in what he did. His color still lifes and the photographic series he made of the Peruvian natives in the old portrait studio he found there are superb. I still have a collection of his covers and layouts in the garage to this day. I just can't bear to part with them.

It is interesting to me that Penn and Cartier–Bresson were both painters, and it was only late in my life that I discovered that Degas was also a photographer! Not that these disciplines are interchangeable, but they continue to influence each other, and I have certainly learned from both in the design and composition of my own work.

Claire Bloom in her dressing room, when she was filming Limelight *with Charlie Chaplin. Selznick Studios, 1952.*

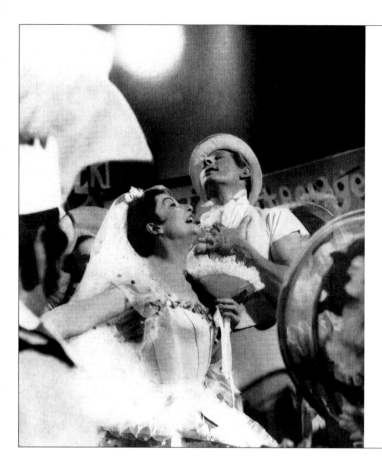

←—— Renée Jeanmaire and Danny Kaye

A Time for Witches
and Princes

• Hans Christian Andersen's fairy tales are coming to life on the screen. Scenes on these and the next two pages, from the film in-the-making, were photographed on the set. Danny Kaye plays the cobbler storyteller who interprets the Dane's bewitching, dreamlike remembrances of childhood. He is assisted by a trio of Parisians: Renée Jeanmaire, who danced *The Diamond Cruncher* and *Carmen* ballets in Paris and New York; Roland Petit, her partner, who is doing the choreography for *Hans Christian Andersen*; and Antoni Clavé, drafted to do the sets and costumes. Two sprightly Broadway talents, Moss Hart and Frank Loesser, also had a hand in the adventure: one writing the script, the other the music. A December release is in the cards for this Samuel Goldwyn film.

BOB WILLOUGHBY

"Hans Christian Andersen," with Danny Kaye and Zizi Jeanmaire, was my second *Bazaar* assignment, and my first experience of really working for many days on a film set. It was terrific, and I was fascinated by the entire process. While I was watching rehearsals one day, a gray apparition approached me. (I say 'gray' since he had gray hair & moustache and was dressed all in gray, even his shirt and tie were gray, and he had gray cigarette ash down the front of his suit).

He was asking me about my camera, and I was a bit distracted, since I wanted to watch the action on the set. He persisted and I finally told him that I had an Eastman Kodak reflex camera. (It was the closest thing I could get to a Rolleiflex since the war.)

The gray man turned out to be Gjon Mili, the great *Life* magazine expert on strobe-light photography. I was so embarrassed, talking about my little camera, thinking he was just some amateur, when in fact he had lit the entire set with huge banks of strobes, and had half a dozen assistants helping him.

He showed me his unique camera that he had made, with an incredible wide-angle lens. You can imagine how I felt.

He was very kind to me, and we kept in touch over the years. I really enjoyed his company. He had great stories and could go on for hours. He was a brilliant photographer.

Harper's Bazaar used four pages of my photographs in their July 1952 issue (see above).

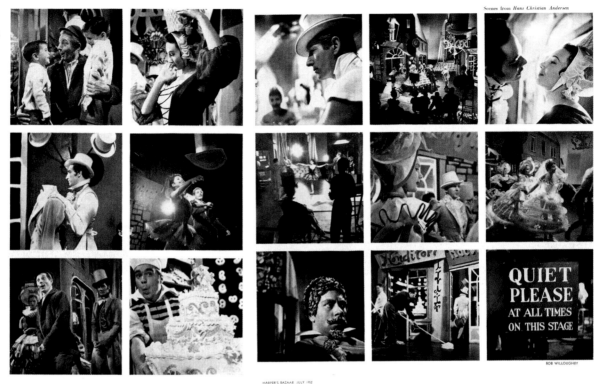

I spent one memorable evening many years later with Mili, Eliot Elisofon, another fine *Life* photographer (and gourmet cook), and Alexander Schneider, the first violinist with the Budapest String Quartet. It was St. Patrick's day, and New York was snowed in. The streets were impassable, and Mili whipped us all down to the subway and then to a Chinese restaurant that was obviously a favorite of his, and we ate in the kitchen. They told me this was a great honor!

Coming from Los Angeles and taking a subway for the first time was one thing, but eating in the kitchen, with the waiters rushing around us, and yelling orders in Chinese, I felt as if I were in some New York twilight zone.

By this time I had given up my Speed Graphic, my view camera, my flash bulbs, all of my studio lighting. The photojournalistic style of *Life* had influenced photography all over the world, and I was no exception. In 1983, Star Black, writing an article in *Popular Photography* about my work, headed the article with: "A retrospective look at the multifaceted career of the man who virtually invented the photojournalistic motion-picture still."

The problem was getting an exposure in low-light conditions, especially with a reflex camera and a f3.5 lens. We didn't have the fast films in the early '50s that we have today. We had to experiment with film developers and "push" the processing of the film to make it faster. Heating the developer was one of the techniques, but that often ended up in disaster with reticulated film.

My agent Charles Block called to tell me that 20th Century Fox had a press call for a party that was to honor Marilyn Monroe, and he wanted me to cover it.

Ray Anthony, the popular band leader, had written a song called "Marilyn," and there would no doubt be other celebrities to photograph. I told him that I just didn't feel this was my kind of photography, but the logic of his argument was too irresistible. "You need money to pay the bills, and anything you get on Monroe will sell!"

Reluctantly, I went. There were at least 50 other Hollywood photographers there, waiting for Marilyn to arrive. Fox had flown Marilyn from the studio to the party in a helicopter, hoping to make a dramatic entrance. As the chopper was landing, the downdraft blew all of the umbrellas, the music from the orchestra, several ladies' hats and God knows what into the pool. I was standing up above, laughing at this scene.

The photographers all rushed toward the landing helicopter, and I just stood where I was. And then an amazing thing happened: Marilyn walked right up to me, with all of the other photographers trailing behind her. For one very brief moment I had her alone. It was probably the only single shot of her that was made that afternoon, and it was just pure luck.

As I was about to take the photograph, and looking down at her through my reflex viewfinder, I could feel the hairs on the back of my neck rising. Marilyn had some sort of energy field that it would seem she could switch on or off when she posed, which I don't think I will ever see again. Hollywood's publicity departments called it sex appeal and thought it was achieved by showing cleavage, but they missed the point. This attractive energy is something you are born with. It is there to see at any age. Some people have more, some less, and I prefer to call it gender. (Beverly Hills, 1952.)

Look gave me an assignment in 1952 to photograph feathered hats at the M.H. deYoung Museum in San Francisco—my first fashion assignment for a national magazine, and I had never photographed hats. The *Look* fashion editor had picked a model who I had never seen, and the plan was to meet at the airport. When I first saw her, I almost went into shock. Here was a girl with her hair wrapped up in a scarf, no makeup, and she was probably a foot taller than I was. I couldn't see how in the world I could ever photograph her.

To make matters worse, I had never flown on an airplane and I was going to a strange city for the first time, with a model I didn't like. My stomach was in turmoil, and I was certain this was going to be a disaster.

I can't even remember taking a taxi to the museum, or who I met. The model went off to dress, and I started loading the camera and looking for a place to do the first shot. When she emerged, I could not believe my eyes. She was beautiful.

It was my first experience of working with a high-fashion model. She was a terrific and elegant model, and *Look* ran the pictures.

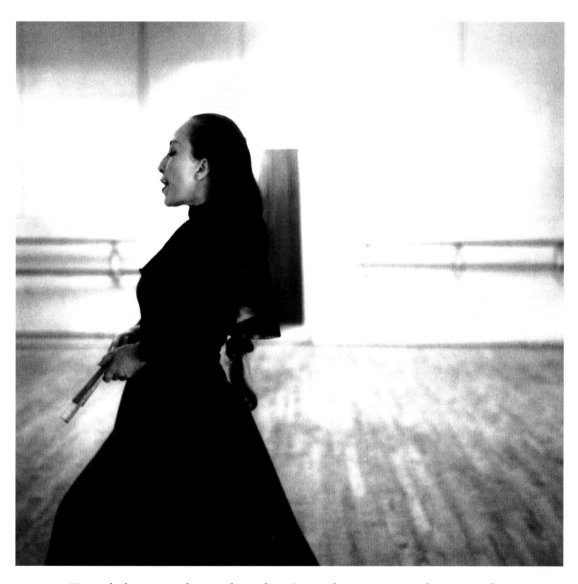

Famed choreographer and teacher Carmelita Maracci rehearses in her Los Angeles studio, 1953.

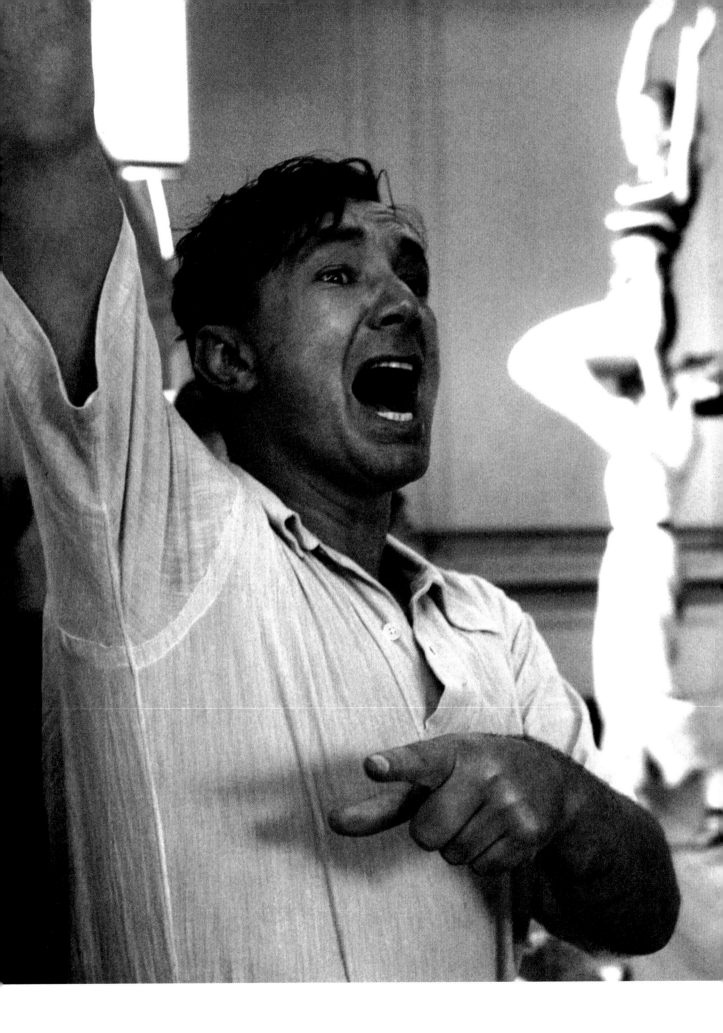

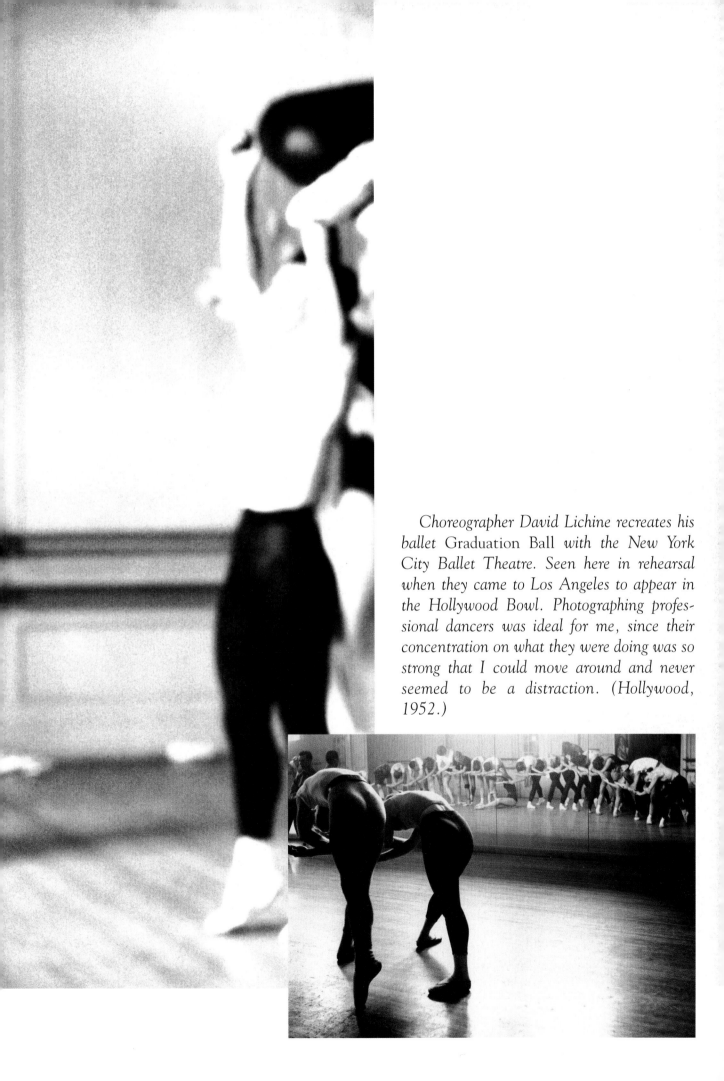

Choreographer David Lichine recreates his ballet Graduation Ball with the New York City Ballet Theatre. Seen here in rehearsal when they came to Los Angeles to appear in the Hollywood Bowl. Photographing professional dancers was ideal for me, since their concentration on what they were doing was so strong that I could move around and never seemed to be a distraction. (Hollywood, 1952.)

Eva Loraine was the director and teacher of The Children's Ballet Company in Pasadena. They were giving a concert at the Wilshire Ebell Theater, and *Redbook* magazine assigned me to cover it. The shot of Bonnie Patterson (below) dreaming in the wings was made there. I was so intrigued with the group that I went several times to photograph them at work.

The photographs ended up in many magazines, including a layout in *Dance* magazine (bottom of facing page). The little girl on the cover is Cynthia Gregory, who went on to become the prima ballerina of the NYC Ballet.

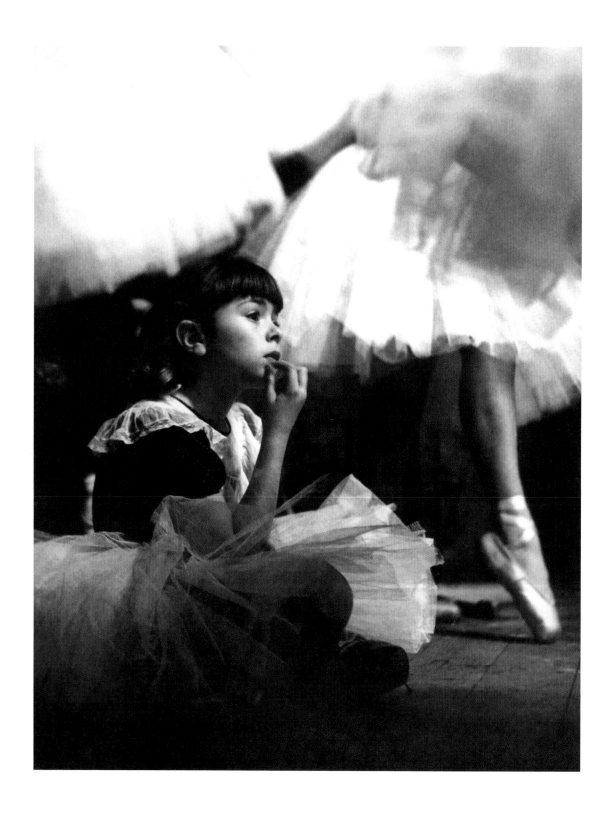

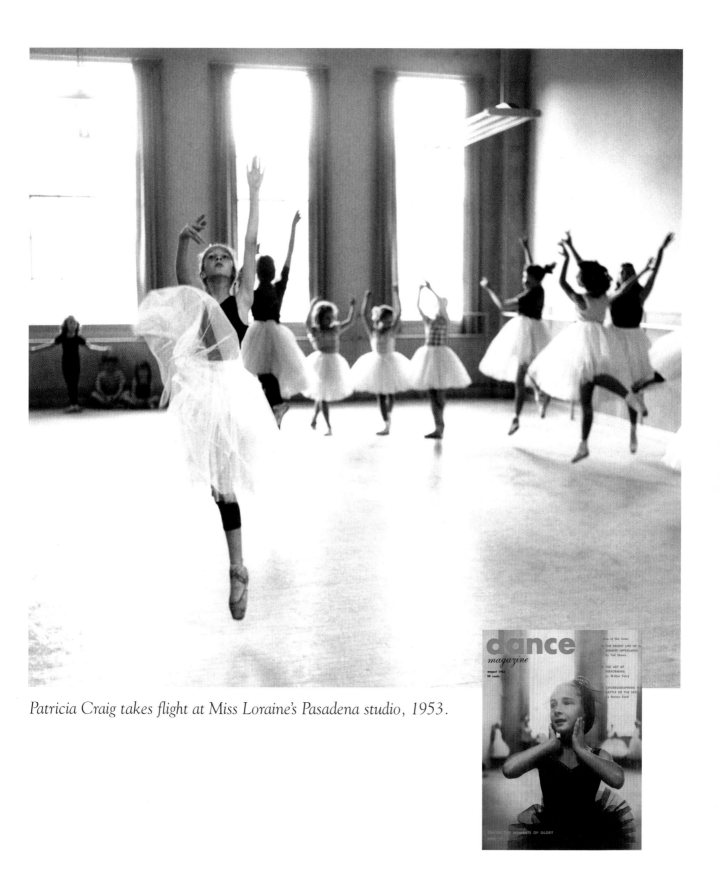

Patricia Craig takes flight at Miss Loraine's Pasadena studio, 1953.

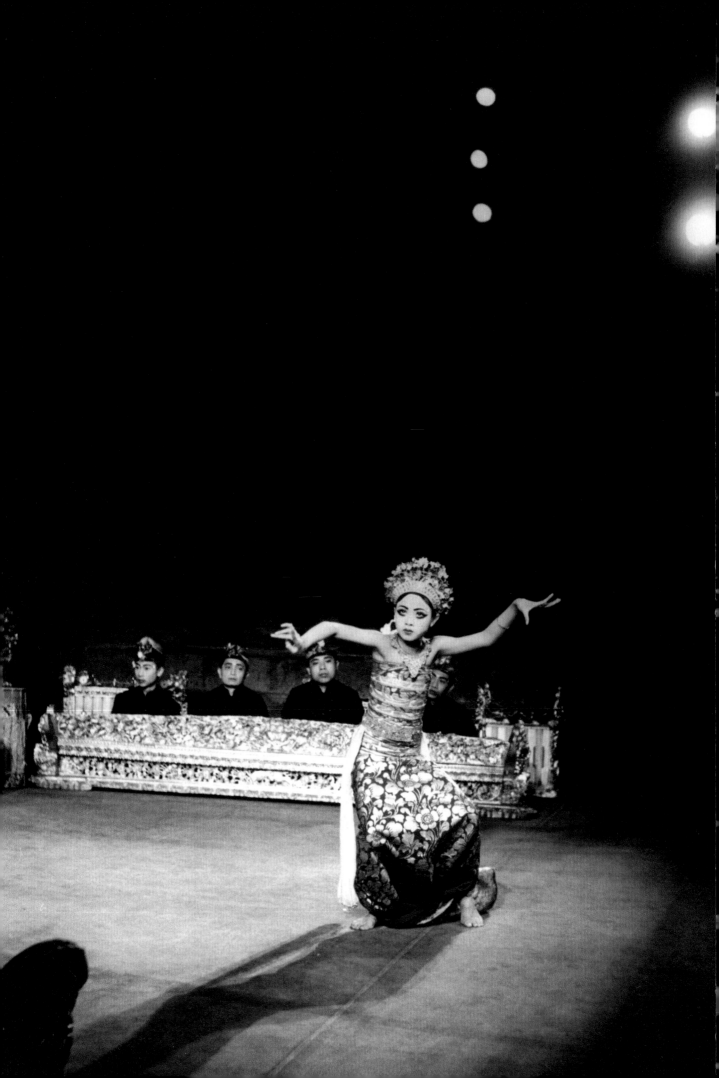

Marge and Gower Champion, on the MGM set of Lovely To Look At. *The Champions were a terrific team on and off stage. Working with them was always an easy and happy occasion.* Harper's Bazaar, *1952.*

(facing page) The delightful Dancers From Bali arrived in Los Angeles and won my heart. Little Ni Gusti Raka weaves her enchantment in the Legong dance, accompanied by the exotic sounds of the Gamelan Orchestra, 1953.

Normally defying gravity, dancer Gwen Verdon is seen here in a rare tranquil moment, posing for her Harper's Bazaar *portrait in 1953, when she was dancing up a storm in* Can Can *on Broadway.*

(facing page) Judy Garland reprises her "We're a Couple of Swells" number, in her International Variety Show. Los Angeles Philharmonic, 1953.

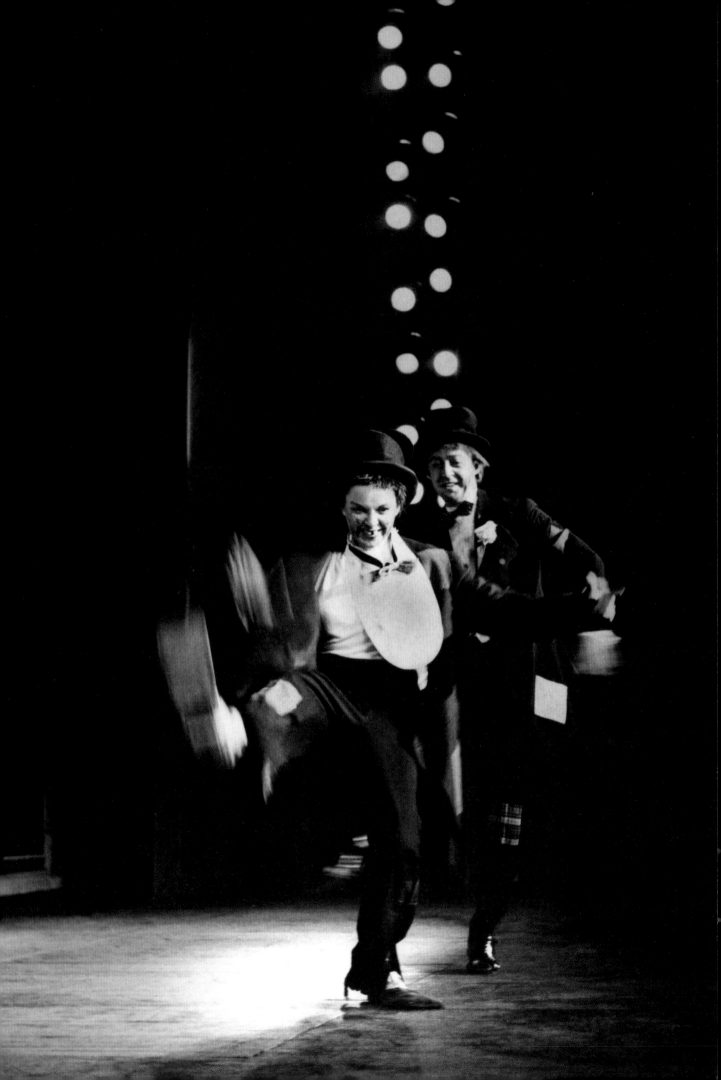

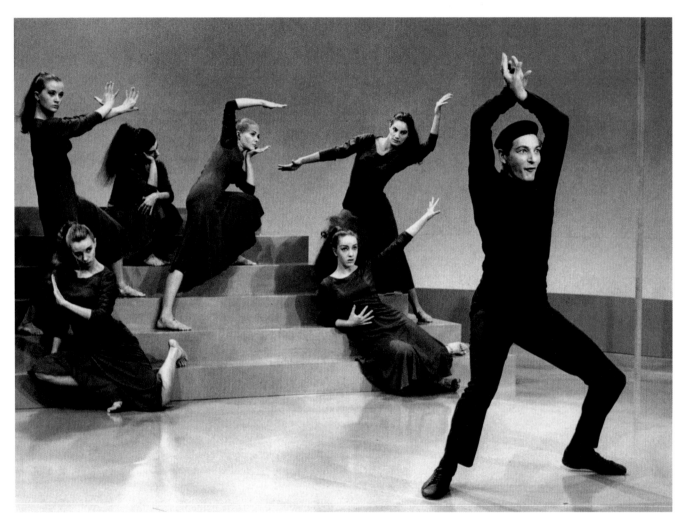

Danny Kaye seen here in rehearsal on the set of White Christmas, *pokes fun at modern dance in his "Choreography" number. Paramount Studios, Hollywood, 1953.*

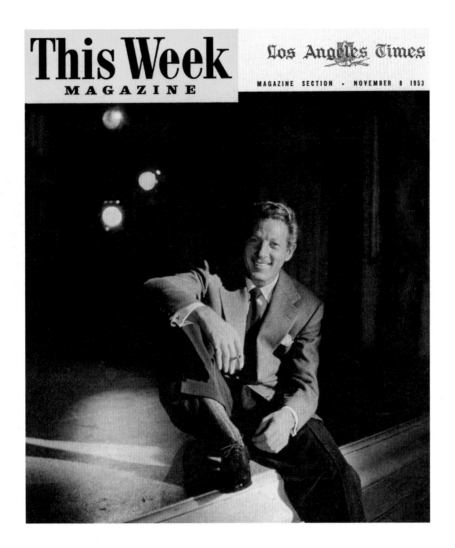

I always felt that Danny Kaye was funnier off the screen. I had the advantage of photographing the rehearsals, when he wasn't sticking strictly to the script. On one occasion, producer Melvin Frank looked at my photographs and said that he wished his film was as funny as the pictures I'd just shown him. I suggested that he roll the cameras during rehearsals, to catch that spontaneity and genuine humor he was looking for.

I needed to shoot the cover for *This Week* magazine, and asked Danny when we might do it. His first question was "How long will it take?" I said it would take about a half an hour. He stopped me, pulled me over to him, and like a kind teacher told me that I should never ever say something as realistic as that.

"Say that it will take only 10 minutes. That doesn't seem like such a big deal, then when you're there, and you're having fun, if it takes a bit longer no one will notice." He was absolutely right.

Danny had a great facility of mimicking different accents. I was with him on the stage at Paramount Studios, where he was filming *White Christmas,* and one of the lady visitors was French. He carried on a brief conversation with her, and turned around when called for rehearsal. The lady confessed to me that she knew he was speaking French to her, but she couldn't understand a word. He was that good. He told me that it had everything to do with cadence, every language having its own rhythm. I think it's more like "Kaye-dence." He had enormous talent and was a pleasure to work with. Paramount Studios, 1953.

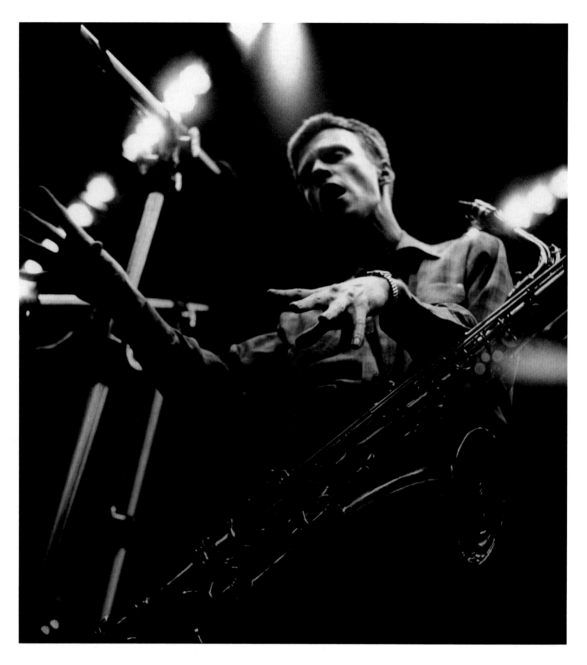

Dorothy Wheelock was the feature editor of *Harper's Bazaar*, and I would offer her suggestions on what was happening on the West Coast. Gerry Mulligan and Chet Baker were two of the personalities they went for. Gerry, with his big rumbling baritone sax, combined with the lean line of Chet's trumpet riding on top, created a special sound that became associated with West Coast jazz.

It had humor and drive, and made me smile whenever I heard it. I covered one of their recording sessions, and Gerry was in complete control. He knew exactly what he wanted; he heard his arrangements in his head. He sat at the piano, playing out chords for his sidemen, stopped them midsteam when it didn't please him. It was really a treat to be there.

I saw them perform at The Haig, the little club run by Dick Boch (who later had his own record company). If the patrons were not paying attention, as was the case the night I was there, he simply stopped the music, stood with his big hands folded over the sax, and waited. Saying nothing, just standing there. When the noisy ones noticed that the music had stopped, they knew why, for he was looking right at them. Then he would resume, having waited for their attention. (Los Angeles, 1953.)

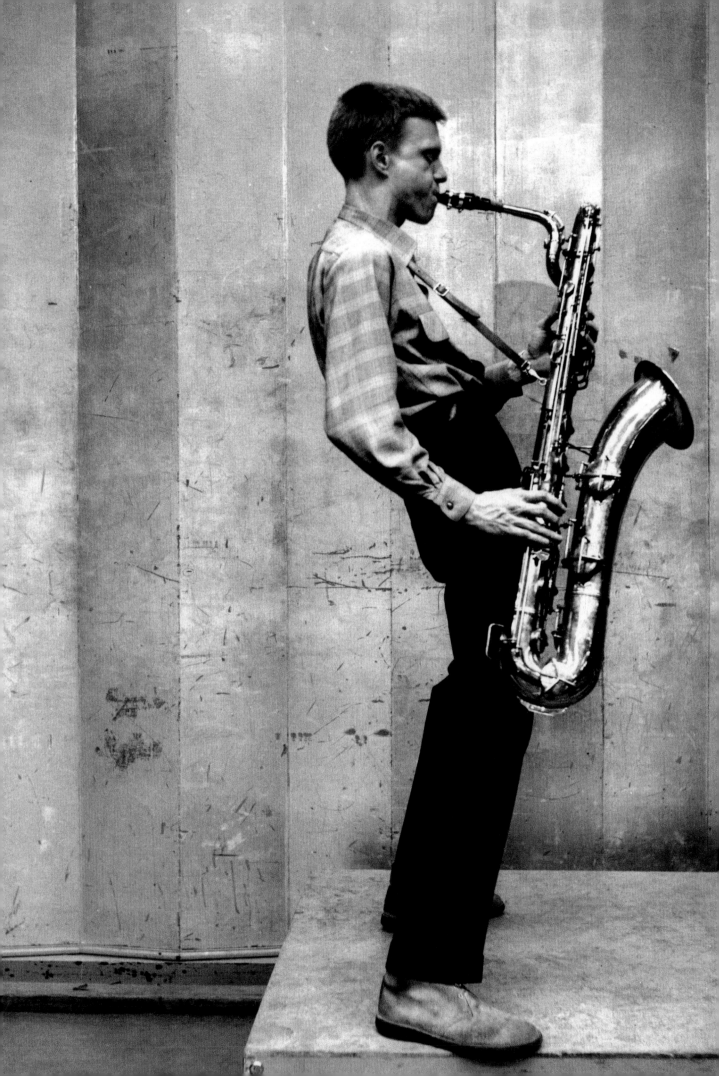

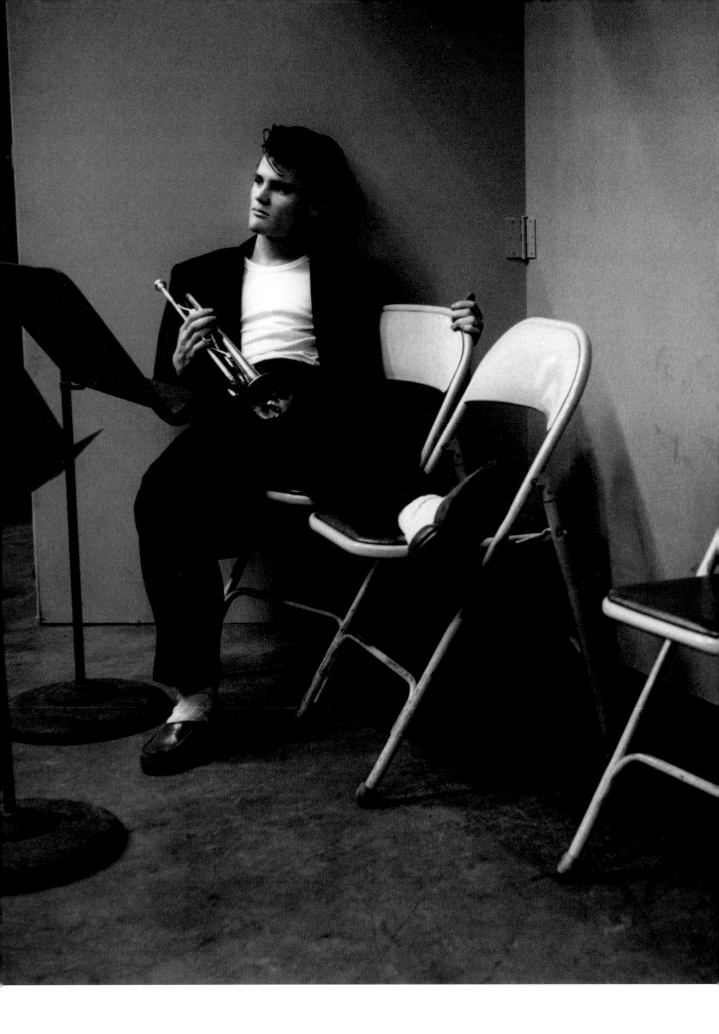

Chet Baker's "little boy lost" image suited the way he played and the way he sang. His phrasing in both was charming and sometimes had a melancholy quality that touched one's nerve endings. It made you want to hear him play it again. At one recording session, he cut a track of "My Funny Valentine" that the sidemen applauded when the recording was finished, something I've never seen again.

It may sound strange to compare Marilyn Monroe with Chet, but in retrospect they both had a wistful quality about them when they were not performing. Chet's life was a perilous run at the best, and now I feel somewhat sad for him whenever I hear his recordings. A rare and fragile talent. (Recording sessions in Los Angeles, 1953 and 1954.)

Mia Zetterling was brought over from Sweden, after much critical acclaim for her acting in Europe, by Paramount Studios to star with Danny Kaye in Knock on Wood, *both photographed for Harper's Bazaar, 1953.*

(facing page) Richard Burton in his second Hollywood film, after receiving an Academy Award nomination for My Cousin Rachel, *was photographed in his dressing room at 20th Century Fox Studios, when he was filming* The Desert Rats.

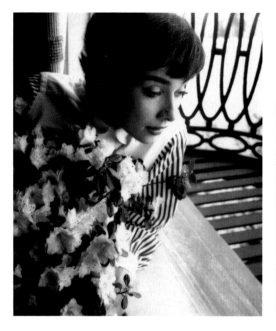

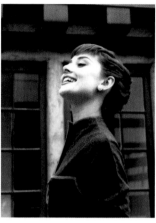

(*above left*) *Audrey in her Los Angeles hotel room. 1953.*

(*above right*) *Head up, finished with posing, walking happily to the car to take her home. Audrey was touring with the stage play of* Gigi *at the time, 1953.*

(*facing*) *Audrey Hepburn in the Paramount Studios still gallery; behind the camera, Bud Fraker, photographing Audrey for her first Hollywood publicity pictures.*

Charlie Block at Globe Photos called me at home and told me that I was to go over to Paramount Studios to photograph another new actress. She had just finished a film in Italy called *Roman Holiday*, and would be at the studio to do publicity shots. Young actresses were an everyday thing, and this assignment didn't especially thrill me. After all, I was now working for *Harper's Bazaar*.

When I arrived at the studio, the still session with the Paramount portrait photographer Bud Fraker was already underway. When there was a moment and I was finally introduced to this new young lady, I was completely disarmed. I had anticipated she would be pretty, but she was really something else. She had poise and self-confidence.

A beauty, yes, maybe a forest elf would be more apt? I thought, "well, here is someone special!" I wasn't the only one that felt this. I could see the way the crew working there that day treated her—not like the new kid on the block, but as if she were a known star.

It was Audrey Hepburn. I didn't know it then, but fate would happily bring us together many times over the coming years.

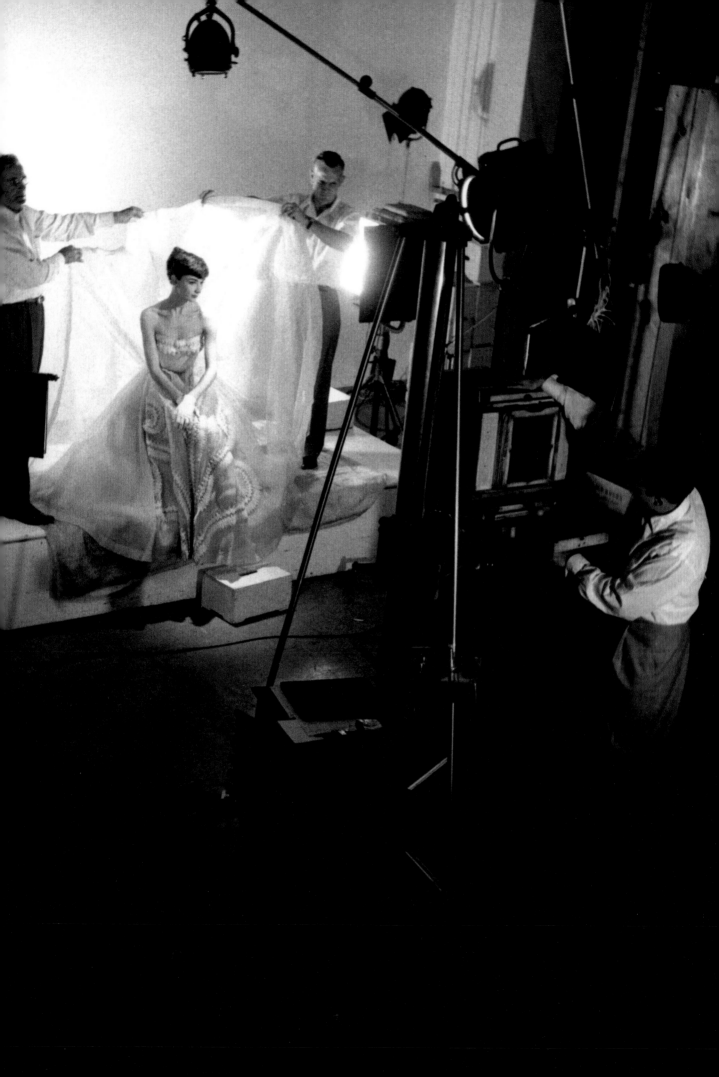

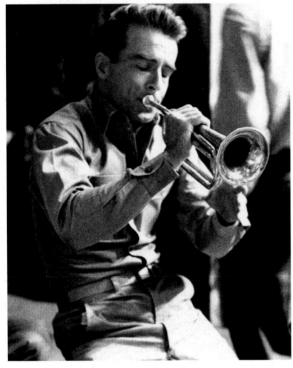

Collier's magazine assigned me to photograph Frank Sinatra on the set of *From Here to Eternity*. I drove over to Columbia Studios not knowing just what to expect, given the stories I'd heard about him. I cannot tell you how cooperative and helpful he was. We went off the set and shot pictures outside on the studio lot. We stopped for a Coke and had a fine time. He was really charming. The portrait of him in his dressing room is an example of "ol' blue eyes" at his best (facing page). Less than a year later, I went back to shoot some things on *Suddenly*. He had won his Academy Award, and here was a totally different character. I just packed up the cameras after trying to shoot a few frames and left.

While I was on the *Eternity* set, of course I shot other things, including the image of director Fred Zinnemann's hand (top) directing the grips and the camera crew where to put the camera for the next shot.

(left) Montgomery Clift as Prewitt playing his bugle. *Harper's Bazaar*, July 1953.

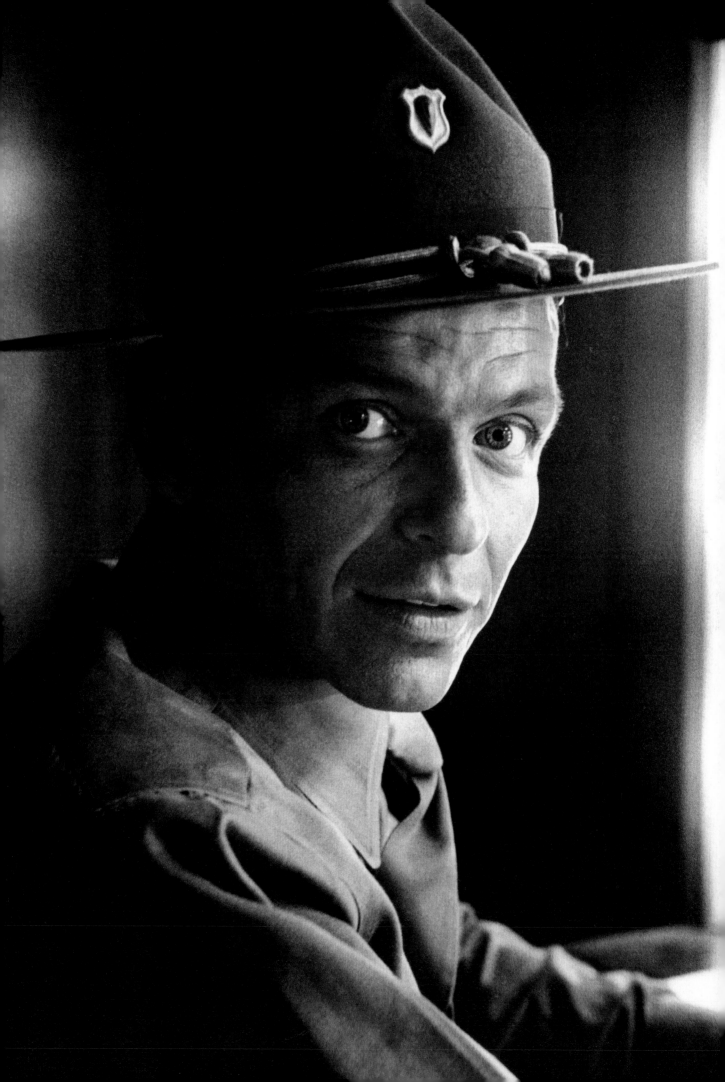

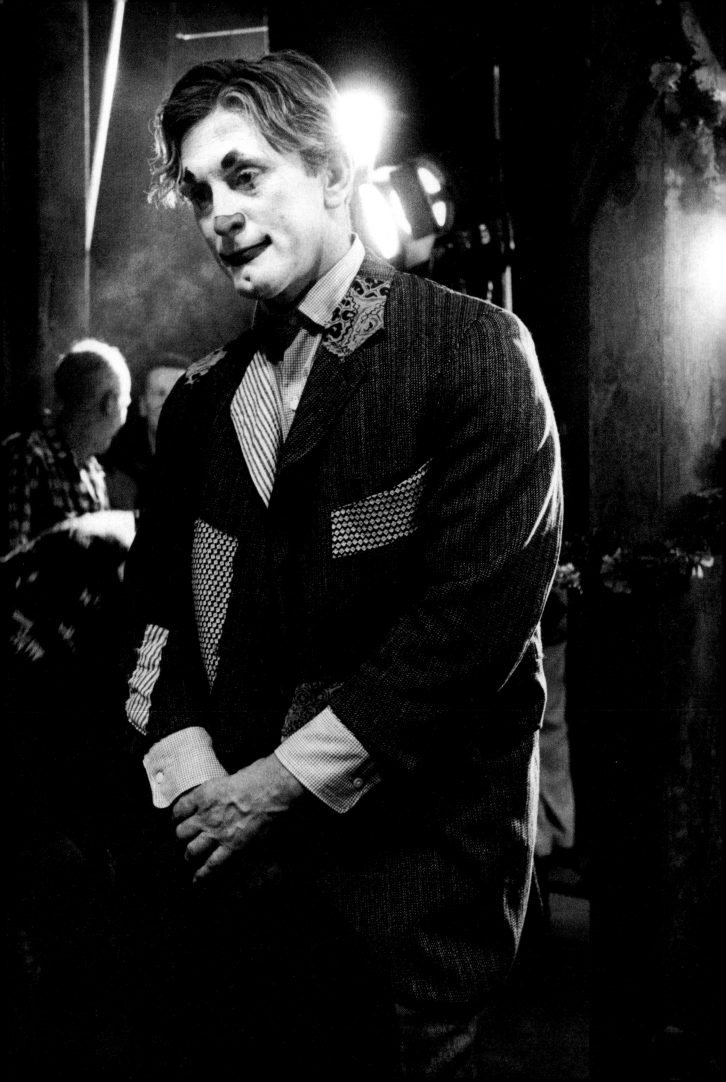

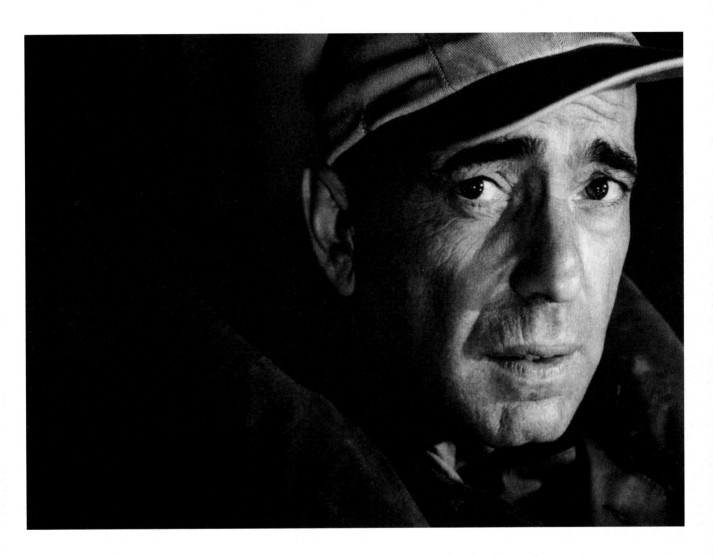

It was a thrill for me to photograph Humphrey Bogart. Columbia Studios had invited a group of photographers to the set when they were doing the storm at sea sequence, with tons of water splashing down on the set. I didn't know the story, and when they broke, I stopped to ask the director Eddie Dmytryk, to fill me in on what the action was that they were filming.

Bogart was talking to Eddie, and told me that I should have read the book, instead of "bothering our busy director!" He then proceeded to tell me the story, much to the amusement of Dmytryk. It was great just to hear his familiar voice directed to me. I knew he had not been serious in his reprimand, but to make sure I knew it, he kindly put his arm around my shoulder and walked me back to where they were filming. Columbia Studios, 1953.

(above) Humphrey Bogart as "Captain Queeg" in The Caine Mutiny.

(facing page) Kirk Douglas seen here waiting for filming to resume on the Columbia Studios set of The Juggler. *He is dressed for his part as a clown as he entertains the refugee children in Israel, where the film was mostly made, 1953.*

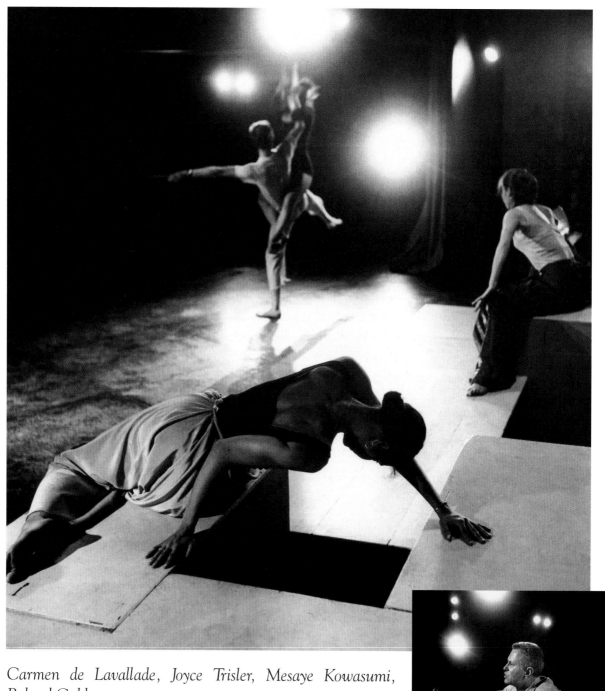

Carmen de Lavallade, Joyce Trisler, Mesaye Kowasumi, Roland Goldwater.

(right) Lester Horton directing. Los Angeles, 1953.

The Lester Horton Dance Theatre on Melrose was a small place with a heart. The graduates of Lester's became a roster of the best in modern dance: Alvin Ailey, Carmen de Lavallade, Bella Lewiztky, James Truette, and Joyce Trisler. Rudi Gernreich, the well-known west coast fashion designer, was at one time part of this group. Lester was one of the first choreographers to incorporate ethnic dance and music into his dances.

The dancers learned to play the instruments, make the costumes and paint the scenery. It was a terrific grounding in dance and theatre. I have never seen a group so dedicated, and they were wonderful to watch. I started taking photographs of the group, and there was a special beauty, Lelia Goldoni, with a profile like one of the Greek coins I always admired. I can still visualize the performances, and the memorable way she moved when she danced.

This was the time I started flying back to New York to meet the editors, and these were long flights, stopping in Chicago to change crews. I could sleep most of the way, which was a great asset, when one was working such long hours. Those five-minute naps I used to take were a life saver. One of my friends told me that once, when we were in the car driving somewhere, I fell fast asleep as I was talking to him, right in the middle of the conversation, woke up a few minutes later and carried on the same conversation to his complete amazement.

The feature editor of *Harper's Bazaar,* Dorothy Wheelock, happened to have a lovely daughter, Gay Edson. I was invited to their country house in Oyster Bay, and this was another nice time in my life and the first opportunity I got to relax. It seemed like I was always wound up like a tight spring. Here, I could go for a walk when I wasn't going somewhere. It sounds crazy, but this was a first. It was a time of Gay collecting wildflowers for the house, and quiet. Yes, quiet. Something I hadn't realized before, but something that I needed very badly.

In the morning, we would pick up Carmel Snow, the great fashion editor of *Bazaar*, and we would all drive into the city together. It was a way of life far from anything I had known before. During the day, I made my rounds of the editors, watching them down double martinis at lunch, and wonder how they did it—I discovered they weren't the geniuses that I had imagined they were, but mostly just hardworking journalists. In the evening, we would drive back to the calm of Long Island.

While I was in New York, Globe made appointments for me to see some of the fan magazines. This was something I felt was below "my work." I was very snobbish at the time. That attitude changed very quickly one afternoon. I was with one of the fan magazines, and sold them a cover of Kim Novak. They gave me a check for $450. Well that was nice, but the best part came when walking back to my hotel, I passed an antique shop on 59th street. There in the window was a gorgeous gold Spanish-18th century chalice, just winking at me.

I tapped at the door, and a lady came to open it. I asked the price of that treasure in the window. Yes, you guessed it, it was $450! (I had that beautiful chalice for 30 years.) Normally I never would have been able to buy anything that expensive, but now selling my photographs to the fan magazines seemed quite practical!

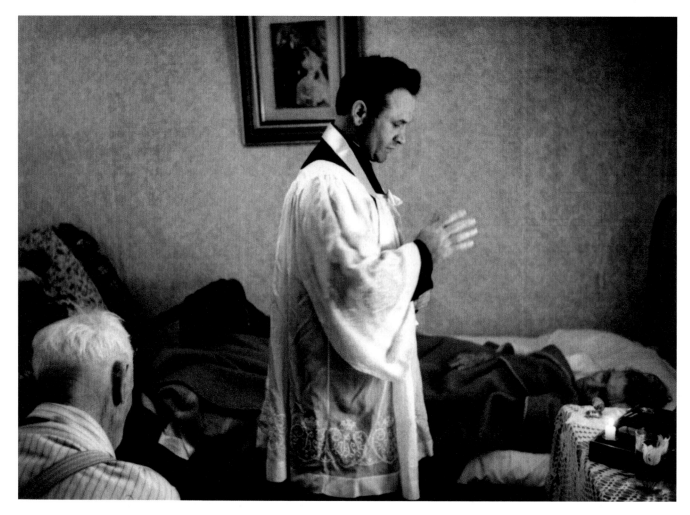

Fr. Gabrielli is administering the Last Rites of the church to this dying woman, while her husband kneels praying at the side of the bed. Their wedding photograph hangs above them in a poignant reminder of when they were joined, and now at the completion of their cycle together. Forbestown, California, 1953.

Jubilee magazine was a very special Catholic publication edited by Ed Rice, and the famous Catholic writer Thomas Merton was one of the contributors. They did marvelous picture stories, and I started working with them in 1953. My first assignment was to do an essay on a mountain priest, Father Virgil Gabrielli. His various parishes were in the old Gold Rush area in Northern California. He made his rounds to all of the small towns that were without a resident priest.

He was a certifiable character, careening around the corners in the mountains, with me "white-knuckling it," and him loudly singing Gilbert and Sullivan!

Looking over at my pale face, when once I thought we would go over the edge, he assured me that since he had an "in" with the Lord I should have more faith, that he would get me there in one piece.

He did more than just say Mass—he helped right the old tombstones in the cemetery, gave the children haircuts. Whatever was needed when they were short a hand, he was there for them.

Another one of my assignments from *Jubilee* was to photograph St. Labre's Indian Mission in Ashland, Montana. (This is near the Little Big Horn and Custer's Last Stand.) I was very impressed with the genuine kindness shown to everyone by the hardworking community running the Mission.

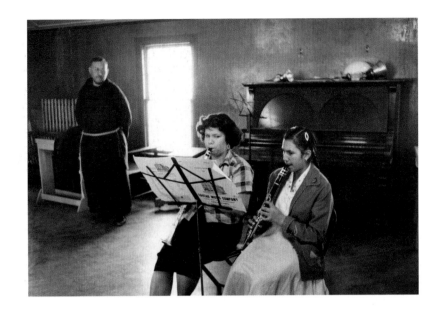

(above) Capuchin Monk Fr. Marion, OFM, listens to the music lesson of two Cheyenne Indian girls.

(below) Fr. Marion and Sr. Estrella on a windy day at St. Labre's Indian Mission. Ashland, Montana, 1954.

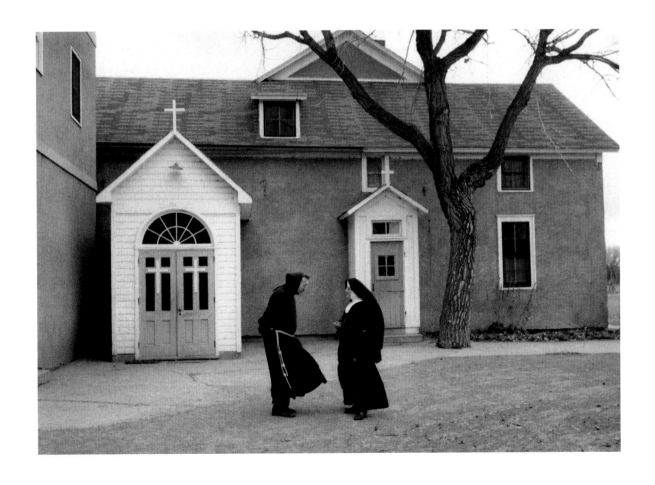

I had mixed feelings about New York. On one hand, it had all of the magazines that I needed to see, the theatre, the ballet and the Metropolitan Museum.

To digress a bit, I think one of the most important assets that I had as a young man was my ability to concentrate, and absorb information. I say this in retrospect, as I wasn't so aware of it at the time. As an example, the first time I went to the Metropolitan Museum. I waited for the doors to open one Saturday morning. The next thing, I noticed one of the custodians pulling the curtains of the top windows in the Egyptian section. I asked what was happening, for he was taking the light away from the art. He said that the museum was closing in a few minutes. I thought he was kidding me. I had been so absorbed in the museum all day, I was never aware of the time going by. This came as a shock to me. I returned Sunday, and much the same thing happened. I recall being very disappointed that I had never seen the treasures on the second floor.

The negative aspect of New York was the isolation I felt. Living in a hotel room, staring at the faceless buildings, I found myself sitting in Central Park in the evenings, not knowing exactly why, but needing nature around me, and the quiet of the early evenings. It was one of the reasons I took the assignment to shoot the Indian Mission in Montana. I could only take New York in small doses before it became oppressive.

As a young photographer, New York was my Mecca. I remember, just as I was about to make my first trip there to meet the editors, I was going along Santa Monica Boulevard in Los Angeles, and an antique store I had never seen caught my eye. I stopped, and found a treasure that has been with me ever since. Out in their yard, I discovered a very large painting of the Madonna and Child, folded over and neglected. It was in poor condition, but I thought it was a wonderful naïve painting and bought it.

Now that I owned it, I was responsible for its care, and I had to see that it was restored and framed properly. I took it to the local framer, and they recommended Ernst Tross to restore it. The painting had been painted on canvases sewn together, so there were large seams on the back. Tross dug out holes in a fiberboard so that the canvas would lie flat. The big decision came then. It was going to cost me $100, which at that time was money I had saved to buy myself a suit to go to New York.

I made the only decision I could. I wore my old sport coat. The painting, I discovered later, was 18th century, from Peru, of the Cusco School, and it has graced our home ever since. It smiles at me now, here in the hills of Vence, France.

Jacques Tati, the wonderful French comedian and film director (who could ever forget Mr. Hulot's Holiday or Jour de Fête?), seen here on his visit to New York City. Photographed for Glamour, *1954.*

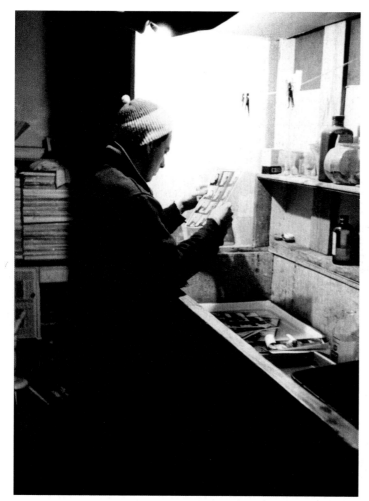

By the end of 1953, things were getting financially better for my mother and me, and I was trying to save enough money to build a proper darkroom and office on the back of our Marvin Avenue house. I was still freezing in my garage darkroom part of the year (I often had to go inside the house to thaw out), and then overheating in another (trotting out ice cubes to keep my developer from overheating too!).

I thought to myself, if the *Harper's Bazaar* editors only knew that their photographs were coming out of this garage, they would faint. You can see me in my first Marvin Avenue darkroom, wearing a woolen cap to help ward off the cold (above). I also bought my first Nikon camera. I was in a downtown Los Angeles camera shop and saw a used Nikon, the S model. I was told that *Life* photographer Howard Sochurek, who had been covering the war in Korea, had picked it up and traded it in. So I was back to a 35mm format again. It took me a long while until I could depend on it and was comfortable using it.

My mother and I lived alone, and while everyone thinks their mother is special, mine really was. There was never any discussion about me getting a regular job. She supported me during these very difficult times, and I think her trust and belief in me in turn really gave me the confidence to press on.

She also truly liked people, and they responded to that. One night, some of my dancer friends brought over some of the members of the Royal Ballet from London, including their distinguished conductor. Mother had already gone to bed, and was sitting in her room reading, letting me have the living room for the guests. The conductor spent the entire evening sitting on my mother's bed, deep in conversation.

(above) Otto Preminger hired me to cover part of the making of Carmen Jones, *his updated version of the opera* Carmen, *this time with black actors.* Life *ran the story with with Dorothy Dandridge and Harry Belafonte.*

(left) Dorothy Dandridge with singer Olga James, RKO Studios, Hollywood, 1954.

Judy Garland dressed as a tramp, for the "Lose That Long Face" sequence in A Star Is Born, *waits for production to begin.*

(facing page) James Mason, who played Norman Main, in this remake of the famous film with Janet Gaynor and Fredric March. Warner Brothers Studios, 1954.

Early in 1954, Judy Garland started making *A Star Is Born* at Warner Brothers Studio, and there was a lot of interest from the various magazines. I went over with seven different assignments, including *Collier's, Harper's Bazaar, Pageant* and *The New York Times.* What this meant was that I was uniquely on the set for an extended period to complete the various jobs.

Normally, when one had a magazine assignment, the studio would let you on the set briefly, if at all, often guiding you to the stars' dressing rooms, or any other place that they felt would not hold up production. "Not holding up production" was the number one studio commandment.

The directors generally didn't want to know about publicity during the production. There were exceptions, but they understandably wanted nothing to distract their actors. When I arrived at Warner Brothers, one of the publicity men there, Mort Lickter, who was nervous about me being there at all (Judy was a problem to them), advised me to use a long lens and hide behind the lights to get my pictures.

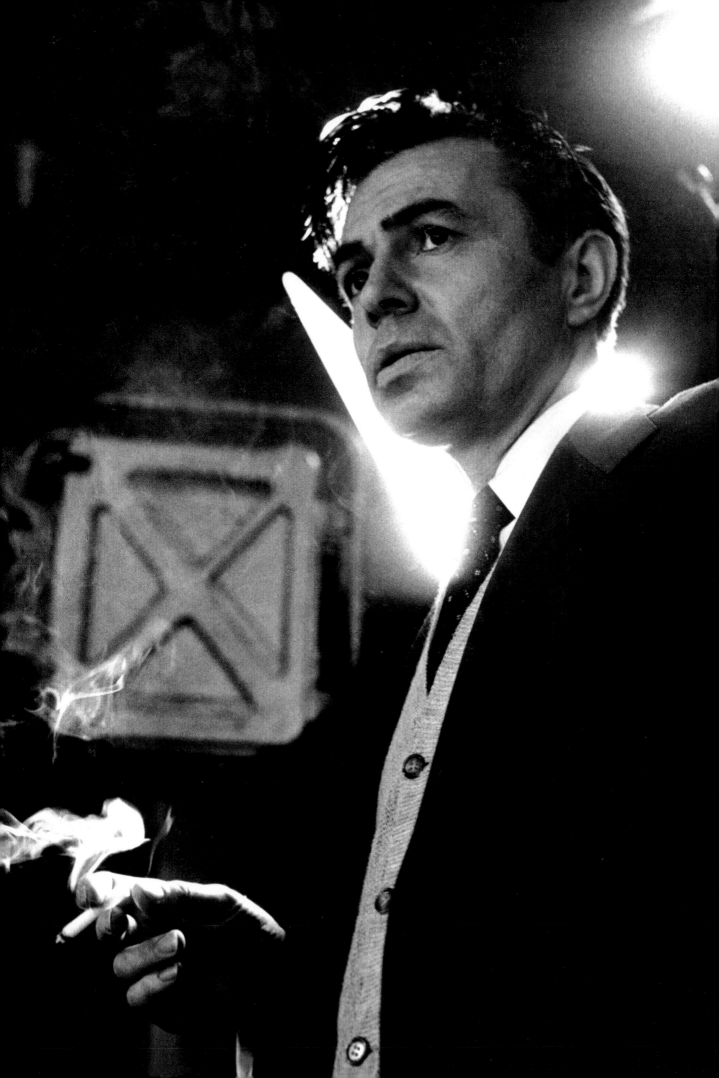

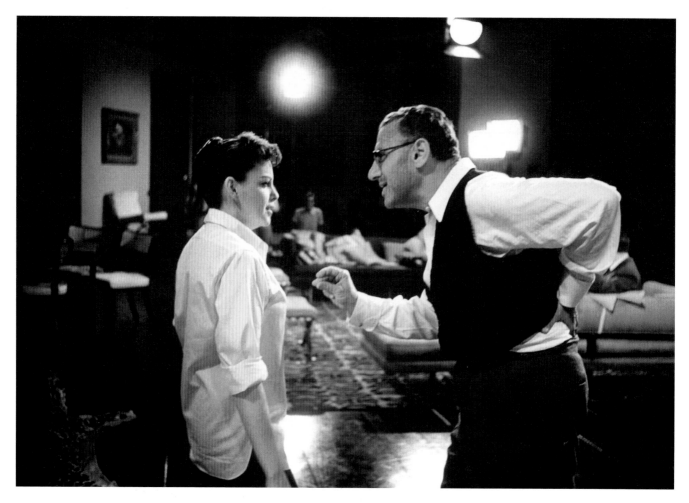

Judy with director George Cukor, 1954.

I didn't know what to expect working on this set, and obviously trying to hide behind the studio lights was totally impractical. Instead, at the first break, I went over to Judy and introduced myself, told her about the assignments I had, that I liked to work in a candid fashion, and asked her to ignore me. I never had a moment's trouble. In fact, in her mind I just became one of the crew, and that meant I was invisible, as the shot on the facing page of her sitting out of the hot studio lights indicates (*Harper's Bazaar,* November 1954). I learned something on this film about being invisible to the actors. I watched rehearsals carefully, saw where I felt the best shot would be and was cautious not to get into the eye line of anyone who was watching the shot. That meant the director, the choreographer, the script girl, the grip moving the camera, sound, etc. I found their rhythm and that was the clue. I moved when they moved, and I became part of the team.

Being part of that team meant I wasn't standing out in the eye line of any of the actors, and consequently was not a distraction. As the days progressed, Judy found me a familiar face, and she often put her arm on my shoulder, to adjust her shoe or just in a familiar way. I wasn't hiding behind lights by this time, and felt I had succeeded in creating a warm feeling between us.

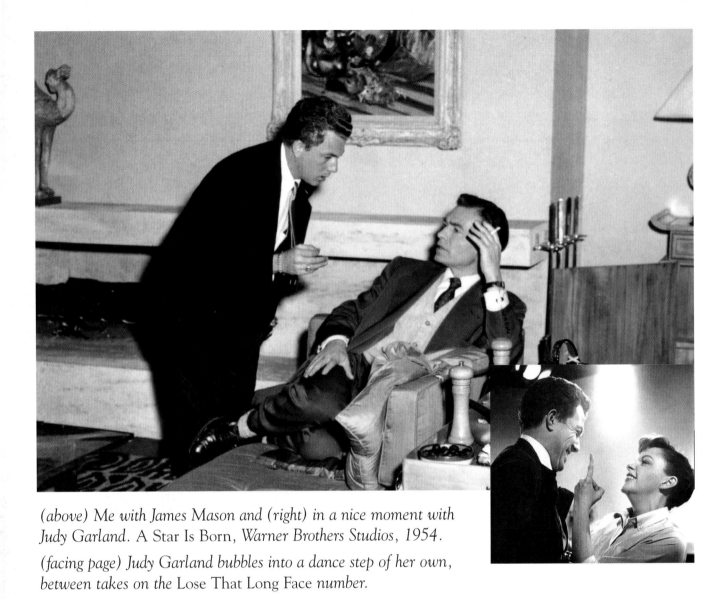

(above) Me with James Mason and (right) in a nice moment with Judy Garland. A Star Is Born, *Warner Brothers Studios, 1954.*

(facing page) Judy Garland bubbles into a dance step of her own, between takes on the Lose That Long Face *number.*

I loved James Mason's accent (a rather plumy Anglo-Irish) and after working with him all day, I could imitate it. When I got home, I would annoy my mother over dinner with my Mason imitation.

Watching the progress of the filming each day was stimulating. My time at the USC Cinema Department wasn't wasted. I could understand what everyone was doing technically, and why the camera was moved. Seeing everything come together was the exciting part.

When the film was completed, I flew off to Arizona to cover the filming of *Oklahoma* for *The New York Times*. While I was there, Warner Brothers' publicity department called me to say they were adding a number to the film, at Jack Warner's behest, and they would like me to cover it for them.

This really threw me, because the unions were a completely closed shop, and I sputtered something about that. They told me that they had it all arranged with the unions and would pay a "stand-by" fee to them for every day I was on the set. "Besides, Judy feels comfortable with you, and asked us to get you!" To my knowledge, this was the first time a studio hired an outside photographer. Later, this became known as a "Special."

As it worked out, *Life* ran my photographs, and, most exciting of all, I had my first *Life* cover (see facing page)! This was the dream of every young photographer. This was not lost on the other studios, who were always looking to get their films featured in *Life*. Whether I liked it or not, from this moment on, the direction of my journey became much clearer.

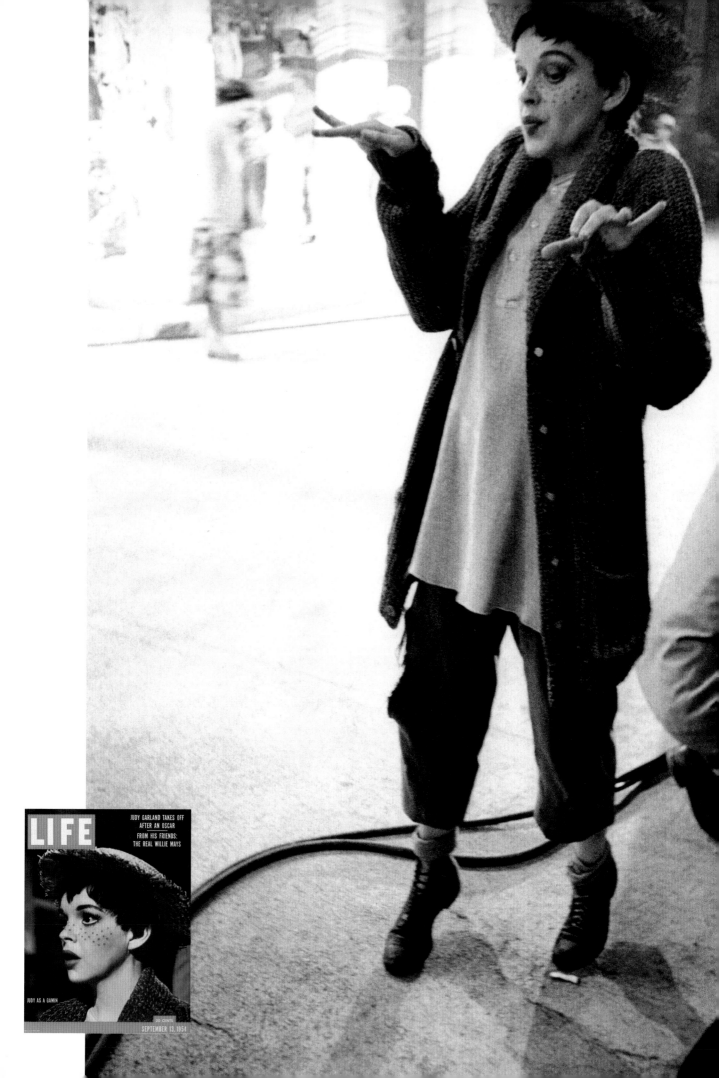

LIFE

JUDY GARLAND TAKES OFF
AFTER AN OSCAR

FROM HIS FRIENDS:
THE REAL WILLIE MAYS

JUDY AS A GAMIN

20 CENTS

SEPTEMBER 13, 1954

(above) Moose Charlap and Carolyn Leigh (lyricists of "Young at Heart"), who were collaborating on the new Peter Pan score for the Broadway bound musical starring Mary Martin. Photographed in the Hollywood Musicians Union Headquarters. Vogue, 1954.

(top) Playwright Clifford Odets with actor Menasha Skulnick, photographed during the rehearsals of his play The Flowering Peach, New York, Life, 1954.

(facing page) Cole Porter turns his world-weary eyes toward my camera. Photographed in his Beverly Hills home with the score of "Silk Stockings" behind him. Harper's Bazaar, 1954.

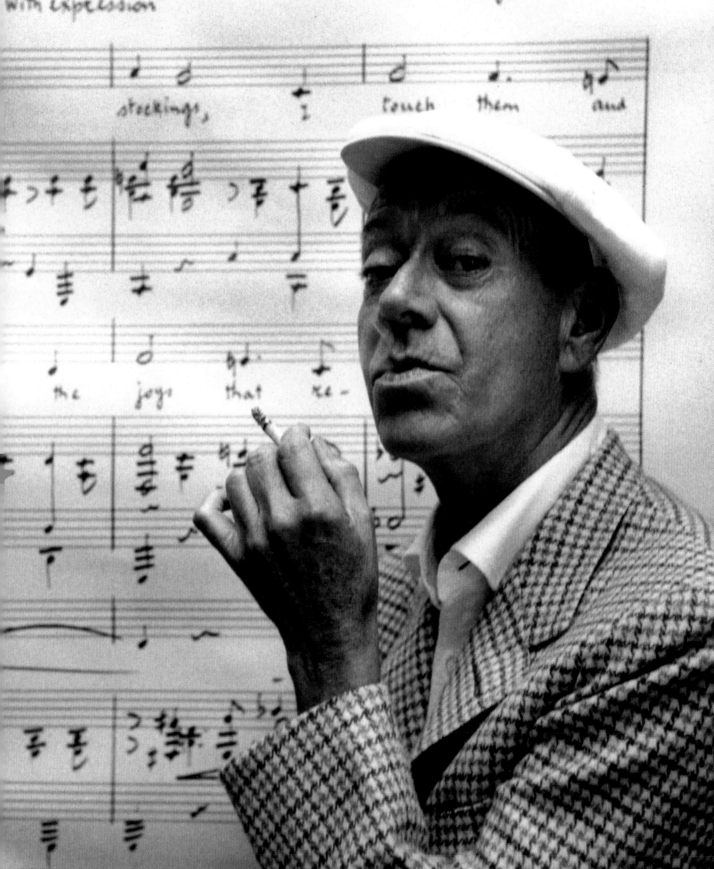

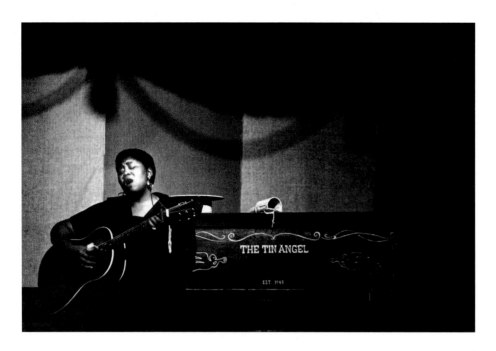

Max and Sol Weiss, who ran Fantasy Records in San Francisco, had become really good friends. Their humor and lifestyle were so different that I'd fly up to San Francisco on any excuse, since I had such a great time whenever I was with them. They recorded Dave Brubeck and Paul Desmond, and discovered the likes of Lennie Bruce and Mort Sahl. They ran the Black Hawk jazz club in San Francisco, and had unique friends like Peggy Tolk-Watkins, who was marvelously eccentric and a talented painter. She owned a club on the Embarcadero called The Tin Angel, where I photographed the folk singer Odetta, who sang in a deep husky voice that transported one back to another time and place (above). 1954.

Brubeck and Desmond, playing together, had a symbiosis in their music that made magic. At times I felt I could even hear them talking to each other. Harper's Bazaar, *1954.*

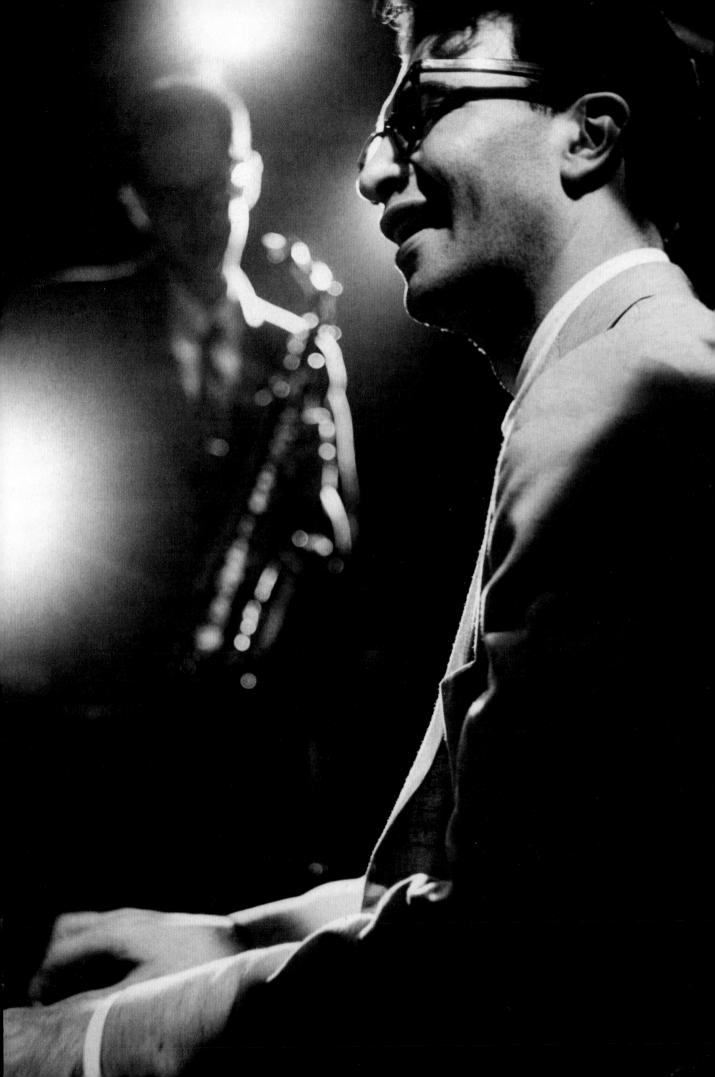

Rock Hudson dreams away in his Universal Studios dressing room, when he was filming One Desire, *1954*

(facing page) Dance asked me to photograph the Ballet Theatre while I was in New York, and I was also at the premiere of their new ballet A Streetcar Named Desire, with Valerie Betis dancing the lead role of Blanche DuBois in Princeton, New Jersey, 1954.

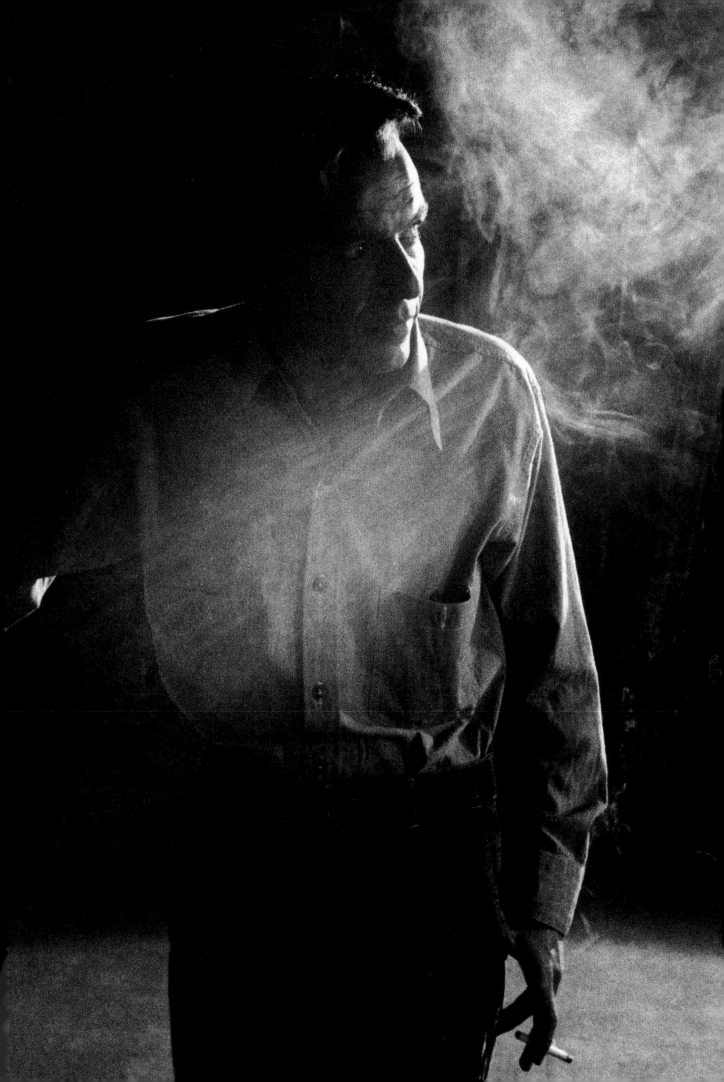

Kim Novak, RKO Studios, 1955.

(facing page) Frank Sinatra, bathed in a swirl of cigarette smoke, intently watches the preparations for the next scene in The Man with the Golden Arm.

The Man with the Golden Arm was my second film with Otto Preminger, after *Carmen Jones*, and while he was a tyrant on the set, we got along well enough. The turning point of our relationship was the day Frank Sinatra, in his role, was caught cheating at cards, and this brute knocks him around. In the usual fashion of film fighting, there is only one angle that looks real, and of course the motion picture camera was there.

I asked Frank if he would mind reenacting this shot after Otto got his print. He was agreeable, and so I started to shoot. Otto pipes in and starts telling me what I should do. Without even thinking, I replied, "Otto, you direct your shots, and I'll direct mine!"

I didn't turn around and just continued shooting. Later, I was told that there had been a dead silence on the set, but that Otto had apparently shrugged and walked away. Luckily for me, Otto seemed to respect me more. (I did two more films for him after this one.) I know he liked me, because he yelled at anyone else on the set, but I never once had a cross or unkind word directed toward me.

He called Sinatra "Francis Albert," and Frank would call him "Ludvig." Frank worked hard on this film, contrary to anything else that has been written, and I was there almost every day. There were times when he did only one take. If Otto asked him to do it again, Frank would look up at the camera operator to see that it was okay, and if so, he would just leave the set. He must have felt he wasn't going to do it any better.

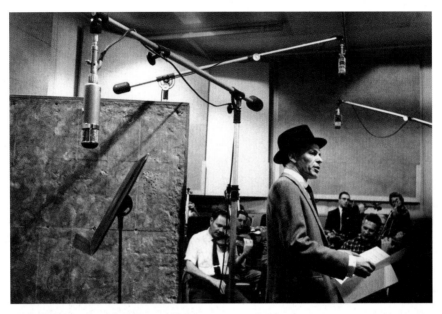

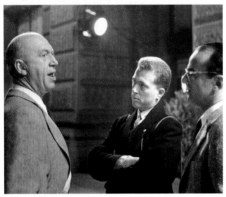

(*above top*) *Francis Albert Sinatra at the recording session for* The Man with the Golden Arm. *I noticed how much more relaxed he was than when we were filming, and commented on it to him. I felt he looked at me as if my elevator didn't go to the top floor, and said: "Bobby, this is what I do!"*

(*above bottom left*) *Otto Preminger, Bob, and Otto's right-hand man, Max Slater.*

(*above bottom right*) *The talented Shorty Rogers, who was directing the score that Elmer Bernstein wrote for the film. Hollywood, 1955.*

(*facing page*) *Otto Preminger showing Kim Novak how to play the scene with some fire. I liked Kim. At this period in time, she was like a big hoarse-voiced puppy dog. Otto would often put the microphone in front of Kim, asking her to call for "Quiet!" on the set. Her soft voice coming out would make the crew laugh. It was Otto's little bit of fun. For Otto, to coax a performance out of Kim, that was another thing. RKO Studios, 1955.*

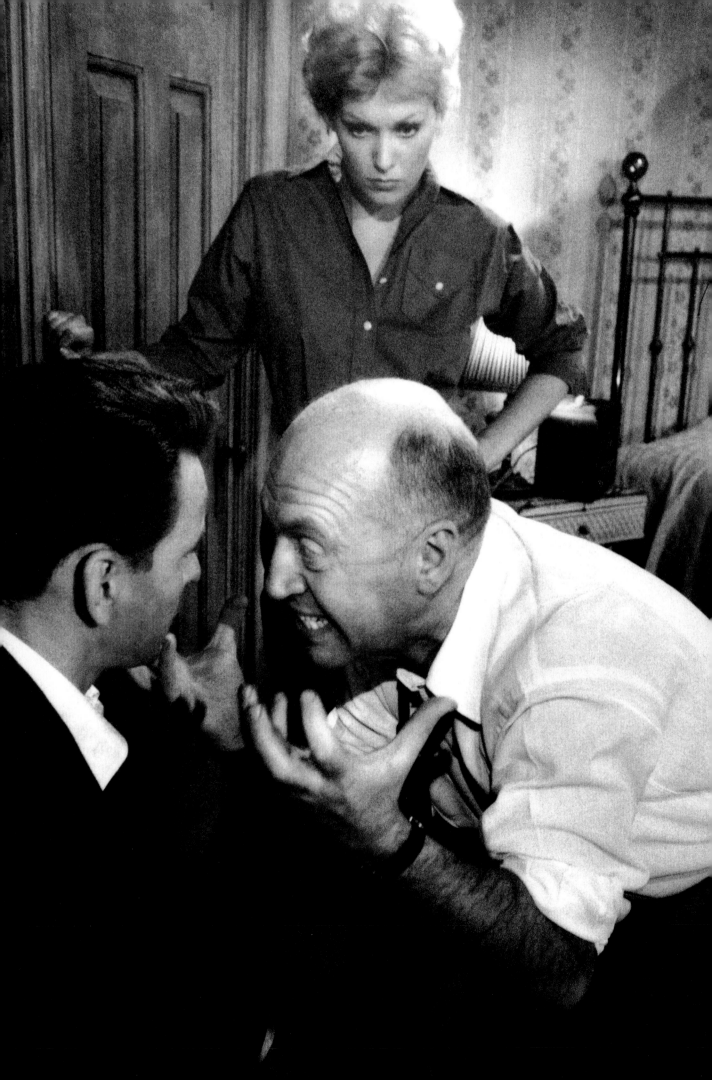

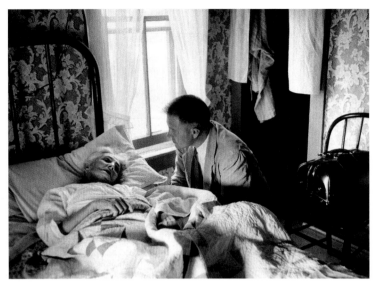

Called out in the early morning, Dr. Will Kamprath attends the needs of an old friend and patient in Utica, Nebraska. A picture story on husband and wife country doctors for Redbook, 1955.

(facing page) The wonderful contact that happens between mother and child is marvelous to behold. Here the lovely Taina Elg and her son Raoul Bjorkenheim share one of those special moments. Taina is probably best remembered for her role in MGM's Les Girls. She completed the trio of ladies with Kay Kendall and Mitzi Gaynor. One of those rarities in show business, she was a beauty with a soul as special as herself. Culver City, 1956.

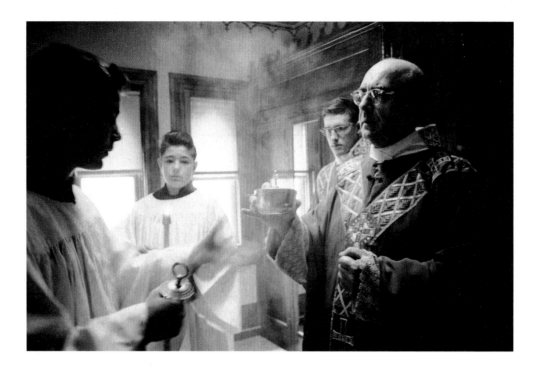

In May 1955, I had several assignments to photograph in St. Louis. One of these was Monsignor Martin B. Hellriegel (above), one of the most influential movers at the time in the restoration of the liturgy to the Church. He was an amazing man, who shook the more conservative elements in the St. Louis hierarchy until he was sent to a mostly black parish of St. Louis (some say to get him out of the way).

A great number of his own parish sold their homes and moved into that neighborhood, so devoted were they to his cause, so enriched by his sermons and the meaning that he brought back to the Mass. They did not want to lose that from their lives. The property values in Baden rose over the years because of the continued influx of people, in an amazing testimony of the spiritual awakening that the good Monsignor was providing the parishioners.

Nothing like that had really ever been seen before in St. Louis, and in fact there seemed to be almost an underground in the clergy who supported Monsignor Hellriegel, but did not wish to rock the boat in the Archdiocese. Pio Decimo Press was founded to record his sermons, and they were distributed widely at the time.

I spent several days with him, relaxing over dinner with him and his friends, photographing him as he blessed the young children and the couples who were going to be married. He brought so much to everyone he came in contact with that one could feel the spiritual energy coming from him. When he touched my head and blessed me, I really felt blessed.

I could never have guessed the effect that this assignment would have on my spiritual life from that point on. It was my first awakening to the fact that someone was guiding me on this journey. *Jubilee*, 1955.

(facing page) Charles, Annabelle and Harriet Allen sitting on their front porch in East Kinlock, Missouri. From a picture story of a Catholic family for Jubilee, *1955.*

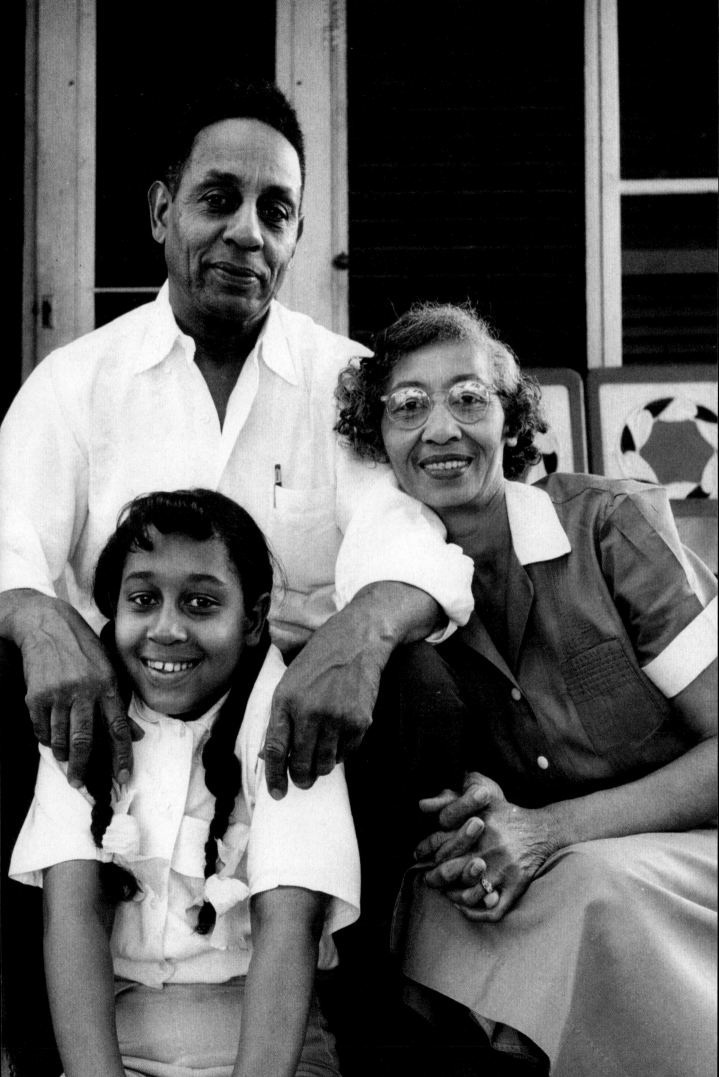

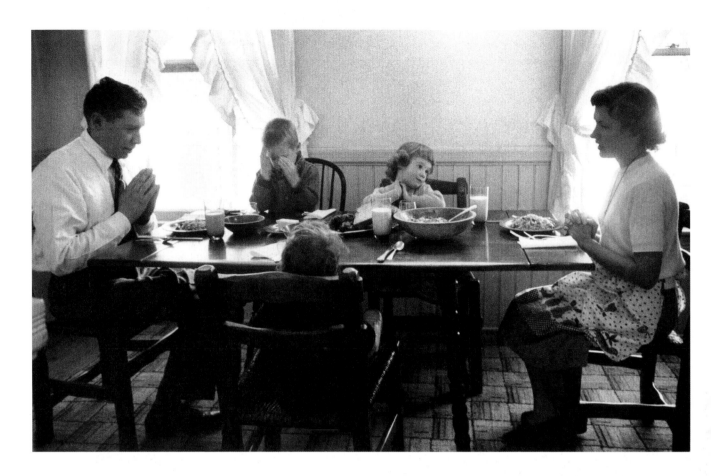

Harold Berliner was my contact when I was doing the story on Fr. Gabrielli in 1953. Their family lived in Nevada City, California, and now I was assigned to photograph them for *Jubilee*.

Harold was an attorney (later District Attorney), and had a greeting card business on the side—Berliner & McGinnis. Harold was a really interesting, knowledgeable man, and in those early days we had many wonderful conversations long into the night, getting to know each other. Printing was also Harold's passion, even when he was attending Notre Dame, where the faculty allowed him to have a small printing press in their basement.

Meeting the Berliners as a family was a truly enriching experience, and the start of a lifelong friendship. As I photographed them, I felt that here was a special family life to be admired, and I would like to have something similar one day. The spiritual key to their family life was Mary Ann Berliner, and if I liked Harold immediately, I loved Mary Ann.

I could feel her spirit and inner peace come shining out. It was something I seldom found in the theatrical world that I had enmeshed myself in. Several years later, I would return to this spiritual root with Dorothy Quigley, my wife to be, and be married in Nevada City, surrounded by their family and ideals.

(above) The Berliner Family Grace, 1955.

(facing page) Susan Strasberg, daughter of the Actors Studio founder Lee Strasberg, came out to Hollywood with her mother Paula, to work on her first film, The Cobweb, *at MGM.* Harper's Bazaar *asked me to photograph her. Here she is at the Chateau Marmont Hotel in Hollywood, wearing my coat for her portrait. I found her a delight, and as fresh and lovely as any young girl can be and she could have stolen my heart in a wink. 1955.*

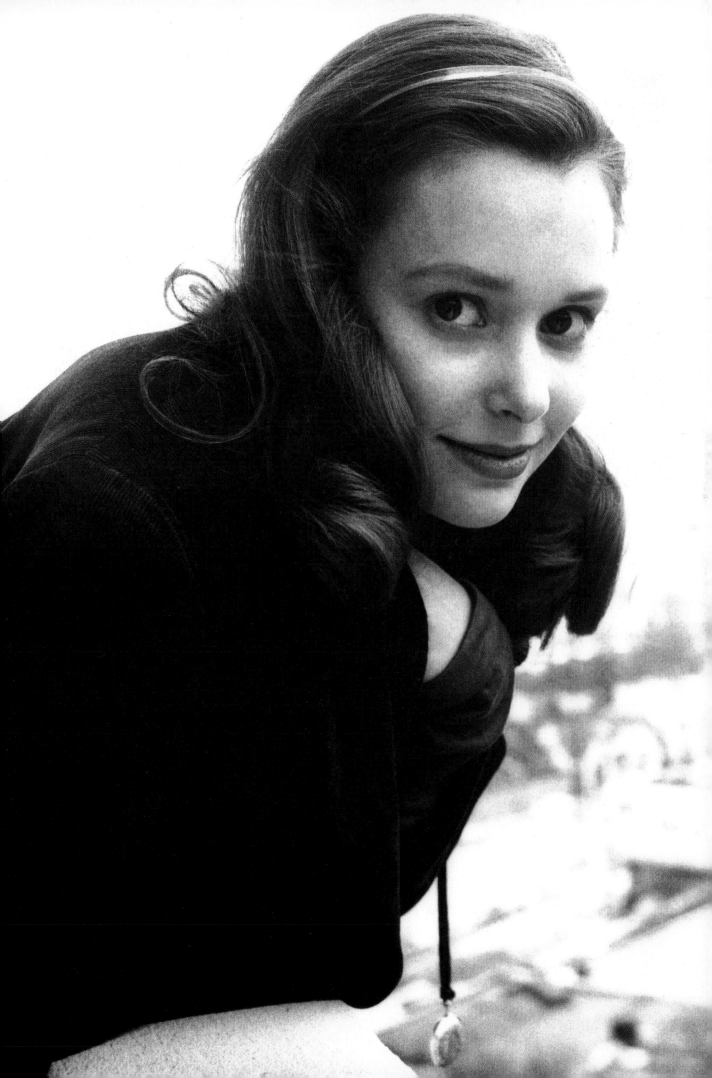

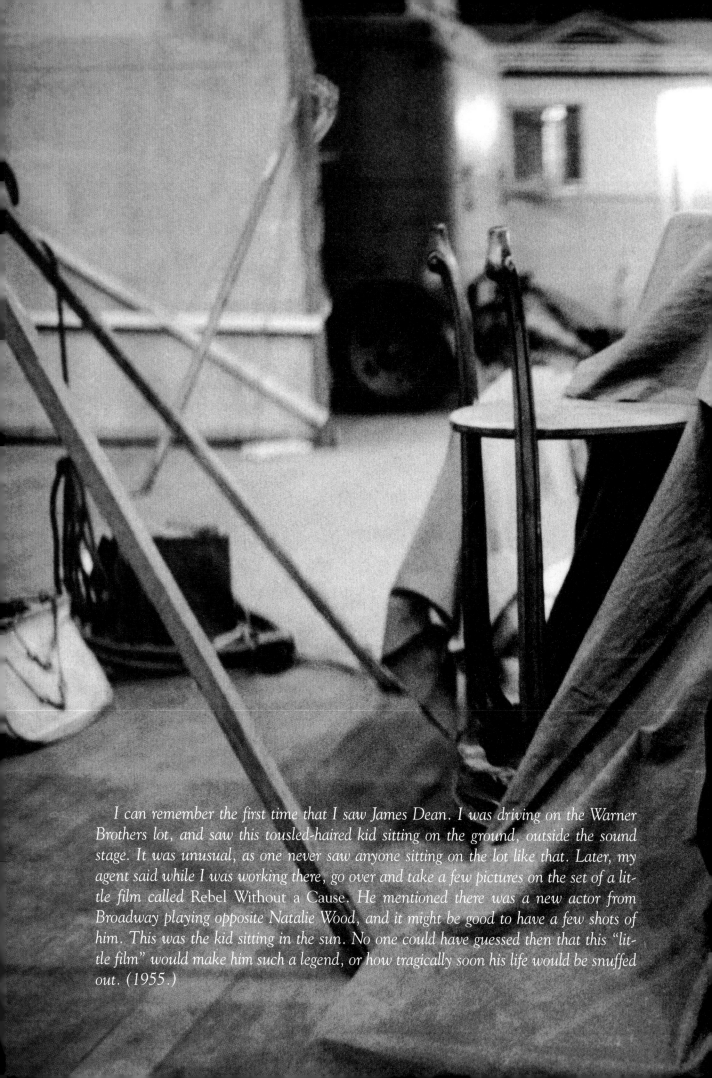

I can remember the first time that I saw James Dean. I was driving on the Warner Brothers lot, and saw this tousled-haired kid sitting on the ground, outside the sound stage. It was unusual, as one never saw anyone sitting on the lot like that. Later, my agent said while I was working there, go over and take a few pictures on the set of a little film called Rebel Without a Cause. He mentioned there was a new actor from Broadway playing opposite Natalie Wood, and it might be good to have a few shots of him. This was the kid sitting in the sun. No one could have guessed then that this "little film" would make him such a legend, or how tragically soon his life would be snuffed out. (1955.)

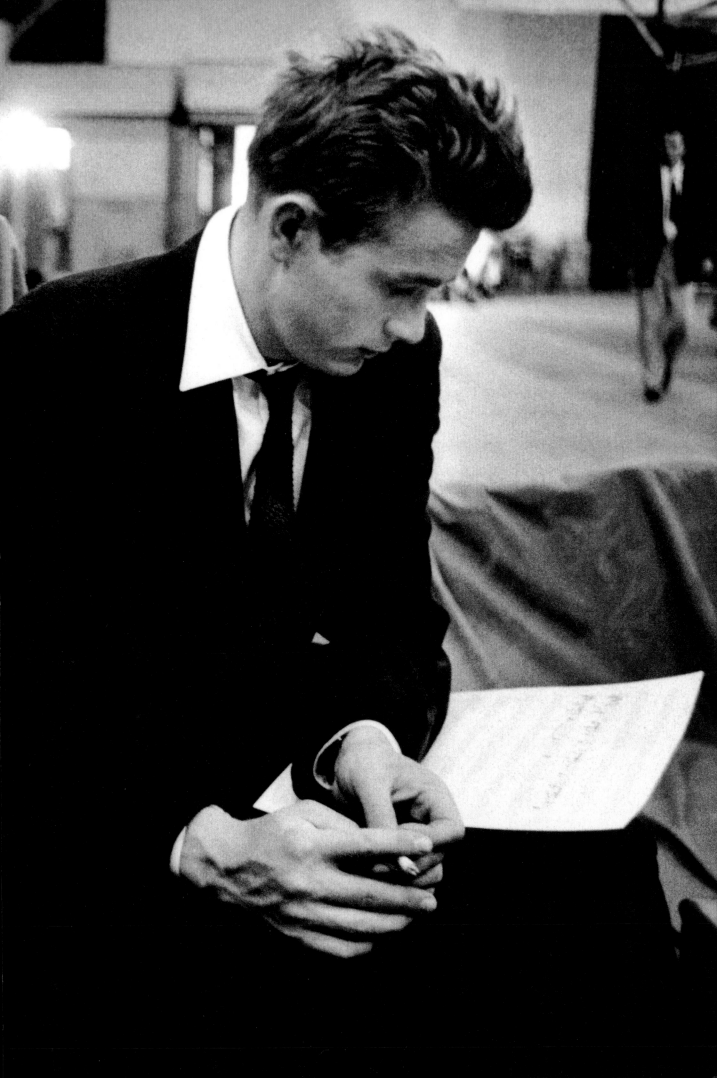

I was photographing Judy Garland's television rehearsals, when I noticed her little daughter Lorna Luft dancing in the wings. I immediately photographed her. It was shown to *Life*, but we didn't hear more until one of the editors told us that our prints were in the "Out" box on one of the picture editor's desks. Publisher Henry Luce came by, and saw them and asked why they weren't being used. They were, and later full-page ads across the country advertised that "Great pictures build *Life*'s great audience." At the time, I felt it typical of how often what I considered to be my best images were never selected by the art directors or the photo editors. (1955.)

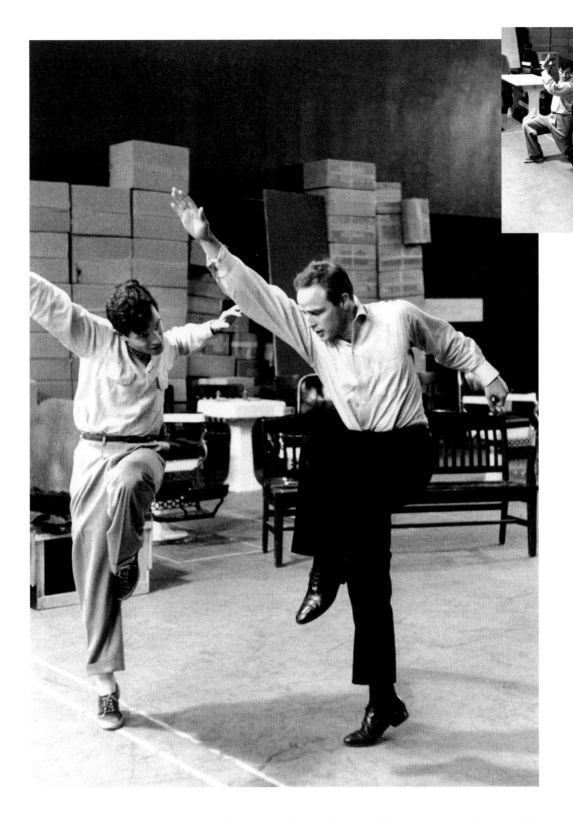

I was assigned to photograph choreographer Michael Kidd teaching Marlon Brando to dance for his role in *Guys & Dolls* at the Goldwyn Studios. Later, I photographed Brando with his voice coach. The magazine layout said "Brando Sings and Dances!" Brando was a great kidder. He borrowed one of my cameras and pretended to photograph the composer Frank Loesser, moving his camera here and there for maybe five minutes, and then handed me back the camera, never having clicked the shutter. What surprised me with his dancing was how agile and fit he was. Not bad for Stanley Kowalski. (1955.)

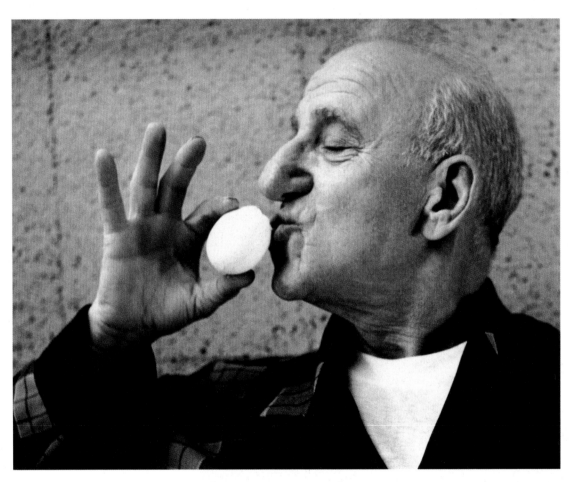

Jimmy Durante, the man of whom they said his nose arrives in the room five minutes before he does! A great American comedian (who after all did discover the lost chord), seen here kissing an egg for an illustration for McCall's magazine, Las Vegas, 1955.

(facing page) Louis Armstrong taking a breather on the MGM set of High Society. Shot for Glamour, 1956.

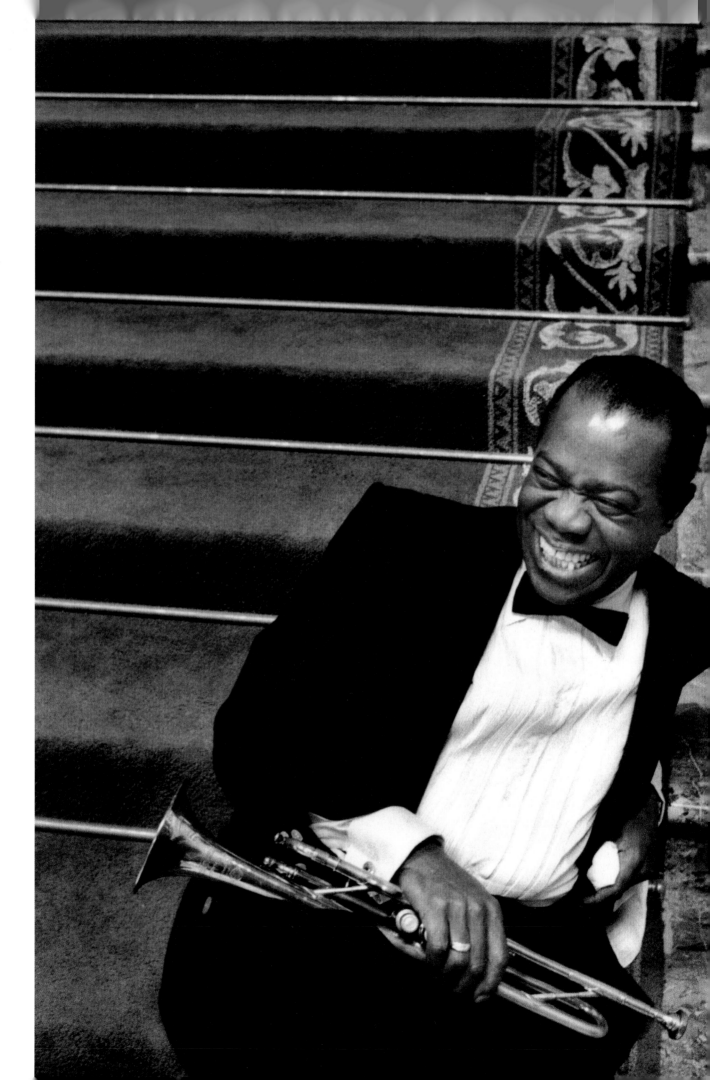

One of my dreams was to visit Europe to see the art I had studied and actually be in the historic places I read about in books. I was now starting to earn money, and this all became a reality in 1956. Max Weiss heard about my plans, and said he would like to come along. Before we could go, I had agreed to do a film, but I felt that would only take a few days.

George Nichols had called me one morning to tell me that MGM was preparing what they thought would be their *Gone with the Wind.* The film was *Raintree County*, starring Elizabeth Taylor and Montgomery Clift. He told me that he had personally gone to New York and spoken to the picture editors of the magazines, asking who they would like to have cover the film, and they all said "Bob Willoughby." Whether this was true or not, MGM wanted me, and not just for a few days, but for the entire film.

He asked my weekly rate, and when I told him, he upped the ante, saying that they wanted me "to be happy." This was an incredible assignment—months of work. There was no doubt about the possibility of me being able to afford to go to Europe after this. I told Max, and we set our departure date for the end of the shooting schedule.

Nichols was Dore Schary's personal publicity man. It turned out that the regular publicity department had its nose out of joint because decisions were being made without consulting them. It was a strange situation for me. I was later told that the unit publicity man was told not to cooperate or help me in any way.

This didn't bother me at all. I just took over many of the duties that would normally have fallen to the unit publicist when on location, such as entertaining the magazine editors and writers who came down to Danville, Kentucky, where most of the location shooting took place.

But before we went on location, and were still filming at MGM, Monty, coming home from a party at Elizabeth's, had a serious car crash. The lower part of his face was badly damaged, and while they could shoot some of the scenes without him, they had to close down the film until the plastic surgery could heal. Monty never looked the same. It affected him a lot, and while I had only worked with him briefly before, one had to be aware of his now somewhat eccentric behavior.

I became very impressed with Elizabeth, how she showed her concern, how she watched over and mothered him. I liked her all the more for being such a genuine friend to him. This seems to be basic to her character, standing by her friends in time of need, as with Rock Hudson, where she has been heading the cause of AIDS with her work with AMFAR. Michael Jackson is another, who had her support when he needed it. In all of the profiles I've seen printed on Elizabeth, I've never seen this sterling quality mentioned.

Obviously the European plans had to be postponed, but I was so involved in so many different things that the time the film was shut down seemed to go in a flash. Monty told me that they had to wire his jaw shut for months to let his face heal. So it was no little accident, nothing much was ever made about it in the press at the time.

Elizabeth Taylor and Montgomery Clift on the set of Raintree County.

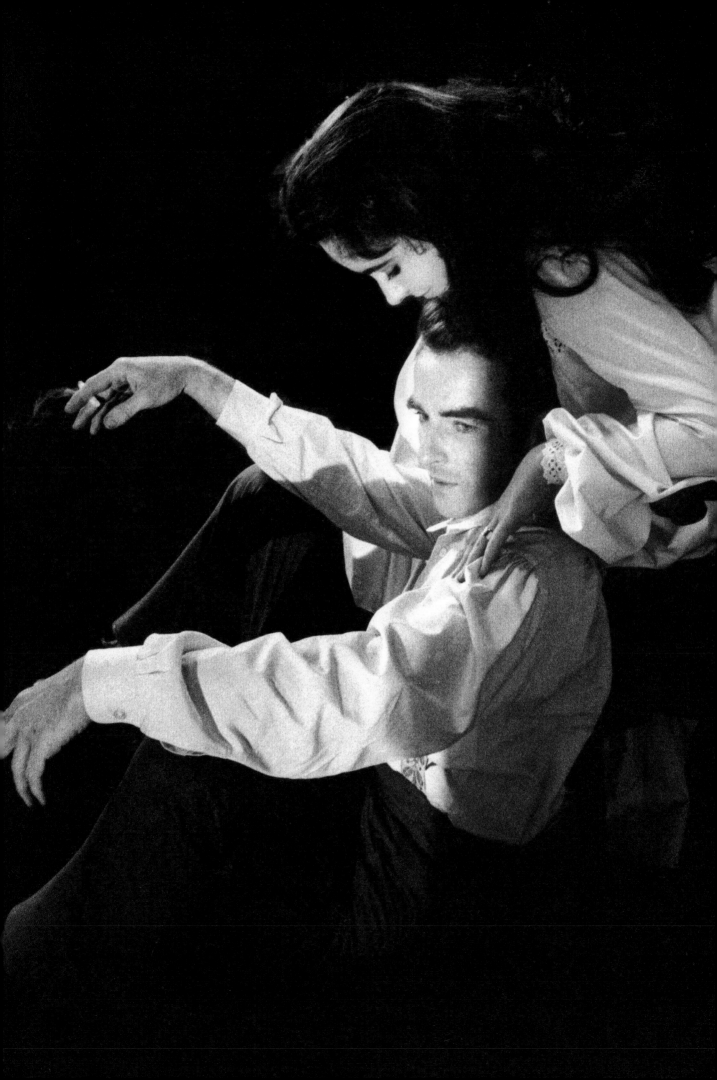

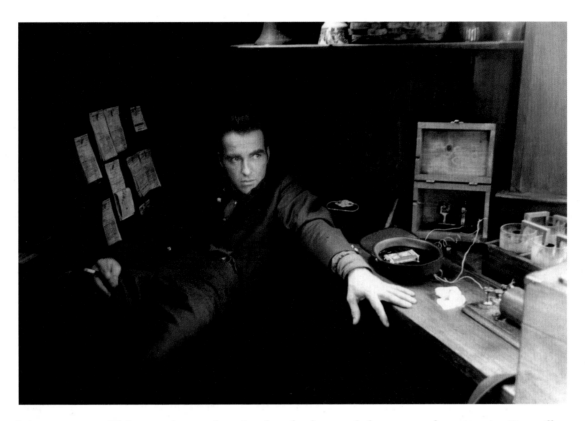

Montgomery Clift quietly smokes in the shadows of the set on location in Danville, Kentucky, 1956.

Our location in Danville, Kentucky was an experience in local customs. It was a dry area, meaning no liquor was served, but you could bring your own. The best restaurant had a choice of three items: country fried ham, country fried chicken and country fried steak. After several weeks, this routine became boring. We tried to find wine without any success, but one day one of the MGM drivers, Limey, who I had asked to check around in Louisville, produced a case of Chateau Margaux. It had been ordered some years before, never picked up, and I was charged the original price. It was like striking gold. Needless to say, I was a hero at dinner that night.

(facing page) Lee Marvin was one of the most unforgettable actors I've ever encountered. He seemed to have the energy of two, even three people, an inexhaustible lifeforce. It's hard to believe that he's now gone. To give you an example, many years later, Lee got into an elevator at Saks with my wife Dorothy and me. He went two floors, patted me on the back, waved goodbye and the doors closed, leaving us alone. Dorothy said she was so glad that he was gone, which I didn't understand, until she told me that she had felt he had taken up all of the air in the elevator. That was Lee. He was a fine actor, told outrageous jokes, and I liked him very much!

PLEASE DO NOT THROW TRASH IN TRACK PITS

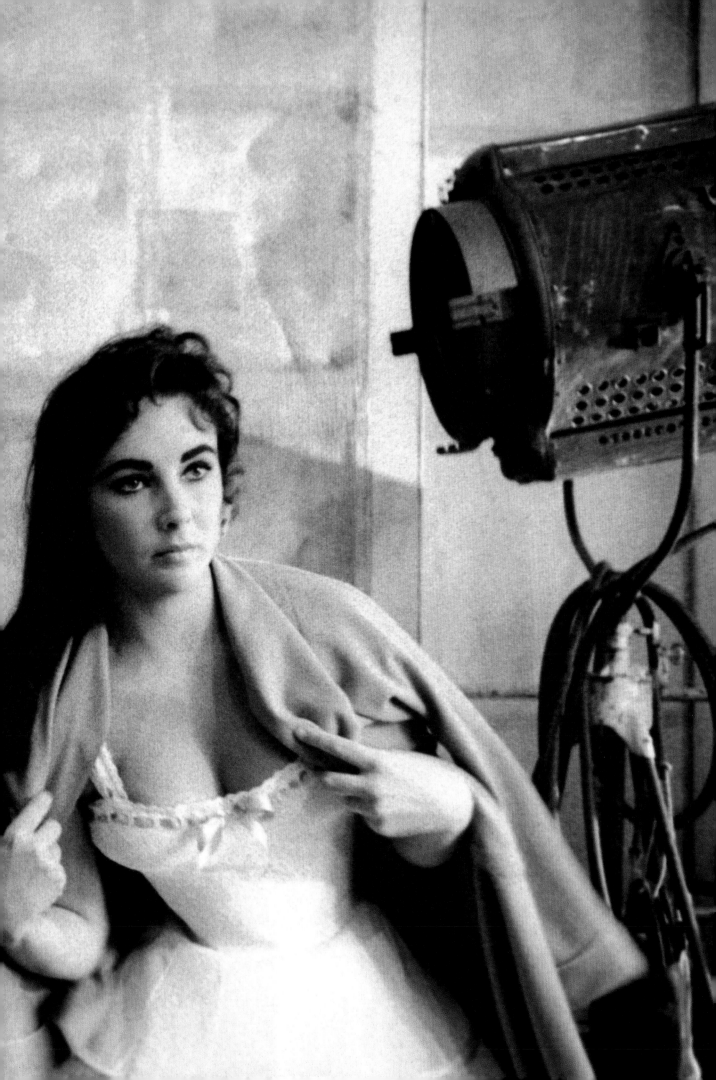

At this time, Elizabeth was seeing Mike Todd, and since she wasn't in some of the war scenes being filmed, she went to Chicago to see him. When she was called back, it turned out to be far too soon, so she was really angry with the production department. She and Monty decided to have a party. I was already in bed when the phone rang. It was Elizabeth inviting me over to have a drink. Naturally I got dressed and went. When I arrived, Hank Moonjean, one of the assistant directors, was there and we were the party. I guess Elizabeth picked us since we were the youngest in the crew.

The music was going, and the first thing I saw was Monty trying to put ice cubes down Elizabeth's blouse, and there was screaming, and running around this rented house they were in. Obviously they had had a few drinks before we arrived. Hank and I looked at each other, shrugged our shoulders and poured ourselves a drink.

I don't remember much more, except Hank and Elizabeth doing the "Lindy" and Monty scrambling around on the floor, but it was one of the best parties I've ever been to. A few weeks later, the mayor and town council had a party for the cast and crew, and it was another lucky night for me. Elizabeth and I were dancing, and since she didn't wish to dance with the locals, she kept me on the floor for a long memorable evening. I went home with the smell of her perfume on me for the rest of the night.

I had an assignment from *Collier's* magazine to show the effect a film company coming into a small town had on the local people. I went there to photograph the town as it was before the film started, and then later showed some of these same people recruited to be extras in their costumes. I photographed the crowds that assembled whenever the stars went to eat or shop.

I needed something much bigger for my lead shot, and since I knew I could not get any cooperation from the publicity department, I went to Jack Atlas, who was there from MGM making a trailer for the film. I told Jack that what we needed was a parade. He liked the idea, and we proceeded to look at the shooting schedule to see when we could get some of the cast for our little adventure.

We scheduled it for lunch time, when we could get as many people on the street as possible, and planted the news in the papers, even as far as Lexington, so we could draw some crowds. We then contacted the fire department, the scouts, the school band, whatever we could think of. Then I went to the production manager Eddie Woehler and lied. I told him the city wanted to honor the film with a parade, and he bought it, and gave a call to all of the ladies in costume that were not working that day, so we had floats, bands and Elizabeth Taylor.

We also contacted the mayor, and told him that we wished to give a parade to honor the city that had been so hospitable. He prepared a plaque to present to Millard Kaufman (the screenwriter, who was acting producer at the time). Well, it was all go. I recall climbing up on the grandstand, and a local policeman trying to stop me. I remember looking at him in disbelief, telling him that this was "my parade"! It seems funny now. I got my pictures, and Jack got the footage for his trailer.

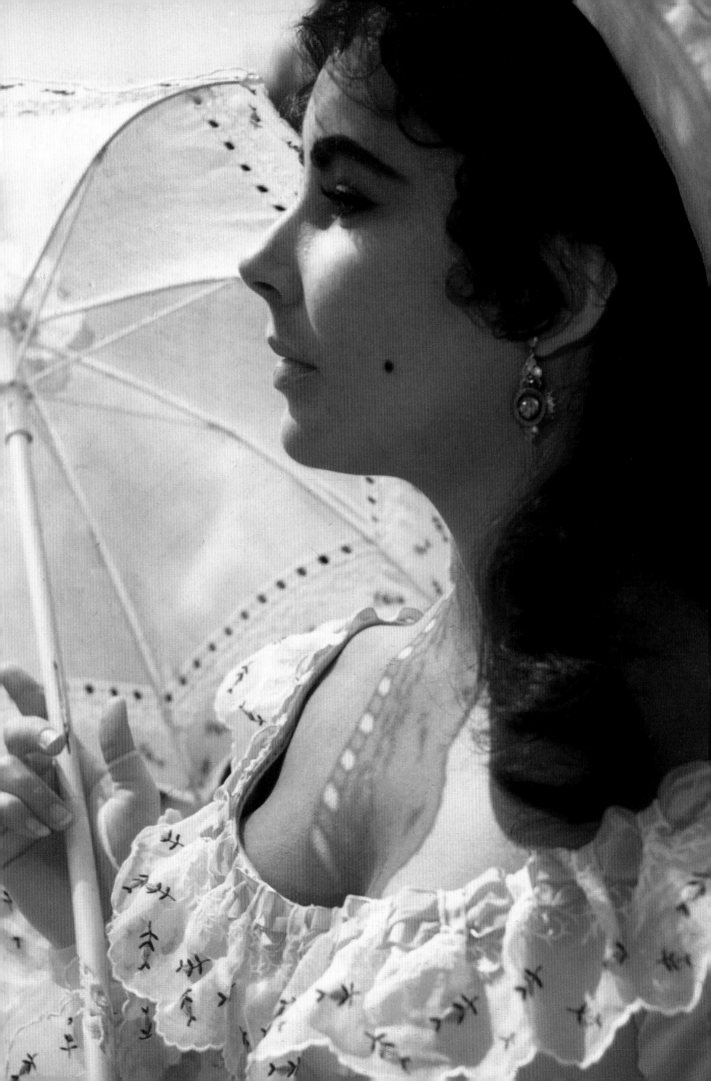

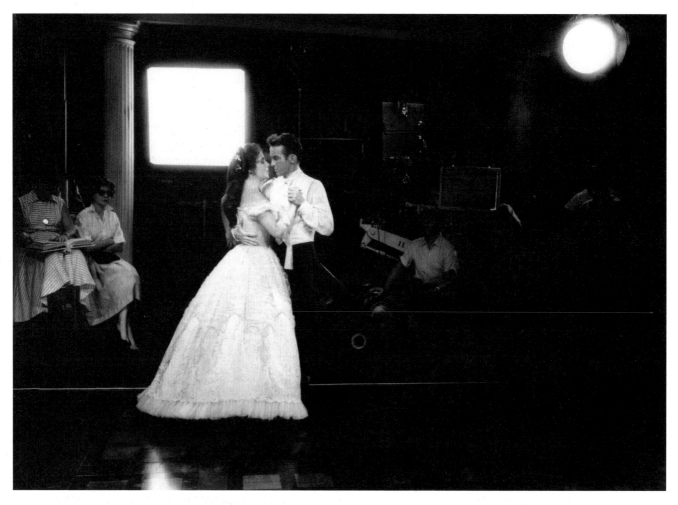

Elizabeth Taylor and Montgomery Clift rehearse a scene from Raintree County. *Margarite Lamkin (second from left), MGM Studios, 1956.*

The powers that be pulled the plug unexpectedly on the Danville location, literally stranding a lot of the cast and crew until commercial airlines could fill the bill. Mike Todd sent his private plane down to pick up Elizabeth, and she asked Margarite Lamkin (the Southern speech coach) and me if we wished to go along. We jumped at the chance, and I had the restaurant prepare a lunch for the trip to Chicago. I still had a couple of bottles of the Chateau Margaux. I packed those and my cameras, and away we went.

The three of us were enjoying the trip, our picnic, the wine in paper cups, and were glad to have escaped sitting in Danville for another week (this was the plane on which Todd was killed about a year later). I remember vividly how, as the plane turned to change course, the sun came in through the cabin window, streaking across Elizabeth's lavender eyes. She was staggeringly beautiful in that light. To this day, I cannot understand why I didn't reach for my camera. Perhaps I was too transfixed or perhaps it was the privacy of the occasion? There is no denying that at times she took one's breath away.

When we arrived in Chicago, it was clear that Todd hadn't expected anyone to be with Elizabeth, but he took us all to lunch in the Pump Room, and that was very nice. (Todd spent the entire lunch on the telephone.) I had given Elizabeth the last bottle of wine, and when Todd asked her about it, she told him that it was from me. He said, "Well, I'll get you a good bottle!" Then Margarite and I flew back to L.A.

We finally wound up the picture, and as Max and I were about to reschedule our European adventure, Otto Preminger called me and wanted me to work on his next film, *Saint Joan.* Since it was to be made in England, it would work out very well. Before we left for Europe, I had to photograph the screen test of the three finalists for the title role in New York City.

Some time before this, I had left my agent, Globe Photos, and was handling all of my own contacts with the magazines. However, with going to Europe, and then working on a film over there, I needed someone to represent me in New York. A young lady who had also been working with Globe was striking out on her own, and I thought I would use her while I was out of the States. Her name was Lee Gross and that temporary arrangement lasted almost 20 years.

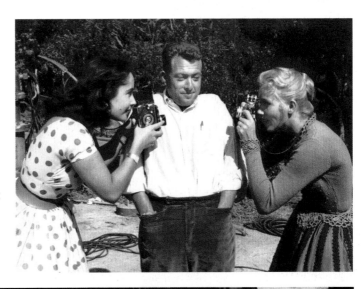

*(right) Elizabeth and Eva Marie Saint
turn the tables on me.
(below) Montgomery Clift,
MGM Studios, 1956.*

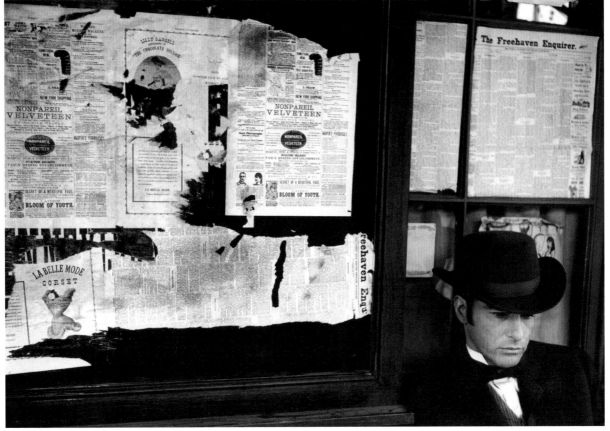

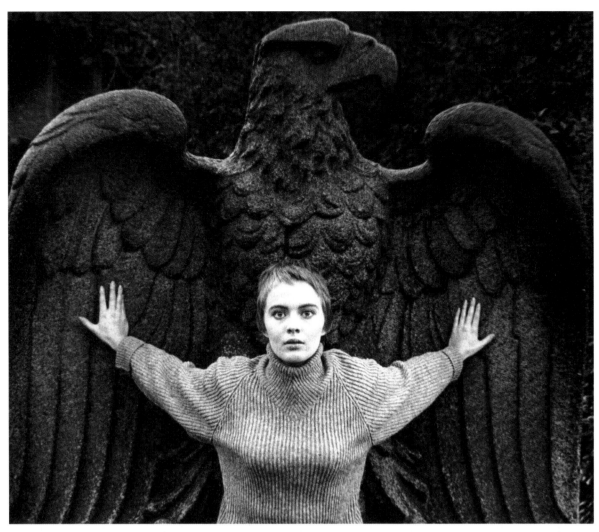

Jean, the day after she won the title role in the film Saint Joan,
Central Park, New York City, 1956.

I photographed the screen tests for Preminger in Fall 1956. This is where I first met Jean Seberg, Otto's final choice to play Saint Joan. By this time, I had a *Look* magazine assignment, and Max, Jean and I went to the Cloisters Museum on the Hudson River so I could photograph some of the color covers I knew I would need.

The three of us hit it off immediately, and we had some fun times. Then Max and I went off to Paris. We would be back to London in time for me to start photographing the rehearsals, and meet up with Otto and Jean again.

Max and I landed in Paris, arriving late at the hotel. The next morning was a panic. I had had a few lessons in French, and I knew that *petit déjeuner* meant breakfast. On our first morning at the hotel, I saw the menu saying *déjeuner*, and so I assumed that was breakfast. *Œuf* was another thing I recognized, and pointed that out to the waiter.

Max, on the other hand, figuring what could go wrong with breakfast, pointed to something and nodded to the waiter. When the food arrived, Max was presented with the biggest knuckle of bone you ever saw. We both stared at this for the longest time. It did have a little meat on it, but for his first meal in Europe, it was too much We've laughed for years about Max ordering Osso Buco for breakfast!

We really liked Italy: the food, the warmth of the people and the art. I was finally where my heart was. One morning, going through the museum in Sienna, I was looking at these early Siennese paintings that I have always loved. Here they were in the flesh, so to speak. It was all so wonderful. Max was ahead of me in the gallery, and he turned around to me and asked if I knew I was singing.

We could not figure out how the people selling souvenirs knew we were tourists. We settled on the fact it must be our shoes, so we went and each bought a sturdy pair. That will fool them, we thought. We weren't sure if our feet would survive. Sturdy was not the word for these shoes—they would have withstood an atomic blast! We walked in agony for days, and they still knew we were tourists.

I had arranged, as a special treat, to fly my mother over to Rome, where we met her. Like us, she had never been to Europe, and we had great times seeing all of the sights. It was the time of the Suez crisis, and we had great difficulty getting back to London for the film because there was a gas shortage. I had found a soldier who was selling his Ford Thunderbird in Paris, one of a few that Ford was testing for the European market. It was an eye-catcher, but we were barely able to get it back to London in time for me to start working at Shepperton Studios. There were many adventures trying to beg for petrol along the way.

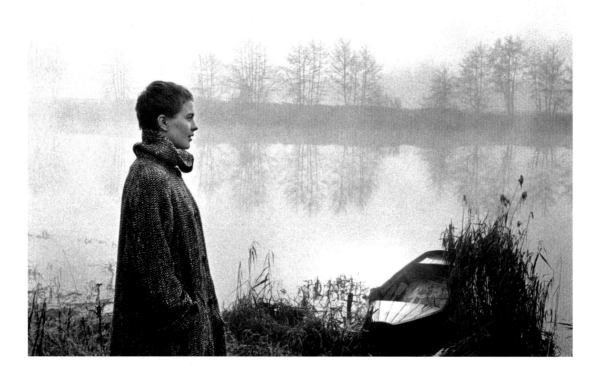

Now back in London, the writer Tom Ryan came on board. He had been sent over by *Woman's Home Companion* to do an essay on Jean making a pilgrimage to the real haunts of Joan of Arc. I had known Tom in New York, and he had also been working down in Danville on a story. It was good to see him again.

Almost as soon as he arrived, the magazine folded. Preminger still thought the idea good enough, so Tom and I went to Paris with Otto and Jean for Christmas. Max stayed in London with my mother, and there is a story of his taking her to midnight Mass on Christmas Eve. Being Jewish, he was waiting outside the church for her, and decided to sit in her wheelchair. Max tells it that two slightly tipsy American soldiers came by and dropped money in his hat, and he was too embarrassed to tell them he was just waiting for a friend!

Back in Paris, Tom, Jean and I and the driver would start out each morning, and head for one of the places associated with Joan. One day along the Loire river, I stopped the driver, seeing that all of the landscape was crystallized ice. It was really beautiful, and I was shooting for a while when Tom mentioned Jean was turning a bit blue! God! We rushed her back into the car, and we were rubbing her hands to get her circulation back. The driver suggested he stop and get something warm to drink, and pulled over the first place he could.

We rushed Jean inside the restaurant, and gave her something to warm her. I remember someone giving her a large glass of cognac. She was feeling much better—in fact too much better! Jean, not being used to strong alcohol, was getting tipsy, and she started telling her school jokes, and wanted us all to sing with her.

Earlier, I could picture Otto's face, if I had caused his young star to catch pneumonia. Now, I could already see the French papers' headlines about their St. Joan being drunk! Tom and I were able to sneak Jean into the hotel, and as far as I know, Otto never heard about it, much to my relief at the time. Otto brought Jean lovely Dior dresses, and took her to the theatre, and treated us all to fine lunches and dinners. It was a lovely Christmas, and that Christmas Eve it snowed, making Paris more beautiful than I had ever seen it. 1957.

(facing page) A very nervous Jean Seberg on one of the first days of rehearsal on the set of Saint Joan*, 1956.*

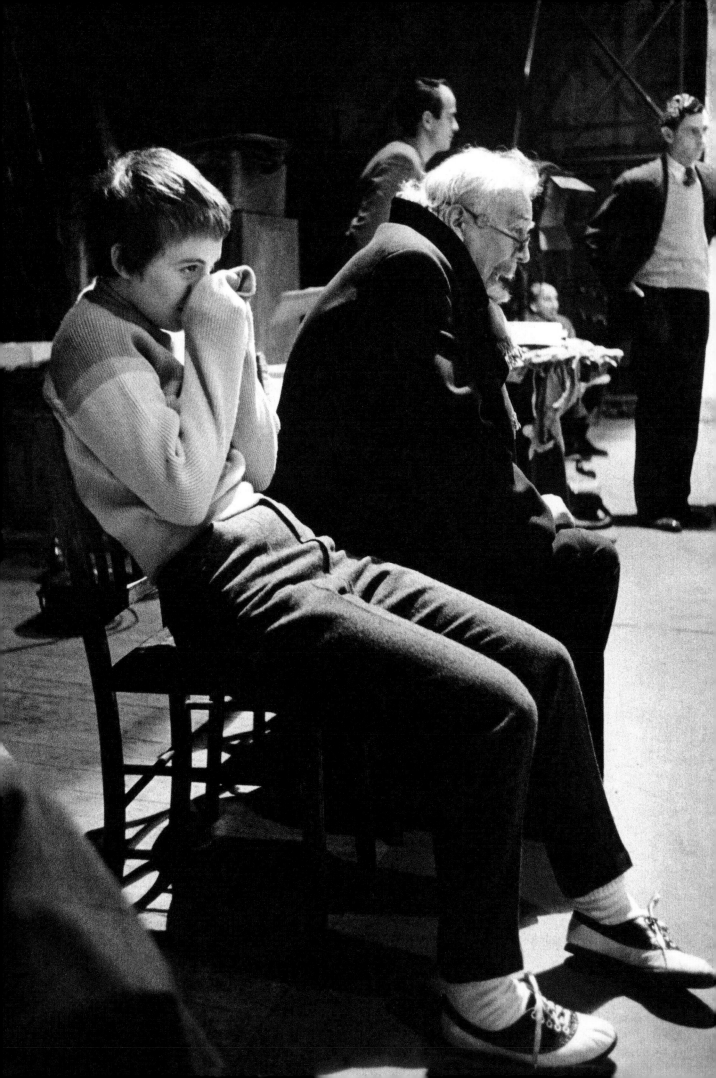

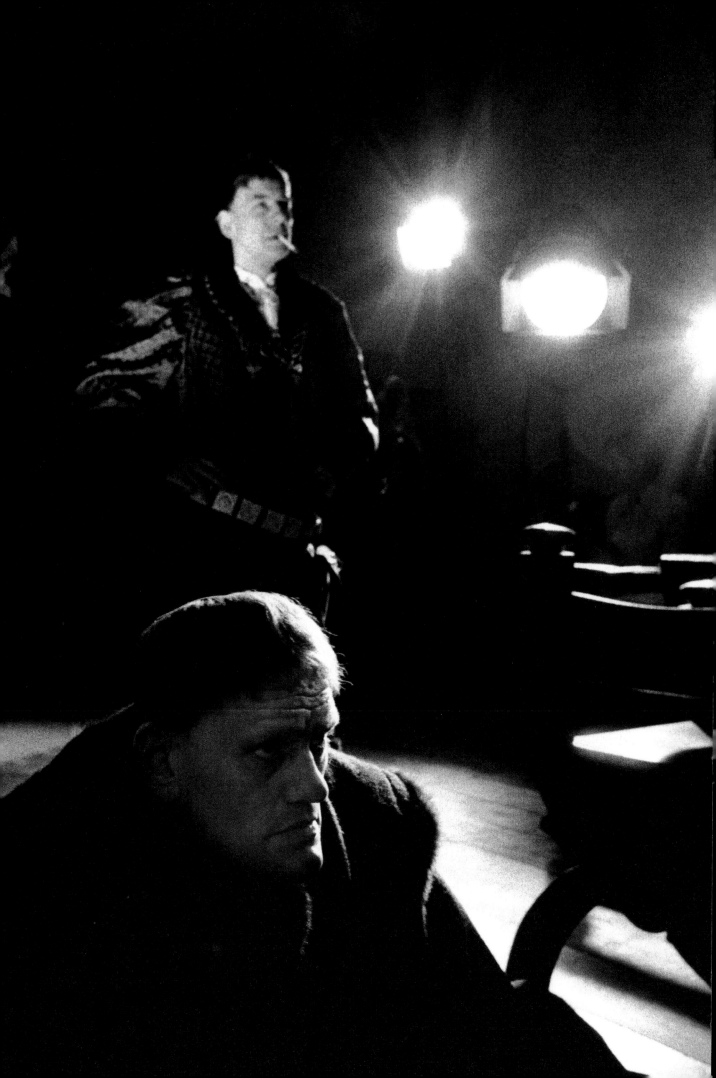

We all flew back to London for the actual filming. Max and I moved out of the Dorchester Hotel, where Otto had kindly put us. Max complained that the elevator operators were dressed better than he was. I must admit that the prices the laundry charged were the same as if we had gone out and purchased the items new.

We moved into the Royal Court Hotel in Sloane Square in Chelsea. When we checked in, we asked for rooms with baths. They were not very up-market at the time, and the only room they had in the entire hotel with a private bath was the bridal suite. We took it, but they gave it to us through clenched teeth. One day the manager stopped me as I was coming back from the studio. He told me that he would have to ask me to leave, and when I registered surprise, explained that it was because we had had "women" in our room.

I could not believe this pompous little man in his striped pants and tail coat. Seberg used to come by every night on the way back to her hotel, and we all ate together so she wouldn't have to eat alone. The hotel dining room had a dress code, so it was easier to eat in the room. We eventually found a flat on Berkeley Square, and we were able to eat at the wonderful Connaught Hotel several evenings a week, and that was a joy.

Jean was really nervous. Here she was, a little girl from Marshalltown, Iowa, facing the cream of British theatre. She was a courageous and very special young lady who went through fire with Preminger. She had a frightening accident on the set when they were filming Joan being burned at the stake, when one of the gas jets feeding the fire exploded and burned her.

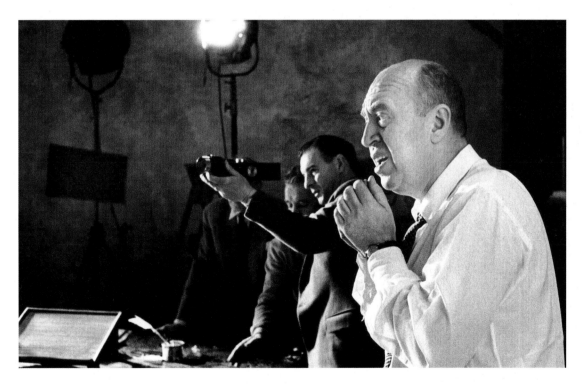

Otto Preminger emoting his way through a scene on Saint Joan, *London, 1957*
(facing page) Sir John Gielgud and Harry Andrews, photographed during rehearsals.

Max and I had found a terrific Italian restaurant in London with the unlikely name of the Brompton Grill. It was run by two Italian brothers, and we were there so often that we got to be friends. We hatched a plot to give Otto a little "shot across the bow." I guess I felt I knew him well enough to do this, though I suspect it might have been a first.

We invited Otto and Jean, Harry Belafonte (who just happened to be in town) and Elsa Martinelli (who was working on the next sound stage). There were about a dozen of us when Otto arrived in the studio car.

He was greeted profusely by the owners and waiters, and the smile on his face grew. He was about to sit down when one of the waiters, again flourishing his napkin, said: "It is so nice to have you visit us, Mr. Hitchcock." Otto looked at him, made a little pout of his lips, and sat down. The wine was flowing, and then one of the owners came over, and again told Otto how nice it was to see him...yes, of course..."Mr. Hitchcock"!

Max and I said nothing, though we were dying to laugh. The third time he was addressed as Mr. Hitchcock, Otto pounded the table with his fist, declaring "I am NOT Mr. Hitchcock!" We couldn't keep a straight face, and catching me bursting, he pointed his finger at me, now realizing it was our little joke, and said: "I'll get you for this, Willoughby!" It was a terrific night, and the first and last time that I ever saw Max wear a tie. His usual fare was a corduroy cap, jacket and pants, with brightly colored socks, often not matching, and in Europe, he used a sword cane.

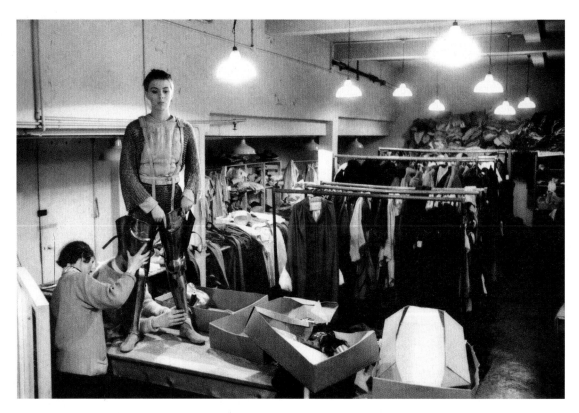

Seberg getting her armor fitted, Saint Joan, *Shepperton Studios, 1957.*

(facing page) Richard Widmark in bed, while Otto Preminger lines up the shot in the background, for the epilogue sequence.

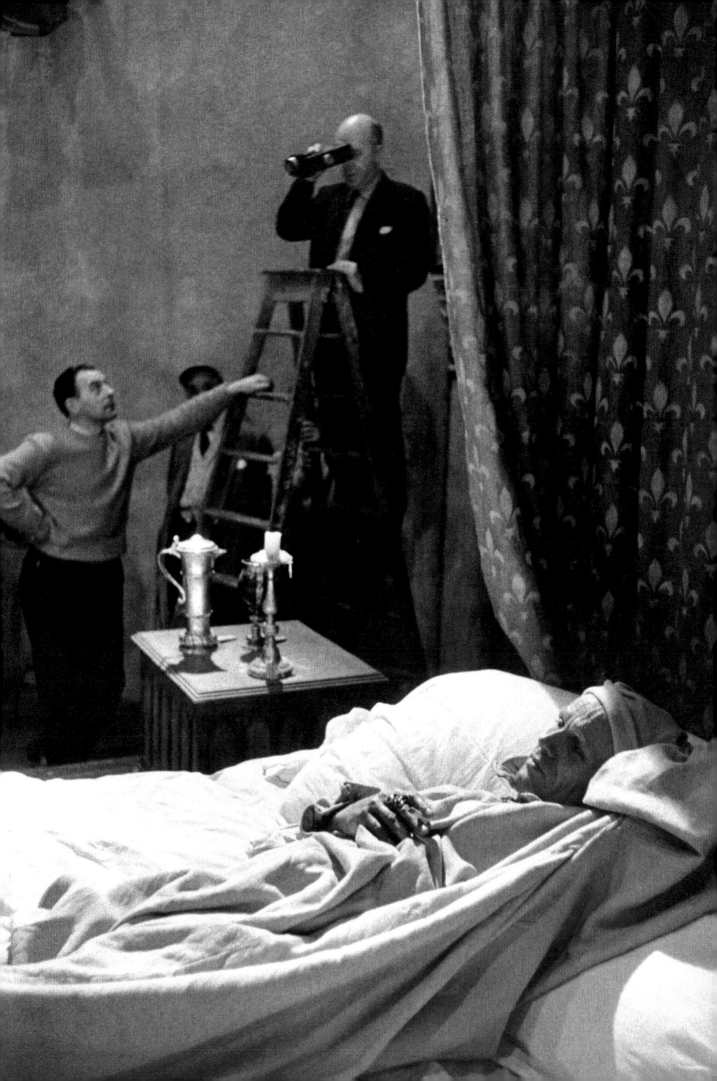

Jean and me in London.

The pressure on Jean throughout the film was extraordinarily heavy, but this little girl from Iowa had such grit that everyone in the cast and crew could not help but admire her. I was certainly her daily support, for we rode back and forth from London to the studio together, and very often ate dinner at night (though Otto wanted her to concentrate only on her role).

I would see her get a tongue lashing from Preminger, swallow it, go off by herself and psych herself up. Then she'd come back and do the scene again. She was no quitter under fire. If there were medals for courage, for bravery in the cinema world, Jean would have won them all.

After her ordeal with the exploding gas jet (and by some miracle she was able to put her hands up over her face, even though she was chained to the stake), and still slightly in shock, one morning en route to the studio the limo skidded on black ice, and slammed us broadside into a lamp post.

It was a mess. Fortunately, no one was seriously hurt. Otto, sitting in the front with the driver, had grabbed the wheel and turned us into the skid, otherwise we might have rolled. Jean was terribly shaken. Still bandaged from the fire, she didn't need this additional trauma. The car crash had spewed my cameras all over the road, and I had to call my agent in New York to send me new ones so that I could finish the film. People from the crew, seeing the accident, stopped and picked us up in different cars to continue to the studio. The sound crew picked me up, but that ended in another horrible skid and crash on black ice as we were rounding a corner. I'm sure I was in shock myself. I got into a studio car and went back to London and to bed.

The film wound down. Mother, Max and Tom Ryan had all gone their separate ways. Graphic designer Saul Bass (who designed the terrific logos for so many of Otto's films) came to London, and together we shot the ads. It was the start of a long friendship between us.

I was thinking of returning home myself. The long, sunless London winter had worn me down. The sun broke out briefly one rare day, and I rushed to the window to sit and absorb as much as I could, welcoming it like water in the desert. However, that was not to be the case. Lee Gross called me and told me she had an assignment on a film in Rome with Tony Perkins. So I organized all of the things I had shot on *Saint Joan*, and shipped them off to Lee, and as I was waiting for my new cameras to arrive, I prepared for the next adventure.

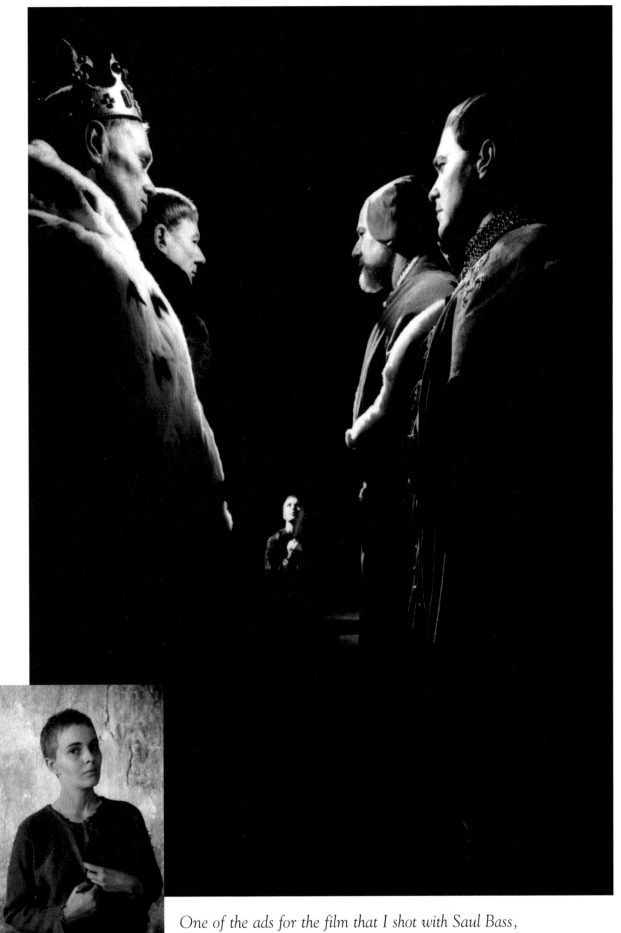

One of the ads for the film that I shot with Saul Bass,
and my portrait of Jean as the martyred Joan, 1957.

Dame Elisabeth Frink, one of the strongest women sculptors I've ever known. Seen here in her Chelsea studio, long before her sculptures were sought after all over the world. The drawings are the early stages of her "warrior birds" series. London, 1957.

(right) Young actress Ann Dickens, a fragile beauty (who reminded me of Gene Tierney) who stopped me in my tracks one day, and I asked to photograph her. London, Hyde Park, 1957.

(facing page) Playwright John Osborne, sitting in the empty Royal Court Theatre, which produced his Look Back in Anger. That play was to make him a theatrical luminary. London, 1957.

I arrived at Cinecittà Studios in Rome to work on the film *This Angry Age* with Tony Perkins (above). It had a French director, an Italian crew, an English camera crew, and American and Italian actors. My language skills at this point were zero, and my confusion with all of this prevented me from functioning.

I hired a young interpreter to translate everything for me, otherwise I don't know what I would have done. The added bonus of this was that she also knew all the great restaurants in Rome. One day she even bargained for a Proto-Corinthian pot for me. I thought the dealer and she would come to blows. I tried to stop her, as it became so fierce. The dealer said as I was leaving, "Don't ever bring her back here again!" But thanks to her, I came away with my treasure.

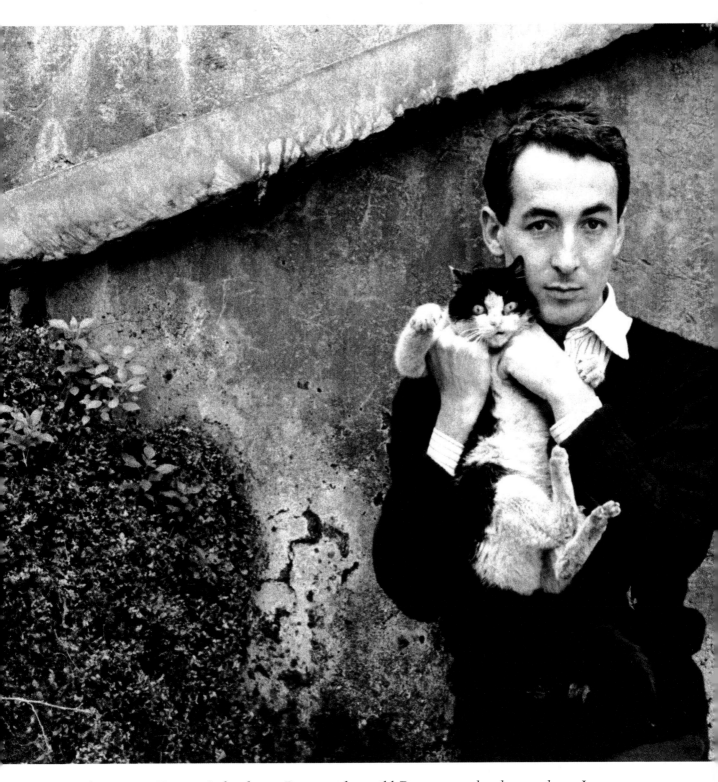

The painter Enrico Colombotto-Rosso with a wild Roman cat that he caught as I was about to photograph him. He used cats in his work as a mysterious element, so it was quite appropriate for his portrait. Rome, 1957.

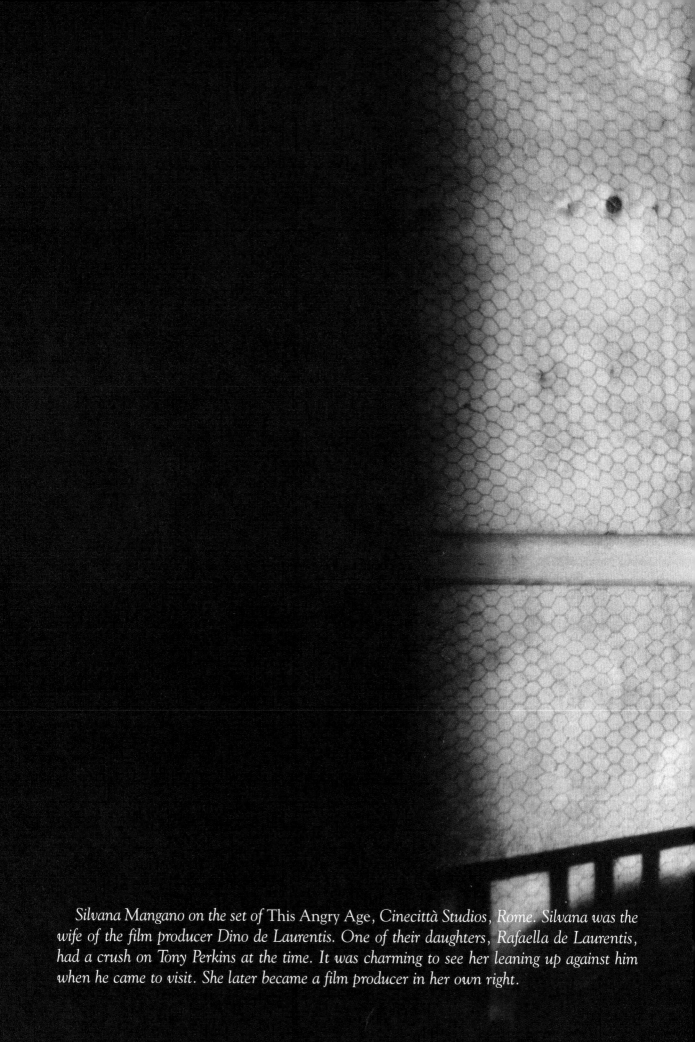

Silvana Mangano on the set of This Angry Age, *Cinecittà Studios, Rome. Silvana was the wife of the film producer Dino de Laurentis. One of their daughters, Rafaella de Laurentis, had a crush on Tony Perkins at the time. It was charming to see her leaning up against him when he came to visit. She later became a film producer in her own right.*

While having dinner one evening in Rome, a little girl walked into the restaurant to get some pasta for her family. I said, "My God, there's a Botticelli." Virginia Fagini was a classic beauty. I asked her parents if I could photograph her the following Sunday, and these are two of the images.

After that, every time I was in Rome I photographed her (which started me on another project of girls growing into women). I've photographed her now for well over 30 years, while she was married and then with her daughter Valeria Sasanelli. I keep pressing Valeria to have a daughter of her own, so I can get three generations, but she says she is too busy now becoming an architect! 1957.

When I was about to finish with the film, Lee called me from New York to say she had an assignment for me from *Look* magazine to photograph Rock Hudson in *Farewell to Arms*, which was being filmed in northern Italy.

(top left) Director Charles Vidor and Rock Hudson on the set of Farewell to Arms, *Grado, Italy, 1957. (top right) Santina Mauro, Osteria Rochet, Zompitta, Italy.*
(facing page) Rock Hudson, Palm Sunday, Udine, April 14, 1957.

I took the train from Rome to Udine in northern Italy. As I watched the changing landscape, the stress of my Roman assignment slowly disappeared and I fell asleep. The next morning, I could hardly believe my eyes, for the light, the textures of the buildings, the people and landscape just blew me away. I was intoxicated with the beauty everywhere I looked. I'm sure the unit publicity man who met me at the train must have wondered what he had in tow.

I had an assignment to photograph Rock Hudson for *Look* magazine, and I set about it right away. Rock was happy to get away from the film, so I took him off to the countryside that was filled with yellow rape flowers for miles around, with church towers breaking the horizon, and beyond them snow-capped mountains. It was terrific. We stopped for lunch in a little town called Zompitta. Italian food barbecued on corn husks filled the air in this restaurant with a great welcome, and we both dug right in. This was my first real taste of how great northern Italian food can be. Rock and I enjoyed it all, and I photographed him at our table with the sun streaming through the window.

He was in no hurry to return to this madhouse of a production. We sat there enjoying the wine and conversation. Out of the blue, he asked me what I thought his wife might like for a birthday present. Of course not knowing his wife, I couldn't be of any help, but I thought it curious at the time. There was a waitress there named Santina Mauro, not young, but full of life like Anna Magnani, and I thought she was beautiful.

I had to photograph her. I plunked her down at our table, and Rock helped me by holding up a white napkin as a reflector (see above). It was hard to think I was being paid for such an enjoyable day.

After I had everything the assignment needed, I rented a car, as I wanted to see more of this beautiful region. One of the people from production, Guiderino Guidi, was so happy that I found his country extraordinary that he took some time away from the film, and after checking with the local drivers, sent me on various journeys each day.

The Roman and Romanesque sculpture is unique in the Friuli area. I clicked away and had a great time by myself. One day, Guiderino took me to a little village, bought some bread and ham, and we went to a little trattoria where he ordered the wine. He was so mysterious about a ham sandwich that I couldn't understand it, and asked him, "What's the big deal?" He opened his sandwich and held the ham up to the sun. "Look, Bob, it's the color of champagne! It's the most wonderful prosciutto in the world!" We were in San Daniele.

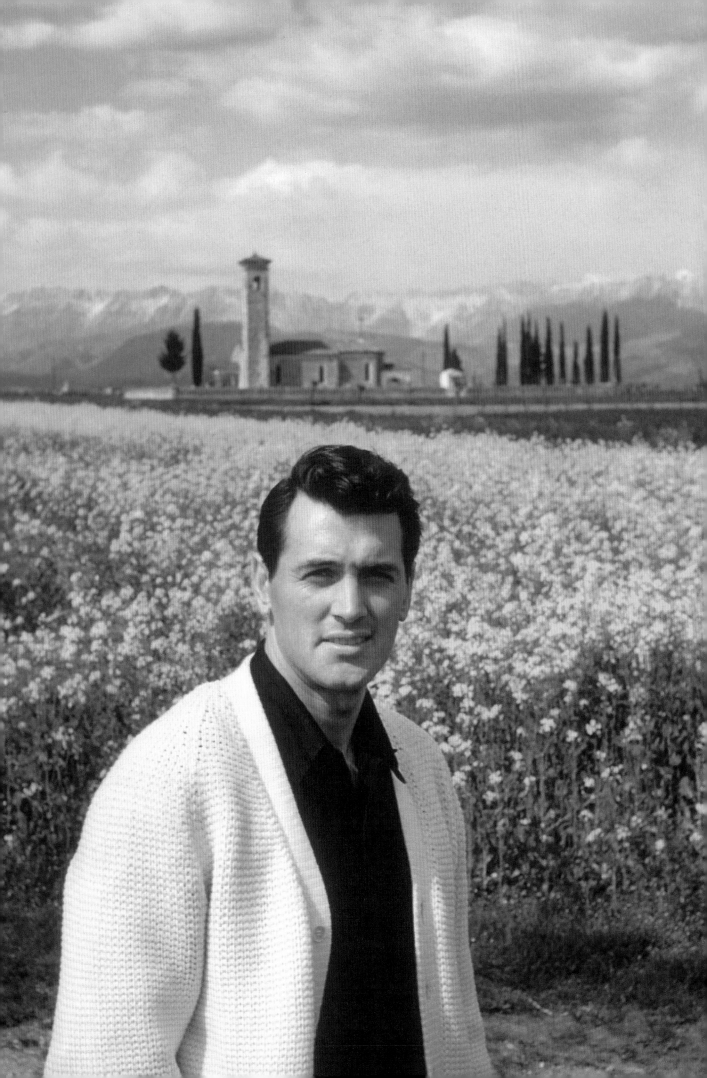

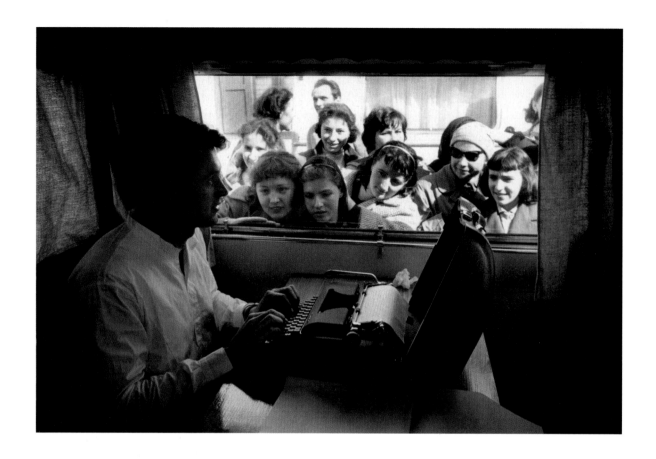

(Letter to my Mother)

My dear love,
Here is the place! What a change, the first day I was so intoxicated with the beauty, I went crazy shooting pictures. It was so wonderful to be in the sun, wonderful to see such exciting snow-capped mountains, picturesque farmland, with rows of the most electric yellow flowers, looking all the world like wild mustard, but I understand not. The people are different, the streets, the air, the flowers … everything seems different, even simple things like chickens, all black, mixed with others of motley hue, are exciting to my eye starved for this type of thing … and more.

This area has Romanesque sculpture on its churches, and in a tiny town of Gemona on Saturday I saw probably the loveliest Romanesque primitive church I've ever seen. I went wild, and stood on my hands, and jumped, and because of this, I think I shall now stay over until at least Thursday and take pictures.

Last night I went to a restaurant we had discovered on our search for backgrounds, and it was wonderful, with a bridge you must walk over to reach it, and rushing water, and flowering trees like you have never seen … purple camellias, different from what you are used to. The food cooked on an open fire in the middle of the room, ah what flavor, with homemade bread and a different kind of bread, yellow like our corn bread, but again not. For coals they burn corncobs, and the chicken last night, just made my hair stand on end. The wine of the land is made right here, and soup and salad and I could go on and on. The owner's daughter looks like a Vermeer painting, and I think I must photograph her too … in the sun, and well, I'm overcome by it all!

This morning is Palm Sunday everywhere as everyone must be Catholic here. Little children carrying branches of olive leaves (no palms here), and down the street they come, trudging with branches almost as big as they … in their best clothes, in the sun-bathed streets, with houses colored in combinations like I have never seen, and if I were a painter, I would go mad trying to paint it all. Then to the market place with stalls of fruits and vegetables. I bought a tangerine (called mandarin here) and then three more, then finally an entire kilo, about a penny a piece, so sweet, so wonderful (again that adjective) I could hardly stop eating them.

Then to Mass in the Cathedral, and with such an altar, huge and covered with tall tall candles, hundreds of them all lit. The sun streaming into the church from up high causing long shafts of light to thrust deep into the choir of altar boys. A high high Mass, with voices from another age, sweetly haunting. The archbishop and a dozen priests … and people kneeling and standing over the entire church with their olive branches.

I traded a piece of my palm from last year in Kentucky with the vendor in the market place for one of her olive leaves, and I'll enclose it later. The border to Yugoslavia is just a stone's throw away from Udine, and in some of the little villages I've visited it's almost to the border. The mountains thrust up into the clear blue sky, with clean cut tops and glistening snow, and all in all I could hardly have missed with Rock Hudson today when we went out and shot a few covers (at least I hope not). He was very nice, and we had a nice time together.

The people's faces here are different too, richer in the good things, the girls are sometimes startlingly beautiful, usually with long long hair, rolled into buns, or down one side in long braids. I must admit I feel 1000 times better than I did in Rome, when I was so depressed by everything. It is really wonderful to be so stimulated, and I do hope I shall grow and benefit from it. The room is OK, and I feel fine. Received your last letter, and thank you, I hope all goes well, and of course always always my love.

B. xxx

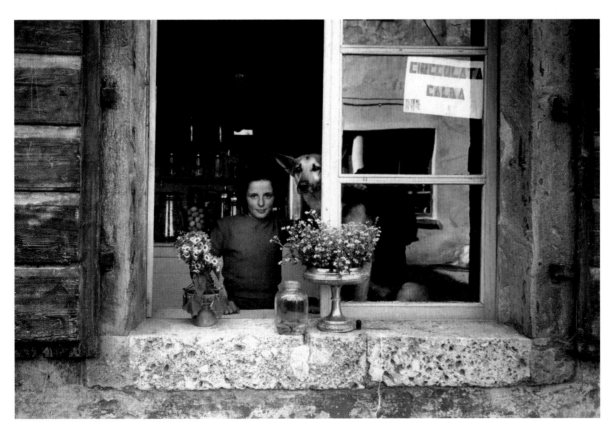

Being back in London quickly dissipated the Italian warmth I had enjoyed. Here I was back in the gray city, and I realized I was really very tired. I called Lee in New York and told her to hold any other assignments for the time being. I went to the famous Foyles bookstore in London, and filled the trunk of my car with books I'd never had the chance to read, a few bottles of whisky, and put the cameras away. Kenneth Haigh had thought he would go with me, but I think he was cast in *Look Back in Anger*, so I headed off for the north in my Thunderbird.

I didn't know it at the time, but this proved to be one the best things that ever happened to me. I had a rare chance to be alone. I headed into the north of England and Scotland, seeing the great cathedrals (Ely, one of the most beautiful Gothic churches I've ever seen) and the landscape, meeting new people, stopping to talk with the farmer who was plowing his field (below), listening to him speak of how much he loved his land and his life (and while he didn't say God), I was left in no doubt they were all so much part of the one to him.

It was all tranquilizing. It turned out to be a journey into myself, and I feel this trip provided me with the time to mature. It forced me to examine my life and gave me sustenance for the years to come.

After Scotland, I put the car on a boat, landed in Belfast, and quickly headed toward Donegal town in the Irish Republic. The children there had just made their First Communion, and I saw all of these beautiful little girls in their white dresses parading up and down the main street. I pulled the car over and booked myself into the hotel.

That was a night to remember. I had dinner and went into the lounge to read. With my Thunderbird parked outside, there was no chance to read that night. I could not buy myself a drink. I thought I must be part of a John Ford movie. I was asked where I was from, if I was married, if I knew their brother who was a priest in California and on and on, all but the color of my shorts. I was introduced to the mayor of the town and the Ford dealer. I had to give them both a ride in the car, and promise that I would go by the Ford garage the next morning to show the car to the mechanics.

When I left the next morning, people were hanging out of their windows waving goodbye. It was my first experience of Ireland, which stayed with me for the rest of my life. I went to Mass in the morning, as I did every morning, and that was my first introduction to the beautiful stained-glass windows of Harry Clarke.

I thought this overwhelming hospitality was just a fluke, but when I got to the Yeats Country Hotel, the same thing happened. I met thoughtful and interesting people, had discussions long into the night, was given the top room with 20 beds, and was told I could sleep in all of them if I wanted! Finbarr Smyth, the hotel manager, and I planned to take two models (there was a fashion show the night I arrived) to the theatre when I got to Dublin, after I had made my tour of the island.

I stopped in Tralee in County Kerry. My neighbor Martha McGeein's mother and father had come from there, and she asked me to take photographs. My contact there was John Caball, a local school teacher. That was the beginning of not only another friendship, but later a collaboration on a book of Irish poetry. Photographed (above) in his home, Dun Kerry House. Legend has it that it was originally prepared for Marie Antoinette, before the French Revolution cut her life short.

The cemetery and the village houses contemplate each other across the sloping valley. The locals in time exchange one residence for another. Ireland, 1957.

Here is an excerpt from a letter I wrote home on May 10, 1957, describing Ireland as I saw it then:

Past Tralee, past Anascaul, past Dingle. Past Slea Head's rocky seascapes, and rain wet cattle, past milk carts, metal canned, jogging uneasily to the steady plod of the donkey. Unheeding to the prods to move out of the way, as my American car jack-knifes by. Past cement square National schools, and young boys hanging from windows shouting to see a stranger, a car, to make a disturbance. Past fields dotted with spring lambs, pressing close to mother for support, for warmth, because nature still attaches them.

Fields divided by grass grown stone walls, crossing and re-crossing each acre, marking the rolling hills like a huge floor plan, from some other time, from some age long ago, now just being lived with like all of the other remains of the Irish past. On this road, this winding stone lined road, I can sometimes stop and look over the side, down into blue boiling water below. Or hill high, I can see the crazy quilt pattern stretch far below, rising up to cover the next hill, like mine.

The rain is soft and gentle, but with a change of wind, it steams into my windshield with a passion. This road has led me to Dunquin, the far extreme tip of Ireland, the land of the Irish speaking, and the Blasket Islands and a tiny primitive guest house called Krugers. So as I sit on my bed to type this, I must sit as close to the dresser as possible to catch all of the light from the candle and my flashlight. It wasn't always like this, tells Kruger, "We had one of your (meaning American) generator-motors," as he points to the hanging light fixtures in my room. "The truth is when we got our liquor license, we wanted to put in a bar. We looked around, and the generator-motor was right in the place... the place we wanted to put the bar." He confided that there was one other problem, beside not having running water in the rooms. "I suppose you'll be wanting a bath?" I confessed that the thought had occurred to me, and to have a tape recording of that beautiful soft Kerry accent, and his description of "going to the kitchen when no one's around," and "two kettles of hot water in a nice pan," and a wink, and a lift of one pantleg, "like I did meself, last night," as if he had returned to the church.

I wanted to get away ... but this was too far away!

In another letter from May 22, 1957:

I stopped at a service station for petrol, to move my legs, to check my map and there were three little children, red haired and grimy, and one named Rita was 10 come June, and her birthday was one day before mine. I told her that made her one day older than me, she giggled and hid her face in her hands. I suggested that we have a party there, and since she couldn't speak anymore, her little sister offered to get the ice cream ... so we all sang, except Rita, who was red, and happy, and I waved goodbye, and it was one the nicest parties I ever went to.

I've taken a few snaps, for fun, to remember the cloisters, some of the faces I love ... to remember the women gossiping, the lakes of Kilarney, and Dingle Bay. Brave dare-devil road sitting birds who don't move until the car was upon them for sure, who were never hit, but forced me to clench my teeth a hundred or two times, and the blind curves that you are certain will reveal a herd of cattle or sheep on the road, a dozen bicycles, or donkey cart ... and did.

Of filled churches, a brown-colored kerchief sea. Of teas in homes with cookies and buttered bread, and crotchet tea cozies, and talk of butchers and grocery men, of freckles, and the good luck I was sure to get when two of us heard the cuckoo sing. And parks with grazing sheep, and prancing dogs, heel snapping and herding. Of little boys running and laughing down hills with wild flowers, throwing stones, and chasing new lambs with bleating protests.

Of Confirmation day and veils, and beaming white dressed street walking little girls, out making calls on their other girl friends, of reading by flashlight in a rustic inn. Of two little boys who begged for a ride, and when I said OK, and started the engine, they both cried, and wanted to get out ... and never did take that ride. Of nuns and priests on bicycles, and flocks of school girls uniformed and medaled.

Of men standing around on the street corner betting, of men standing in the evening on the street corners ... just standing watching their town go by, as they will each night of their lives. Of packs of Irish greyhounds, walking with their light-footed trainer, who nods to these street standing men ... local hero. Of gossiping women, who gather each morning, brown shawled and full of news. Of filled churches, and each person who passes the church, "signs" himself automatically, of scapular pinned waitresses, and Pioneers who never drink ... of dances in the parish hall with a sign forbidding "Rock & Rolling," and another night the production of *Oklahoma*, with baggy panted cowboys, with brogues singing Rogers & Hammerstein as if it were part of their own folklore. And juke boxes and neon signs, of fields filled with the softness of new lambs, of sunsets and seas, and gray days, and the sound of Gaelic on the ear. Of children off to school in the mornings, girls arm in arm, heads together, boys with books strapped to backs with harnesses, pull and tug each other as if they expected some parts to come off ...

Philomena Barrett,
Tralee, County
Kerry, Ireland, 1957.

I can't leave this chapter in my life without relating one more lovely story. While I was getting away from the cities (which I now realized just diminished my spirit), I still had a living to make, and Otto Preminger had asked me to call him in London toward the end of May. I was now in the West, and it seemed like the only phone for miles around was in the little post office.

Walking into the post office, which was also a grocery store, I met two nice ladies, who looked at me gravely when I said I wanted to phone London. They had, they confided to me, done that once before, when one of the local's grandfather had died, but it had taken them all day, and they were not very encouraging. "How long will you wish to speak?" one asked, and I said I didn't how long it would be, but I would pay for whatever time it was.

They talked it over between themselves, and then came back with this: "When young Morris called about his grandfather, he took three minutes, and I'm sure your call can't be as important as that!" To their amazement, the call went through immediately. They looked at each other in disbelief. I did get Otto, and I was cut off at exactly three minutes. With a nod of their heads to me, as if to say: "now there, you've had your talk," they presented me with the bill.

It was long enough to discover that Otto wanted me to work on his next film, *Bonjour Tristesse*, in the south of France. That wasn't too hard to take. I finished my tour of Ireland, with a wonderful impression of the place and the people, and went back to England, and then home for a brief time with my mother.

Then it was back in Paris, we started working on *Bonjour Tristesse*, and once again I was with Otto Preminger and Jean Seberg. Gone were the grubby clothes for Jean, now replaced with smart little black dresses from Dior (above). I was now seeing France with different eyes, having had the opportunity to return to L.A., and clearly see the difference in the two worlds. Otto helped this transfer of affection, by introducing me to the restaurants, the wine, and this good way of life. His influence is probably one of the reasons that we live in Europe today. What a joy to be working outside in the sunshine, away from foggy England.

Jean was buoyant, and had several romances, one with a young French lawyer, François Moreuil, who she later married. We were based at first in St. Tropez, and this was a swinging time for this now famous port. In fact it was too good, as the crew was spending late nights in the discos, and not being as sharp as Otto thought they should be the following day. He packed us all up, and we ended up down the coast in a more family oriented seaside resort, Le Lavandou, without a disco in sight.

The French crew were good, and as part of their contract, had a running buffet for lunch, at which they were served wine. The English camera and sound crews thought they deserved the same. The first lunch that they tried that strong local red that the French were used to, I found their pale white bodies sleeping in the sun, scattered all over the villa we were using.

Jean Seberg on location in the Villa Lazareff, where they filmed Bonjour Tristesse, *1957.*

Working in the south of France is so much more enjoyable than coming as a tourist. The people at the restaurants tend to treat you differently if you're a regular, and this location was no hardship. It was also a great pleasure to work with such nice people as Deborah Kerr (below) and David Niven. You can tell just how agreeable David was, when one day I was offshore in a boat, and he offered to carry me and my cameras to dry land (above).

Deborah and her husband, Tony Bartley, had rented a small yacht, and brought their two little girls along with Bill Holden and his wife, Brenda Marshall. When I moved my family to Ireland many years later, I met Tony again. Now remarried to Vicky Bartley, and again with two lovely little girls, we are friends to this day. Tony was one of the great Spitfire pilots in WWII.

(facing page) Jean Seberg at the Villa Lazareff near Le Lavandou, France, 1957.

On my return to our little house on Marvin Avenue, I had a great welcome from my mother. She had good friends, and I knew she hadn't been lonely, but we had been separated far too long. As an only child, I had always lived alone with my mother. She had shared the ups and downs of my life, nursing me through polio when I was two and all of the other childhood dramas and diseases. I was never an easy child, but she had lovingly stuck by me through it all. Our lives were intertwined. Home then was where the two of us lived, and it was plain just how much she had missed me while I was gone, and I realized then it had been the same for me.

Work had piled up in the office, but now I was bothered with an uneasy feeling that something serious was about to happen. I often had premonitions, the sense of things about to happen (just a notch up from intuition). It happened so regularly that some of my friends said I must be psychic. My agent would call to tell me about an assignment to fly, say to Mexico, and I would tell her that I already knew, that I had dreamed about going there the night before.

Another time I was photographing Barbara Ruick (a very special young lady who had a lovely singing voice) at Fox Studios for a *Life* cover, we became so tuned in to each other that, without realizing it, we were communicating without talking. Her agent, who was there, flipped out, demanding to know what was going on. It was just something that happened between us without our realizing it. I actually thought this carrying on was a bit spooky, but there was really nothing I could do about it! Often it gave me a heightened sense when photographing people, so I just treated it as a gift. After I was married, I never dreamed about things that were about to happen again.

The sense of something imminent this time was too strong to ignore. Thinking back, I must have equated it to the fact that I didn't have long to live. One of my priorities then was that my work not be lost, and I began a printing regime that took me several months. Night after night I would go in and print my favorite images, and of course I never told my mother why I was so involved in this project.

The Museum of Science and Industry in Exhibition Park had agreed to give me an exhibition, and so I prepared "Through the Looking Glass." I went nightly to the museum and had it all hung. The brochures were printed, and the night the exhibit opened, my mother had a heart attack and died. I was totally unprepared for this. While my mother had had a stroke years before, she seemed to be doing just fine. It was such a shock, such a loss, and while that time now is very hazy, I do remember a few things.

Father McGovern, our parish priest, gave her the Last Rites. I followed the ambulance at tremendous speed on the freeway and through the city streets. I was afraid to lose them since I didn't know which hospital they were taking her to. There was torrential rain at the funeral. I said my good-byes to my mother, and was numb with the realization that I would never see her again.

I never went back to see the exhibit, and told my secretary to go to the museum when it was finished and pack it all up. The premonition about death was not about me, but my mother, unexpected since she was so young. Los Angeles, 1958.

8 Part V—SUN., APRIL 13, 1958 Los Angeles Times

IN 'THROUGH LOOKING GLASS' show of photographs by Bob Willoughby at California Museum of Science and Industry is this portrait of girl. This show has great human, artistic interest. On view to April 30.

IN THE GALLERIES

Photographs Rate as Art

County Museum's Costly Goya Inferior Example of His Work

BY ARTHUR MILLIER

Art is where you find it. I went to the California Museum of Science and Industry to see the Church Design exhibit. It's good.

But on the second floor is an extraordinary show of photographs by Bob Willoughby, 30, Los Angeles-trained free-lance photographer, called "Through the Looking Glass." These had the art I, for one, did not find in the County Museum's newly acquired $270,000 Goya portrait of a Marquesa with a lyre.

The Willoughby photos of people, movie sets, moods and seasons, shot the world over, have beauty without tricks. Their author has the rare perceptive eye for design, exquisite tonalities and the expressive moment (To April 30.)

(above) This excellent review of the exhibit, was not one of the usual dull photography reviews, but written succinctly by The Los Angeles Times Art Editor Arthur Miller.

(right) The cover of the brochure the museum printed up. Los Angeles, Exposition Park. *1958.*

The California Museum of Science and Industry in Exposition Park presents

through the looking glass

an exhibition of photographs by BOB WILLOUGHBY

Antoinette Swarz Willoughby, 1900–1958.

131

*Dr. Cyril D.
Willoughby, DDS,
1898–1958.*

I had a few assignments that kept me busy, but our home was now so empty, I didn't have the heart to do much. A few months later, my father also died, and even though I rarely saw him, there was this secure, probably subconscious feeling that he was there. I'm sure it's the same with everyone when one loses both parents—a feeling of being totally on your own for the first time.

I went to see my grandmother more often (my father's mother, who had now not only outlived her husband, but all of her children). She had 10 acres of oranges in Covina, and I took friends out there, and she treated us to her superb fried chicken lunches, which were so good we groaned with delight. She was a wonderful character, with a personality and humor everyone responded to. She was "Johnnie" to one and all.

I decided I needed a change of scenery. A French art dealer I knew in L.A. was going off to Asia, and he had a scheme with his in-laws that involved one of the maharajahs in India selling his antique guns. He suggested that I take photographs of the collection, supposedly only as a photographic record of the inventory.

It was all supposed to be hush-hush, since the Indian Government was giving the maharajahs a chance to sell off some of their possessions before they nationalized them. I did think it could make a good story, and the trip was timely for me. I told Lee what I was about to do, she wasn't happy, but she could understand me wanting to get away. I said goodbye to my friends and set off on another part of the journey.

Hawaii, then Japan, were the first stops, and since I was with a man who had been with the French Department de l'Extrême Orient, who knew the museums and dealers, it was a real education seeing things in this new context.

I was amazed to discover that, in a sense, I took my mother with me. Every time I saw something beautiful that I knew she would have enjoyed, a tree, a landscape, or people she would have liked, I felt I was seeing it through her eyes.

Japan was an amazing experience. Here was a culture that nothing had prepared me for. I was overwhelmed with this tranquil sense of harmony almost everywhere I looked—a garden with all of its various elements and textures working together as one. Even in a business section of Tokyo, I looked into a charming small private garden, and there stood a large granite stone block, scooped hollow on top to form a bowl for a single goldfish. A small bamboo tube slowly dropped fresh water into the top, drop by drop.

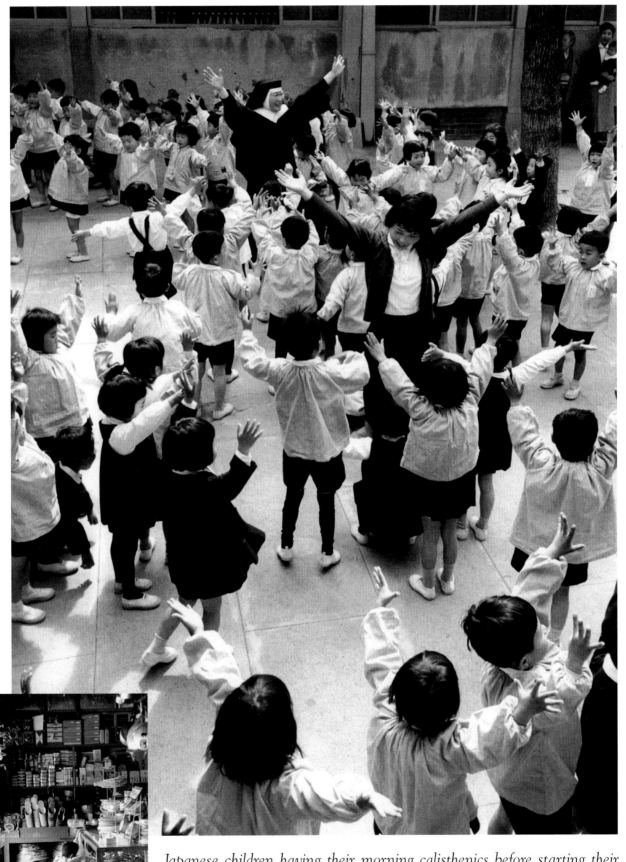

Japanese children having their morning calisthenics before starting their classes. The children in Japan are so beautiful.

(left) A little boy pauses, as he must have every day on his way to school, to gaze once more on this dream-filled showcase of shiny pocket knives. Kyoto, Japan, 1958.

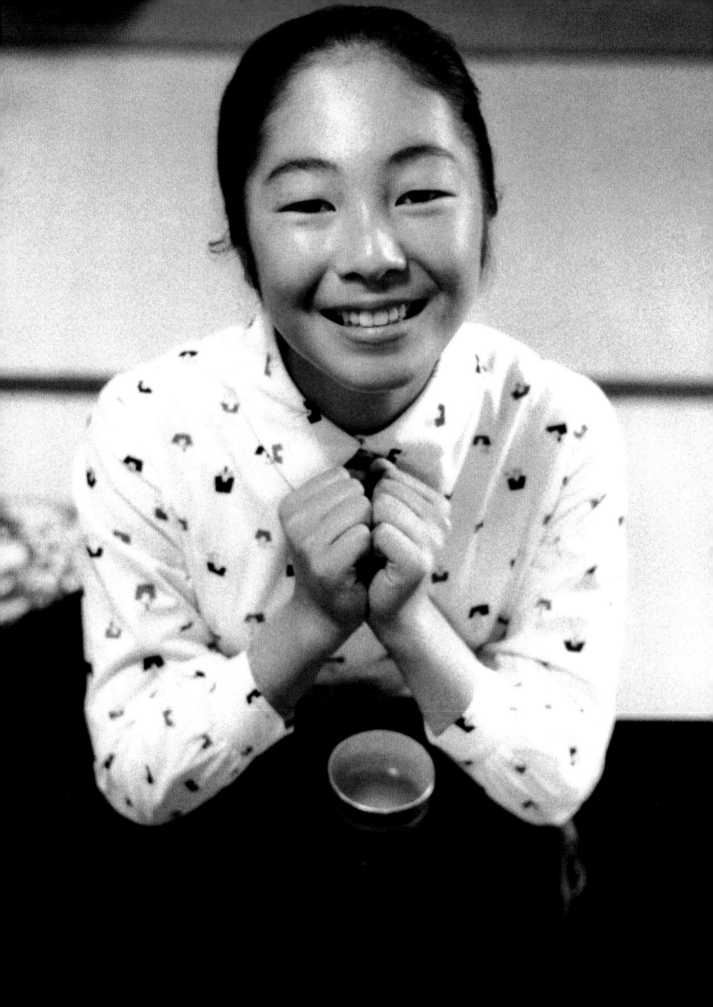

We were staying at the Imperial Palace Hotel, architect Frank Lloyd Wright's famous building, and one night I saw a large family having dinner. There was a Japanese girl so radiantly beautiful there, and I was compelled to go over and ask if I could photograph her.

Madame Chiyeko Hachisuka was very gracious, and allowed me to make arrangements with Takako Sano for the following day. She later invited us down to their home in Atami on the Japanese Riviera. Here was a classical Japanese home that even had its own hot springs. We were invited to have a Japanese bath in one of them.

They explained the ritual of soaping in one pool, rinsing and then bathing in the next. What I didn't expect was to have a young Japanese girl come in and apply the soap! Well, it was another new experience for this pilgrim. I slept on the floor with one of those wooden pillows for the first and last time that night. What a wonderful treat to not only have the opportunity of seeing a place like this, but to spend a night there as well. I kept in touch with Madame Hachisuka, and she came to visit us, in Los Angeles, years later.

From Japan to Hong Kong, and then to Saigon. One early morning I photographed this peaceful river scene (below) and was entranced watching the lovely young girls, with their long black hair hanging down their backs, dressed in their white tunics and black trousers, on their way to school. As lovely as they were, I was glad this was just an overnight stop and that we would be flying out the next morning to Siem Reap in Cambodia to see the fabled temples of Angkor Wat.

Saigon didn't give me good vibrations. There were large political posters everywhere, and the street life gave me a feeling of unease that I couldn't put my finger on.

I was staggered by Angkor Wat (below right). Books hadn't given me any idea of just how wonderful Khmer civilization really was. The beauty of the carved-stone friezes that surround the main temple is astonishing. The organization of the elements in the sculpture is mind boggling, and I am in awe at the culture that could produce it. This was magic, and I wanted to see as much here as I possibly could. I took a body-wracking journey in an old Land Rover over jungle "roads," in the tropical heat to see Angkor Tom. It was amazing to see the great stone heads of Buddha overrun by the encroaching jungle.

Then I went to Bangkok where I saw their ballet, and their glass inlaid temples, and to Rangoon, to Calcutta, and then to New Delhi. It was there we learned that Oscar's brother-in-law had dropped the idea of purchasing the maharajah's antique guns for bigger fish, as Britain was selling off its World War I arsenal. That eliminated one of the main reasons Oscar had made this trip, and he left for home. I stayed on to see more of the spectacular art and architecture of India.

(facing page) Takako Sano, photographed at the Imperial Palace Hotel in Tokyo, 1958.

135

Me in front of the Sphinx.

I flew from Bombay to Beirut, but when we arrived the passengers were not allowed to leave the airport because of the conflict going on in the city. There were soldiers with automatic weapons closely watching all of the passengers, which was a little off-putting, since one of the soldiers had his finger on the trigger. The airport was interesting in spite of that. There were so many different people to look at, so many different worlds all blending together, that while I was sorry not to have been able to get in to see Beirut, the airport on its own was amazing.

Then I went to Cairo, and I found that here, too, was another historic world where I could "touch the stones." The collection of beautiful things at the Cairo Museum from those great cultures kept me enthralled. I would study one case, leave it and get about twenty feet away and was compelled to go back to look at it again, to store it all in my memory banks.

It was a pilgrimage to places I had only read about in books, and to be there, to be able to touch the stones. This tangible contact with history was marvelous. Unfortunately, I caught some bug that the doctors later described as walking pneumonia, which left me without a lot of energy. So I made plans to start heading back toward home.

I briefly rode a singing camel called Bing Crosby, saw the pyramids, bought a fez and some Coptic textiles, and did about everything in close access to Cairo that I wanted to do, but as I didn't feel too energetic, I passed on any major excursions up the Nile. Then to Istanbul, to see the great Santa Sophia, or Blue Mosque, and its wonderful mosaics. I loved the outdoor restaurants with the Turkish singers improvising the melody against the music, which reminded me of some of the jazz singers I knew at home.

Then to Athens. Their great museums brought me face to face with so many familiar objects that I have always admired. There was just so much to see, but not enough energy, so I flew to Rome for a few days, and called on Virginia Fagini and her family, and photographed her for the second time, as I would from then on every time I went to Rome (facing page). 1958.

I made one more stop before getting home, flying to St. Louis, to see Sr. Celine (below right), formerly Celine McGeein, Martha and Cyril's daughter. She had been my secretary until she decided to join the Daughters of Charity, and I hadn't seen her since she had become a nun. When she appeared in the convent garden, she looked so radiant, glowing with inner peace, that it made me happy to see she had obviously found what she had come for. There had always been a strong bond between us, but now it seemed to have moved to another dimension. I knew she would be a guarantor for my spiritual life.

Back home, I visited a doctor for tropical medicines, as this bug that I had picked up in India was still with me. Although every week he would give me a "shotgun" treatment of medicines, hoping that one of them would do the job, it took several months to eventually solve the problem. I found the Marvin Avenue house now too sad for me, and started looking around for a peaceful house with trees.

Sophia photographed in the Paramount wardrobe department with all of the dress models made for other actresses. 1958.

I had an assignment to photograph Sophia Loren at Paramount Studios, and I was directed to a cabin-like dressing room that had been wheeled onto an empty sound stage. She was sitting in a pair of slacks, listening to Sinatra records. "I love Frankie!" she told me. She was lovely and warm, and I liked her immediately. I started taking a few pictures when director Martin Ritt stopped for a visit. (I knew him as an actor, and had photographed him in *The Flowering Peach* rehearsals in New York for *Life* magazine.)

The dressing room was small, and to separate myself as much as I could, I found that watching the action in the mirror was less intrusive. Sophia apparently had the same trick, and our eyes made contact in the mirror several times, forcing her to laugh, knowing we had found each other out.

The music was still swinging along, when one of the tracks must have triggered something. Martin put the music on full blast, grabbed Sophia and took her outside to dance, and dance they did—it was a panic! Some of the makeup people from the next set came running over to see what was going on. It was all so spontaneous and such great fun, everyone was laughing, and I got some terrific pictures (below).

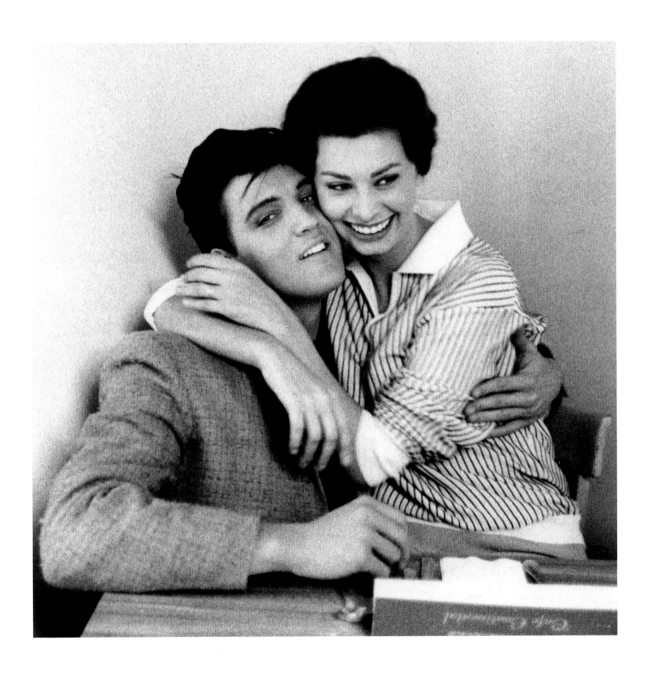

Later, when Sophia and I were having lunch in the Paramount commissary, she suddenly jumped up, having seen Elvis Presley come in. She just swooped him up (I don't think she had ever met him), brought him over to our table, and sat down on his lap. She hugged him, rumpling his perfect hair, and made a great fuss over him. He was so embarrassed, especially when he saw I was taking pictures. He didn't quite know how to deal with this irrepressible Italian lady. She was, well, Sophia!

Who wouldn't have loved it? I'm very sorry that I never had another opportunity to work with her, since she made me a fan that day.

(facing page) Lauren Bacall, someone I felt right at home with, and that deliciously husky voice always seemed about to laugh. Photographed in her garden. Beverly Hills, 1958.

There was a time when I thought I must be Margaret O'Brien's personal photographer. I had assignments one after the other from *Collier's, This Week, Life, TV Guide* and *Esquire.* It was amazing! I was with Margaret and her mother so often that I was invited to Margaret's wedding as one of their guests.

Margaret had told me she was discouraged about her career, as she was still thought of as "that little girl that cried," and wished that the studios would realize she was now a woman. I thought that could be a good story. I took her over to Western Costume and rented an orphan outfit, then to the famous Frederick's of Hollywood, where we could get the slinky gown, à la Marilyn Monroe (above). Margaret may have grown physically into a woman, but inside, she was still a sweet, naïve little girl.

I rented a studio to do the shots, and we had a lot of fun doing it. The orphan picture went first—she can cry at the drop of a hat! Then the slinky gown. It was a panic getting her into it. We had clothes pins in the back of the dress from top to bottom, pulling it tight to show off her figure as much as possible, and pushing her breasts up with Kleenex. This was obviously a new experience for Margaret. We met again at *Collier's* magazine when the film was processed. Margaret saw the results and held her hand to her mouth, gasping, "Oh my, is that me?"

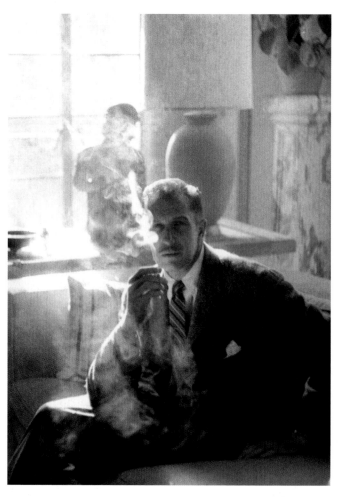

Wasn't 1958 the year for the O'Briens? First Margaret, and Hugh, and now it was a young Irish beauty with a lovely singing voice named Erin O'Brien. I had photographed her for a starlet story in 1956, and now she was back with interested people behind her. I photographed her for *Look* on both coasts—in New York on the Steve Allen television show, and then back in L.A. My mother's now-empty room was all white, and I sometimes used it as a studio, as the afternoon light was bright and clean. Both the *Look* cover (above) and the *Life* cover of Margaret were shot there.

(top right) Vincent Price answered the door to his Beverly Hills home. Anyone who has seen his films will recognize that liquid chocolate, southern gentleman voice of his. Here he was leading me into his large Spanish Colonial living room, calling me Bob, and asking me where I would like to photograph him.

(facing page) Alfred Hitchcock, posing for a diet illustration for McCall's magazine. I found an extra large plate so the food would look smaller, borrowing an idea from Hitchcock himself. He would often use an oversized object in the foreground in his films to change the perspective or increase the camera's depth of field. He gave me the appropriate wistful look at the meager fare he was being served. 1958.

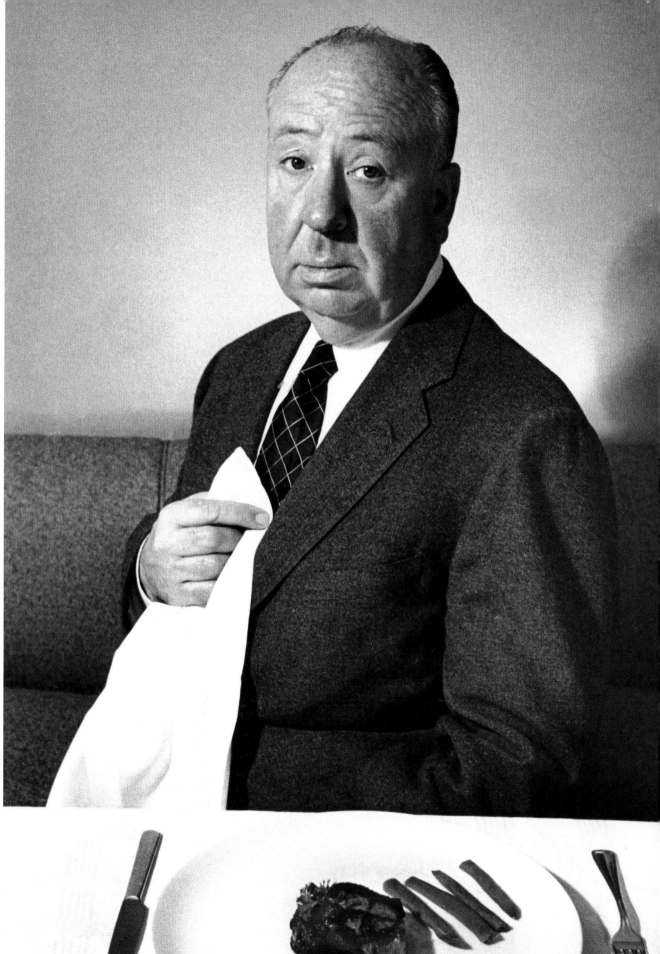

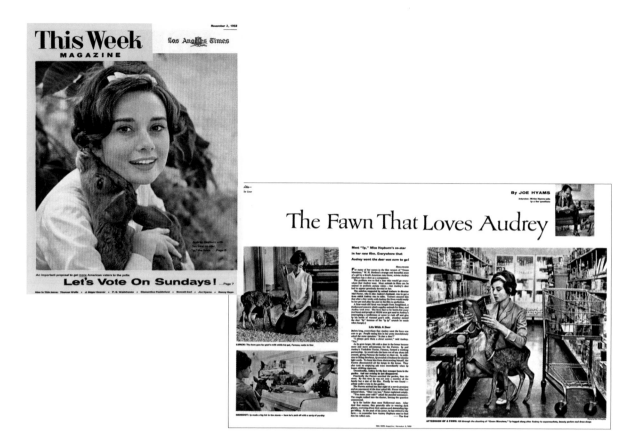

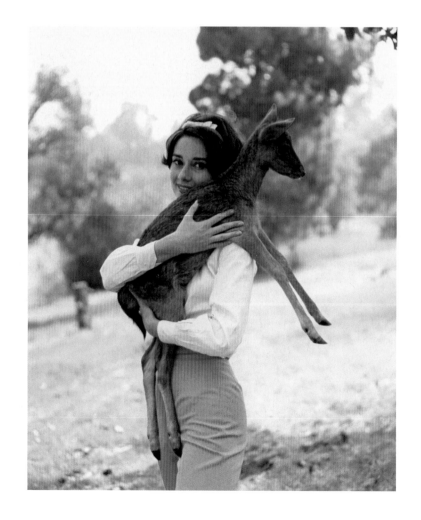

MGM called me to ask if I would like to work on their next film—*Green Mansions*, with Audrey Hepburn. I didn't need any persuasion for Audrey, I was now known to the studios as a "special," an outside non-union photographer who was hired to come in and photograph special aspects of a film. The fact that there was always a studio still photographer working on the set made no difference. This went on for the 20 years I worked in Hollywood, so I felt that it was a great compliment that they would not only pay me, but the additional fees to the union.

Before I started working on *Green Mansions*, I photographed Audrey and the little fawn deer that was living with her. The animal trainers advised the production that if they wished the fawn to follow Audrey in the film, then it had to think Audrey was its mother. So Pippin lived with her for months. Audrey's natural calm made her a perfectly suited surrogate mother for this nervous little fawn. She fed it, took it shopping in Beverly Hills, and even had afternoon naps with it. It loved her and followed her everywhere.

When Audrey was away, it missed her, and when she came back, it would nuzzle up against her, and be excited to see her. No one else could come near it, unless Audrey was there. Audrey's little Yorkshire, "Famous," turned out to be very jealous, as it had always been the prima donna in the household. I have photographs of it pouting behind lamps, grumbling to itself, when the deer was getting Audrey's attention, like a rival sibling. (Beverly Hills, 1958.)

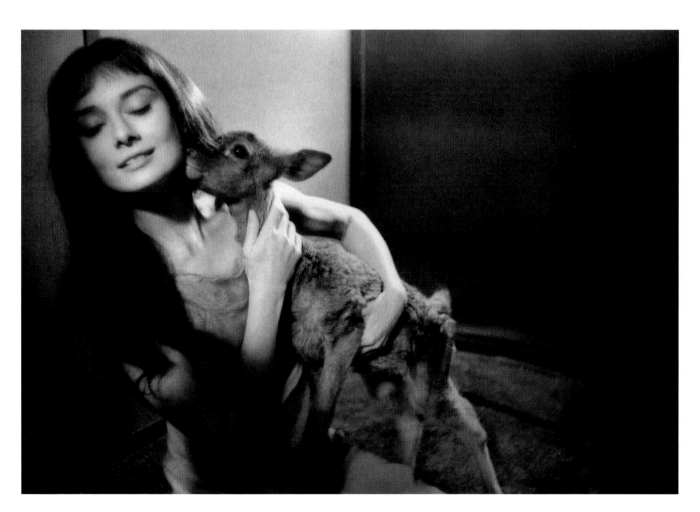

Audrey with her fawn Pippin, 1958.

Tony Perkins, Audrey Hepburn and Mel Ferrer rehearsing.
Audrey as Rima, blending into the forest, wearing the wispy costume designed for her
by Dorothy Jeakins. MGM Studios, 1958.

MGM had planned years before to photograph *Green Mansions* in South America, and Vincente Minnelli was scheduled to direct it. He spent over a year researching locations, and then it was shelved for one reason or another. Now Audrey Hepburn was playing Rima, and Anthony Perkins was the young man who discovers the "bird girl" in the jungle in Hudson's romantic tale, and Audrey's husband Mel Ferrer was going to direct.

It was nice to come into this MGM-created jungle on Stage 5 every morning with all of the exotic birds and animals. Audrey and Tony were great to work with, and there were plenty of visual opportunities to photograph. I used my old lenticular screen on my close-ups of Audrey, since she was initially supposed to be an unreal forest spirit.

Audrey and Mel were a loving couple on the set. I would see her bring him coffee in the morning, handing it up to him on the camera boom. They held hands walking down the street at lunch, and it was nice to see how close they were on this film.

But Mel was no director, and when he gave Audrey a direction that made even the grips turn their eyes to heaven, Audrey did exactly what he said. I never once heard her offer an alternative suggestion. It was the kind of relationship that, while she may have known he wasn't going in the right direction for the film, I figure she must have felt the most important thing was not to undermine his self-confidence as a director.

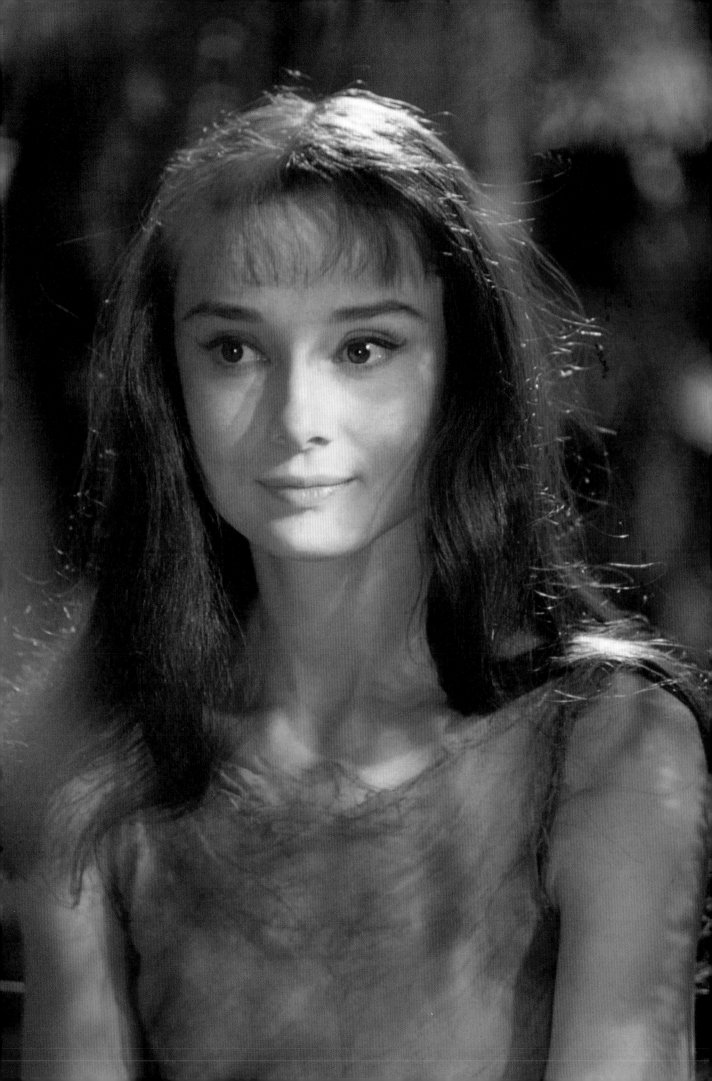

Audrey Hepburn photographed doing a series of exercises that were shot for McCall's *magazine on the set of* Green Mansions.

The first area I started looking in for a new home was out near the beach in Pacific Palisades, the Rustic Canyon area that I knew since I had photographed there often. Also, the photographer Peter Gowland and his wife Alice lived down there, and I felt certain that was where I might find a spot. On the weekends, I hopped in the Corvette and drove around looking in likely places.

One Sunday, as I was heading down to the beach, I saw some flags out on Sunset Blvd. and a sign for an open house. I turned the car around and backtracked to a private street I had never noticed before: Rivas Canyon. I found the house with the flags, but there was no one there (facing page). I guessed the open house had been on Saturday. I walked all around, and it was easy to see inside, for it was like a great glass tent. It was wonderful, and in a tree-lined canyon.

I loved it at first sight, and called around to see if I could get someone's attention, and that's the first time I met Nancy Walkey. Nancy lived across the street, and had built the house on her property on spec. I learned later she was fussy about who she would sell it to. Some people who looked at the place talked about wall-to-wall carpets and curtains. That was not for this house—this was Nancy's baby. Thornton Abell had designed it, and Nancy was waiting for just the right people to come along who could appreciate it. I certainly hoped I could fill her expectations.

Nancy was from an old California family, and we clicked immediately. That part was good, but how to actually afford to buy the place was the real problem. Even with the full amount from the sale of Marvin Avenue, it would not be enough for the down payment.

Nancy had a friend at the Bank of America, and she took me into Westwood Village to discuss the financing. If I cashed in my life insurance policy (since now I had no one to worry about), sold my Bolex movie outfit, and every other thing I could, maybe I would scrape by. If I could do that, then the bank manager could work out a monthly payment I thought I could deal with.

Nancy was terrific. She helped at the bank, and waited to see about the sale of Marvin Avenue. I had several assignments, a Remington Rand ad, and a big fashion assignment for *Cosmopolitan* magazine that would take me weeks to do, and would bring in some of the money needed for my dream house.

Maria Schell, photographed at the Bel Air Hotel, 1958.

(left) Audrey Robinson at the Palace Court, San Francisco.

The *Cosmopolitan* fashion assignment took me all over, using the natural beauty of California as the background. It was a terrific assignment, and I spent weeks organizing and shooting. I used Max and Sol's Black Hawk Jazz club in San Francisco and Cal Tjader's great Afro-Cuban group.

It all going very well, when ominous signs started coming from the *Cosmopolitan* editorial department. They wanted to reshoot one shot using an advertiser's hotel as a background, on another we had to include one of their advertisers' cars, and so it went. I had already finished the layout when all of this occurred, and then spent another two weeks trying to tie it all in with things that their advertising people had promised their clients.

(above) The top California fashion designers: (left to right) Paul Whitney, James Galanos, Rudi Gernreich, Gustave Tassell & Bill Pearson. I photographed this in a handball court in Los Angeles (with a tip of the hat to Irving Penn). 1959.

I now had almost double the lab and model fees, and it was getting close to my escrow payment. Marvin Avenue had finally sold, and I had the green light on the Rivas Canyon house.

The photographs were sent in, but no money was forthcoming. I waited so long that I finally had to call the publisher. Apparently *Cosmopolitan* was going under, and he blithely told me that I should sue them. I had to figure out what to do now (1959).

One morning, I had a telephone call from Pat Newcomb, who was then Elizabeth Taylor's press agent. She told me that Elizabeth was going to marry Eddie Fisher in Las Vegas. She wondered how much I would charge to fly there and photograph her reception. I told Pat I was honored that Elizabeth thought of me, and I wouldn't charge her anything, but to make the airplane ticket L.A.-Las Vegas-NYC return. This is just what happened. I flew to Las Vegas, and rode with the wedding party to a house outside of town. It was a small, private, family affair. I met both sides of the family, including Mike Todd's sons, and had a nice afternoon.

When I got to New York the best I could do with *Cosmopolitan* was to get the offered fifty cents on the dollar. I had to take whatever I could collect immediately to meet the escrow on Rivas Canyon. While waiting at the airport for my flight back to L.A., I saw Craig Ellwood, the architect. (I had photographed him for *Harper's Bazaar* some months earlier, and had even looked at one of his designs when I was house hunting.) We decided to join forces for the ride back to L.A.

As we sat in the back of the 707, I heard a voice with a Scottish accent advise someone that he couldn't smoke his cigar on the plane. The man, my guess, was probably from Vienna, and was obviously flirting with the young stewardess. He said: "Do you mean if I smoke my cigar, the plane will go down?" Together, the two accents were so delicious, that I had to turn around and see who they were, and that is the first time I saw Dorothy Quigley.

I saw her often the first part of the flight, because we kept asking her for ice. Craig had fortuitously brought a bottle of scotch with him. Ms. Quigley, who was busy serving the rest of the passengers, finally brought us an air-sickness bag filled with ice to keep us going.

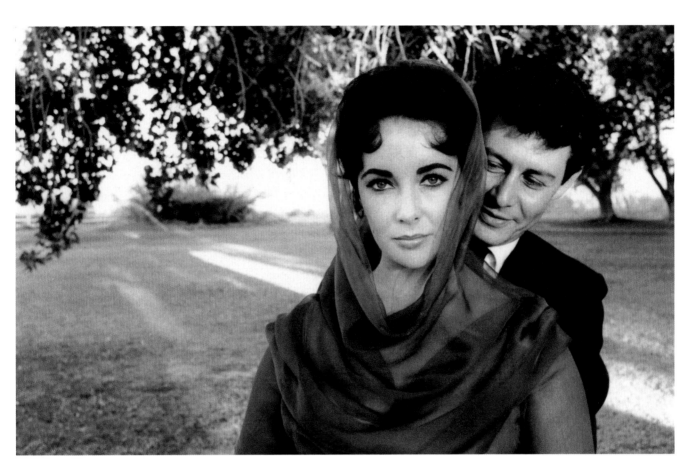

Elizabeth Taylor and Eddie Fisher.

Craig and I were having a fine time, and I was telling him about the problems with collecting my money from the magazine and about the new house, when one of the other stewardesses leaned over and asked why didn't I propose to Dorothy, as it would be so romantic! Even after a few drinks, this seemed a bit out of the blue, but I did make a point of getting Dorothy's phone number. She told me that she flew to L.A. twice a week, and I warned her that I was just moving into my new house, and I would probably be busy for a while.

Craig's wife, Gloria, was meeting him at the airport, and he very thoughtfully offered to drive me home. As we were walking out to the car, the flight crew was standing on the curb waiting for their bus. I nodded hello to Dorothy, and Gloria leaned over to me and said, "Bob, that's the kind of girl you should marry!" Since Craig had also said much the same thing on the plane, I thought it all a bit weird and wondered was it the phase of the moon or could it be some sort of conspiracy?

(above) My scribbled note of Dorothy's phone number. 1959.

(facing page) One of the fashion shots from the Cosmopolitan California *layout. A San Francisco cable car early in the morning. Max Weiss as a worker with the lunch pail. 1959.*

Bill Cartwright and my photographic assistant, Nick King, were the first people to see the new house (above). They had the sport of going through the place, finding as many faults as they could. Of course, they really loved it. Now it meant moving in, and my friend Richard Kaplan borrowed a good-size truck. I can remember us bumping along, with me sitting on the roof, holding the top of the Peruvian Madonna. Bill and Nick were there to help unload everything, and we opened a bottle of wine and christened the place. What an exciting day it was to sleep for the first time in a home of my own.

Another coincidence happened with Dorothy Quigley We had arranged to meet, and then she wrote to say she had forgotten that it was the very week she flew to San Francisco, and so we couldn't meet as planned, but she gave me the date of her arrival in Los Angeles the following week. Charlie and Lucy Bader called one evening to ask if I would like to come over to their house for a party. They had a cousin flying in, but it turned out to be that same night that Dorothy had written me about. So fate stepped in to be certain that we got together again.

I told them that I had an empty house, and to bring the party over to my place, and just by chance I knew a stewardess who was arriving a half hour later, so we could go to the airport together. We all waited to meet Dorothy's plane, and I brought Dorothy to Rivas Canyon and the new house that night for the first time. (1959.)

(left) My first film advertisement: Gregory Peck and Deborah Kerr in Beloved Infidel.

(below) The Columbia record cover that I shot in Hawaii in 1959.

REAL GONE GARB FOF

To the rest of the world Beatniks may seem to be off their trolley but those above are clearly on one. This beach trolley runs through the town of Venice, Calif., a capital for Beats on the West Coast and the chicks standing on it are showing how unbeat beat clothing is becoming.

For fall, U.S. designers have come up with what the fashion world calls beat-knits, loose sweaters that are respectable versions of those Beats live in. These sweaters are now selling in college shops throughout the country. Worn with the tight black trousers, skirts and leotards that Beats consider the end, they will give a gone look to campus wear this fall.

The beat-knits come in muted colors—black, khaki, gray and

On one of Dorothy's flights to L.A. she accompanied me and *Life* magazine's West Coast fashion stylist Gloria Kamberg, when we went to shoot down in Balboa. Dorothy had to sit between the bucket seats in the Corvette where the gear shift was.

Dorothy has great legs, and I can remember what she was wearing as if it were yesterday: a very short brown and white gingham skirt. I shifted all the way down the coast to Balboa, and back home. I was well and truly lost. Dorothy and I were married six weeks after the day we met!

FALL, BEAT BUT NEAT

People keep stealing our stewardesses

n—but make up for this restraint gerated patterns that are way out. road-striped blazer (Cortina, $35). rned like a piebald pony skin (Cata- e couch has on an oversized Orlon 3) while the one leaning over the back wears a shaggy wool pullover with large stars (Catalina $17). Perched directly above her is a sweater in an enlarged herringbone pattern (Catalina $13). The girl with the bongo drums wears a jersey that hangs like a sweat shirt (Margaret Pennington $25). The male Beats in this picture, who wear standard garb that Beats consider to be in, look all flaked out.

For this *Life* fashion layout (above), I asked Max Weiss to fly down from San Francisco to reprise the role he did for the *Cosmopolitan* layout and to bring his lunchbox. My assistant Nick King (center) is lying down on the job. Shorty Rogers (far right) is the terrific jazz musician that I also tried to use in as many layouts as possible. (I thought in this way, it would be like a little trademark, but the film work eventually took over, and I did fewer and fewer fashion assignments.) (Venice Beach, California, 1959.)

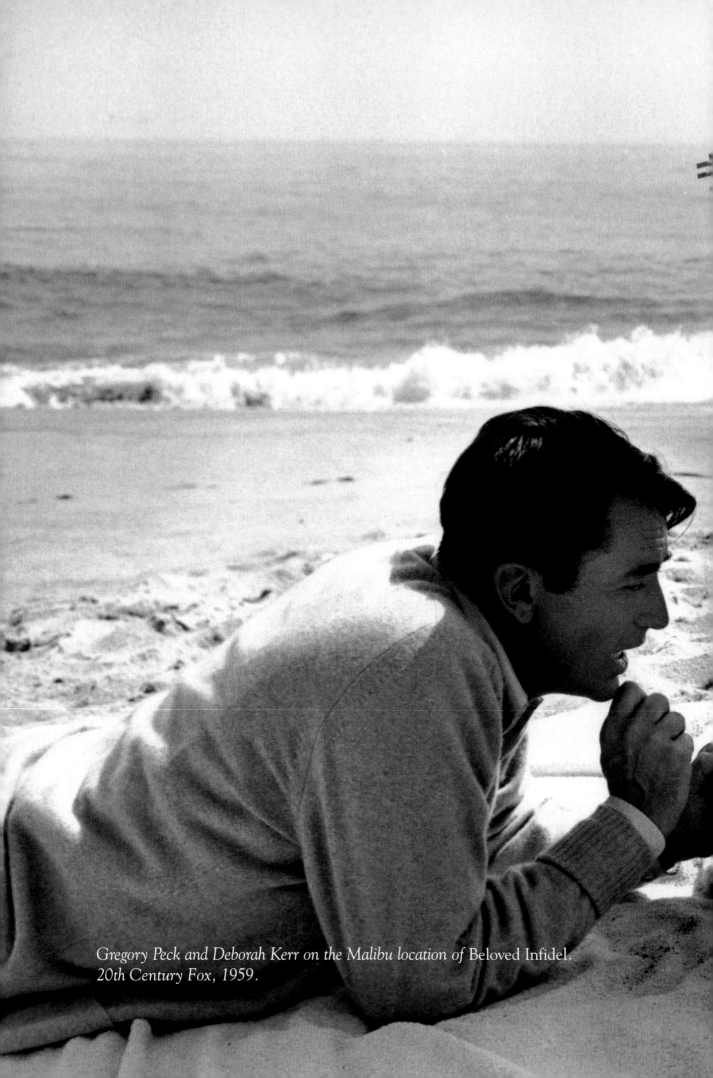

*Gregory Peck and Deborah Kerr on the Malibu location of Beloved Infidel.
20th Century Fox, 1959.*

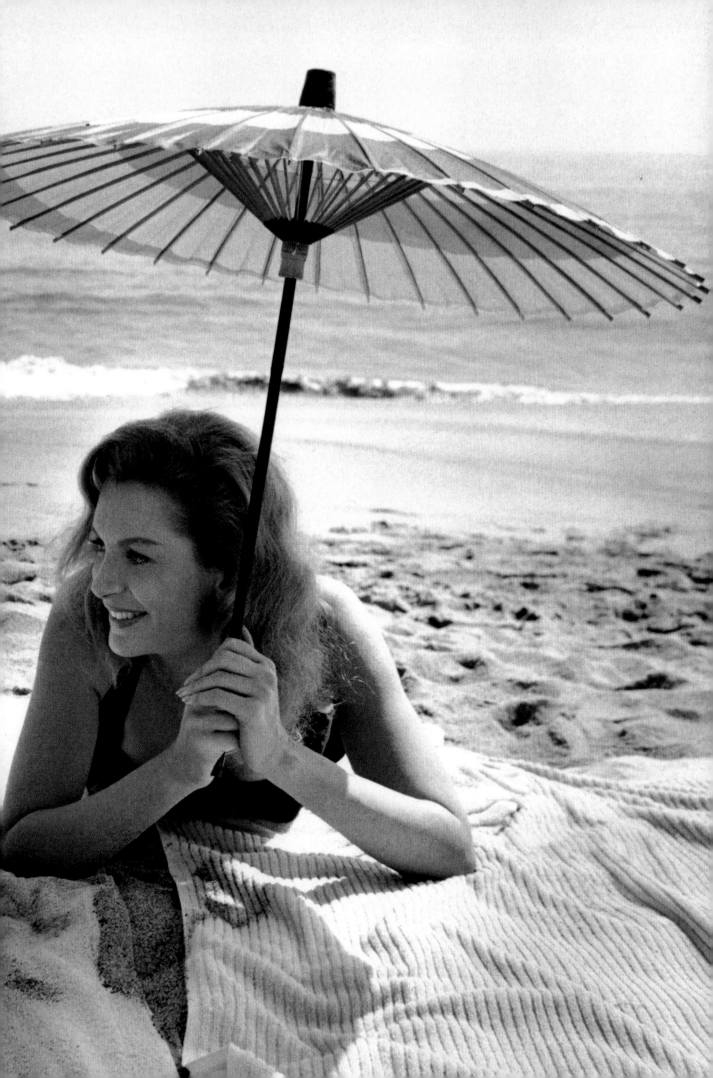

It was June 30, my birthday, and I had arranged to meet Dorothy at the plane when her flight arrived from New York. She had brought a birthday cake for me and two lovely glass candlesticks from Georg Jensen. She looked so lovely and excited as she met me with her arms filled with her little surprises. It was the night I proposed to her.

Dorothy Quigley was such an honest young lady, with none of the theatrical world's gloss. I have always been attracted to this quality, and one can see this in the type of girl that I would photograph on my own. Often when I would meet someone I would say to myself, I could trust him, or trust her. I recognized this in Dorothy's character, even an innocence that touched me.

Because of my work, most of the ladies I had romances with tended to be in show business. They had careers that drove them, and while they were all very interesting and attractive, if I were to get married I wanted someone who wanted to be a wife and mother, for that to my mind was an important career in itself. I came from a broken marriage, and the attrition in the world I was working in is legendary, certainly not conducive to the kind of long-term relationship I was looking for.

When Dorothy had her flights into L.A., we had nice times together. The Berliners met her, (and Mary Ann warned me not to take advantage of her). I drove her out to meet my grandmother, who gave us one of her famous chicken dinners. On one trip, Max was in town, and the three of us planted my mail box on Sunset Blvd. We drove the Corvette down with a pick and shovel, glasses and a bottle of champagne, dug the hole, poured a bit of bubbly on the box, toasted the passing cars, and celebrated the fact that I could now receive mail!

When Max would meet any of my friends that didn't know I was getting married, he told them I was marrying a stripper named Bubbles. Wild stories and non-sequitur humor were Max's everyday bread. To this day, 40 years later, we still get letters from him addressed to Bob and Bubbles. Dorothy was coming into quite a different world than she had known before.

We planned to be married with the Berliner family, who I admired so much. I had seen too many theatrical, glitzy weddings, all designed for show. I wanted this to be a serious religious moment. Dorothy was Catholic. She kids me how romantic I was the night I proposed—I had gone through the list of things I was looking for in a woman in my mind, and being Catholic was one of them, and told her that I saw "no reason not to marry her."

Harold and Mary Ann arranged for us to be married in St. Canice's Church. Dorothy flew back to New York and told her mother Jean Quigley that she was going to be married in Nevada City in two weeks. This was all too fast and furious for "Quig," as everyone now calls her. The two of them arrived the night before we were due to fly to the Berliners. I was used to catching airplanes, and so, one would have thought, was Dorothy, but getting these two out of the house the following morning was something else. I put the box that held the wedding dress in the back of the Corvette, and we flew down Chautauqua Blvd. toward the airport, as I now had only minutes to make the plane. The box with the dress fell out, to all sorts of squeals from the ladies. They tell me that I had suggested we forget the dress, and make the plane. I did run back for the dress, we did make the plane, and Quig reminded me all the way to Nevada City that she didn't even get "a cup of tea" before we left.

We were waiting at the church for Dorothy, and Fr. William Daly, the Irish priest who was to marry us, looked at his watch, as the bride-to-be was due about a half an hour before, and threatened to go on with the ceremony without her. Dorothy told me that Mary Ann had put sheets over the seats in the station wagon to protect the wedding dress, piled the children (and Dorothy) in the car. They all blessed themselves (knowing they were very late) and zoomed off to the church.

Dorothy on our wedding day, with the admiring Berliner girls: Mary, Anne and Margaret, and Dorothy's mother Jean Quigley at left. Nevada City, California, July 18, 1959.

The wedding party: (center seated) Dorothy and Bob. (back row) Mary Berliner, (altar boy) Jim Frey, Jean Quigley, Harold and Mary Ann Berliner, Fr. William Daly and Hal Berliner. (front row) Margaret, Judith, Ruth and Anne Berliner.

(below) Dorothy cutting the wedding cake, surrounded by all of the excited Berliner children and Jim Frey, Fr. Daly and Mary Ann Berliner. Grass Valley, California, 1959.

The honeymoon was cut short. Lee called to say that I was assigned to shoot a film called *The Best of Everything* at Fox, and they wanted me right away. From that, I went right on to *Can Can*, with Frank Sinatra (above) and Shirley McLaine (facing page). My assistant Nick and I were used to meeting deadlines. We knew which plane was the last to leave for New York, and he often drove a package out to catch it when the magazine's deadline was tight.

One late afternoon, I realized that we might not make it, and I called Dorothy down to the office to help. She was very willing. "Go over to the file," I said. "What's a file?" she replied. Nick and I looked at each other. I stood up, turned her around and asked if she could please make us some tea, and that established the roles we played from then on. Dorothy managed the house, and I managed the office, and it's been a very successful arrangement ever since. Personally I think she was a very "canny scot"! (1959.)

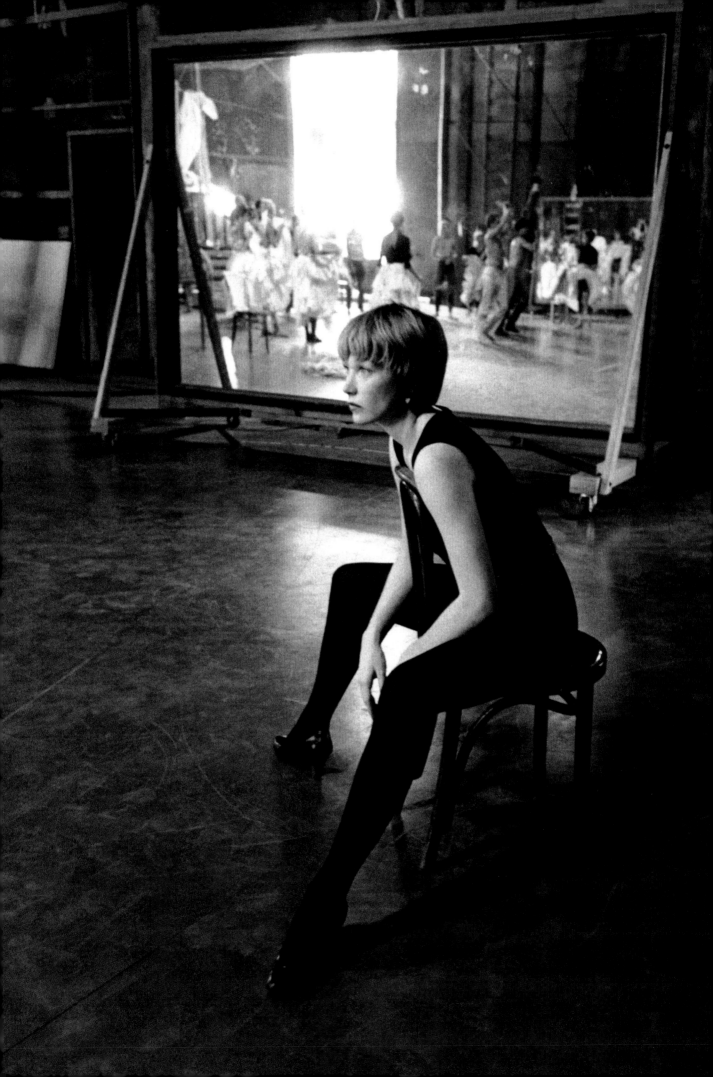

(*above left*) *Maurice Chevalier, photographed for an ad for McCall's magazine. 1960.*

(*above right*) *Louis Jourdan on the cover of GQ magazine.*

(*facing page*) *Academy Award collector and famous costume designer Edith Head, photographed at her Beverly Hills home for Harper's Bazaar.*

(*below*) *Now the most important person in my life, Dorothy, was beautifully pregnant, and our baby was due in July. Life was very sweet: a new home, a new bride, and soon a new son. I was flying! Pacific Palisades, 1960.*

(right) Herbert Marshall waiting outside his tiny dressing room to be called, his name taped to its side. A far cry from the time that he was feted as one of the great Hollywood romantic leads. 1960.

Assigned to *Midnight Lace* at Universal Studios, I was delighted to work with Myrna Loy (above) whose voice and wonderful profile I had always thought terrific when I watched '30s films like the *Thin Man* series. One night, Dorothy, Tom Ryan and I had dinner with her. It was a special evening.

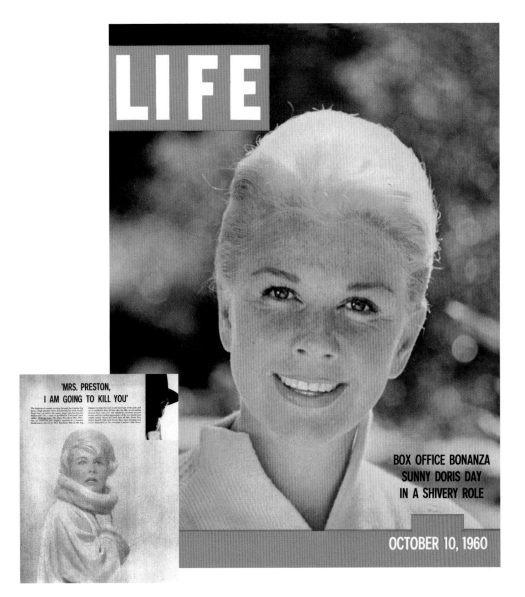

LIFE

'MRS. PRESTON,
I AM GOING TO KILL YOU'

BOX OFFICE BONANZA
SUNNY DORIS DAY
IN A SHIVERY ROLE

OCTOBER 10, 1960

(below) Photographing Doris Day and Jack Lemmon for a Columbia Studios ad, at Doris' home. In the same place, I shot the ads for Pillow Talk *with Doris and Rock Hudson.*

I must have had at least a dozen different assignments to work with Doris Day, and she was great fun to be with. Her husband, Marty Melcher, always had some deal going, a promotion for a new kitchen, a hi-fi, you name it, and I liked them both very much. Doris really did have a soda fountain in her house instead of a bar!

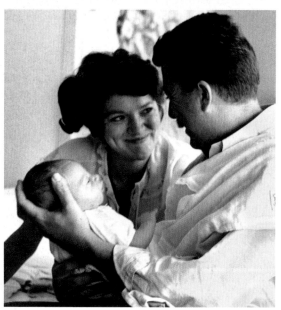

(top) Our neighbor Nancy's daughter Cory Walkey irreverently blows a bubble with her gum in the midst of all the ancient art. Pacific Palisades, 1960.

(facing page) Mary Berliner, a special young beauty with a presence, and an amazing calm dignity for a child that I'm sure she inherited from her mother. Grass Valley, 1960.

Christopher Stewart Willoughby arrives, July 15, 1960 (above left). I don't think there is anything like the awe-inspiring experience of holding your own child for the first time. Christopher was heavier than I had expected, and then the awareness of my responsibility for his life hit me. What a wake-up call to maturity it was and what a wonderful time to share with my wife.

(above) The Rat Pack at the Sands, during the time they were filming Ocean's 11 in Las Vegas in 1960. They filmed all day, then did the Summit Meeting on stage every night.

Where they got the energy to keep that pace up I cannot imagine, and at the same time they were playing practical jokes on each other, drinking, and chasing the ladies. I found it truly amazing.

Dean Martin had the fastest draw with a funny retort in his group of bright and talented comrades—Peter Lawford, Frank Sinatra, Sammy Davis Jr. and Dean Martin, they are all gone now, even the Sands Hotel is no longer there.

(facing page) A wistful Marilyn Monroe, on the 20th Century Fox studios set of Let's Make Love. I photographed a little layout for American Weekly magazine on the men in Marilyn's life, and when it was over, I saw Marilyn sitting alone, and quietly moved over to where I could photograph her. This image of Marilyn best captures what I felt about her, a vulnerable child trapped in a woman's body. On one assignment, I waited at the Beverly Hills Hotel for her to appear from her bungalow for over two hours, and then she sent word she couldn't make it, beset with her own collection of demons.

(facing page) Marilyn Monroe on the set of Let's Make Love.

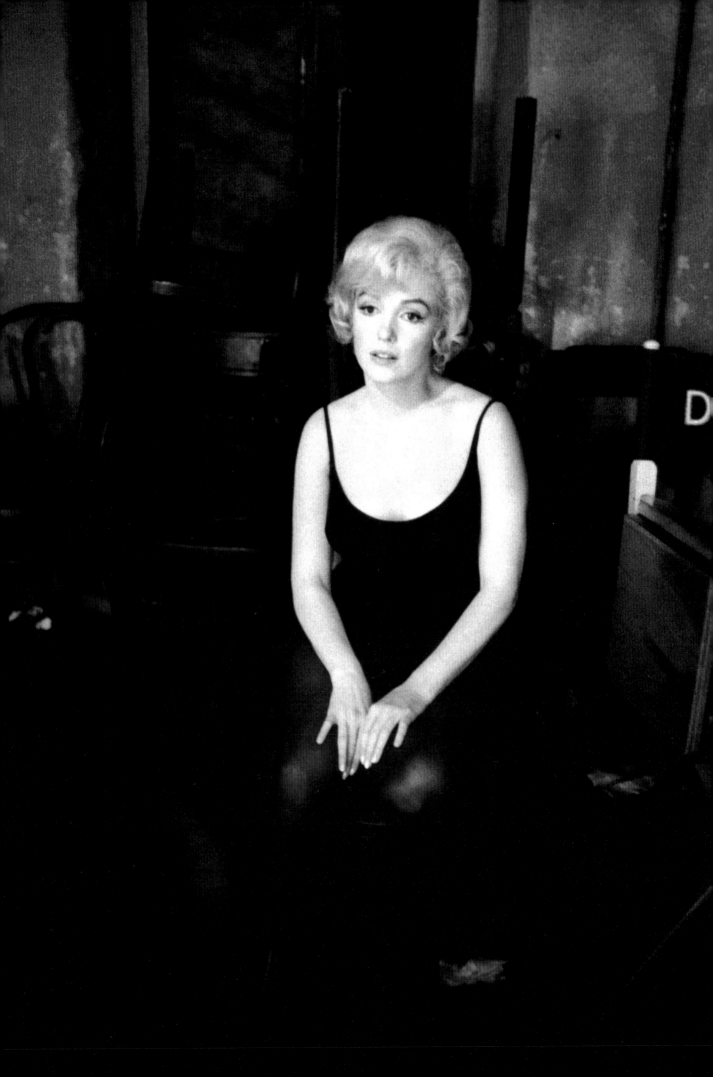

WEST COAST OPULENCE WITH ORIENTAL TOUCH
Evening Extravaganzas

Photographed for LIFE by Bob Willoughby

Brocades copied from priceless antique patterns, 14-carat gold thread and trimmings, embroidery Oriental in feeling and so rich it has a third dimension—all of these make up a California extravaganza in fashions for evening wear. These opulent styles are shown here along with another West Coast extravaganza: Universal's set for the movie version of *Flower Drum Song*, a costly and meticulous re-creation of San Francisco's Chinatown.

Fabric is given the wh clothes which are a culmir toward the elegant and sum are tailored and timeless, a evening dresses above by winner of this fall's Fashic They are inevitably expens since the brocades cost up because they are so simply an investment that will be

Universal Studios assigned me to cover their film *Flower Drum Song*, which had a wonderful set of San Francisco's Chinatown. My brief with the studios was to get them space in magazines such as *Life*. The problem was that if the magazine's film critic didn't like the film, no matter how good the photographs were, they didn't use it. I had to use my experience of their tastes in the past and figure another angle if I wanted to get space. I did this on every film, and *Flower Drum Song* was no exception.

I felt the set would be a terrific fashion background, and told *Life*'s fashion editor Sally Kirkland about it. She liked the idea, and in the end they used six color pages, more than the film would ever have received in a review.

One of the big challenges for me on this fashion layout was that I had to light an entire movie set. This was my first time doing anything like this. Fortunately, I had one of the top gaffers at Universal to help me.

The model Helen Matler (above, left on the camera crane), who was standing on one of the little bars, looked faint, and I had the crane quickly lowered. She then told me she was pregnant. Helen was a daredevil, and on another Life fashion shoot at the Watts Towers, she was swinging from the superstructure 60 feet off the ground. (1961.)

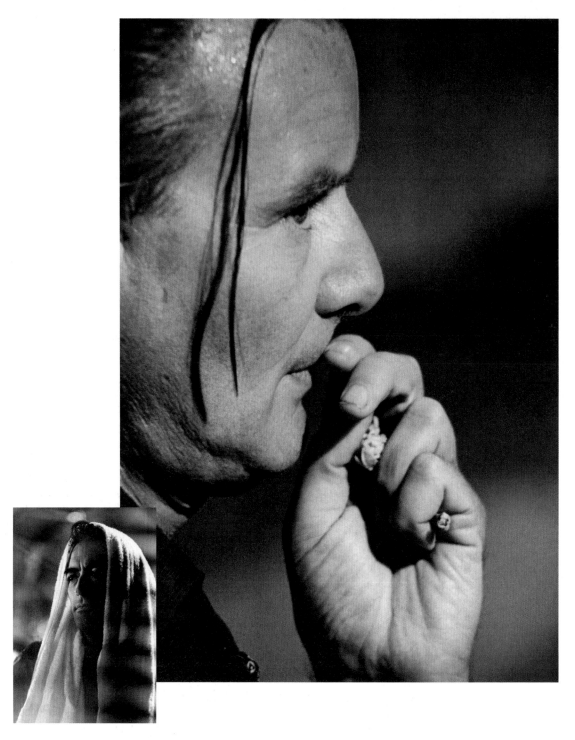

(*above*) *Director J. Lee Thompson who directed* Cape Fear *at Universal Studios, was a bundle of nerves, with a habit of tearing off pieces of paper from his script and chewing them into little balls as he watched the filming.*

(*left*) *Gregory Peck, always the gentleman, always professional, a thoughtful actor, and it was always a pleasure to work with him.*

(*facing page*) *Robert Mitchum, who plays the heavy in this violent film, was one of those actors like Bogart who could take lines from a very ordinary script and make them sound believable. I think today Jean Reno has this rare ability—to me, the sign of a very good actor. (1961.)*

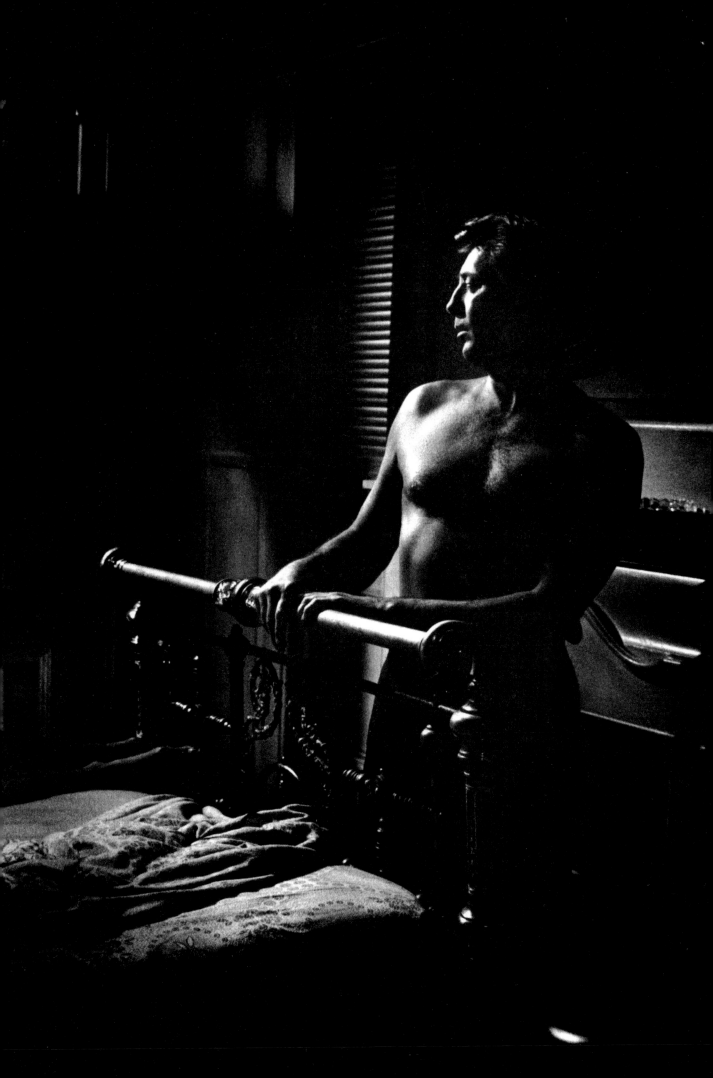

Outbreak of New Films for Adults Only

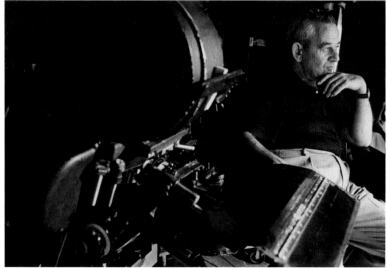

The Children's Hour was the second time that Director William Wyler (above) had filmed the controversial play by Lillian Hellman. The first, filmed in 1936, skirted the lesbian issues because of the restrictions of the censors at the time. Dissatisfied, Wyler felt he had never touched on the essential character of Hellman's acclaimed play, and decided to film it again, this time with Audrey Hepburn, Shirley McLaine and James Garner. Wyler brought Miriam Hopkins back, who was in the original film (top right), and even had her carry a photo of herself from that time.

Wyler, an obsessive perfectionist, would do one take after another, then shoot it from another angle, and then another. One time when I returned to the film after being absent a week, Audrey Hepburn told me that they were still on the same master shot, and she was really exhausted giving the performance over and over, day after day. On another film, *Friendly Persuasion*, Gary Cooper told me that he had walked down a flight of stairs 35 times, until finally Wyler said it was okay. He said as far as he knew, he did it the same every time. Wyler would never tell him what to do, or what he wanted.

For my layouts, I needed to synthesize the story in a few images, and when he finally had his print, I would ask if I could have the actors for a minute, and would then direct the actors for my stills. Wyler always stayed to watch what I did. On one shot at the cemetery, I shot my setup, and the camera operator told me later that they had returned the next day to do my shot. (facing page) Fay Bainter and (above top left) a lead shot from *Life* with Bainter and young Karen Balkin. (Goldwyn Studios, 1961.)

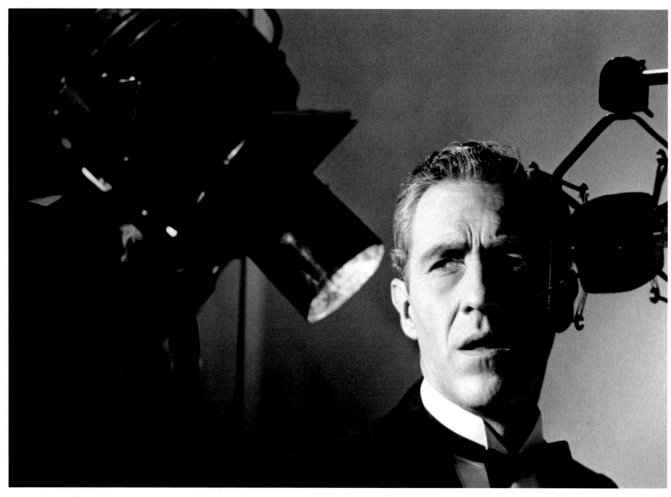

(above) Jason Robards on the 20th Century Fox Studios set of Tender Is the Night, 1961.

(left) Audrey Hepburn and Mel Ferrer came to visit us in Rivas Canyon with their young son Sean. Our Christopher and Sean celebrated their first birthdays together. Audrey holds Sean and Dorothy with Christopher.

(facing page) Kim Novak on the set of Notorious Landlady, Columbia Studios, 1961.

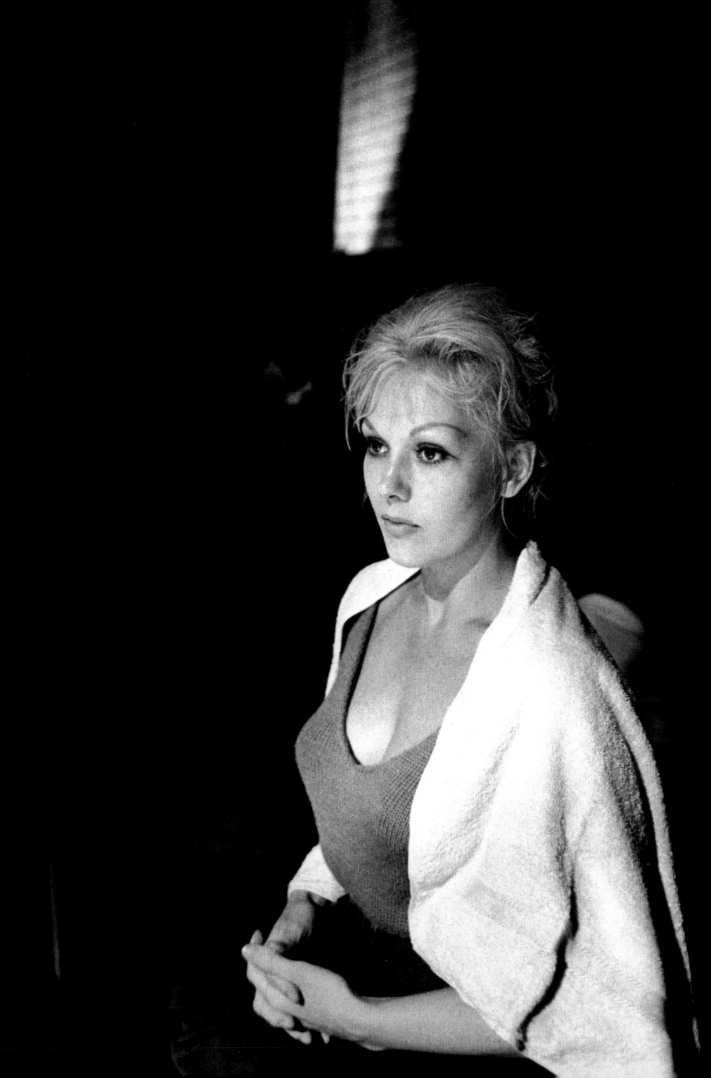

Dorothy was pregnant with our second son (above). Just at this happy moment, there was a devastating fire in the west side of Los Angeles, from Beverly Hills to Malibu. The possibility that Rivas Canyon would go was very likely. We could see the 100-foot-high flames at the end of our canyon, and then came the decisions what one would save first.

We started piling up the art, and took it over to my assistant's garage. Then I realized my negatives and color prints were far more precious to me, and we took these entire files and stored those, I think, with my aunt who lived in Venice. The library next went to another friend in the Pacific Palisades, which was close, but seemed safe. It was all intensive work, and as the fire got closer, I sent Dorothy and Christopher back to her mother's in New York City.

Happily, Rivas Canyon was spared, but the fire came right to the end of the canyon, and there was very little sleep for any of us on the street. Soon after we had replaced everything, I received an assignment to do two films in the U.K. The first was originally titled *The Lonely Stage*, which became *I Could Go On Singing* with Judy Garland. Two of our producer friends, Stuart Millar and Larry Turman, had these back to back. The other was *Summer Flight*, with Susan Hayward.

We took off for London, with a very pregnant Dorothy. We had made arrangements with our local pediatrician in the Palisades, who had a contacted a close friend who was a pediatrician in London to take care of Dorothy. It just so happened that the doctor happened to be the Queen's doctor, and at the last minute he was called off to Africa for one of the royals. So not only did I have to find an available pediatrician, which in London was no easy thing, but a place for us to live before I started at the studio. Dorothy's mother was with us, so that was a help. One morning, an ad caught our eye for a house called Vine Cottage.

I remember it said "have your own Mediterranean villa in the heart of Chelsea." Because we needed something immediately, this seemed pretty good. We made the arrangements, and when we started to move in, we all had this feeling that it wasn't clean, and Quig burst into tears when she walked in the front door.

I bought white paint, and painted the outside walls. We scrubbed the place again, even though it had just been seen to. I could not analyze why we got this feeling, but it was definitely there and we all felt it.

Over the coming weeks, I tried moving the furniture. I took off dark drapes, hid the art that was on the wall in the closet, replacing it with brighter things. We bought potted plants and put them everywhere, inside and out. Nothing seemed to help. Being used to solving problems, it baffled me that nothing I did could shake off the creepy feeling the house gave us.

tuart Millar and Lawrence Turman announce completion of their production

THE
LONELY
STAGE

Judy Garland sitting alone on the stage of the London Palladium, 1962.

Meanwhile, the production was having its own problems. Judy started off very well, but needed constant reassurance. Dirk Bogarde (facing page), her co-star, was wonderful with her. When he was around, the film went smoothly, but when he had days off, or at one point was finished with his part, it was a mess. The British crew was not used to sitting around the set waiting for the star to appear. I thought of Monroe, who had perhaps the same devils inside.

She was a truly great talent, and at the recording session, it was phenomenal how she could touch everyone there with her voice. Yet she must have felt so insecure to need the constant petting and soothing. Judy and I still got along very well. One day, she had been entrenched in her dressing room, so I thought to maybe cheer her up, I would show her some of the prints that I had just received from the lab.

On one shot she commented that it "looks like I have a wrinkled crotch." Without thinking, I blurted out one of my dumb non-sequitur humor replies, "That's what everyone says!" She exploded, and threw all of the prints at me. At first I thought she couldn't have taken me seriously! Surely she's just joking with me, and standing outside her dressing room, puzzled by the reaction, the door opened. Ah, I thought, she's going to say "ha ha!" But it was just a snowfall of prints that hadn't gone out the first time. With this I wondered, what have I done? I collected all of the prints, and headed right to the producers' offices.

Grim-faced, I told Larry and Stuart what had happened. I really hadn't meant to create more problems for them, and I blurted out the story. They just fell on the floor laughing, and took me back to the set and told the director Ronald Neame the story, and he too thought it very funny!

I could not understand how they could treat it so lightly, given the production problems they already had. Ronald Neame, such a nice man, went to Judy's dressing room, and brought her out. I got a hug from Judy, and she worked the rest of the day with no problems. Happily it didn't turn out to be the disaster I thought it was going to be. (Shepperton Studios, London, 1962.)

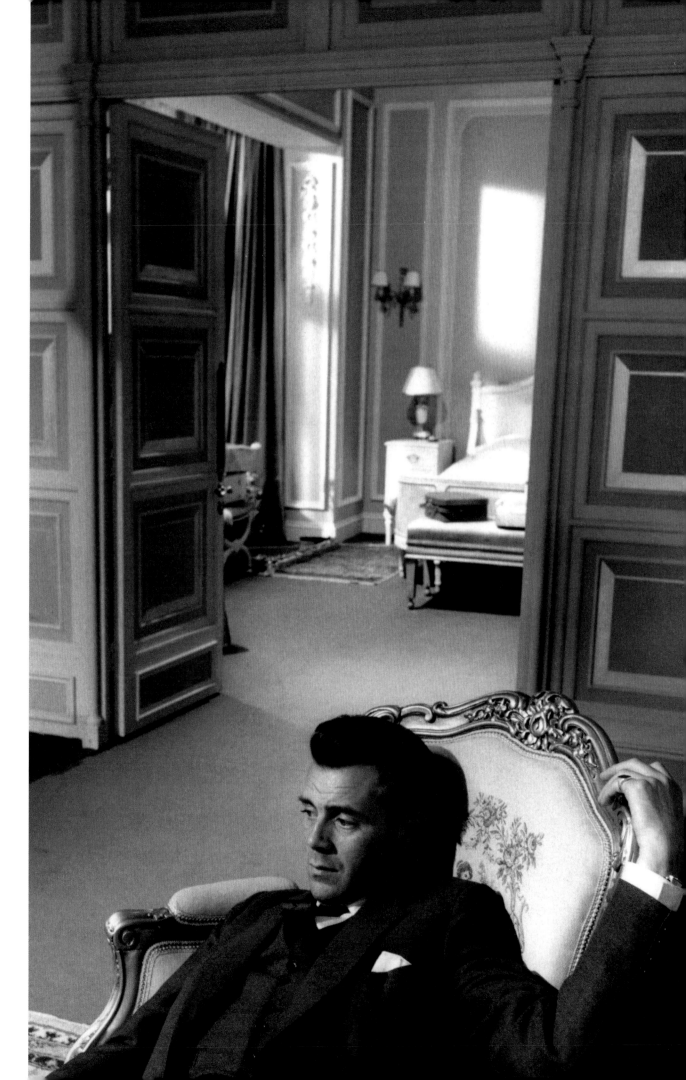

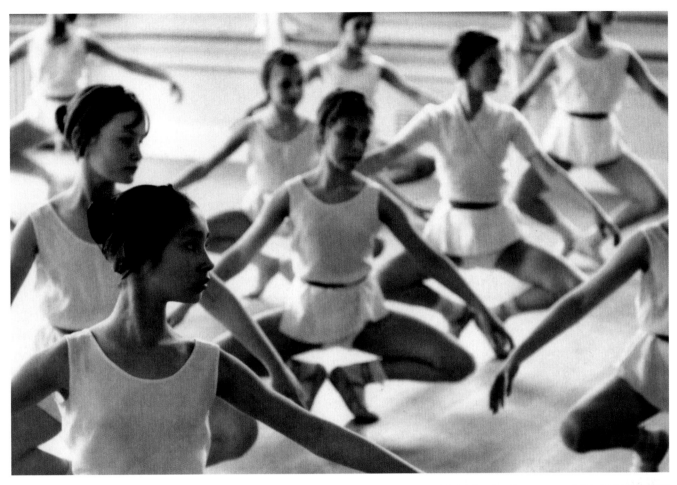

I photographed the Junior School of the Royal Ballet for *Queen* magazine, and this was a great break for me from the films. I've always loved photographing dancers, but my assignments never seemed to go in that direction, so this was like a holiday. In the process, I discovered two stunning beauties. Patricia Whittle (right and on cover on facing page), who graced at least three of my magazine covers, and Ingrid Boulting (facing page) who had such beautiful skin and a profile worthy of Vermeer.

After spending several hours photographing the nun-like existence of these dedicated girls, I was happy to find a group of them doing the twist in the foyer to a record player. It made me stop and take out my cameras again.

I've seen fashion shots years later using Ingrid as a model, but I never knew what happened to this great beauty. As for Patricia, I tried several times contacting the Royal Ballet, as I wished to send her copies of the magazines, but drew a blank. (Richmond Park, U.K., 1962.)

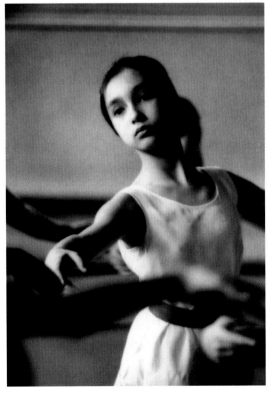

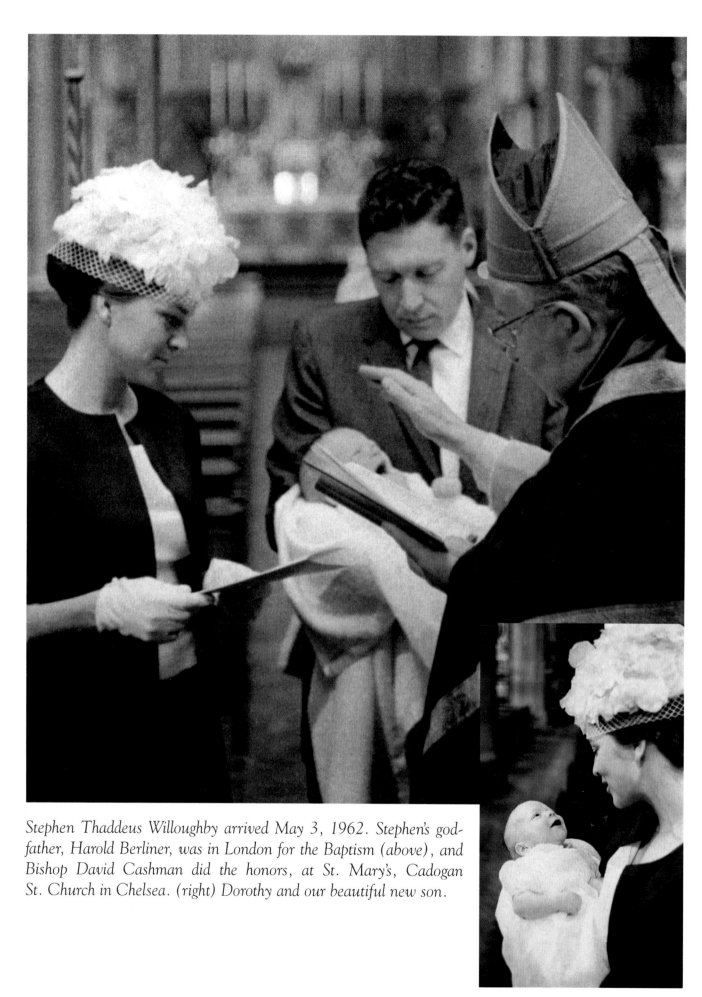

Stephen Thaddeus Willoughby arrived May 3, 1962. Stephen's god-father, Harold Berliner, was in London for the Baptism (above), and Bishop David Cashman did the honors, at St. Mary's, Cadogan St. Church in Chelsea. (right) Dorothy and our beautiful new son.

The London house was still weird. The first night that Dorothy could go out after Stephen's birth, we hired a babysitter. Quig, Dorothy and I had a nice dinner at the Guinea, and returned home a few hours later. The woman who was babysitting opened the door, and said "Oh, thank God!" and ran out of the house. She had obviously waited for our return, afraid to leave the babies alone, but didn't even wait to be paid.

The photograph above shows us all out in front (with the our new red XKE Jaguar). One day I was out washing the car, and the neighbor across the way, who was watering his garden, came over, and we starting chatting, and asked if I knew what the house used to be called. He told me, "It was Vice Cottage, and during the war it was a house of prostitution!"

After working all day, it was my nightly therapy to soak my neck in a bath after carrying heavy cameras all day. I would get into the bath in the Chelsea house, and couldn't wait to get out. It was claustrophobic and depressing. The man told me that two people had committed suicide in the bath, and I hadn't told him anything about what I had felt.

Growing up in California, we didn't have ghosts, but something was certainly letting its feelings be known around that house! I had a call from Paris that they wanted me to photograph another Audrey Hepburn film Paris *When It Sizzles*. So later, Dorothy, baby Stephen and I drove over to France with all of the luggage and children's gear. Quig was going to fly over the next day with Christopher. She would not stay in the house overnight by herself, and we had to get one of her friends to come over for that one night.

We wound up the Garland film, to the relief of the crew. The last shot was on the river, and after Judy left, the crew all decided to celebrate then and there. I worked with Judy once again on her TV show. I really liked and respected her. She seemed like a lost soul, and to this day feel sorry for her, and pray she is happier now wherever she is.

I still had a commitment to work on *Summer Flight*, and so it meant flying back and forth to the U.K., which wasn't bad, except that French customs made me check in and out on every flight, and they went over every camera and lens number. Dorothy had found us a terrific apartment on Avenue George V. It was a three-flight walkup, and one of the reasons it was available, as they were about to install an elevator.

It was also August, so Paris was deserted, and Dorothy was driving around with no problem. She could park right in front of the apartment. I never mentioned the fact that, come September, everything would be very different!

Working on the film with such easygoing people was great. The French crew called me Monsieur Click Click. Bill Holden (above) was very special, and we spent hours talking together. He told me all about his love of Africa, and the plans for his safari club, but never discussed work. I could see he was lonely and needed someone to talk to. Often on the way home from the studio, he would ask me to come in for a quick drink at his hotel. This film was no hardship, as I was working with two of my favorite actors, my family was with me, and it was Paris!

Everyone was in love with Audrey, but no one more than Bill. I got a fashion assignment to photograph Audrey on the set for French *Vogue*, and that was great fun. A film axiom is that if you laugh too much while you're making a film, it's not going to be funny on the screen. Well we laughed every day, and had a great time. Just to give you a little idea of the zany goings-on, can you imagine the *Crazy Horse* girls and Noel Coward?

Sizzle was a fizzle, a remake of an earlier French film called *Holiday for Henrietta*. Tony Curtis was there for a cameo (and I hear he received a Rolls Royce for the trouble). He also brought his young and truly beautiful girlfriend, Christine Kaufmann, to the set, where we met for the first time.

Audrey Hepburn. Boulogne Studios, 1962.

Director Richard Quine, the morning after, in his Louis XV Paris apartment, complete with table tennis, parakeets and congo drums. Kim Novak came to visit Dick (a long-time flame) and left him in a sorry state. Dick was always helpful to me in getting the images I needed, and I believe that the convoluted script on Sizzle was just too complicated to come off. I thought I was on top of the script, but half the time I didn't know where we were, and I think he may have had the same problem. That was why I tried to find other aspects of the film to shoot for the magazine space we were looking for. Paris, 1962.

(facing page) Audrey Hepburn in one of the Vogue *fashion shots with her little dog Famous on the set of Paris* When It Sizzles.

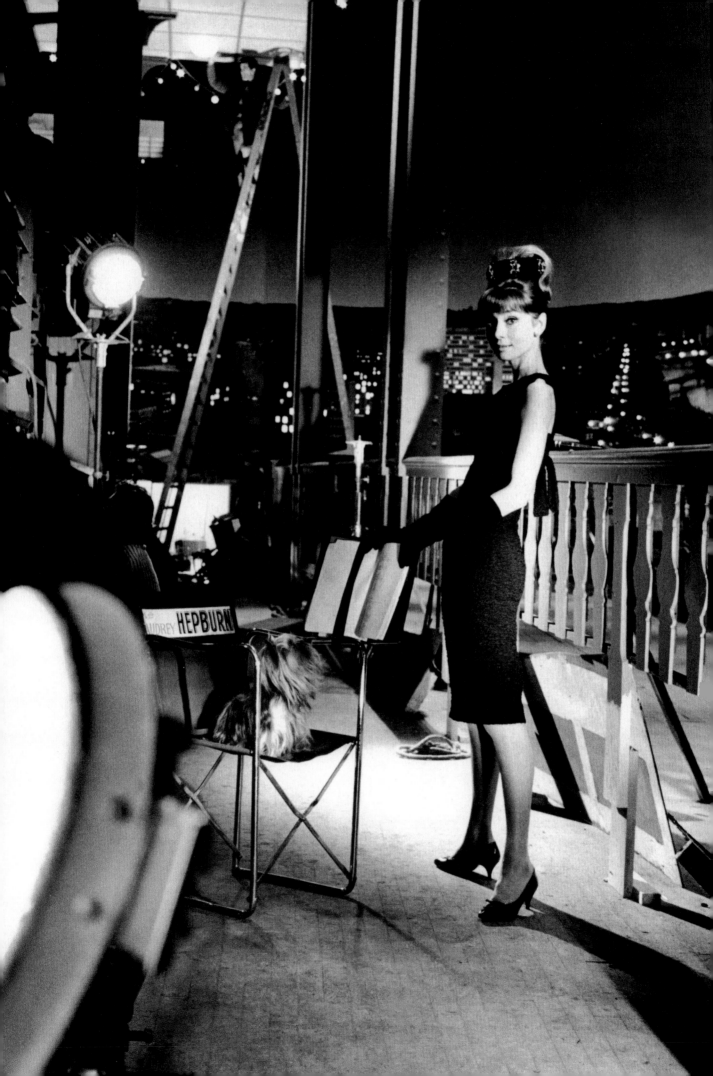

When William Burroughs and I were introduced, we were in a completely different apartment, and I felt something wasn't right. I said, "This isn't your place, is it?" He looked closely at me for a minute, and confessed it was his friend's, and that his apartment was too messy. I told him, "This place doesn't reflect you," and that seemed to click with him and he took us downstairs to his place, with his newly washed socks on a makeshift clothesline. (Photographed for the *London Times*, 1962.)

With all three films now wrapped up, I decided that Dorothy and I should have a little holiday. We asked Quig's sister, Betts, to fly down from Glasgow, and the two watched the babies, and Dorothy and I drove off in the Jag. I wanted to show Dorothy all of my favorite things, like the Duccios in Sienna. After a week, Dorothy told me she couldn't say "how beautiful" any more, after seeing so many churches and galleries. We had driven from Paris all the way down to Naples, to Pompeii, back up through Italy, stopping in Rome to photograph Virginia Fagini. Then on to Venice, when we heard the sad news from Quig that my dear grandmother Johnnie had died.

We headed back to Paris, and it took several weeks until we could get everything packed to fly home. When I did get to Johnnie's apartment in Covina, everything was gone. Her "friends" had just helped themselves. Fortunately, I had left all of the financial business with her local bank manager, who had very kindly gone to the hospital and taken care of those details. But all of our family things had been stripped clean, never to be seen again, just like in the film *Zorba the Greek*.

Anna Conwell Willoughby, 1874–1962.

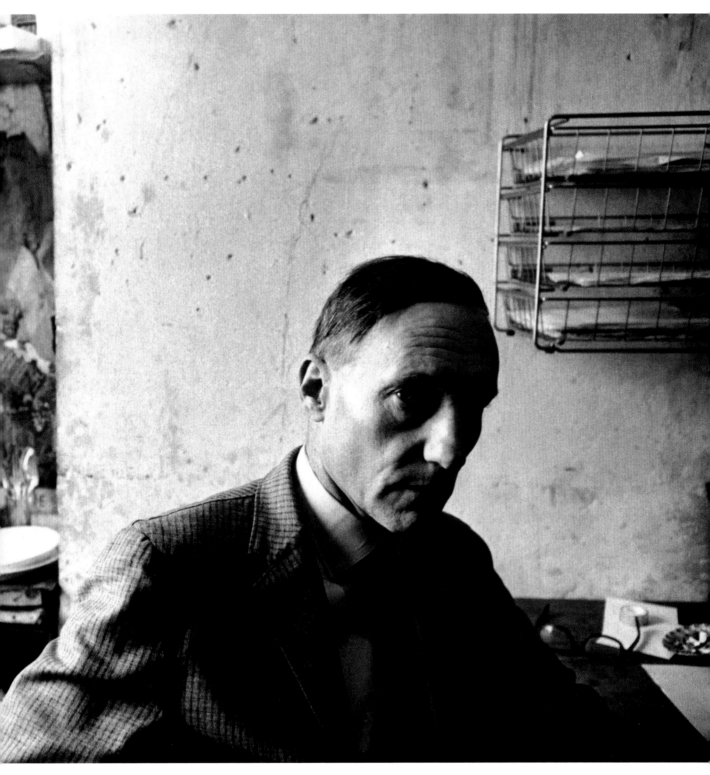

William Burroughs, in his Paris apartment.

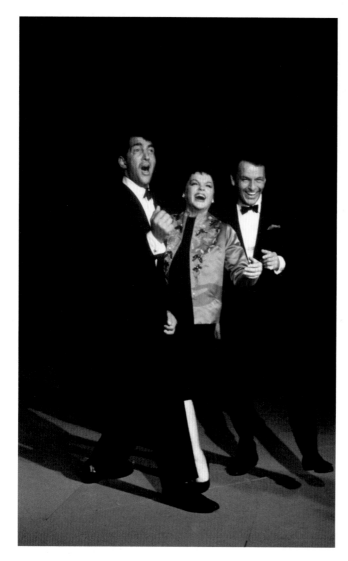

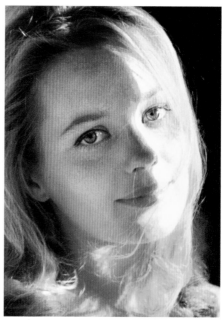

(*above*) *Virginia Fagini had now grown into a beautiful young woman. This triggered the idea of the Girls Growing book that I've been working on ever since. Rome, 1962.*

(*facing page*) *Peter O'Toole, photographed at the Beverly Hills Hotel, just after he had finished* Laurence of Arabia.
One reviewer described this photograph of Peter as looking into "his heart of darkness." I feel it reflects his energy and troubled spirit that future directors would never seem to capture in his films. Photographed for Glamour *magazine, 1962.*

(above) Dean Martin, Judy Garland and Frank Sinatra on Judy's TV show. Dean and Frank knew how to keep Judy's spirits up, and were always pulling some funny little gag that wasn't in the script. Director Norman Jewison just gave in to them during the rehearsals. I hadn't seen Judy in such good form for a long time. I know she loved and appreciated those two. (NBC-TV, 1962.)

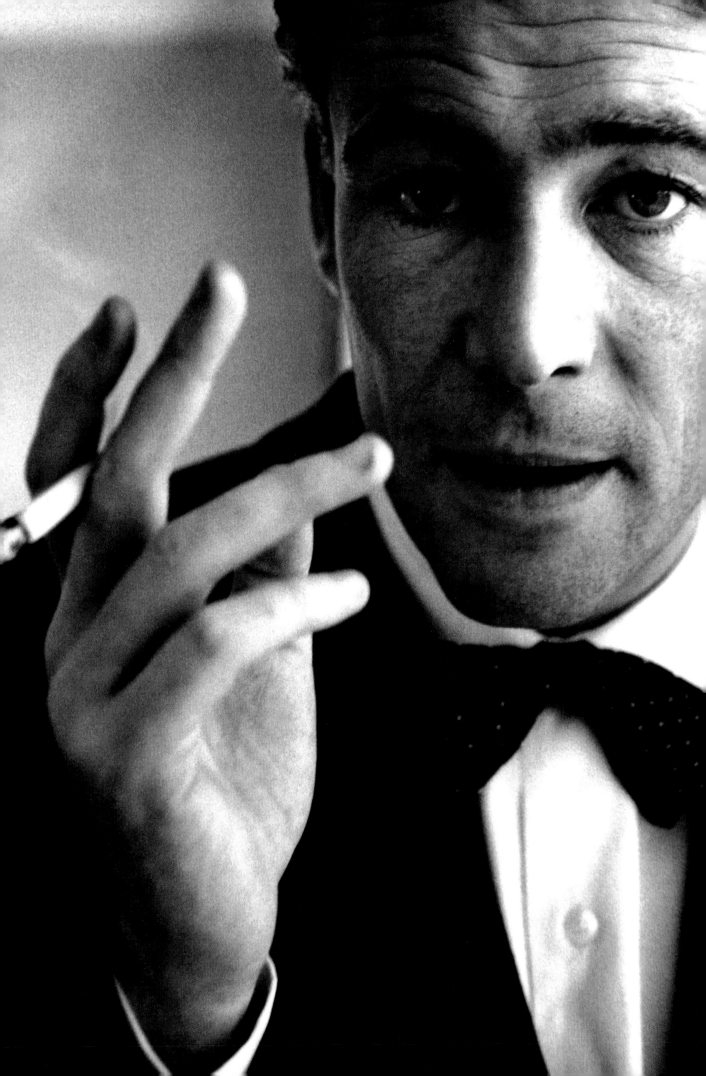

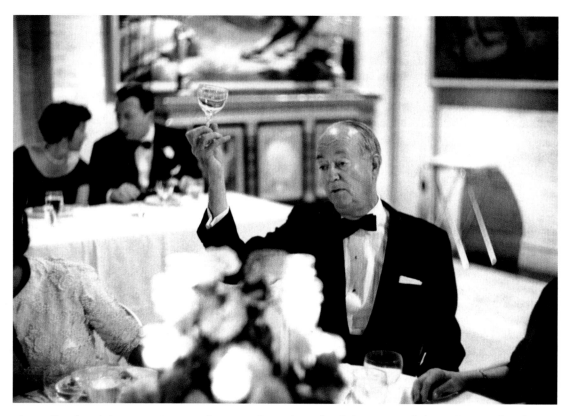

At a fund-raising evening at the new Los Angeles Museum of Art, I saw this bene-
factor wearily waiting for the waiter to recognize his plight. Photographed for Vogue
magazine, 1963.

(facing page) Two wedding guests, Josephine Hallett and Theresa Dray, check out the
action at the reception, Santa Monica, California, 1963.

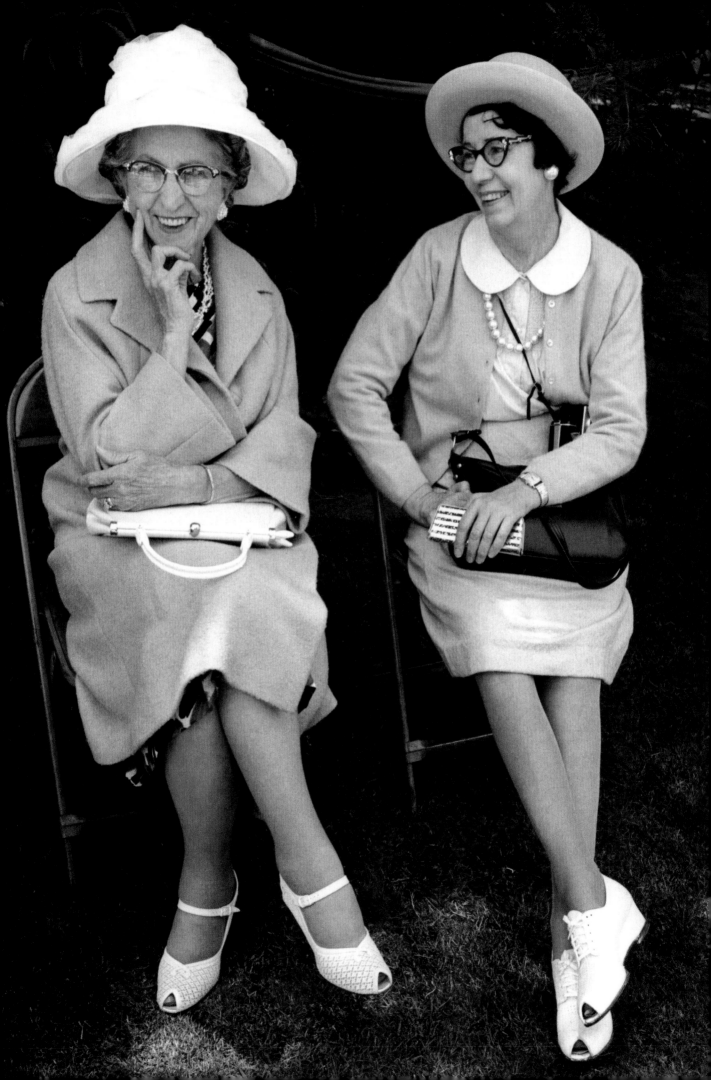

Warner Brothers assigned me to cover *My Fair Lady*, and it was a real lifesaver. One of the things that I noticed when out of Hollywood was that if I were gone two months, it took me that long to get back to work. Since we had been in Europe for over seven months, assignments had slowed down to a trickle. The call from Warner's was very welcome.

(below) The Covent Garden set. Filming was finished for the day, and director George Cukor was sitting by himself deep in thought, when Audrey Hepburn rode up on her bicycle (with her new dog Assam), to discuss the following day's shooting schedule. For her role as Eliza, Audrey had to be in makeup at 6:30 each morning, especially when she had to be "made-down" for the role.

The makeup people applied "'fuller's earth" to her hair and under her fingernails to transform her into "a girl so deliciously low, so horribly dirty," as Professor Higgins referred to her in a line from the script. This was the antithesis of Audrey, but you would never hear her complain of anything.

(facing page) Audrey Hepburn as Eliza, a picture I have always liked. Audrey's expression reminds me of Hogarth's painting of the "Shrimp Girl." Warner Brothers Studios, 1963.

One of my musician friends, Paul Desmond, told me Audrey was his dream girl, and I said, well let me see if I can get you clearance, since Cukor kept it an absolutely closed set. I told Audrey about Paul, and made all the arrangements. Paul came out and we had lunch together in the studio commissary, and then we started walking back to the sound stage, he stopped. " No ", he said, "I can't do it ! " I assured him that he would like Audrey, and that he had come this far. No, he didn't want his dream to be shattered in any way with reality, and turned around and left. He did dedicate one of his tracks with Dave Brubeck to her, but as far as I know they never met.

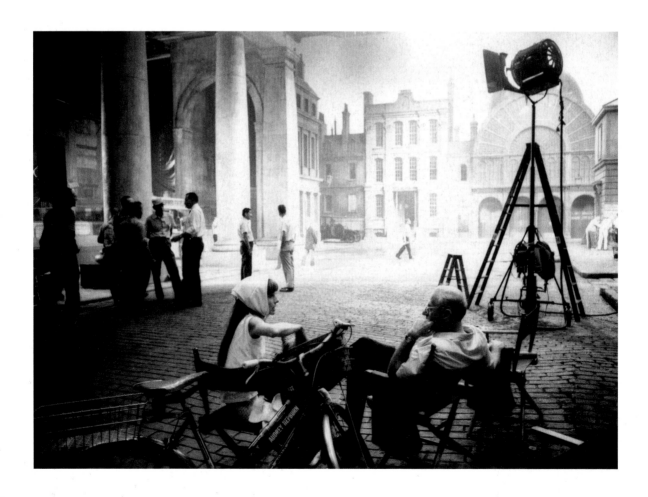

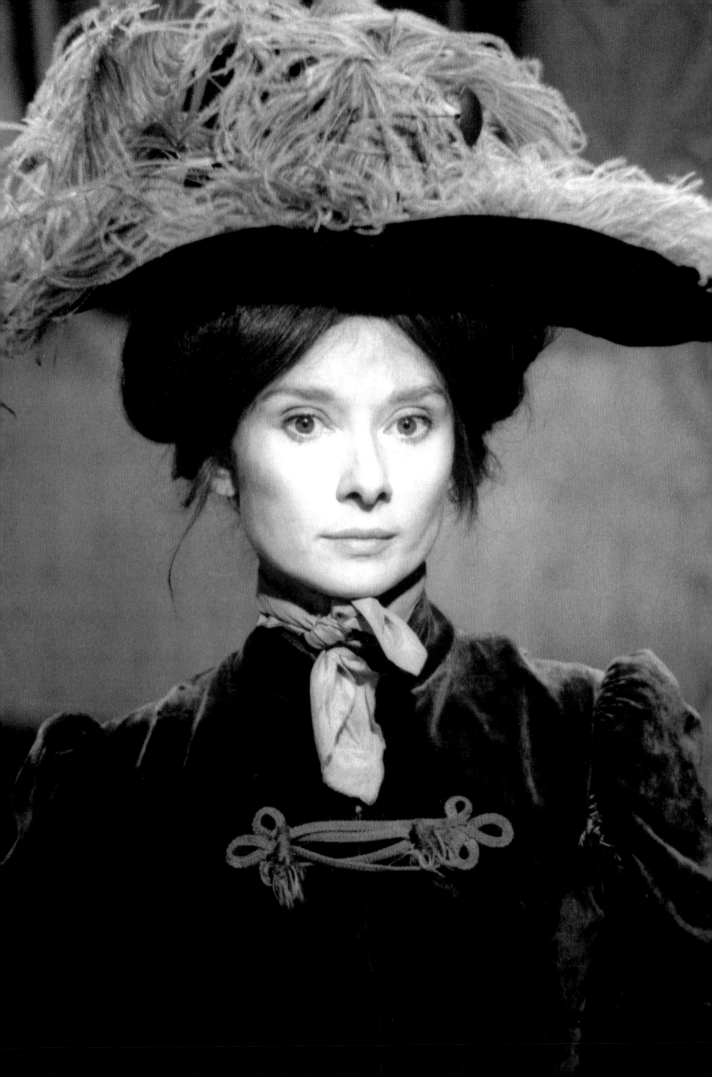

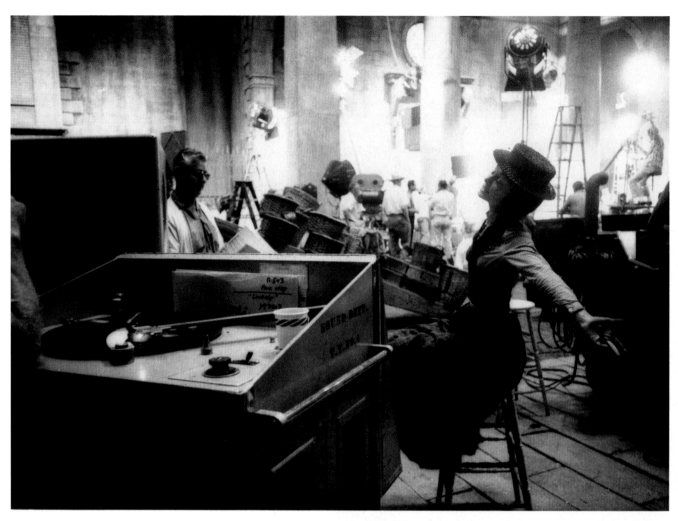

Audrey Hepburn rehearses the "Luverly" number with the playback, carefully watched by Rudi Friml Jr. (left), who is checking that her lip-synch is perfect before she starts filming.

(right) Rex Harrison and Audrey Hepburn.

(facing page) Audrey in her mauve Cecil Beaton dress, Warner Brothers Studios, 1963.

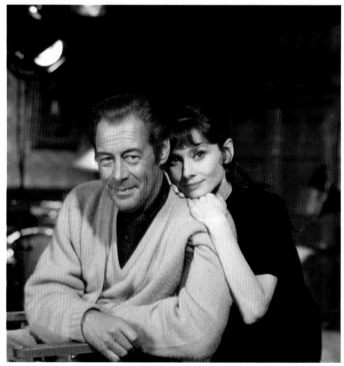

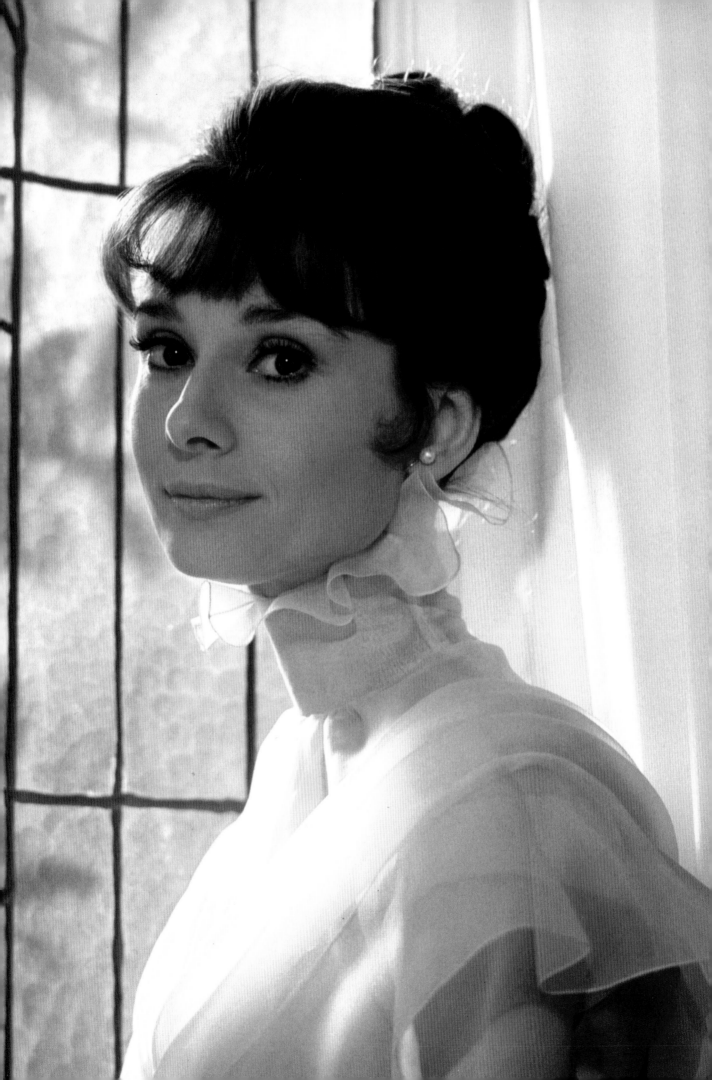

Dr. Claude Claremont, director of the International Montessori Schools, visiting this new one in Santa Monica.

(facing page) When photographing the Montessori School, I came across this wistful young boy sitting alone in the empty cafeteria. He had obviously refused to eat his lunch, and was told he could just sit there until he did. Quite a strong resolve for one so young, and it is one of my favorite photographs of children. Santa Monica, California, 1963.

Glamour magazine had assigned me to photograph Barbra Streisand, who was not well-known then, but the magazines felt she was "hot," as they say. I kept getting the runaround from her, and finally telephoned her in Lake Tahoe where she was performing. I told her, "Look Barbra, I'm probably just as good a photographer as you are a singer, so let's get real!" She seemed to respond to that, and asked me where I wanted to photograph her when she came to L.A. I said, "Any place except in front of a microphone."

She made a date for the pool at the Beverly Hills Hotel, and I went over on my lunch hour from My Fair Lady. She was late, but finally came out with a "beehive" hairdo, and a strange young man, who I later discovered was her husband, Elliot Gould.

She was very cooperative, and I made her look like an Arab princess with towels, since the cabanas at the hotel pool looked like Middle Eastern tents. We had a good time, and when she was asked by Look magazine to be photographed with her new baby years later, she told them she wanted me. By then she was a big star, so Look brought a West Coast photographer back to New York, which was a first for me. The shots above are two of my favorites from the session in Beverly Hills in 1963.

Dorothy and our first son, Christopher, Pacific Palisades. 1963.

Dear Dorothy — we
think you are
so clever — Blessings
and love to you
all.

MR. AND MRS. MELCHOR G. FERRER

The arrival of our third beautiful son, David Joseph Willoughby, October 17, 1963.

(facing page) David's birth announcement with Christopher and Stephen's hands welcoming him to the family.

(right) Ray, our nice milkman, checking the results of Christopher drinking his quota of milk. Pacific Palisades, California, 1963.

Universal Studios called me to work on Alfred Hitchcock's new film, *Marnie*. Since they had already started, and the publicity department hadn't supplied me with a script, I asked Mr. Hitchcock to give me an outline of where they were in the shooting. He sat me down in an adjoining director's chair, and proceeded to tell me about the entire film. It was a rare treat, for he was a great storyteller, and he had the entire film worked out in his head before he even started to shoot.

He told me that it was anticlimactic for him, once he had the images in his head, to actually film. I know that on one of the days I was there, he had saved up all of the exits and entrances through doors, etc., which were so boring to him that he briefly fell asleep, and eventually told the assistant director to do it. He then retired to his dressing room, and they continued shooting. These days, with a more dynamic form of editing, these kinds of cuts have been dispensed with.

I also had a chance to work with Sean Connery (above) on and off the set, and he's as straight as an arrow. One day, several years later, I was walking on the Warner Brothers lot and Sean and another man came walking by. He stopped to say hello and called me by name. Amazing!

I was also reunited with Tippie Hedren. I had photographed her when I was first starting and she was a young model. Now she was starring in a Hitchcock film. He liked cool blondes: Grace Kelly, Eva Marie Saint. Thinking back, I cannot remember a brunette heroine in any of his terrific films. Since I had studied at USC with William Cameron Menzies, I also had an opportunity to discuss some of Hitchcock's early films that he made with Menzies in Europe. It was an assignment I enjoyed very much. (1964.)

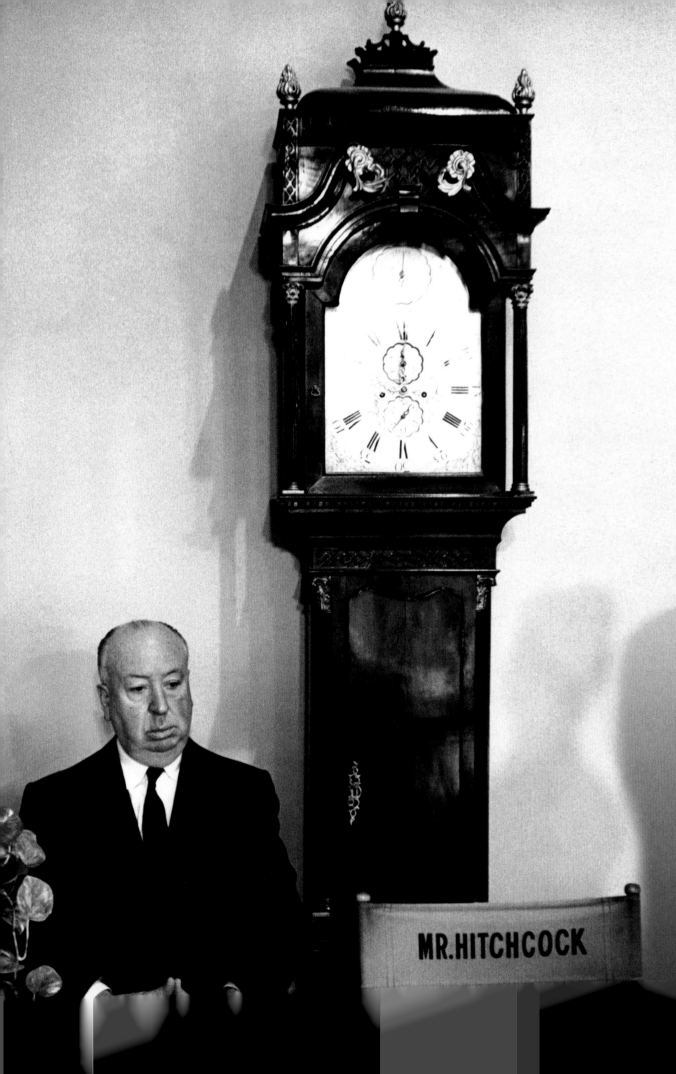

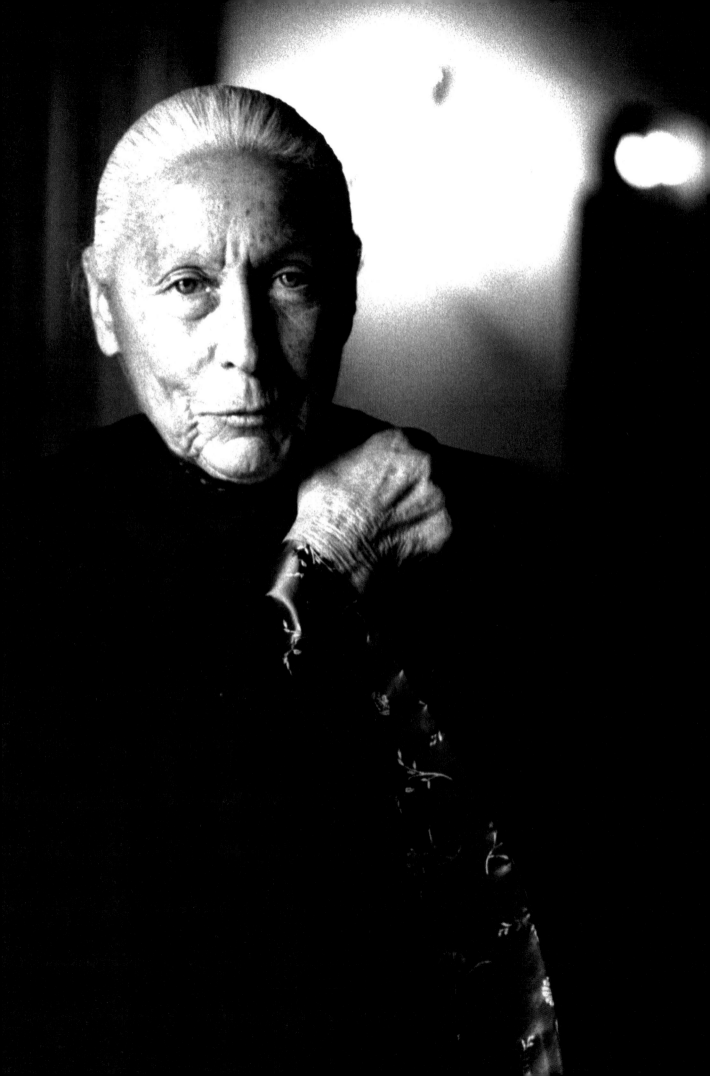

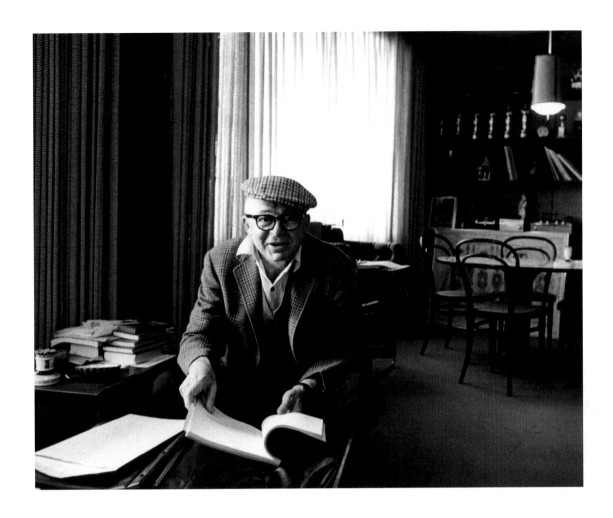

The irascible and monumentally talented director Billy Wilder, photographed in his office at the Goldwyn Studios, Hollywood, 1964 (above). Blake Edwards told me a story of how Billy needed to pass through Blake's office to get to his own. Billy hated Blake's secretary's perfume so much that he bought her another scent, with the card saying "from a secret admirer." This was much appreciated by the secretary, who started wearing the new perfume. Billy thought he had solved the problem, but then Blake got wind of it and found what the perfume was that Billy hated, and sent it to his secretary with a similar message. And so it went in those golden days of Hollywood.

I first saw Marta Feuchtwanger (facing page) at a friend's home, and I thought she looked like Kaethe Kollwitz, the great German artist. I had to photograph her—what a strong face she had, and what a strong personality it reflected. She was the widow of the author Lion Feuchtwanger, who she had helped escape from a German concentration camp. They then fled to America. (Pacific Palisades, California, 1964.)

After my success in getting space on *My Fair Lady*, Warner Brothers hired me to work on their next film: *The Great Race*. This was a very big project, which took us to Vienna, Salzburg, Paris, and all over the U.S. It was a hard film to describe. There was pettiness, excess, interesting locations, once some danger for me, and was an unforgettable experience.

(below) Blake Edwards throws a pie (with a great deal of feeling) at Natalie Wood's face. Jack Lemmon (far left with pie on his face) also watches with pleasure. My radio-controlled still camera is mounted over the motion picture camera, so as I shot this image, it took a close-up of the pie hitting Natalie in color. (top right) *Life* used the pie fight for a double page color spread. (1964.)

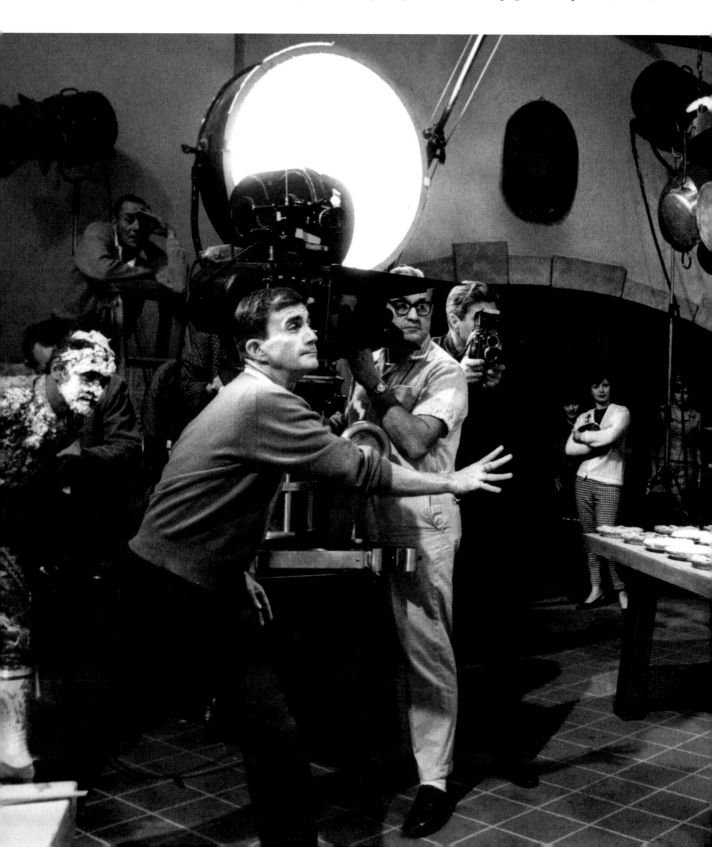

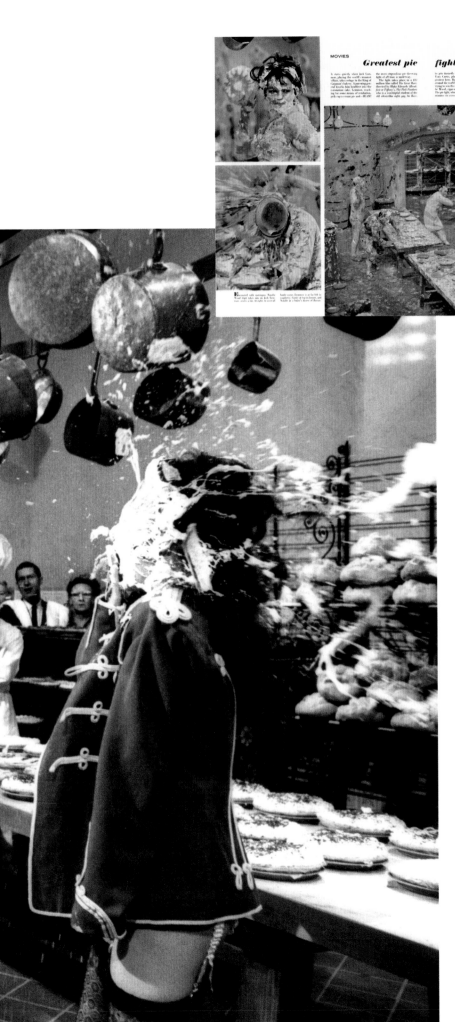

Greatest pie fight ever creates a horrendous SPLAAT!

It starts quietly when Jack Lemmon, playing the world's meanest villain, takes refuge in the King of Carpania's bakery. A pan-swinging sword knocks him headfirst into the decoration cake. Lemmon, reaching for some means of retaliation, picks up a cream pie and—BLAM!—the most stupendous pie throwing fight of all time is underway.

The fight takes place in a $1/2$ million film called *The Great Race* directed by Blake Edwards (Breakfast at Tiffany's, The Pink Panther) who is a worshipful student of the old silent-film slapstick. In *Race*, by pie thrusts, Lemmon against Tony Curtis, playing the world's greatest hero. Both are careening around the world in antique autos, trying to win the affection of Natalie Wood, cigar-chewing reporter. The pie fight, which runs only four minutes on screen, took ten days to shoot and used 4,000 real cream pies—mostly strawberry, blueberry and lemon, all colorful flavors. Edwards finally yelled "Cut," and the whole messy cast of actors turned on him and smothered him with a couple of hundred pies they had stashed away for their revenge.

Berserked with meringue, Natalie Wood (top) takes aim at Jack Lemmon, center, hit, at right, in one of battle scene. Lemmon is at far left in raspberry. Curtis at top in brown, and Natalie in a baker's dozen of flavor.

When I was working on *My Fair Lady* with my good friend Mel Traxel (the unit still photographer), we were so frustrated by the assistant director Buck Hall turning off the lights as soon as they got their final print, causing us to lose so many good photographs, that I wanted to do something about it, other than strangle Buck! Was Buck being told by Warner to cut all the corners, as the film was behind schedule? I never knew, but it was a great pity, and angered us both that we couldn't do our jobs the way we would have liked.

Working on any film has its limitations for stills. Since we couldn't shoot during the actual filming because the sound crew would pick it up, we were forced to shoot during the rehearsals. Often the actors are not in their full costumes since the lights are so hot, or they had their hair in pin curls, or they were walking through it. There were a dozen things that hung us up. Only during the musical sections, when everything was prerecorded, could we photograph, and then not so we would distract the actors. It is a fine line one has to tread.

After my experience on *My Fair Lady*, I started looking for an engineer who could make a sound blimp. I went through several unsuccessful attempts, until I found Irving Jacobson in Hollywood. While he was designing it, I was experimenting with a radio-controlled unit that was designed to set off strobe lights. Two *Life* photographers, Jay Eyerman and Larry Schiller, had produced a motor drive for the Nikon (long before Nikon did) and this was adapted to take a male plug for the radio transmitter, or radio receiver.

I did the tests on this, and when I had a problem, I would tell them and they would see if they could resolve it. Going under anything metal (such as the sound boom) would absorb my signal-lock, and the motorized cameras would start clicking away all on their own. It was trial and error, but by the time we went to Europe on *The Great Race*, I had it working very well. The asset this gave me was that I could clamp a camera where it normally couldn't be, such as on a high crane shot, or hidden someplace on the set.

At first I tried using a motorized camera over the lens shade of the movie camera, with a long cable release. This proved to be a hazard to the crew when they were moving the crane, as someone was sure to get tangled up in the line, so the radio control gave me more freedom. I had brackets built especially to clamp over the Panavision camera, then another to slip into where they had already provided a clamp for a "basher light" just over the camera lens. I did look into getting a tiny TV camera and monitor, but the technology was not what it is today, otherwise I would have done that back in 1964.

Tony Curtis and his wife Christine had a new baby, which they took with them to Europe. In Salzburg, Tony and Christine had a fridge in their room, so they could keep things for the baby in it. When Natalie Wood heard of this, she demanded a room with a fridge. If Tony had an awning over the entrance to his trailer, Natalie felt as if she were being ignored if she didn't get one as well.

Tony loved this, and never lost an opportunity to tease Natalie, and frankly, Natalie was a pain most of the time. I have photographs of Blake trying to reason with her when she was looking for "motivation" and holding up production. One time in Salzburg at the Domeplatz Cathedral, she didn't want to wear the costume that she had already approved, and Blake looked around (smoke coming out of his head) at the several hundred extras, and he said they would just shoot the scene without her.

Something like this happened again at the Eiffel Tower location. Tony Curtis and Jack Lemmon just shook their heads at the new drama and said, "Here we go again!"

Natalie Wood looking appropriately delicious, The Great Race, *1964.*

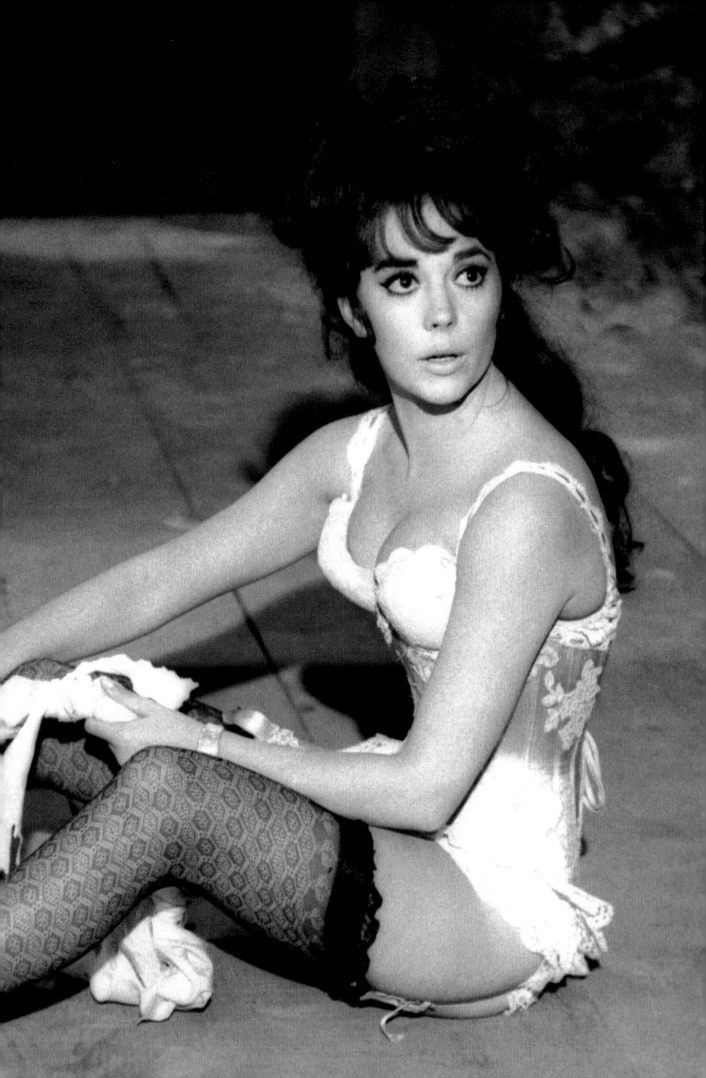

(above) Tony Curtis at his best, as The Great Leslie, *1964.*
(facing page) Jack Lemmon *(playing a dual role)* as the Prince,
photographed in Vienna.

The Vienna location was great because in the museums there was a joint exhibition of "Wein Um 1900," a period in Viennese art that included some of my favorite artists, such as Gustav Klimt and Egon Schiele. I found a gallery in Salzburg that had Klimt drawings for sale, and when Blake and Tony heard about it, they also went to buy one.

One day back at Warner Brothers, I was trying to squeeze into a corner when the cameras were about to roll, and cinematographer Russ Harlan called to me. He insisted that I come over and stand in front of him, which was very generous, since he needed to see everything himself. There was a stunt car with hydraulics that was being driven by Peter Falk. Something happened, and it went out of control, and with its sharp pointed front drove right into the place where I had been standing a minute before. That was the end of shooting for the day. I stood there somewhat in shock, as there would have been no way for me to have escaped. I thank Russ to this day for whatever instinct he had at that moment. He surely saved my life!

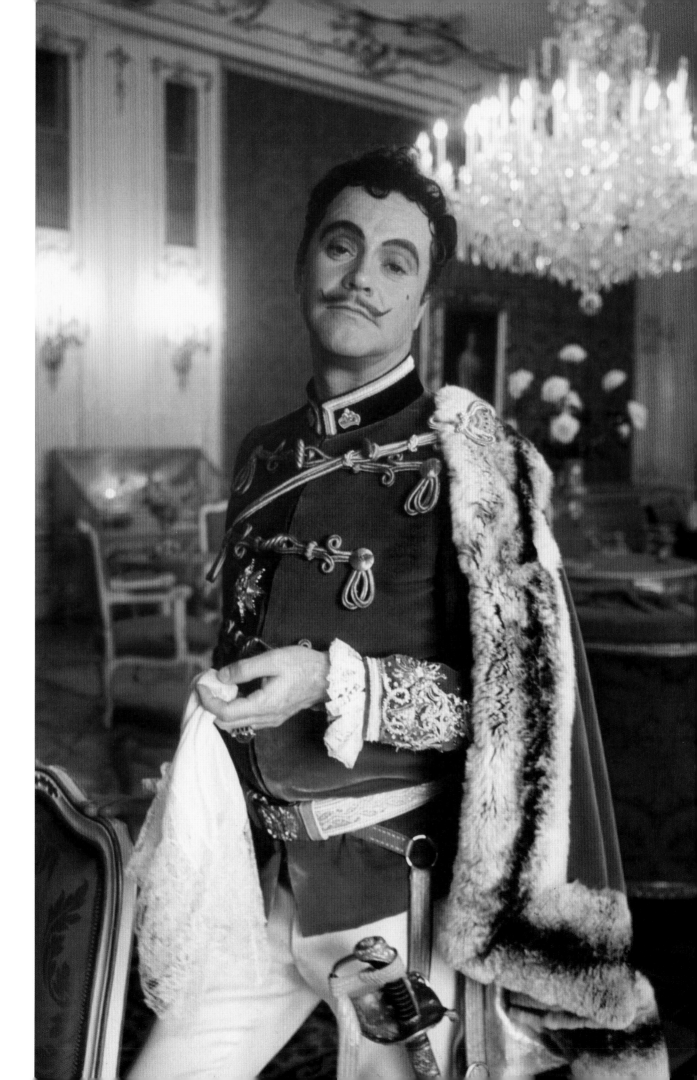

Saturday Evening Post · January 16, 1965 · 25c

THE LIFE, TIME AND FORTUNE
OF HENRY LUCE
AMERICA'S GREAT OPINION-MAKER

TROUBLE IN RETIREMENT HOUSING

POST

JACK
LEMMON
as Professor Fate in
'The
Great Race'

THIS WEEK

Des Moines Sunday Register

(below) Tony Curtis saw me with the antenna on my radio receiver and figured I was fair game. I fought to the death, but kept my hand on the radio transmitter (in my left hand) hoping to record this bloody battle.
Warner Brothers, 1964.

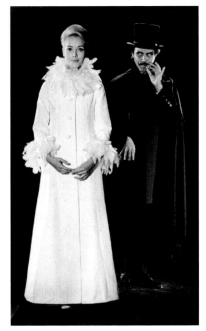

*Bad Bad Black
Goody-Good White*

In the film, Tony Curtis, as The Great Leslie, is always dressed in white, and his car is white. Jack Lemmon, as Professor Fate, is in black, as is his car. Always looking for another way to get space, I suggested this to *Life*'s fashion department. They not only ran the fashion story, but later the pie fight, so I broke twice with *Life*, which won me a lot of points. Photographed on the tundra set at Warner Brothers, 1964.

By the end of the film, Mort Lickter from the Warner Brothers publicity department came to the set to ask if I would mind not shooting the following day. He told me that Natalie Wood felt as if I was Tony's personal photographer, and she wanted to bring Bill Claxton on to shoot pictures of her. I told him that I didn't mind, I had basically everything I needed, and anything to make Natalie happy and their job easier was good with me.

It was a wonderful morning, and I was sitting out on our terrace relaxing, and appreciating this unexpected day off. Dorothy answered the phone, and it was Mort in a panic. Tony saw Bill Claxton on the set, and asked where I was. Hearing the story, he told the publicity department that they had better get me back or he wasn't going to shoot. He begged me to come as fast as I could. The publicity department was in hot water. The film did stop shooting at 11:00 AM, breaking for a very early lunch. Tony was only doing this to bug Natalie, of course. I drove back to the studio, and didn't even bother to unpack my cameras. I knew what was going on, as I had seen this game played before.

The multiple film locations made the story line very complicated, and I had so many diverse photographs that I suggested we have an exhibit to give the public a little taste of what was to come. Warner Brothers liked the idea, and Lee set up a show at the Art Directors Club in New York City, and then it was to move to L.A. where the studio was setting up a big tent for the public to see. As we were setting up the L.A. show, Mort called me, again very agitated, and said that I would have to add seven more prints of Natalie to this exhibit. Her publicity agent Pat Newcomb had been to the New York show, and counted how many photographs there were of Tony, and it seems there were seven more than of Natalie. Life in Hollywood among the stars!

I must mention beautiful Christine Kaufmann, Tony's wife. We had such great discussions about art on the locations. She had exquisite taste, and showed me the carpet she had designed and had made for their dining room. She was one of the most beautiful women I've ever photographed. She had an antique dress that she asked me to photograph her in (facing page), a classic beauty from another age. (1964.)

Tony and Jack posing for color covers on the Warner Brothers back lot, 1964.

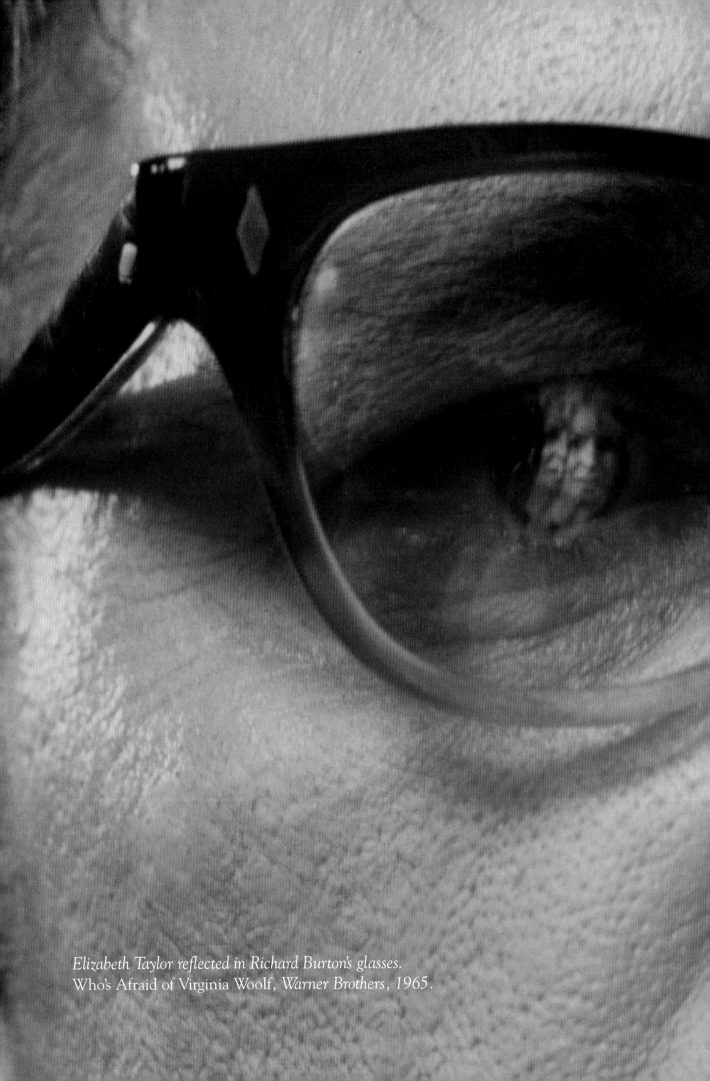

Elizabeth Taylor reflected in Richard Burton's glasses.
Who's Afraid of Virginia Woolf, *Warner Brothers, 1965.*

I started working on *Who's Afraid of Virginia Woolf?* at Warner Brothers. With Elizabeth Taylor, Richard Burton and a new director from Broadway, Mike Nichols. While I had read the script and plotted out my shooting days, I wasn't prepared for the intensity of the acid and bitter dialogue (see facing page). Nor, may I say, were several of the crew, who left after the first week. I think what affected the people working on the set the most was the repetitive hearing of the same strident dialogue eight hours a day, which ground one down.

The Burtons were both professional actors, so from what I could see, the dialogue didn't affect them as much or at all, but it was hard for the crew not to take it home with them. Richard didn't care much for George Segal, and I felt his constant put-downs were very unkind, but it seemed to roll right over George. He might have been very hurt by it, but put on a brave face. In fact Richard had no charity to anyone as far as I could see. He was a fine actor, and it was interesting to see him in action, and observe the differences, as in the scenes with Sandy Dennis, who was a Method actress from New York.

Burton would do the scene precisely the same each take, while Sandy tried various things, but it was never the same. Burton knew how he wanted to play the scene and it was acting technique, while Sandy dug into her emotions, and the difference between them was dramatic. I don't think Burton was affected emotionally by the intensity of the moment. He seemed able to separate himself from it all, while Sandy (who was emotional and, I felt, vulnerable to begin with) was wiped out after some of the difficult scenes.

Elizabeth seemed to be able to handle Burton at times fairly well. One of her memorable put-downs that I heard her tell him was "Remember, Richard, I'm the one making the million dollars," which wasn't lost on him.

One day, the film editor Sam O'Steen and I were talking, and he told me that he was in the screening room watching the rushes, when Jack Warner came in and sat down. Apparently this was the first time he had seen any of the film. "My God!" Sam, told me he said, "I'm making a five million dollar dirty picture!"

Warner was a certifiable character, and the things I've heard him say to Nichols, the Burtons, or to an audience of guests at a large party were just off the wall. He liked calling me "Mr. Mustache." When I would take a picture with him in it, his standard joke was, "If they're any good, you can keep a dozen!"

The light levels on the set were extremely low, as cinematographer Haskell Wexler was shooting the film in black and white, and lit the set with photofloods. While interesting, it made shooting color very difficult, and I had to buy a special fast 180mm lens to get the head shots I needed. The photofloods had a short life span, and they often blew during a crucial take, which meant that they had to re-shoot the scene, heightening the tensions of the actors and the frustration of director Nichols. Each morning, the gaffer Frank Flanagan would have every photoflood on the set replaced with fresh ones. However, the final result won Haskell an Academy Award in 1966.

Nichols was opening the film up from Albee's play, and they shifted the location to film some exteriors at Smith College in Northampton, Massachusetts. The college was closed for holidays, and we shot every night all night, and it was very cold. There was really no place for the crew to get warm or even sit down comfortably. It meant standing, and stamping one's feet to try to keep warm, and it seemed an eternity waiting for the filming to begin each night. It was not an easy location for the crew. (1965.)

(facing page) Albee's dialogue for the film created a George and Martha as vicious as any husband and wife in motion picture history.

(below) I give Elizabeth a shoulder rub.

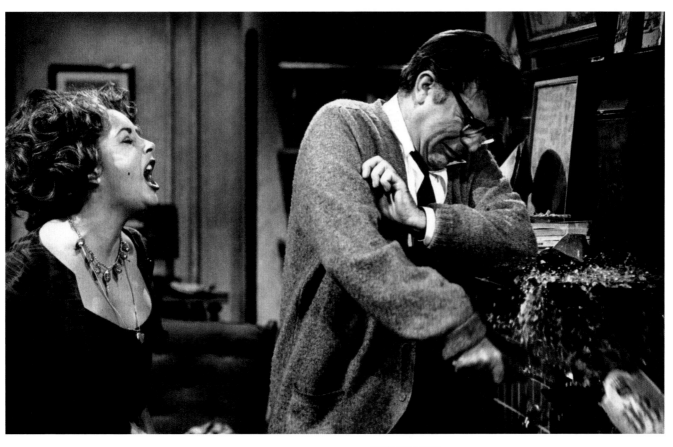

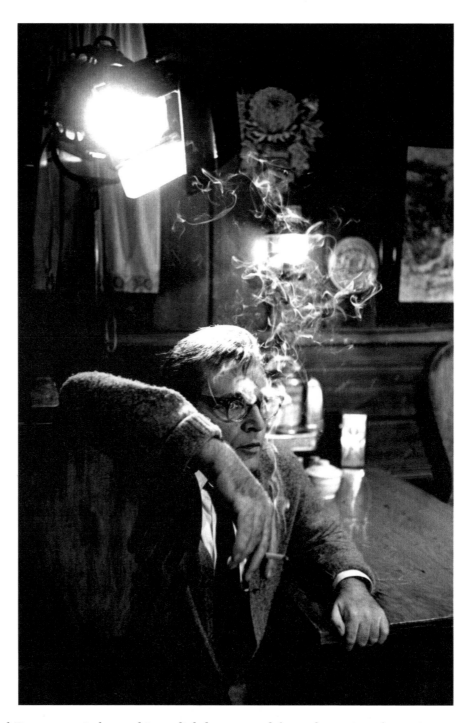

Richard Burton, quietly smoking, slightly removed from the action, but missing nothing.

(facing page) Elizabeth Taylor, who gained a good deal of weight for the picture. I heard that Nichols had wanted her to lose weight for the part, and she told him that then she would look younger. The magazines made a big thing of this "new image." Frankly, I got used to seeing her in the aging makeup, wig and dowdy clothes, and when I photographed the Burtons away from the set, the transformation back to how they really looked blew me away.

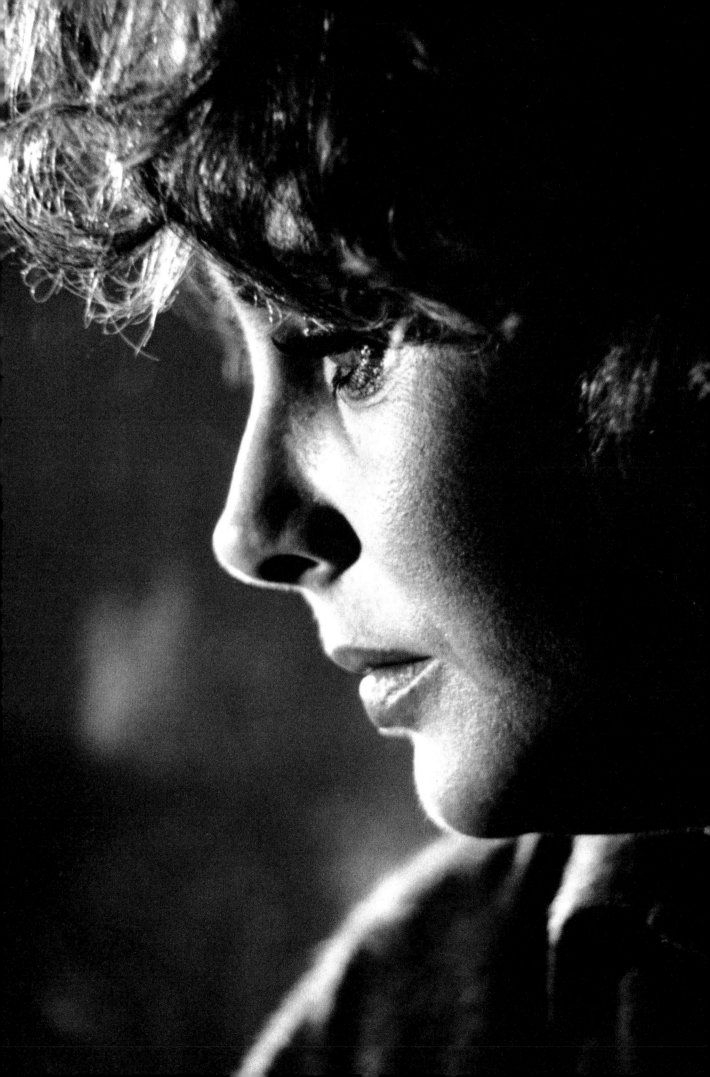

The night shooting was difficult, and double pairs of long johns, heavy coats and caps didn't suffice. A long, hot soak in the tub when I got back to the motel in the early morning was needed to thaw out. The area around Northampton was a treasure trove of American antique stores, so I rented a car, and my long-time friend Mel Traxel and I investigated them. Each day we took a different route, had a nice lunch out away from the studio's catered food, restoring ourselves for another night of bone-numbing cold.

I think all of this antique hunting was really just a catharsis from the miserable night work, but we had a lot of fun, and bought a lot of things. When we were set to leave, I had to call movers to ship my things back to Los Angeles.

One of those nights, while Mike and his cohorts were warm inside their rented house on the campus playing Scrabble, I went in to photograph it. In another room, the Burtons were holding forth. Richard had obviously had a few drinks, and for the first time he turned his abuse on me. I couldn't believe it. It just came flowing out and for what? I called my agent, told her what had happened and that I wasn't going take any more of it. About an hour later, she called back. Warner had pleaded with her to convince me to stay, as anyone else would be faced with the same problems, and as I was already settled in with the cast and crew.

I did stay on, but decided I would ignore Burton. I photographed everyone else and studiously avoided him. (I agreed with Elizabeth—she's the one making the million, and she's the one that would get the space.) I think it was about two or three nights later that Burton came over to me, put his arm on my shoulder, and said something about "Bobby" and a "misunderstanding." I thought, "what a miserable so-and-so."

After the film, the cast and crew were invited to the Burton's Beverly Hills house for a party. I told Dorothy that I didn't want to go. Of course, there was no way she was going to miss that party! All the way over in the car, I was telling her what a real S.O.B. Burton had been. When we arrived at the house, the party was in full swing, and Richard came over to greet us. He leaned over and kissed Dorothy's hand, and led her into the room. He absolutely swept her away with his great supply of charm. There was no way I could ever convince her that he was anything other than the most charming man she had ever met.

Of course, all of the magazines all over the world were interested in this film, and I not only got covers on *Life* and *Look*, but a *Saturday Evening Post* gatefold. But not so much as a "well done" from the Warner Brothers publicity office, I might add. (1965.)

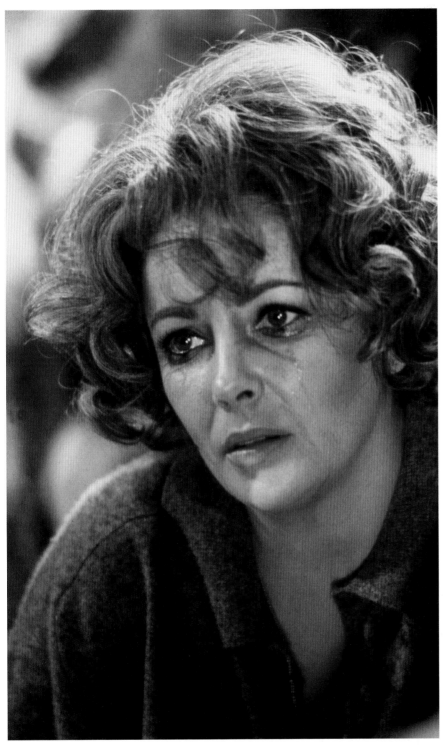

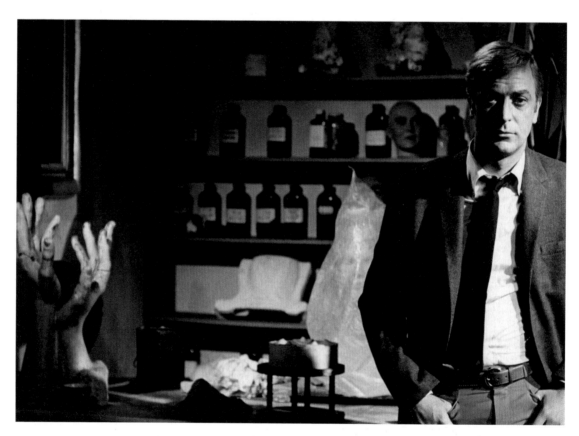

Michael Caine on the set of Gambit. I had just started on the film, and Michael saw me from across the room with my long lens pointing his way. He checked the light, and moved into his key, out of the shadow. It was a professional gesture on his part, which took me off guard. Normally, I try to be as invisible on the set as I possibly can. The actors have the problems of the coming scenes to think about, so I always try to avoid getting in their eyeline. He was marvelous to work with. Universal Studios, 1965.

(facing page) When I saw Frank Sinatra resting against the wall under this sign, I knew that I had a photograph that would make many people smile. Marriage on the Rocks, Warner Brothers Studios, 1965.

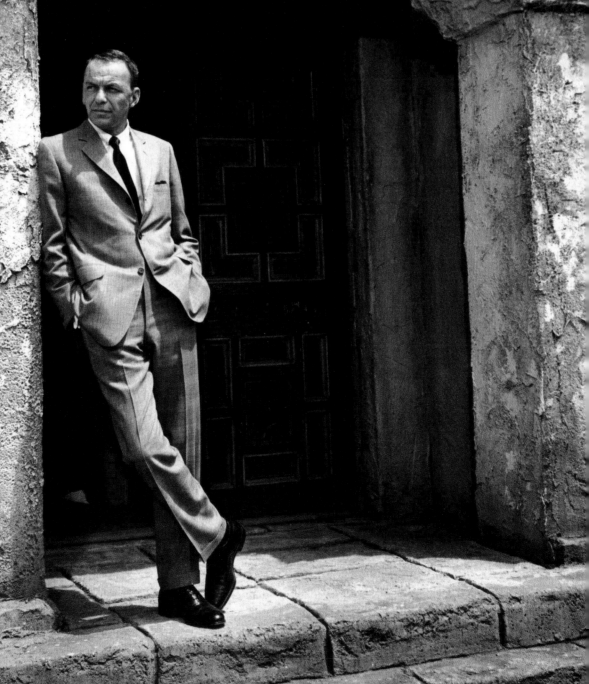

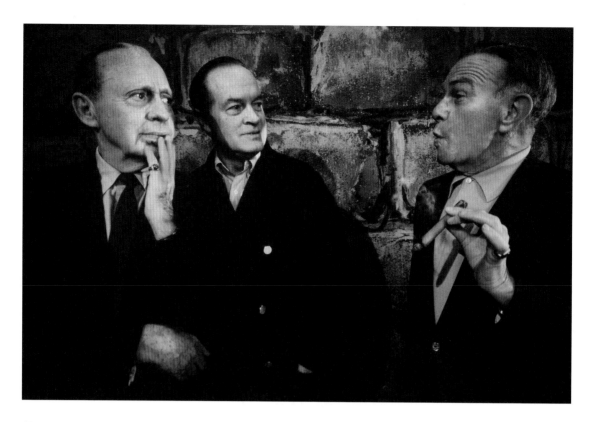

Esquire magazine arranged for me to photograph these three famous comedians at the end of 1965. We were meeting at the TV station where Bob Hope was doing his Christmas show. When I arrived, Bob was in a Santa Claus outfit. He just thought he would pop in with Jack Benny and George Burns, get the shot and go back to taping.

I reminded him that the magazine was not being published at Christmas, and that I needed him in his civvies. Bob is the most agreeable and professional person to work with, but he would have to take off his Santa outfit and makeup, and it would take too much time. I prevailed, telling him that I felt in reality this would be an historic photograph. He did change, bless him, and this won an art director's award for the magazine.

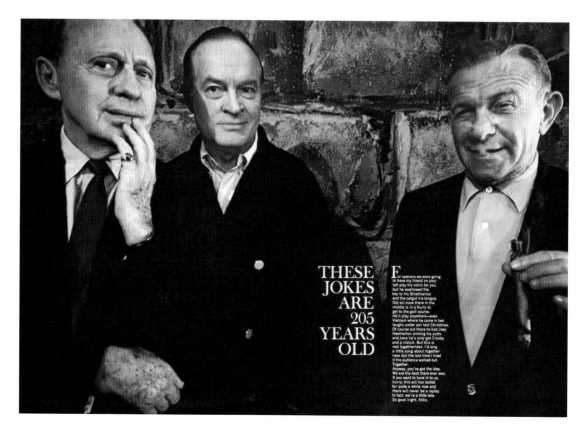

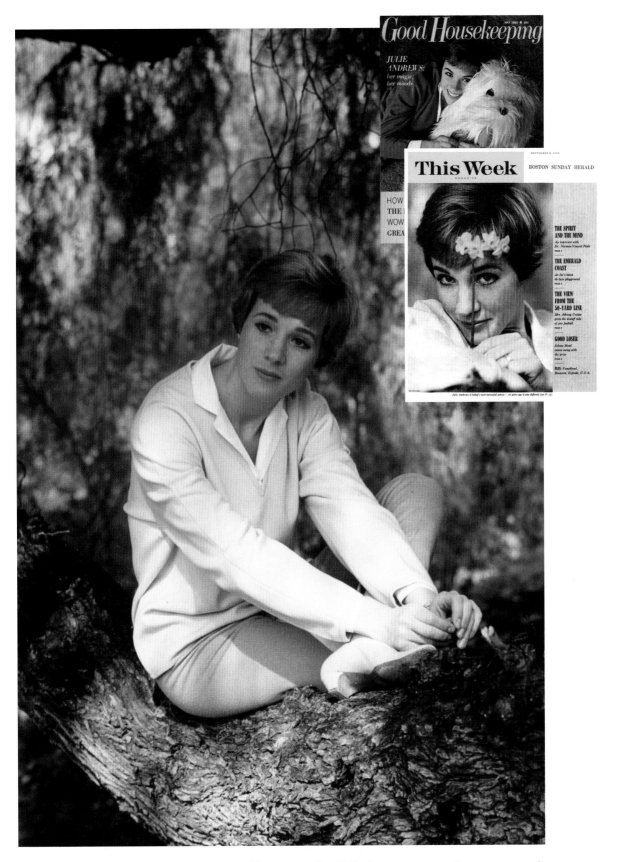

Julie Andrews, here in the garden of her Beverly Hills home, was a dream to work with. We had great fun that afternoon, and I would have the pleasure of working with her again in the years to come. 1965.

Dorothy the boys and I returned to the Berliner's for a reunion. How big the children had grown in the 7 years in between! Grass Valley, 1966. (above right) Tony Curtis, his beautiful wife Christine Kaufmann and their daughter Alexandra come for tea. Our boys loved to wrestle and climb all over Tony, and he pretended not to mind. Pacific Palisades, 1966.

(facing page) Rex Harrison shows one of his fellow actors something amusing in the newspapers. 1966.

I started my locations for *Doctor Dolittle* in Castle Combe, England. The company was plagued with weather problems. When they wanted sun, they got rain, and when they finally put the artificial rain on to complete a sequence, the sun came through. This was a lovely, quaint and prize-winning village, but there was a LOT of dissent by the locals, to the point of sabotaging the electrical generators. Eventually the studio gave up, and moved it all to the Disney Ranch in California.

I had an assignment for *Look* magazine to cover *Doctor Dolittle*, and if the production people had problems, I had even more, mainly with the director, Richard Fleischer. If I used my radio controls on the camera boom, he said it would interfere with Rex's radio mike, even though I had carefully checked with the sound department, and was on a completely different channel. If I used a long extension cord on the camera, he found something wrong with that. It was one thing after another. I have never worked with a director who actually seemed as if he didn't want his film documented, and I've worked with the most difficult people in the business.

In the end, every picture in the *Look* layout was something that I did on my own, and didn't appear in the film. Producer Arthur Jacobs, who knew my problems, helped me whenever he could, but in the end, I had to bring in bottles of whisky for the grips and electricians so they would move lights to my own little production I had going where Fleischer couldn't see. Rex Harrison, Tony Newly and Samantha Eggar all helped in this conspiracy, otherwise I would never gotten any pictures for *Look*. (Castle Combe, England and the Disney Ranch in California, 1966.)

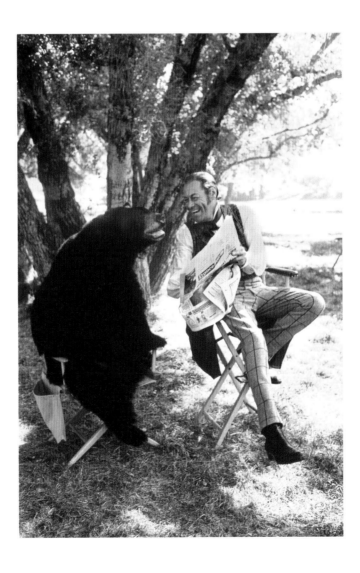

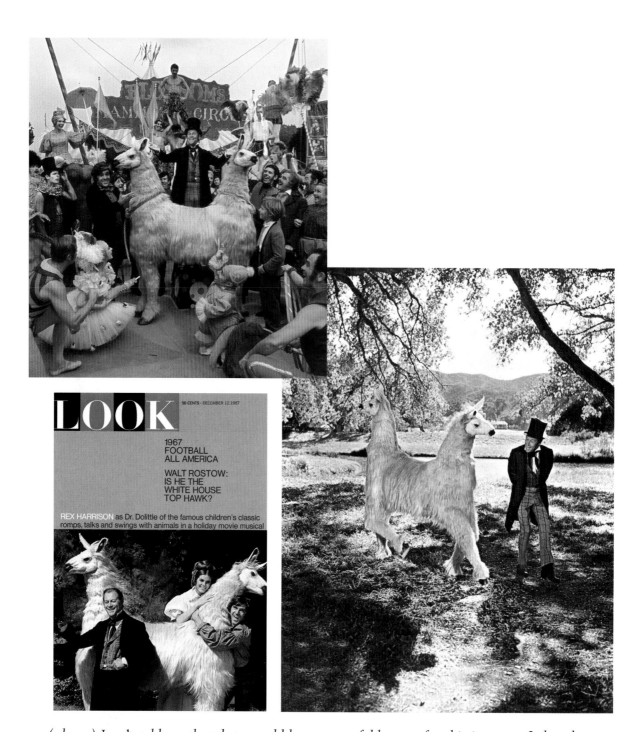

(above) Look told me that they would have a gatefold cover for this issue, so I shot the one above on Dr. Dolittle with that in mind. At the last minute they used it on only one part of the page. It would have made an ideal gatefold, with Rex and what appears to be a llama on the front, and then to open it to see the "pushmi pullyu" with another head. (20th Century Fox Studios, 1966.)

(facing page) Lucille Ball did a television special in "swinging London" with Tony Newley. It was the time of Carnaby Street, with all the mod clothes, so I suggested that we do a mod fashion layout. Lucy loved it, and helped pick out the accessories. She was a whiz at doing this, and we had great fun in the process. They also made me second unit director, getting all of the scenic shots of London they would cut in to the film. It was my first and last assignment like that, and I enjoyed it very much.

AND LUCY IS WITH IT IN LONDO

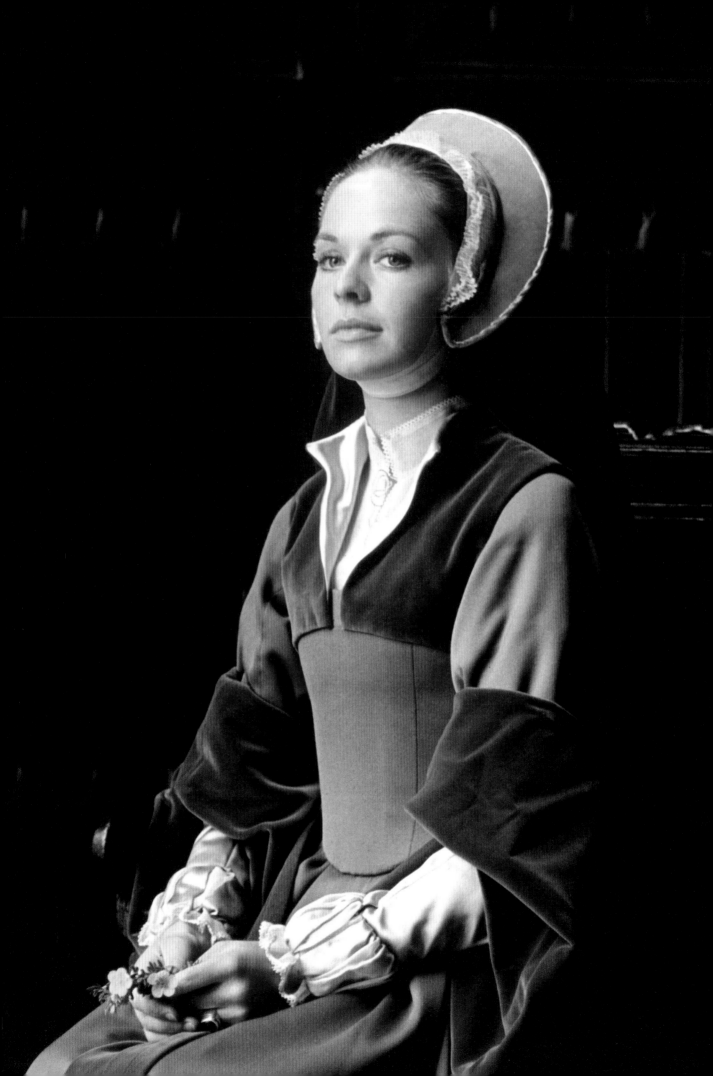

The wonderful British actor Paul Scofield, photographed after filming was over for the day. Shepperton Studios, U.K., 1966.

(facing page) Susannah York as Margaret Roper. The York rose is my little visual pun.

A Man for All Seasons is the kind of film that I enjoy working on—very professional people, such as Paul Scofield, Robert Shaw, Susannah York and a host of others, plus working again with director Fred Zinnemann for the third time. The studio didn't give me a lot of time, but I had the idea to do a story on the real St. Thomas More. I did all of the research, and found that his skull, in a metal case (which his daughter kept under her bed after he was beheaded), was buried in Chelsea, under the floor of a church.

The studio agreed that they would pay for the repair to the floor, if the authorities would allow me to photograph it, but the idea was refused. I went down to Buckler's Hard, where they were filming because they still had a tidal river there, much the same as London had at the time of Henry VIII and Sir Thomas. I photographed what I could on the film, and then wanted to get some color head shots of Susannah York.

I had photographed her for *Harper's Bazaar* in California, and we had become good friends. Beaulieu Castle was being used as a background, and so I arranged for the wardrobe department to meet us there with Suzy's costumes, and in the meantime, photographed her in some of her own clothes. I think we had been photographing for over an hour, and then she changed into a formal costume and I went inside the castle to photograph her at the door, when my motorized camera jammed. I had never had a camera jam on me before, however, I had two others, and picked up another one and proceeded to shoot.

Now I took Suzy inside the castle and took photographs of her with the medieval backgrounds, and amazingly that camera also jammed. I could not understand this—one breaking down may be possible, but not two! Then I remember being upstairs in the long hall, and there was something, a feeling hard to describe on this summer's day, but there was an unexpected coldness, a sudden damp chill that made me shiver, and I turned to mention this to Suzy and realized she was about to faint. I called the wardrobe ladies, and told them we had had enough, and would they take Suzy downstairs and let her rest somewhere.

Now I was really very interested to discover what the problem was with my motorized cameras. I had a changing bag with me, and went outside to the car, and opened the first camera inside the bag, and there was no film. No film in my camera? That scared the hell out of me. It is impossible to shoot a Nikon motor drive without loading and setting the counter for the numbers. Yet there was no film. I could feel my stomach tighten. I opened the second one, and the third, they were empty as well. All of the photographs we took outside the castle were perfect, but what happened to the things inside the castle I would never know.

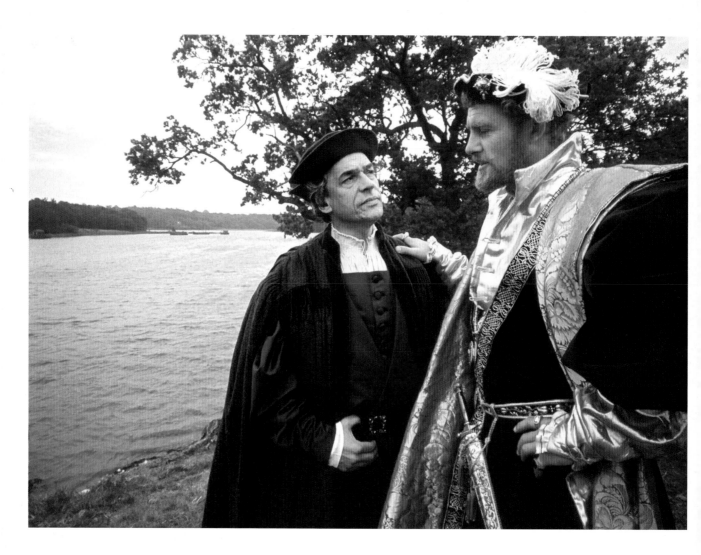

I must have been looking a bit shocked when Lady Montague came by, and asked me what was the matter. I told her the story, and she said, "Oh, not to worry, that sort of thing happens around here all the time." She then proceeded to tell me stories of how another film crew that had been working there had continuing film jams in their Panavision cameras, and they kept sending the cameras back to London for repair, but they couldn't find anything wrong with them, as they worked perfectly in London.

She told me that things got so eerie on that film that when they were working at night the script girl refused even to go to the bathroom on her own. She then pointed out the ruins of an abbey just across the way. She told me that musicologists from London had come down to record the chants that are heard from the monks at night. This was my second experience with the strange goings-on in England.

(above) Since I was on this film very briefly, I had to re-create scenes. I had the pleasure of directing two of England's finest actors, Paul Scofield and Robert Shaw, in the scene when Henry VIII comes to Chelsea and visits the Lord Chancellor, Sir Thomas More.

One nice moment came after taking a few pictures with Shaw in his magnificent costume. We stopped at a nearby pub, pulled two of the bar stools out into the sun, and there was Bob having a beer with Henry VIII dressed as he was in regal splendor!

Beaulieu Castle, Buckler's Hard, U.K., A Man for All Seasons, 1966.

(facing page) Delicious Susannah York in the castle grounds. This is just about as close as I got to the castle without any interference from the resident ghosts.

242

(above) A very pregnant Dorothy and our son Stephen settled down for an afternoon nap. Pacific Palisades, 1966.

(below) Promotional picture and brochure noting some of the different magazines that published my work during 1966.

CORONET, COSMOPOLITAN, ESQUIRE, FAMILY WEEKLY, GLAMOUR, GOOD HOUSEKEEPING, HARPER'S BAZAAR, HOUSE BEAUTIFUL, LADIES HOME JOURNAL, LOOK, LIFE, MADEMOISELLE, McCALL'S, METROPOLITAN NEWS GROUP, MOTION PICTURE, NEWSWEEK, NEW YORK TIMES MAGAZINE, PAGEANT, PHILADELPHIA NEWS, REDBOOK, THE SATURDAY EVENING POST, THIS WEEK, TOWN & COUNTRY, T. V. GUIDE, U. S. I. A. AMERICA ILLUSTRATED, VOGUE, LIFE INTERNATIONAL, LIFE ESPAGNOL, LONDON DAILY S... EVERYWOMAN, LONDON DAILY MAIL, WEE... WOMAN'S JOURNAL, BUNDE ILLUSTRIERTE, BRIGITTE, DAS NEUE BLATT, DER STERN, FILM UND FRAU, FREUNDIN, HOR ZU, HUSIKLEXICON, REVUE, QUICK, ECHO MODE, ELLE, PARIS MATCH, EPOCA, L'EUROPEA, CHATELAINE, BILLEBLADET, EVA

In one of my favorite photographs, Jack Lemmon on the Columbia Studios set of LUV *smokes his cigar while waiting for filming to resume. 1966.*

The Columbia Studios film of Murray Schisgal's play *LUV* reunited me with Jack Lemmon and Peter Falk, and introduced me to Mike Nichols' original teammate, Elaine May. Clive Donner, a nice and helpful English director, was brought in to direct what is essentially an American play about New York characters. It is as strange as hiring Fred Zinnemann to direct the musical *Oklahoma*. But then there were many anomalies when I worked in Hollywood.

The film was a black comedy, and here again was another problem that the producers failed to understand. I saw the Broadway show, and when someone is pushed off a bridge on stage and a bucket of water is thrown up in the air, that's funny. But when you go to a real bridge and push someone off, they're really going to be killed, and that's not funny! The camera creates reality for the audience and changes the context.

We filmed in New York and Niagara Falls, and there were some really very funny scenes between Jack and Elaine, but you could not overcome this handicap of making the transition from a stage play to the screen. I can think of maybe only one or two that have succeeded, but never a black comedy.

The arrival of a lovely daughter! Catherine Jean Willoughby, December 21, 1966.

I had a telephone call from *Look* magazine in New York, asking me to fly back to photograph Barbra Streisand and Elliot Gould's baby who was about to be born. This was a marvelous assignment, since not only was this an exclusive with the new Streisand baby, but I had never heard of a West Coast photographer being asked fly to New York to photograph an assignment. It had always been the other way around!

I told them to thank Barbra, who had obviously asked for me, but that Dorothy was also expecting, and I would only do the assignment after our baby was born. Dorothy gave birth to Catherine, and I flew to New York. Barbra sent Dorothy a telegram, thanking her for being so cooperative.

Normally I like to work with natural light, but when I got to New York, it was snowing and the skies were far too dark, and this didn't cheer me up. I went to *Look*'s offices, and borrowed some of their lights, and then senior editor Ira Mothner and I went to Barbra's apartment. She had just come home from a recording session, and put on the tapes for us to listen to while she went to change for the photographs with her new son Jason.

The sound on those tapes (which Barbra supervised) was just incredible—not only her voice, but the orchestration as well. Barbra called to us, asking how we liked them. Ira and I just looked at each other (we were both fans) and were really stuck to tell her what we thought. Was there a sufficient superlative? We just said it was terrific. When she finally came out, she took us around the apartment asking where I would like to start.

The light was dirty gray, not the right feeling for a mother and child image that I would have ideally liked. However, with her tapes playing in the background, I set things up in the bedroom, and when they brought little Jason in, I started to photograph. The day went well, and Barbra really was the proud mother.

Elliot came in at the end of the session, and I took a family portrait. It was a good afternoon, and then I flew back to my own family, with a nice feeling about how everything had worked out.

Catherine comes home from St. John's Hospital, and the boys meet their sister for the first time. Eileen Fisk, our Scottish nanny (left), Stephen, Christopher (kissing Catherine), and David peeking around to check out the new arrival being held by Dorothy. We're very proud of Eileen, who later returned to school and is now a pediatrician and teaching professor on the East Coast. Pacific Palisades, 1966.

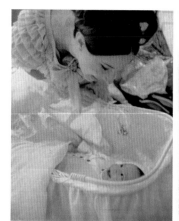

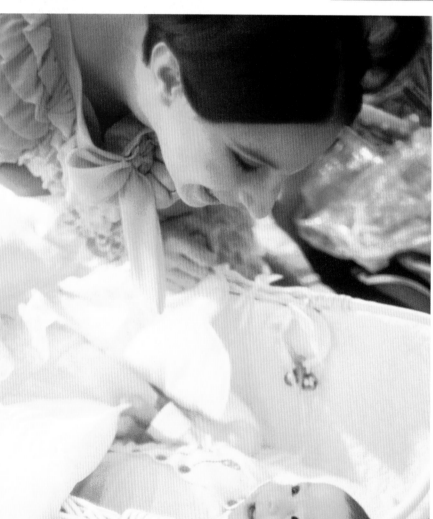

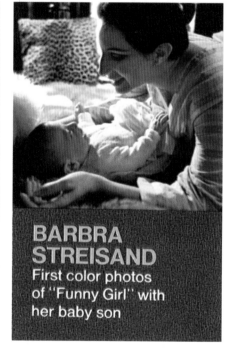

BARBRA STREISAND
First color photos of "Funny Girl" with her baby son

248

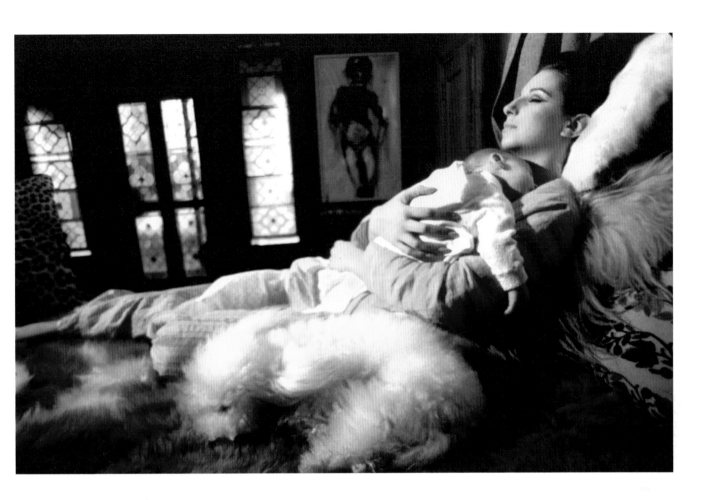

Timing was everything. Barbra was preparing for her TV special, Elliot was opening in a play and they had found a two-day window of opportunity for me to fly back to New York. Our Catherine was born on December 21, Jason on the 29th. So it was an amazing fit. *Look* used five pages, plus part of the cover.

Barbra's dog, Sadie, was very jealous of the attention that the new arrival into her world was getting. She tried every which way to get Barbra's attention when I was shooting. Barbra, thinking back to our meeting in 1963, told me that she has a phobia about water, and so I asked her why she had chosen to be photographed in the Beverly Hills pool. She said it was the only place she could think of, since I didn't want to photograph her performing. (New York City, 1967.)

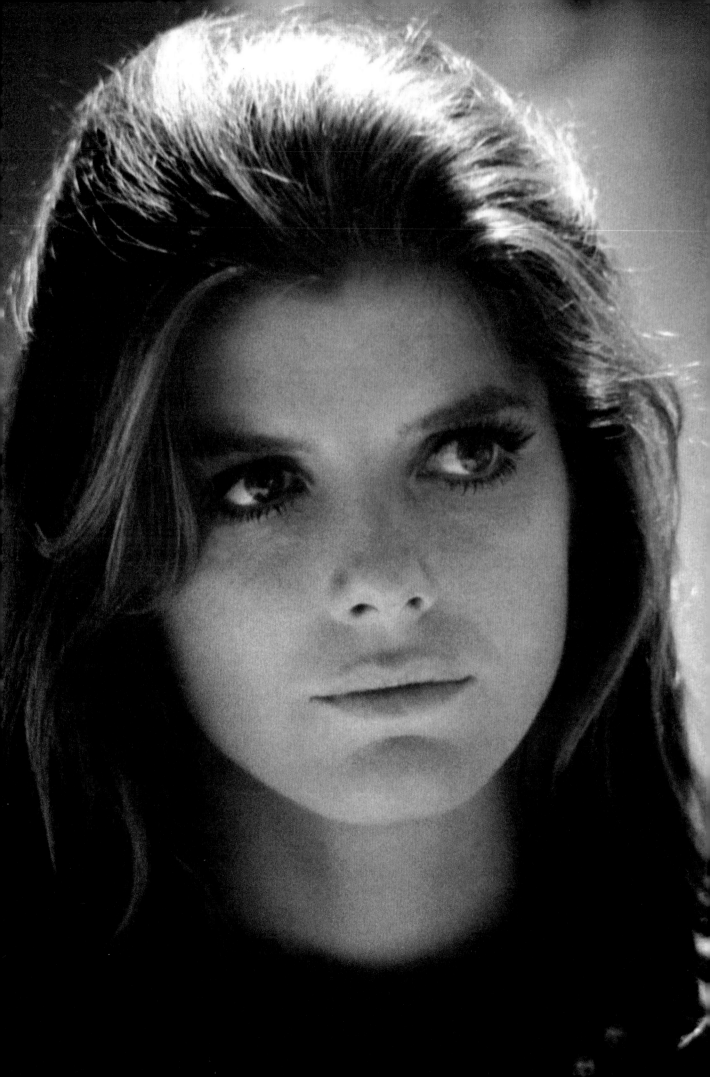

It was the usual practice for the studios to send me a script if they wanted me to cover a film for them. I'd break it down to see if there were things in it that I thought might interest the magazines. If there was a big production number, an interesting set, or the actors were so important that I knew I could get some space for them, I would tell them what I felt I could do, and the time it would generally take me.

When I received the script of *The Graduate*, which had been written by the best-selling author Charles Webb, I just couldn't believe it. It was so bad, I couldn't understand what prompted them to do it.

The book had been an instant best-seller at the time, but a good book doesn't guarantee a good screenplay, any more than a stage play does. I called my good friend Larry Turman who was producing it, and told him that I would like to work again with Mike Nichols, but I just didn't see anything I could do. Larry got the message. He said, "Say no more, forget the script, Mike and Buck Henry are rewriting it, and I'll get one over to you as soon as it's off the copy machine."

This script was better, but it didn't have much for me. Ann Bancroft was a terrific actress, and that was good, but the leading man was being brought out from New York to do his first film, and I had never heard of him. It's a bit tricky in a situation like this; one just can't tell the publicity department that their script is no good. I had done that once with Richard Zanuck and never heard from him again. In the end, I told them I would do a week or ten days to see what I could get.

I started with the rehearsals. The sets weren't even built yet, just an empty sound stage with the walls marked off on the floor in gaffer tape. Mike casually introduced me to the cast. I had photographed Ann Bancroft before, and Katharine Ross was breathtakingly beautiful. I knew I could get good photographs of her, no problem. Then there was Dustin Hoffman, a short fellow, who didn't look much like a leading man to me.

I thought back about the kid I used to babysit named Dusty, and I asked him, as we were shaking hands, if by chance his mother's name happened to be Lillian, and his dad's Harry. He looked at me very quizzically and said, "Yes." "Well, if that's true, then I used to babysit you and your brother Ronald on Orange Drive a hundred years ago!" An amazing coincidence.

The rehearsals started and Bancroft and Hoffman ran through the lines of one of the scenes. Mike listened, letting them do it their way, and when it was over, told them to do it again, but this time play it for laughs. That was when I could see just what a good director could do to transform a scene. He guided them and all of the time was making witty remarks that had the skeleton crew laughing, but he was taking the material in a completely different direction, and it was a very exciting thing to watch. (Paramount Studios, 1967.)

Lovely Katharine Ross, photographed at the rehearsals of The Graduate.

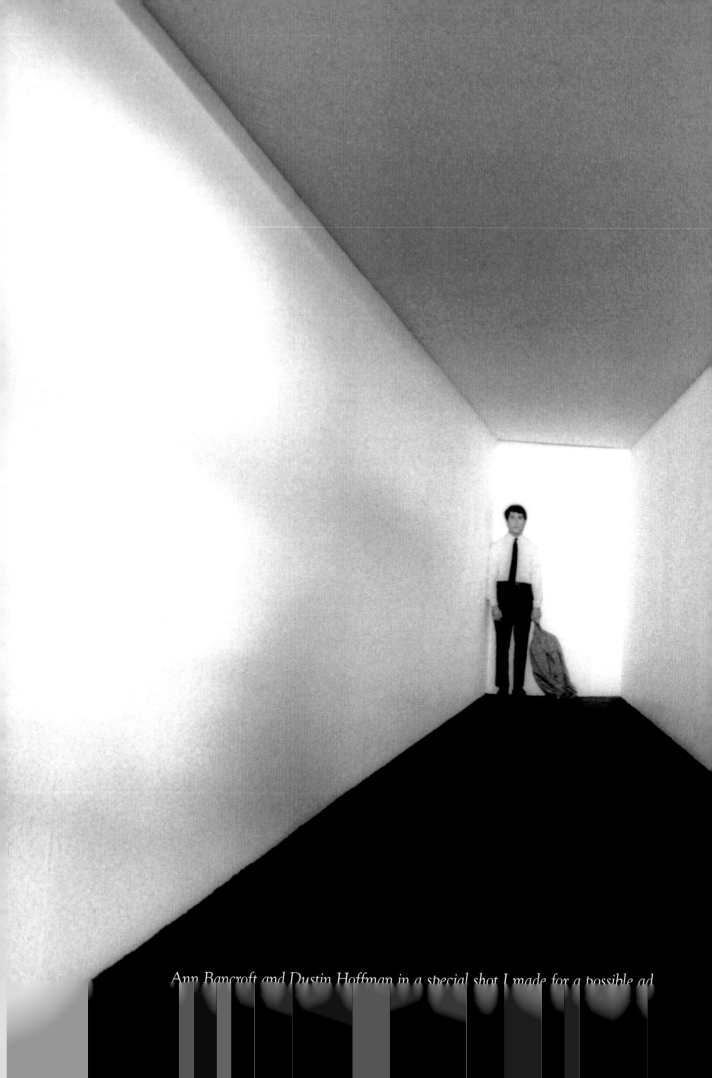

Ann Bancroft and Dustin Hoffman in a special shot I made for a possible ad.

I think I should explain a little of how I worked on various films at the same time. I would read the script, make a note of what I thought were visual possibilities for me, and then get the film production breakdown to see just when these scenes were scheduled.

I had a large corkboard in the office that was segmented into the days of the month. I used little cards of different colors to indicate the film or other assignments, as sometimes the scenes I wanted could come weeks apart. My secretary would call each morning to the various studios to see if the schedules had changed, and these cards would be moved around accordingly. Sometimes I was working on three or four different projects at the same time, and this was the only way I found I could keep track of them.

I had been working in San Francisco, on *Petulia*, and when I came back to Paramount, I found a lot of energy on the set. The crew and actors were up, and I asked cinematographer Bob Surtees what was happening. He said Mike Nichols had been asking him to do something with the camera that was a bit more offbeat, and he had countered with something even more off the wall. At this point in time, the studios were fairly conventional in the way they liked to see their productions appear on the screen—nicely lit, few shadows, and everyone looking beautiful.

Consequently, Bob Surtees rarely was given the opportunity to do much experimenting, but in this case Nichols was pushing him, and Bob was happy. It changed the look and character of the film completely from the script that I had read, and this seemed to generate a good feeling and, along with the fun that Mike Nichols and the cast were having with the script, kept the crew laughing.

Nichols and Buck Henry were adding material. Buck played the desk clerk at the hotel where Dustin was going to rent a room for his assignation with Mrs. Robinson. That wasn't in the original script, and I suppose it was like the material from Nichols' earlier comedy routines he and Elaine May would have done years before.

Katharine Ross and Dustin Hoffman escape from the church in the finale of The Graduate, *Paramount Studios, 1967.*

(Amerika cover) Of all of the many covers of Katharine Ross, I liked this one on the USIA's, America *magazine, printed for Russia, the best, 1967.*

When I finally saw the film, it was very different from the script I had read, and much much better. It was the only film I ever worked on that started out with a mediocre script and overcame that handicap.

The scenes at the church were exciting for me, as Ben (Dustin) battles his way out of the church with his lady in tow, and starts swinging a large cross. They were shooting with a hand held camera, which meant that I could use my motor drive, and really capture the sequence as it was being filmed. I was using a wide angle lens at the moment of the cross swinging, and it looked in my viewfinder for all the world that it was surely going to hit me, but I hung in there and I got a really terrific sequence as they fought their way out the door.

Something serious happened to Ann Bancroft at this location, that was never mentioned in the press afterwards. She completely collapsed, and I was amazed that there didn't seem to be anyone on that entire set who was going to do anything about it. I finally went to the pay phone in the church and called an ambulance. When they were taking her away, the assistant director (who should have been doing the phoning) cautioned me not to take any photographs. I reminded him I was working for the same people he was, and suppose something happened and they wanted these photographs for any reason, did he want to be responsible for them not being taken? So I did photograph the moment, and they still sit in my files, but I've always wondered what happened that day, as I had to fly off on another assignment.

Warner Brothers assigned me to photograph *Petulia* in San Francisco, and I was interested to have an opportunity to work with director Richard Lester, who had done the Beatles' films, which were great fun to watch with zany camera work.

When I arrived in San Francisco, armed with the script that I had expected to cover, there was nothing like that being filmed. In fact, it was so weird I couldn't figure out just what was happening. I asked Lester to clue me in, and he advised me not to read the script. This didn't help me in figuring out what might interest the magazines. I heard later that someone at Warner's had said that they had a perfectly good script which hadn't been touched, that they could film sometime in the future. (below) George C. Scott told me after one scene was completed that he wished he knew "what they were shooting!"

Julie Christie, on the location in Sausalito, California, 1967.

Lester had brought two cinematographers with him from London, and while I was there it was quite usual that he had two or, more often than not, three cameras rolling at the same time. No wonder George was confused. He didn't know which camera to play to, or if they were photographing him at all. In the end, I just documented what was going on, and went back to a fashion idea with Julie Christie.

She has fine bones, and she looked terrific in the little Paris dresses they provided for her, and this basically is what I concentrated on. She seemed private and withdrawn from everything, and so I didn't get to know her very well, but she was very agreeable to doing the fashion shooting, and we got more space on the film than I had any right to expect.

Dick Lester was a lot of fun, and plainly enjoyed me documenting whatever he was doing, always playing to the camera. I told him when I left for the last time that it had been a pleasure, but that some time in the future I hoped we could work on the same picture together. There were good actors in this film beside Christy and Scott, such as Richard Chamberlain and Shirley Knight (who I had photographed several times before), a sensitive actress with a delicate beauty who seemed on this film to always be on the verge of tears.

I've seen *Petulia* twice now, once recently, and I still can't figure out how the film gets a rave review from critics like Leonard Maltin, when it is a confused muddle.

Richard Chamberlain posing in front of Aubrey Beardsley drawings. Tony Walton was the art director on Petulia, *and his elegant taste made portraits like this easy to do.*
(facing page) A portrait of Julie Christie on location in San Francisco. 1967.

My old buddy Tom Ryan had now graduated, becoming a producer on his own after being Otto Preminger's assistant and co-producer for several years. He asked me to do some publicity on his first film, *The Heart Is a Lonely Hunter*, with a new young actress named Sondra Locke.

I flew to New York, where she was doing wardrobe tests, and luckily I got an assignment from *Look* right away. The photograph of her on the Staten Island ferry (above) is part of the New York shooting. I then went to Selma, Alabama, where she was filming with Alan Arkin, and continued working with her. The two of us got along very well, and I felt that I had done a good job for Tom. *Look* ran the pictures for several pages. We also got space in *Seventeen* magazine and several others. Sondra later had a romance with Clint Eastwood for many years, and appeared in several of his films. (1967.)

(above) My son David in full armor, tentatively feeding our neighbor's horse.

(right) The arrival of Jings, the boys' first dog (half Pulli and half Malamute) creates great excitement. 1967.

(right) Young Erica Petal, competing in the yearly horse show in nearby Will Rogers State Park, was too charming not to record.

Paramount Studios' publicity department telephoned, asking if I would come over and meet a new director who was doing his first film in Hollywood. I had never been asked to come over and meet a director before. Sometimes a studio might call about a new young actress, but never a director, so I was intrigued. When I arrived, I was ushered into one of the executive offices and introduced to Roman Polanski.

We smiled at each other, but no one had yet told me why I was called. What I did notice was that he looked younger than me. We sat down and discussed a variety of things, but never what I was doing there. In retrospect, I guess I was just being vetted by Roman, since a few days later Paramount called me to do *Rosemary's Baby.*

I started reading the script before dinner one night and, since I had just a few pages left, I took it to bed with me. Dorothy was already asleep, and when it was finished, I put the script down next to the bed, and put out the light—*Rosemary's Baby,* where the wife is raped by the devil! Well, the script just being in the same room with Dorothy gave me a decidedly uneasy feeling. I put on the light, got out of bed and put it outside in the hall, and closed the door. That was how strong I felt the imagery was just from reading the script!

I had broken the script down to see how many days I would be working, concentrating on what I could visualize would be the best days for me. The first day on the film, I realized that Roman sparked that set, and that every day was going to be visually exciting. Roman produced such energy that he swept the actors and crew up into a virtual whirlwind of activity. No lingering over each shot, he was whizzing along. As soon as they got a print, he was already at the next setup.

I could see he never made a master shot. What this means is that he would never shoot a scene with all of the actors included. This was the classic way a film was made, and the closeups were used to punch up the dialogue or dramatic moments. This created big problems for me, as individual shots of the actors in stills were little use in creating a story line.

While he could cut all of these individual shots together, I could not. It made me rethink the way I would approach this film. I asked him why he didn't seem to ever shoot a master, and he smiled that I had stumbled onto something. He confided to me that in not doing a master, it made it almost impossible for the studio to re-edit his picture. This was another first for Roman, something I had never encountered before, protecting his film from the studio before it was cut together. I now better understood my problem, and started to re-create the key point in the story line. So after Roman had made his shot, I did mine.

Some of the cast were people that I had seen on the screen as a boy, and some came from Broadway—Ralph Bellamy, Ruth Gordon, Sidney Blackmer, Patsy Kelly, Maurice Evans—and the stars, Mia Farrow and John Cassavetes, all made a terrific ensemble and all were marvelously professional. Roman knew exactly what he wanted, and I find actors respond very well to this in a director. So this was a great film to document. There was never ever a dull moment.

John Cassavetes was the most serious actor on the set. Every scene seemed pivotal to him. He was a director himself, and he went to great pains to understand everything that was going on, sometimes I felt to the extreme. Mia, on the other hand, was full of life and fun, and Roman was much the same. I could see John was often distracted by their high spirits, when I think he felt they should be concentrating on the movie instead of practicing "quick draws" with their toy cowboy guns and holsters.

When you have a downbeat film, the actors need this release, to laugh, to get rid of the oppressive feeling of the play. *Virginia Woolf* also had a lot of laughs, but nothing like the high jinks on this set!

Mia Farrow perched long-legged on a scaffold, the studio recreation of the Sistine Chapel above her. Rosemary's Baby, *1967.*

Ruth Gordon and John Cassavetes.
Rosemary's Baby, *Paramount
Studios, 1967.*

*(facing page) Color from the dream
sequence, where Rosemary (Mia
Farrow) thinks she dreams about a
naked witches' coven standing
around her bed, and then being
raped by the devil.*

For the dream sequence, I experimented with infrared color, basically not designed for tungsten lights, so I had to shoot many tests with different color-correction filters to find the right combination for the series you see here. I then added the defraction grating I had made as a young photographer, and I was really very excited by the result. Especially so since we had just sold the layout to *Look* magazine.

Just at that moment *Look* changed their art directors. Art directors being what they are, and not wanting to use anything that their predecessors did, took my hard earned images, and put a solid color overlay on them. To me this was a terrible disappointment, the studio was of course happy to get the space, but I was very bitter about it at the time.

Mia was seeing Frank Sinatra during the filming. I heard that he wanted her to leave this film, and come with him to Florida, where, I believe, he was filming. He had taken her to lunch this day, and had wined and dined her and Mia returned to the set full of the joys. She was like a giggling school girl, tipping over the assistant director's chair, climbing on top of the wardrobe. She was a panic, and of course I was clicking away. As she was being bundled off to her dressing room, she leaned in to me, giving me a most memorable parting line : "Older men always try to spoil me!"

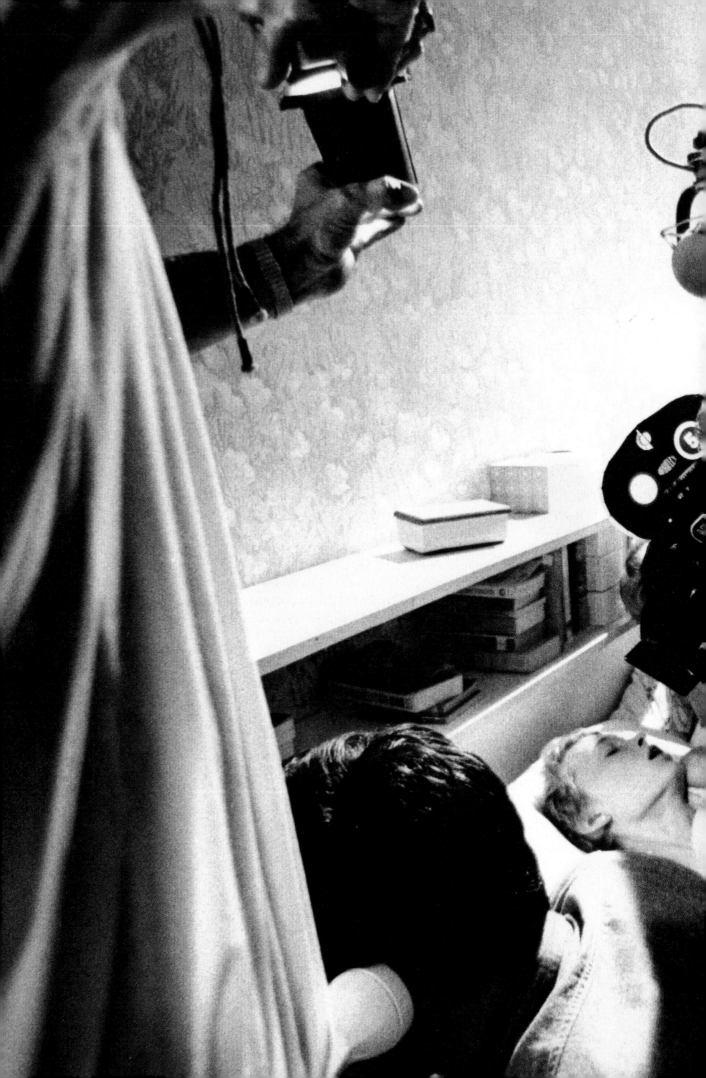

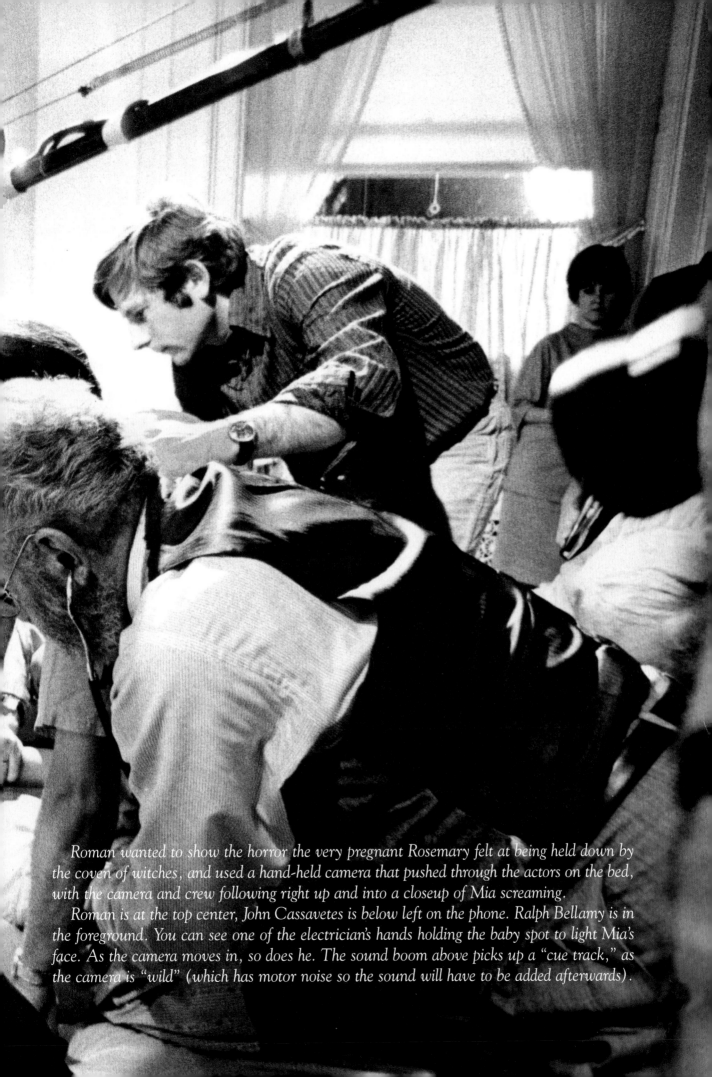

Roman wanted to show the horror the very pregnant Rosemary felt at being held down by the coven of witches, and used a hand-held camera that pushed through the actors on the bed, with the camera and crew following right up and into a closeup of Mia screaming.

Roman is at the top center, John Cassavetes is below left on the phone. Ralph Bellamy is in the foreground. You can see one of the electrician's hands holding the baby spot to light Mia's face. As the camera moves in, so does he. The sound boom above picks up a "cue track," as the camera is "wild" (which has motor noise so the sound will have to be added afterwards).

Because of the way Roman was filming, I had to restage many key story points. One shot I needed was Mia (as Rosemary), having taken some of the drugged chocolate mousse, feeling dizzy when she got into the kitchen. I wanted to convey the effect of the room spinning, and used a very wide-angle lens to distort the image. I noticed Roman and John standing over at the edge of the set smoking, and asked them if they could bring their smoke over where I needed it. I had two of the highest paid special effects people blowing smoke into the shot for my photograph (above, Paramount Studios, 1967).

Director Anthony Harvey watches Katharine Hepburn rehearse a scene for The Lion in Winter.

(facing page top) Peter O'Toole as Henry II. Katharine Hepburn as Eleanor of Aquitaine. France, 1967.

1967 had been an amazing year. I worked on six movies and did a CBS-TV special where they created a book of my pictures. *Mission Impossible* had asked me to come in and shoot pictures of Barbara Bain, as one of their segments needed a photographer, who was played by Anthony Zerbe.

I won the silver medal in the International Photography exhibit "Vom Gluck des Menschen" in Germany, my work was included in the International Exhibit at the Canadian Expo 67, "The Camera as Witness," and now I was being asked to work on my seventh film in Ireland and France: *The Lion in Winter.*

When I received the script from producer Martin Poll, written by James Goldman, I knew it was the best script I had ever read. With actors like Peter O'Toole and Katharine Hepburn, I thought what a fantastic film it would be. We were starting in Ireland, and since I was hired for the entire film, I brought all of the family so we would all be together for Christmas.

The director was a former film editor named Anthony Harvey, and it didn't take long to see that he was way out of his league with actors as strong as Hepburn and O'Toole. Martin Poll told me that they had another film planned for this period that fell through, and they patched this one together literally overnight. Douglas Slocombe, the cinematographer, had filmed all of those marvelous Ealing films with Alex Guinness, so we had a great combination on board.

The filming went well enough in Ireland. It was when we got to France that the locations seemed too difficult for the production people. We started in Mont Majour Abbey, just outside Arles. For some reason the director decided to shoot all of the interiors first, when the days were hot and sunny. It is an absolute rule on locations to shoot the exteriors first, and save the interiors for the rain or gloomy weather, so I could not understand what was going on. We emerged daily from the very interesting and ancient buildings the art department had restored temporarily, to eat our lunch and enjoy sitting in the sun.

Anthony Hopkins in his screen debut as Richard Coeur de Lion.
(facing page) Timothy Dalton as the young French King Philip.

When the interiors were finished, and with no further cover sets, it started to rain. I don't mean that it drizzled. It was torrential rain that washed away the sets the art department had so carefully built for the landing of Eleanor when she visits Henry. These were rebuilt further up the side of the bank, as the river was incredibly swollen, and these were washed away as well. Finally, they had to settle for her landing on a mud bank.

The rain continued, and I can remember spending a day playing the pinball machine with Bobby Penn, the very good English still photographer, in the local bistro. It was demoralizing for the crew to sit and wait out the rain, when they knew how the film should have been scheduled.

Hepburn took no prisoners when it came to dealing with O'Toole. His usual routine was for the production not to schedule him for a Monday, as he would "not be presentable." She would take none of that. She was professional and expected everyone working on the film to be the same. O'Toole was no exception. Obviously he wasn't used to having a sergeant major boss him around, and I think he loved it. They became great friends during the filming and would play practical jokes. In one scene, Katharine walked through the doorway of the castle with Len, one of the Lee electricians, instead of Peter. She was a tough, no-nonsense lady, and had the respect of everyone.

Peter O'Toole, faced with this new talent, warned the boys that he would act their pants off, and so there was a little competition going during the scenes which contributed to the character of the film. Tony Hopkins had this fantastic gift for mimicry. While we were waiting for sun, he would entertain us with all of the voices of the crew preparing for a take. The assistant director calling for quiet, Doug Slocombe looking up at the sun with his blue glass, and with his slight stammer telling everyone to stand by! It was amazing!

He was also Welsh, and could imitate Richard Burton's voice perfectly, even to the dialogue of Beckett that Burton had played with O'Toole. Peter knew that here was a force to reckon with, not that he didn't have his hands full already trying to keep Kate Hepburn off his back. Anthony Harvey muddled through, but with this cast and script, he literally just had to stand back and let the actors go.

Harvey really disliked the publicity man Bob Joseph, for reasons that Bob told me he could not understand. He forbade him to even come on the set when we were working, which wasn't ideal for gathering publicity ideas, to say the least. One day, I had an important message from New York, and Bob took his chance and sneaked into the cellar. He was talking quietly to me away from the shooting, when Harvey spied him, and rushed over and pushed down one of the tall flats that were part of the set on top of him! Only Bob's feelings were hurt, but it reveals a little of the director's character, or the pressure he felt on this film.

One of the locations was in Carcassonne near the Spanish border. It has a wonderfully restored defensive castle, with all of the ramparts intact. I called Dorothy to bring everyone down, and made arrangements in my hotel, as I knew the boys would love to see a real medieval castle.

One of the first shots there was with Tony Hopkins. He was in full armor, and seated on a horse, which he had told me he was frightened of. The fact is there was never any reason for him to be on that horse at all. It should have been a stunt man, since the visor was closed. The horse must have sensed Tony's fear, or was frightened by the lights... who knows, but it threw him to the ground, with a loud crash. It was a terrible moment, as I knew he could have been killed hitting his head like he did.

Tony only broke his arm, and the shooting was called off, with the word that if it rained the next day, they would pack up and return to the U.K., waiting until Tony's arm was healed to resume shooting. I was up at 6:00 AM and drew the hotel curtain to see if it was raining. It wasn't raining; it was snowing! I don't know how many years it had been since it snowed in Carcassonne, but this was really freakish weather.

The company did pack up, and I made a deal with the publicity department that I would stay on and finish the picture, and not charge them for my time during that period, as long as they would pay me the per diem, and they said okay. So Dorothy and I found a villa in Ste. Maxime, and we all had a lovely holiday for about four weeks, until I flew to London for the re-shoot in Wales.

When I got to London they were having an unseasonable heat wave, the press talking about frying an egg on the sidewalk, that sort of thing. We boarded a train for Wales, and I remember when we changed trains to get where we were going, the weather had gone coolish. By the time we made it to our destination, it was snowing again! I felt that if there was ever a location where someone up there was trying to get a message through, this was it.

The film was a critical success. Hepburn won the Oscar for her performance, as did Goldman for his script, both justified, but Peter was sadly passed over, as he would be time and time again. That was a bitter pill for him, I know, as I worked with him many times in the years to come. (France, 1967.)

Peter O'Toole as Henry II.

After shooting all day in Ireland, Katharine Hepburn and her secretary Ms. Goodbody would take their car and their folding bicycles up into the Wicklow mountains, and Kate would either go for a brisk mountain walk or a ride on her bike. This was used as the cover of Look magazine. The Lion in Winter, County Wicklow, Ireland, 1967.

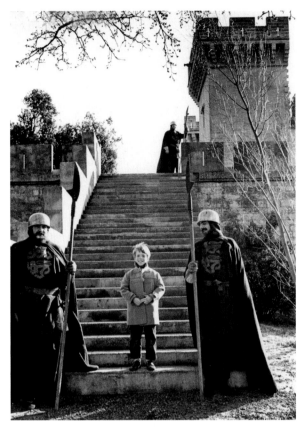

(above) Christopher standing with the guards on the film at Mont Majour Abbey. The family group was taken in St. Maxime in our "Villa Serenite" during our holiday while Anthony Hopkins' arm was mending.

(right) Catherine stepping out with Dorothy, back in our lovely home on Rivas Cayon, our son Christopher keeping in step with the parade. Pacific Palisades, 1968.

(facing page) The beautiful 12th-century architecture of the Mont Majour Abbey's tower and cloister was never really utilized as a background in the film, so I asked Katharine Hepburn to give me ten minutes (thank you, Danny Kaye!) at her lunch hour to let me do a portrait of her. Look used it in their layout of The Lion in Winter, France, 1967.

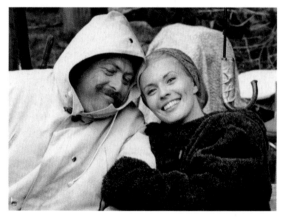

(top) On the location of Paint Your Wagon, near Baker, Oregon. Clint Eastwood would sneak away from the production whenever possible and have a quiet time to himself. Here he tries his hand at fly fishing.

(above) Dear friend Jean Seberg and I had a very happy reunion after many years. She was in good form and enjoying her life. The umbrella was for a light snow that graced this production too.

(facing page) Another old pal, Lee Marvin, photographed here with infrared color. Lee asked me to listen to his recording of I Talk to the Trees, which I liked very much, his gravelly voice giving it nice textures. He, too, was in great form, loving his part of the wild drinking prospector. Oregon, 1968.

(*above*) *Saying goodbye to the composer Alan Jay Lerner and the director Joshua Logan.*

(*facing page*) *Lee Marvin and Clint Eastwood on location for* Paint Your Wagon. *Baker, Oregon, 1968.*

I had been given a big assignment to cover the entire film of Goodbye Mr. Chips in London and eventually in Pompeii, with Peter O'Toole and Petula Clark (above).

I had enjoyed working with Lerner, since he and his famous partner Frederick Loewe had written some of my favorite music. We first met when I was working on My Fair Lady. In some ways, I hated to leave this location, since it offered visual areas I hadn't really explored. I was also leaving some good friends, but the assignment in Europe was too big to pass up.

Petula Clark played the part of a London theatrical queen, who is charmed by this serious professor, who eventually wins her heart.

(facing page) Petula Clark, Peter O'Toole and the boys at Sherborne School helped me create the ad that was used for the film. London, 1968.

Now, back in London with Peter O'Toole, I was amazed to discover that he had become a totally different person. From the fiery Henry II, in the last film, he now had the mild manners of a professor at an English school. This was not just when he was on camera, but it carried over into his everyday relationships with the rest of the cast and crew. He told me that he patterned the character he played after Sean O'Casey, the Irish writer. I assume he tried to maintain this gentle character off camera to keep the feeling for his on-camera work.

The only other time I've seen this happen was with James Mason, when he was playing Rommel. He used to sweep arrogantly into the 20th Century Fox commissary for lunch, still uniformed and acting as the general.

Peter O'Toole and Petula Clark in front of the beautiful ruins of Pasteum, Italy 1968.

Goodbye Mr. Chips was a remake of the original 1936 Robert Donat film, this time set to music. Herbert Ross, who I had worked with on several films when he was doing the choreography, was making his directorial debut. Interesting to note that *The Lion in Winter* was also Anthony Harvey's first film. Back to back, these were probably two of O'Toole's best roles, other than *Laurence of Arabia*.

Peter O'Toole's wife, the fine British actress Sian Phillips, was also cast in the film, and with singer Pet Clark, the four of us hit it off, and they all helped in getting the photographs I needed.

I shot a series of pictures that I hoped could be used as ads for the film and my agent sent them over to MGM in New York. When the film was completed, the studio held a press conference, and they told the press that this was the first time in MGM history that a still photographer had created an entire publicity campaign on his own.

The company was moving from England to the South of Italy with all of the equipment, and that meant I would have some free time there, so I sent for Dorothy and Christopher. We met in Paris, and then went to the island of Ischia, just off the Italian coast. Away from the cities, it was beautiful and unspoiled, and I could imagine, looking down at the sea from the hills above, that at any minute an ancient Greek Trireme would come sailing into the bay below.

It was when we got to the Pompeii location that I discovered how enthusiastic a collector Peter was of ancient art, so the two of us had many hours hunting down souvenirs. To be part of that wonderful historic site every day was such a pleasure. Dorothy and I had visited Pompeii in 1962, but working there was quite a different thing.

One night, Franco, who was one of the curators of antiquities, took a group of us—Peter, Pet, Johnny Jay, Dorothy, Christopher and me—to a restaurant near the side of the volcano Vesuvius. They had a local wine that was so volatile that they couldn't pull the cork in the normal way. There was a special bathtub-like container they let the wine explode into, then the waiters drew the sulfur-smelling wine off from a spigot at the base. It was very good, if one wasn't put off by the initial whiff of sulfur, in fact too good, and Johnny and I both fell asleep on the way home, when Peter and Pet Clark were happily singing in the back of the car. The next day, Peter complained to me that there had been a million dollars worth of talent singing to us, and we (the two stills men) fell fast asleep! Of course, I blamed it on the vino.

My agent had picked up a little film that was shooting in Venice, called *A Nice Girl Like Me*, that I did a few days after Dorothy and Christopher flew home.

Later I flew to Pet's new home in Switzerland, and did a picture story of the family, Pet, her husband Claude Woolf and their two lovely daughters. Pet told me that she was so frustrated that they didn't let her write the music for the film, and she played me a couple of things she had written. According to the reviews, it would have been a very good idea if Pet had written the music.

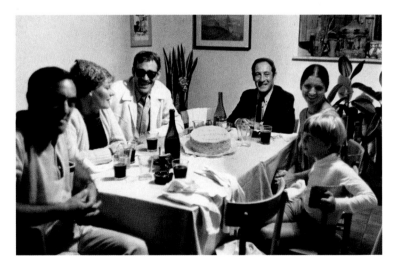

The evening with the wine from Vesuvius—Franco, Petula, Peter, Johnny Jay, Dorothy and Christopher. Franco had a cake made especially for the party. Vietri Sul Mare, Italy, 1968.

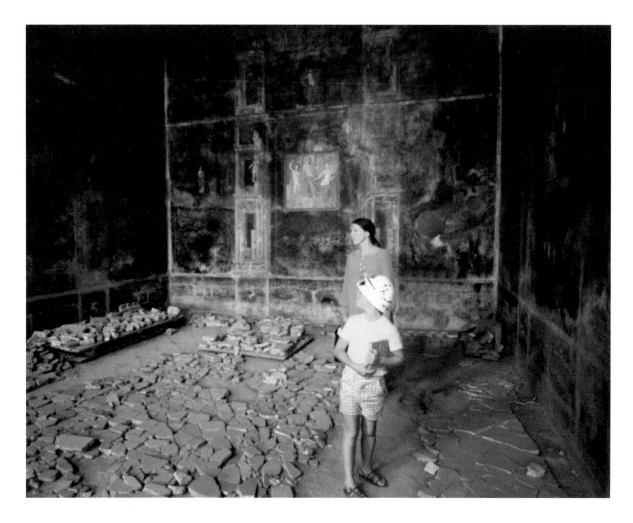

It was a wonderful bit of luck to have met some of the curators at Pompeii, since they allowed us into areas that were off limits to the public, like this villa (above) that was still under restoration. Coming from California with similar climatic conditions, it wasn't hard to picture oneself back in another time, and living in these villas. Such experiences for me serve as a conduit to the past, the same feeling I have from holding ancient artifacts.

The past can just be dry history that one reads about in a book, but to actually hold something made in another era can be like a touchstone that makes that time come alive to me. To be in touch with another era fills some sort of inner need for me. It's an ephemeral feeling, like an empty space in one's collective memory that perhaps too much time has elapsed to remember, but still may haunt one's dreams.

(facing page) Dorothy and Christopher looking down at the seaside Italian resort of Positano, along the Amalfi Coast. Italy is such a treasure trove of history, of beauty, of passing cultures. One sees it in the faces of the people and their way of life. As a parent, one hopes these trips will broaden the children's horizons, will interest them in reading about the places they have been. Life is all too short, and one must try and pass on all of the good things that one has discovered on one's journey to the next generation, if one is to be judged a success.

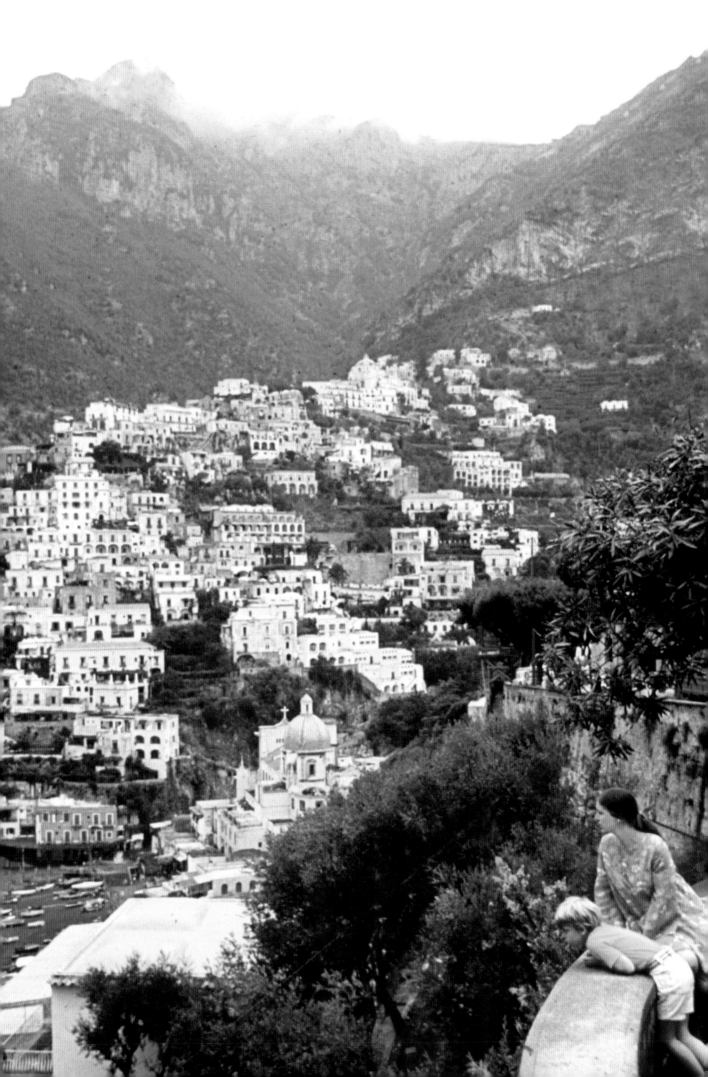

THE DAILY TELEGRAPH MAGAZINE

MIKE NICHOLS

...and how he filmed
Catch 22 with
Orson Welles and others

Number 244 June 13 1969

The filming of *Catch 22* took me to Guaymas, Mexico. It was to be my third film with director Mike Nichols. I had never faced any film with this scope before, and since I wasn't working the entire film, I had to try and re-create the scenes when I was there. For example, the scene with Paula Prentiss (Nurse Drucker) and Alan Arkin (Yosarrian), having their "flutter" on the beach (facing page). David Watkins was the cinematographer, and he only liked the light at certain times of the day. This gave me the time to re-shoot a lot of the scenes with the actors who were on call.

There was a marvelous cast, and I thought it would be an ideal *Life* magazine lead shot if we could get as large a group photograph as possible, since it was almost impossible to do the story line. I checked to see the one week that most of the actors would be available, and planned to shoot in what they referred to there as the "airplane graveyard." It was an ideal background, and to shoot what I had in mind meant I had to contact all of the crafts on the location, for lights, props and the special effects people were crucial.

I had set it for a Saturday, since Mike Nichols had told me that he only had a few pick-up shots to do that morning, and then he would release the cast to me, then at the end of the day I would catch the plane back to L.A., as I was due on another film the following Monday.

I had carefully watched the sunlight, and needed it to be at a certain time of day when the set would be dramatically lit. The time for my shot came, and Mike was still working. The light was moving, and my shot was becoming less and less ideal, and this was the one and only day I would have this many of the actors. I was now frantic after spending so many days setting all of this up. Hours later, after a leisurely lunch, the cast started trickling in, and I placed them in the various

places I had marked out. Finally Mike arrived, and I placed him in the front of the group, and just as I was getting ready to shoot, he said to me, "You know, Willoughby, if I don't like this shot, you can't use it!" and I knew he meant it.

I called to the special effects people to start their smoke machines. They had experimented for several mornings, getting just the effect I was looking for. So much so that when I drove my jeep back to the location, Orson Welles (my hero) called me over, and asked me if that was my production in the background. "Willoughby, you ruined one of my best takes!" Happily he was only giving me a rib. But now my production was for real.

No smoke! And I had a cast of thousands waiting for smoke. The smoke machines that we had tested over and over now weren't working. They sped off to their special effects truck in my jeep, and came back with some smoke bombs. You can imagine the state of my stomach. Nichols was kidding me about my production problems, and it was embarrassing, with so many actors poised for action. The smoke bombs were lit but the effect was less than great. Alan Arkin never looked at the camera once during the entire shoot. We didn't have Jon Voight that day, and so I used his stand-in, he looked so much like him, and with smoke no one knew.

I then had a second shot of the group for *Glamour* magazine, with the airplanes lined up behind them. That, too, suffered from the light not being ideal, but I shot it, and then packed up my gear, scrambled into a car and beat it down the road to the airport, making the plane by minutes. Mike did approve the pictures, and *Life* did use it as a lead shot, but I only wished it could have been what I had originally envisioned. (Guaymas, Mexico, 1969.)

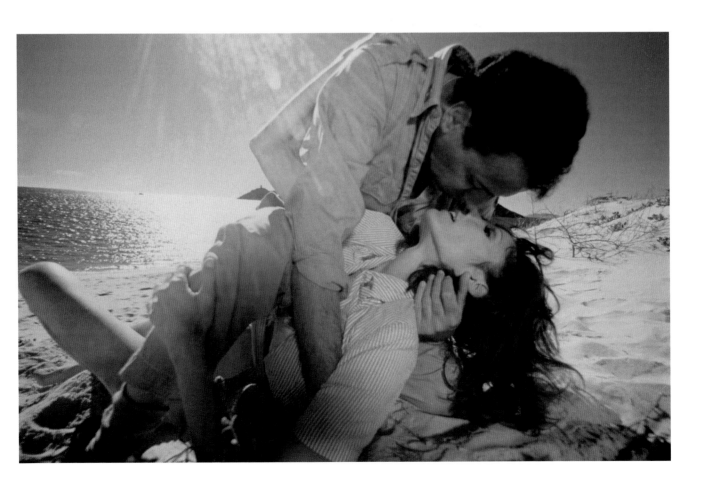

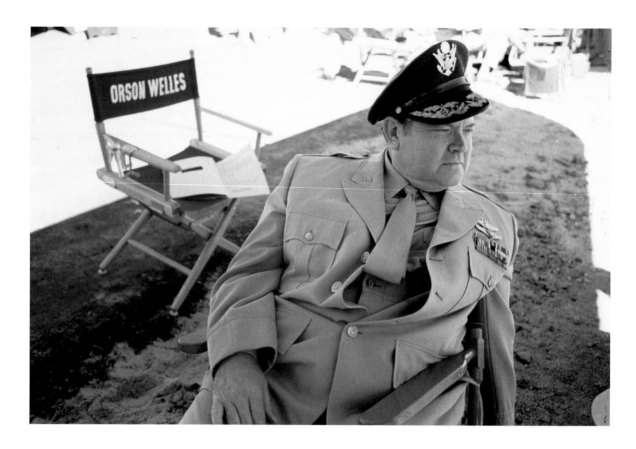

I went to see *Citizen Kane* over 20 times the last time it was shown in L.A. I thought that I knew it cut for cut. Yet there were so many things I wanted to ask Orson Welles, and so one day when we were sitting together in the shade of an airplane wing (above), I dared to broach the subject. "I suppose you're tired of discussing *Citizen Kane*," I said, testing the waters. "Yes, I am!" came his reply, and all of my questions were blown away with those three words. I have regretted asking him in such a negative way ever since. (1969.)

The ad I devised for the film was originally photographed on Alan Arkin's chest, and then I later re-did it for the ad agency with a model in the Pacific Palisades. 1969.

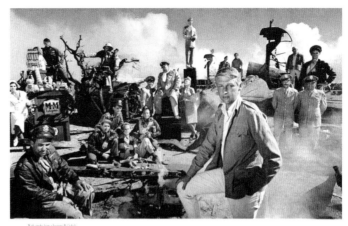

The frantic filming
of a crazy classic

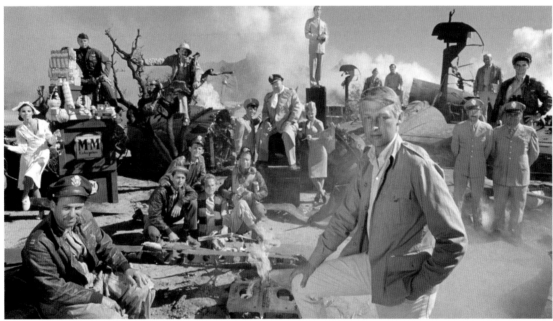

(top right) The lead shot from *Life* magazine spread. (top left) The group shot for *Glamour* magazine, showing the second setup that day, of stomach churning intensity. 1969.

The space we achieved on *Catch 22* was phenomenal. Everything one saw from the film in the magazines was mine: *Life, Look, Time, Newsweek, Glamour, Seventeen, Pageant, Show* and *The New York Times.* It was terrific!

The film, on the other hand, was less than a critical success, and someone told me that Mike Nichols had blamed the failure of the film on the fact that there was too much publicity! A poor excuse for a film that, I could have told anyone who would care to listen, was doomed to failure. It was a black comedy, and like *LUV* failed to translate from the stage because of the reality created by the camera's eye; the same thing applies to Joseph Heller's best-selling book.

You cannot show bombs falling on your own servicemen in a film and think that it's ever going to be funny. There were a lot of very clever people working on this film, and at great cost, even to the second-unit director's life, but no one understood the basic truth: that cinema makes even make-believe things believably real to film goers. (Guaymas, Mexico 1969.)

Part of the Look *magazine layout, Mexico, 1969.*

The cinematographer David Watkins wanted all of the B-25s to take off at the same time, for the dramatic look in the camera. The real problem was that all of these planes had been stripped down for other uses, and were easily rocked in the air by the prop wash of the preceding plane. Originally designed to carry heavy armament and men, the aircraft now were too light, and consequently very unstable.

The cast and crew knew this from experience , and when the planes were landing or taking off in a group like the photograph above, they would all run up to a place that was quaintly known as "chicken-shit hill," as far away from the runway as possible. I wanted to get the shot myself, and locked down two motorized cameras at the end of the runway, one with a long focal length shooting towards the planes taking off (as above) and another extreme wide angle pointing up as the planes flew over.

Jack Geraghty, the studio's still man, didn't have radio controls, and we were stringing cables out so he too could shoot from a safe vantage point as the planes were taking off.

Jack yelled frantically to me to hit the dirt, which I did, and a lopsided B-25's wing came right over my head. I could feel the air sizzle. As I was starting to stand, spitting dirt, Jack was screaming, "Look out, here comes another one!" Down I went into the dirt, and by this time the entire wing was in the air. Fortunately, I had kept my hand on the transmitter button, and got the pictures, but I never saw any of the planes take off.

When I went up with the wing to photograph (you can see how the rear gunner's section had been removed for the camera plane in the picture on the bottom of the facing page), I tried to crawl back to that section with my Mae West and parachute on. While I was crawling back, dragging my cameras along, the jacket caught on the fuselage and with a whoosh became inflated, sticking me in this narrow passage. It seems funny now, but then I had to fight my way back to the main body and take them both off, and then make my way back to the open tail.

Even though I had removed my parachute and Mae West, it still wasn't easy to crawl back to the rear gunner's (now empty) position, trying to drag some of the camera equipment, and keeping my earphones and mike (to be in contact with the pilot) from getting tangled. I could see just how vulnerable the rear gunner would have been, way out on his own and so exposed. I don't know how those young men did this day after day. How brave they all were!

The tail, now being very light, was literally wagging when it caught any of the prop wash from this newly devised air wing. (They were rounded up from use as crop dusters and private collections).

The second unit director at that time was Andrew Marton, who was a director in his own right, but did second unit on a number of important films. He had come to lecture at USC Cinema Department when I was there. When he finished his run with the air wing, he kindly turned it over to me, so I could get some shots, as you can see on the facing page. Trying to keep the camera steady, when the tail was moving up and down, could make a person seasick, and finally I had to give up trying to use my long zoom lens completely. Anytime the camera plane would get in the propwash of the air wing, it would bounce all over. The plane was never designed to fly with so little weight, so it was basically unstable in any sort of turbulence. I was glad to finally get down, but it was rather exciting at the time, controlling all of those planes.

It was now our son Stephen's turn for a holiday, and Dorothy brought him to visit me in Guaymas. He caught several fish (above), and Dorothy and Stephen played golf together (using one ball). It was lovely to come back to the hotel after work, and receive a nice welcome from part of my family. Mexico, 1969.

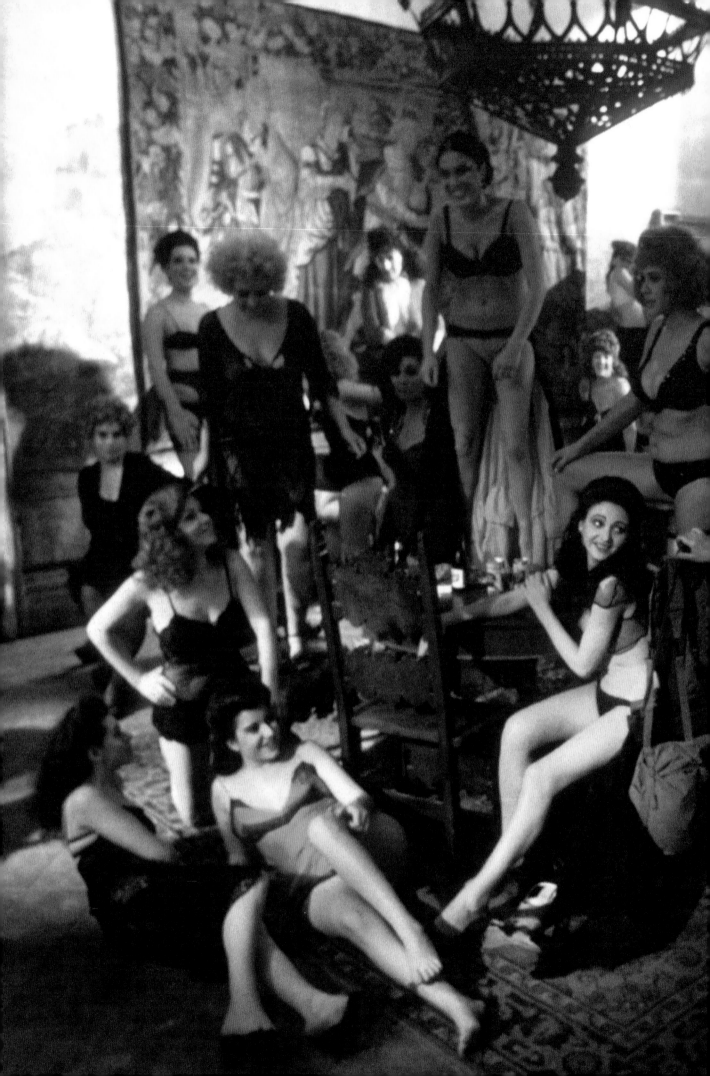

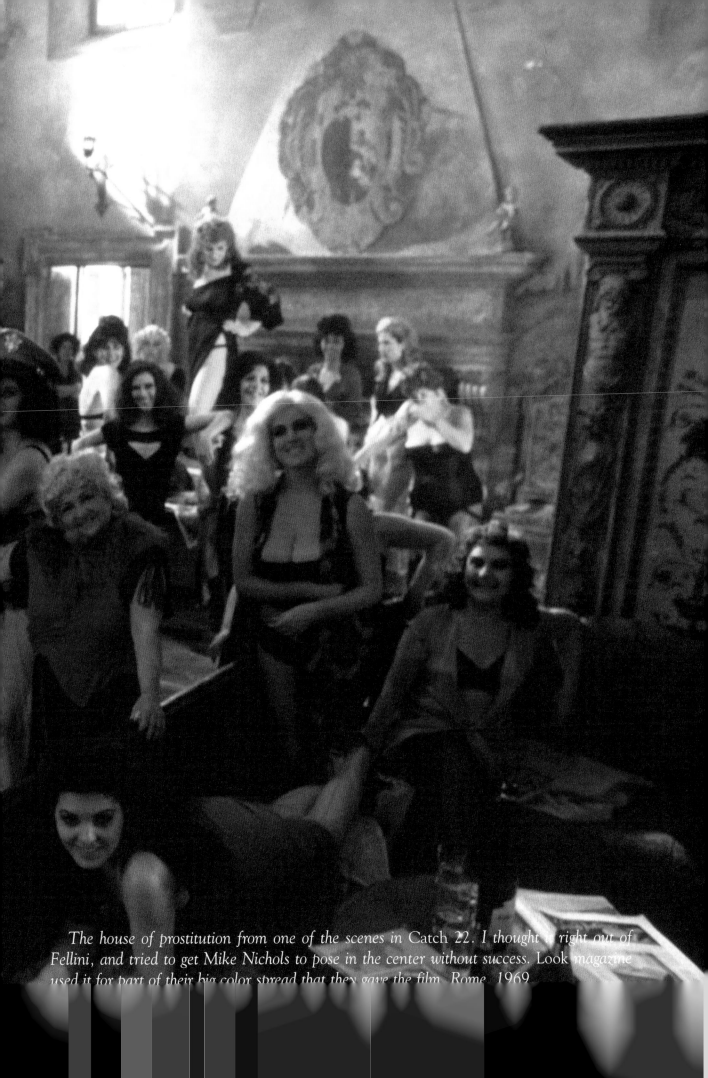

The house of prostitution from one of the scenes in Catch 22. I thought it right out of
Fellini, and tried to get Mike Nichols to pose in the center without success. Look magazine
used it for part of their big color spread that they gave the film. Rome, 1969

I picked up the Rome location of *Catch 22* after I had finished *They Shoot Horses, Don't They?*. I had been many weeks out of touch with the film, and while there were a few of the original key personnel in Rome, it was basically a new crew, and it takes time to get to know them. I always feel it takes me about a week to catch their rhythm, to be able to work easily with them.

One day, Mike Nichols and the assistant director Clive Reeves came over to me, and started asking me about the time I had been photographing in the back of the camera plane, when we were in Guaymas. They said that I was really the only one who knew what it was like. I told them how bumpy it had been, especially when caught in the prop wash of the flight, but I couldn't guess why they were questioning me at this point.

Then they told me that their new second unit director, who was working with the air wing in Mexico, had gone to the back of the tail to take a Polaroid to send to them in Rome, and had been bounced out without a parachute, falling to his death! I described how it was impossible to crawl back through the fuselage and wear a parachute. They nodded, and walked away. That was it. They went back to filming, as if nothing had happened. I just stood there, aghast.

Frankly, I don't know what I expected them to do, but at the time I thought what a bunch of insensitive louts. What was I doing up there risking my neck? Not for these people, for sure. That day, I went over to the Ferrari dealer in Rome, and discovered a six-month-old silver Maserati. I made arrangements with the studio to buy it for me. As I was going on to Ireland to work on *Ryan's Daughter* for MGM and Life, I asked if they could deliver it to me there. (Rome, 1969.)

These were late night shoots in Trastevere in Rome, and the gaffer, Earl Gilbert (who went to high school with me), had worked hard the entire day with his Italian crew setting up the lights for this night shot. When cinematographer David Watkins came on the set, he told Earl it was all wrong, and would have to be changed. I think Earl would have cried if I hadn't been there. David shut all of the key lights down, and when I went to measure it, I couldn't get a reading that I could use. I was standing next to the film editor Sam O'Steen and told him that I couldn't see how Watkins could shoot. The next day Sam told me, after seeing the rushes, that I was 100% right.

I was sitting waiting for action (below) and a young lady said, "Bob, do you remember me? I went to Hamilton High School with you!" It was one of the women extras hired to play a prostitute in the film, who now lived in Rome. I didn't remember her, but it was amazing to think that there were three of us that night in Rome, working on the same film, from the same high school in California. (facing page) Jon Voight as Lt. Milo Minderbender, riding through Rome every bit like a German general leading his troops. This is also from the *Look* layout. (*Catch 22*, 1969.)

ABC Pictures Corp. presents
A Palomar Pictures—Char-Wink Production

"They Shoot Horses, Don't They?"

Bruce Dern and Bonnie Bedalia (center) force their way through the group. Michael Sarazzan and Susannah York are on the left.

(preceding pages) Sydney Pollack standing on the empty set before filming began. One of my images used for the Academy Award ads for ABC.

They Shoot Horses, Don't They? (set in the Depression era, and centered around the degrading spectacle of the dance marathons) was surely the most satisfying film I have ever worked on, thanks largely to the director Sydney Pollack. Here, I was able for the first time to work on a film to my full potential. Not only did I have my radio-controlled cameras in peak form, I now had the first sound blimp that Irving Jacobsen had been working on for me, and I was able to put it to really good use.

The film was physically difficult not only for the actors, because the set often was used as a race track for the sprints, and everything in the set was seen, which meant there was no place for a still photographer to hide. Without my special equipment, it would have been impossible to cover this film, and without

Sydney's great assistance (he would wait for me to be sure my cameras were ready before he rolled his camera, which was unprecedented), I never would have gotten such electric material.

When I read the script, I just didn't believe the audience would buy that Robert (Michael Sarazzan), even in his tired and dazed state, would actually pull the trigger and shoot Gloria (Jane Fonda). Under the beginning film titles, Robert is taken out as a boy, and his father shoots his pet horse. I suggested to Sydney that if they would show the horse when it was shot, start the fall in dreamlike slow motion, with overlapping cuts, extending the time of the fall, never allowing the horse to actually hit the ground, it could be applied to the ending to help make sense of Gloria's death to the audience.

So at the end of the film, as Robert shoots the gun, he would see the horse continue its fall, still in its dreamlike motion, and not see it was Gloria falling. When this shot is about to end, it is actually Gloria that hits the pavement, and back to the reality of the story line. If the audience was given the feeling that in his tired mind he wasn't shooting Gloria, then the ending could be more credible.

Sydney, to give him credit, did actually shoot the opening, but he said ABC, who were producing the film, didn't buy the ending. Too bad, for what they did use didn't work for me. (Warner Brothers Studios, 1969.)

I have never seen a film that took so much out of the actors. Not only was it a daily physical grind, but the very character of the film, with the Depression era exploitation of people who were lured into participating in these dance marathons with the faint hope of making some money, was not very uplifting to play day after day.

Sydney Pollack was a dynamo himself, putting on roller skates and taking the hand-held camera, following the actors into bumps and spills, rolling on the ground with the camera as they fell. The actors could see he was not asking them to do things he wouldn't do.

A double page from part of Life *magazine's coverage of the film.*

In these sprints (above), I would sometimes try to hide my camera in the bunting along the stands, and asked Sydney's permission for the actors to start their action at the point my camera was covering. He was always agreeable. Then I went to Bruce Dern, who was also just great in help-ing me, and showed him where my cameras were, and explained what I needed, and there was never a problem with him, or in fact anyone working on the set. Actors in films are trained to hit their marks, and Bruce did it for me, and I was able to get an image like the one above.

The grips were hauling the camera operator, Duke Callahan, around the 360-degree track on a little wheeled wagon. Duke was holding the camera in his hand, and so I mounted my radio-controlled motor drive on the side of the wagon with special brackets, and the terrific grips who were pulling the wagon around the track would aim my camera at the actors.

It was a dream. I could stand up in the stands out of range of the filming and trigger the cam-era at the exciting moments. I've never had such wonderful cooperation before or after.

(facing page and above) Gloria (Jane Fonda) notices that Sailor (Red Buttons) is failing, as they go into the final sprint. She knows he's not well, but has no idea he is having a heart seizure and will be dead by the end of the race.

Now that I had my new soundproof blimp, whenever one of the actors asked that the eye lines be cleared, I could leave the blimp (with my camera inside) on a tripod or bracket next to the movie camera, and move off at a distance, getting pictures during the dramatic takes that would never have been possible before.

I had a contract with Jacobsen that no one else could get another blimp for a year. It later became an industry standard. I still have the original one, stored in Ireland, but in 1969 it was unique.

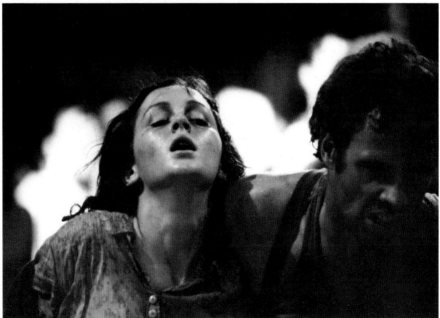

Bonnie Bedalia (who is pregnant) grimaces in pain as her husband, played by Bruce Dern, drives on determined to win at all costs.

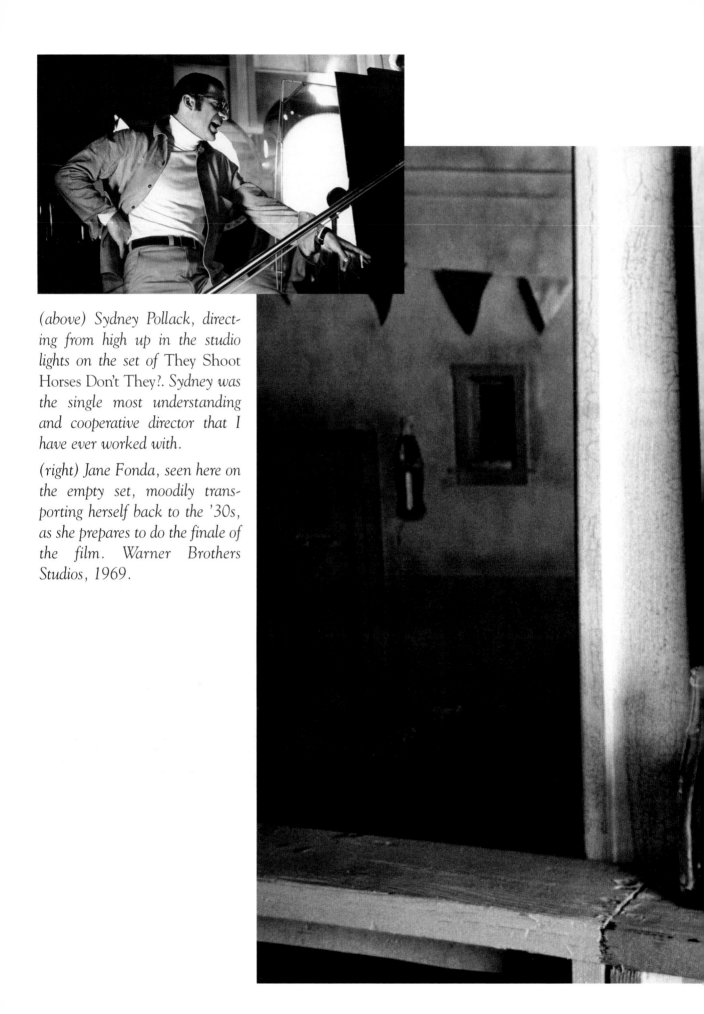

(above) Sydney Pollack, direct-ing from high up in the studio lights on the set of They Shoot Horses Don't They?. Sydney was the single most understanding and cooperative director that I have ever worked with.

(right) Jane Fonda, seen here on the empty set, moodily trans-porting herself back to the '30s, as she prepares to do the finale of the film. Warner Brothers Studios, 1969.

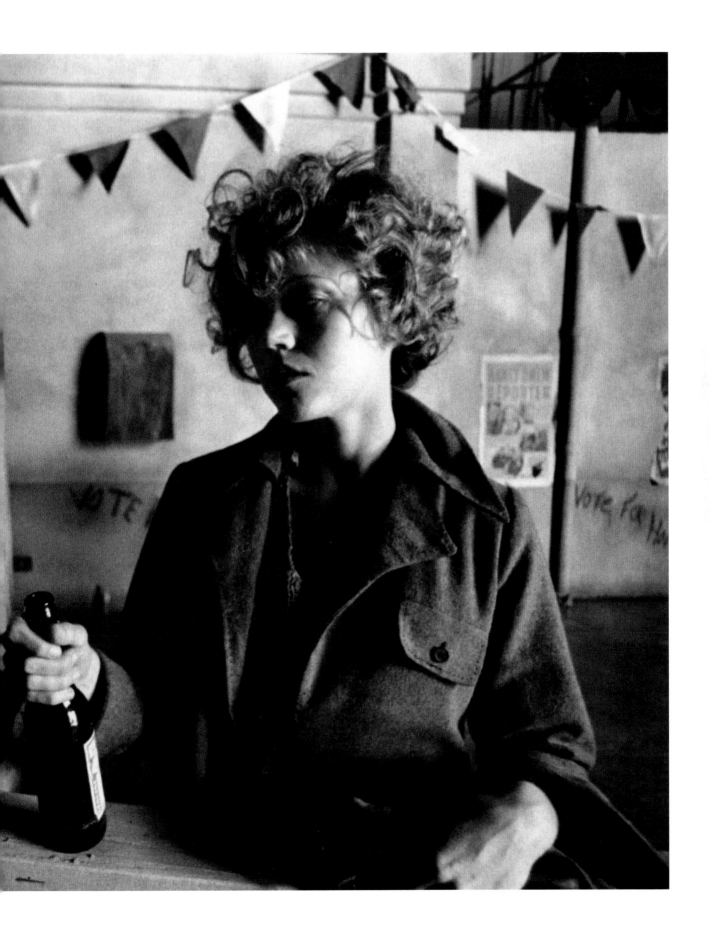

After completing *Catch 22* in Rome, I met my family in Ireland, and we rented a nice little house in Tralee with the help of my old friend John Caball. This was fairly central in Ireland and allowed me to not only drive to Dunquin on *Ryan's Daughter*, but now I had another little assignment from MGM to shoot on a film then called *Country Dance*, with Peter O'Toole and Susanna York, which was filming in Dublin. The Maserati was delivered to me in Tralee, and even though I had been driving sports cars for some years, it took me about two weeks to begin to really "hear" the car.

Driving over Connor's Pass early in the morning with that car was an adventure. (The Italians must have the smallest feet in the world. I had to learn a way to fit my shoe on the accelerator.) The first day on the *Ryan's Daughter* set, the assistant director came over to me, and asked if that was my car with the Rome license plates. I thought he wanted me to move it because it was in the shot. No, I was the only one asked because director David Lean also had Rome license plates on his Rolls, and didn't want my car anywhere near his!

That should have been some sort of clue to what I was getting into on this film. I had an assignment from *Life* to photograph Christopher Jones. He was a nice young man (he had a silver Ferrari, so we had something in common, but luckily he didn't have Rome license plates!). On the interiors, I found it almost impossible to get in to shoot him on the set. I can remember sitting outside for hours in the cold and rain with MGM's still photographer Ken Bray, the two of us waiting to be allowed into the set, after all of the shooting was finished.

Neither of us had seen what Lean was doing, nor were we able to shoot any candids of them at work, which is what I would have needed for the *Life* story. It was just impossible. I had read the script, and knew the action. I shot what I could, with the help of the actors, but it was no more than something a set photographer might have done in the '30s or '40s. It was certainly not the way I worked.

The exteriors were a bit easier, though one day I recall photographing the big Chapman camera crane in a field of bluebells as the actors were rehearsing. Lean came over to me, and asked what I was photographing. I thought that a bit strange, but told him I felt the juxtaposition of this large piece of movie equipment in this beautiful flowered dell was an interesting image. What I realized later is he was really asking me why was I wasn't taking photographs of what he was filming.

The two of us were not in sync. On another day in this same flowered area, he was striding around followed by his camera crew, looking for a place to put his camera. I had already staked out the angle I felt was good. He kept wandering around, and I was just standing there watching. I caught his eye, and just made a gesture with my hands, like a movie frame, indicating here was a good spot. Well, I quickly realized I had really screwed up. He looked at me with such anger. I obviously had committed the cardinal sin of suggesting anything to this tin God.

He walked away. It was about 11:00 AM, and the assistant director immediately called lunch, the company broke, and I knew I had upset the master. When we came back from lunch, the motion picture camera was in exactly the spot that I had indicated, but Lean never spoke to me again. I was used to a lot of difficult people in my work, but he was just off the wall.

I thought, here is a man who has gotten to the egocentric point of not being able to accept an idea or suggestion from anyone. It's his film and it has to be his idea, and he's standing out there all alone. The problem is if he doesn't know what to do at times, he's unable to ask advice, and is the loser. I thought at one point that problem would be the basis of a good movie.

I called *Life* in New York, and told them the assignment wasn't going to work out. They suggested that I take Christopher to London, and take him shopping and see if I could get a story on him there, which we did, but it never ran.

Director David Lean on the set of Ryan's Daughter, *Dingle Peninsula,*
County Kerry, Ireland, 1969.

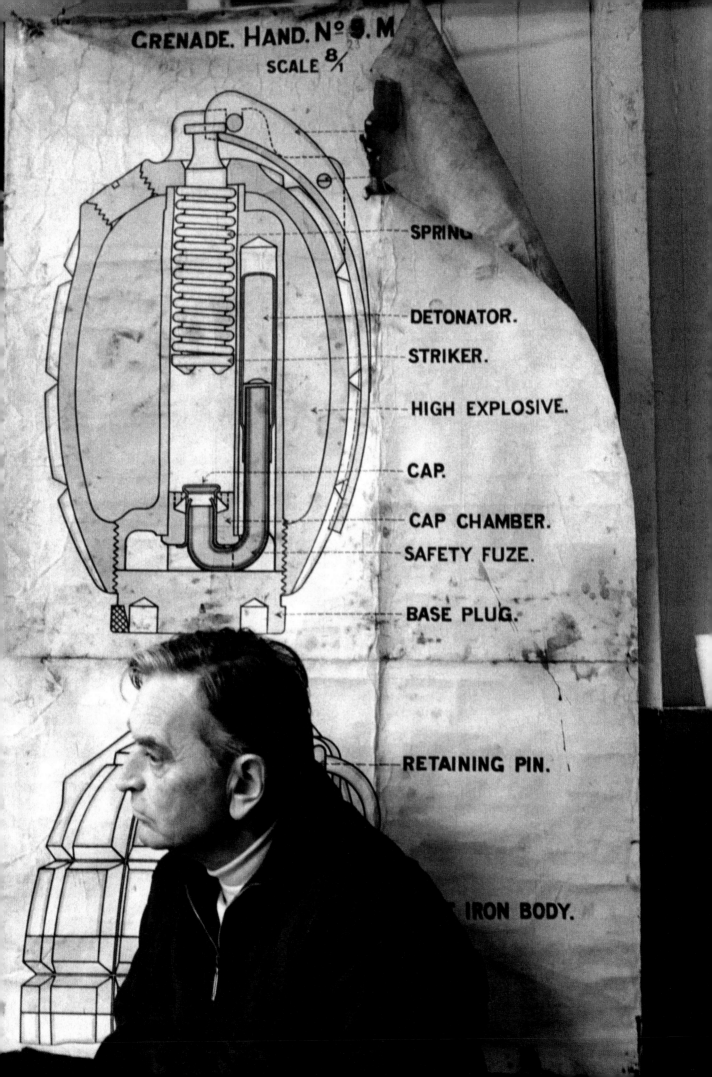

The photograph on the facing page I thought would be a great ad for the MGM film *Country Dance* with Peter O'Toole, Susannah York and Michael Craig (above left, shooting from a different angle). When the film was about to be released, they changed the title to *Brotherly Love*, so this photograph was never used. The film wasn't very good, but we did have a great time, especially when the company moved from Ireland to Scotland. They put us up in the beautiful Gleneagles Hotel in Auchterarder, with their famous velvet-like golf course.

We watched the men in the early morning, spreading the dew on these greens with long bamboo poles (hard to believe, but true). One of the great treats for me was that they served some of the most spectacular food I've ever had the pleasure of eating!

On the last night of filming, they had a party for the cast and crew, but I wasn't going to miss one of those gourmet dinners for crisps. So Dorothy and I stayed in the dining room enjoying their culinary delights. O'Toole kept sending people in to hurry us along, and when we did arrive at the party, they started the dancing (above right).

Dorothy, who is a great dancer, was right in her element. We danced for hours to the Scottish music, and God knows what time we finally found our room. I was told the next morning that Peter led some of the hardier crew out in search of more drink after the hotel bar closed down. (Auchterarder, Scotland, 1969.)

(facing page) Our Catherine at Fenit Beach discovers a ladybug on her shoulder.

(top) A wonderful Fourth of July party we threw at our place for some of our friends on the crew of Ryan's Daughter. Left to right: Joan Sillick, Ken Bray, Jane Terrell, Bayley Sillick, Dorothy, Alicia de Beilefeld (who was visiting us), Mike Brown, Belinda McPherson, Bob Howard and Susan Pierres. That night going home over the Conner Pass, the Volkswagen got stuck in a ditch, and some of the kids had to stay in the car all night. When I came back on the set the following Monday, the assistant director Bob Howard said it was one of the greatest nights of his life. (Tralee, Ireland, 1969.)

(bottom left) The return to the famous Kruger's pub, where I stayed in 1957 without electric lights or water to shower. Seen here with the man himself, Kruger Cavanagh, and MGM stills man Ken Bray.

(bottom right) A family outing to Parknasilla Hotel in the Ring of Kerry for a lovely afternoon. We discovered that the Maserati Mistral was not really designed to carry six people.

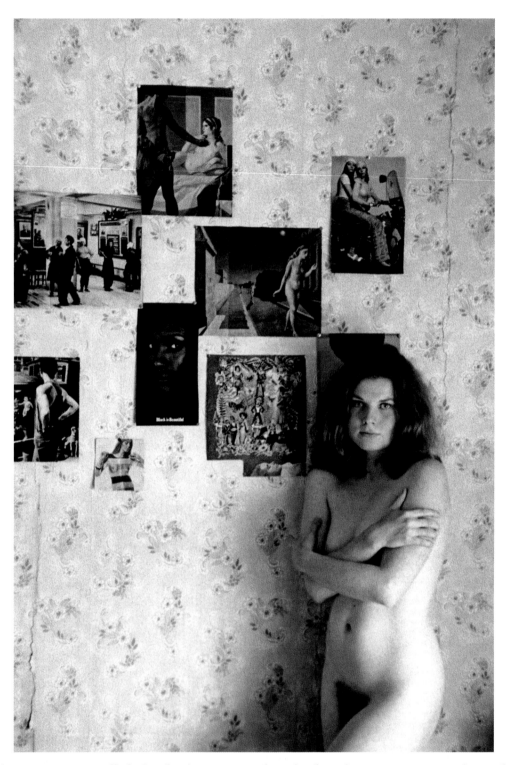

When I saw Joan Sillick for the first time, I thought that there was a mystic force about her, reminding me of the power some of the ancient idols from the Middle East seem to impart. Photographed in her home in Ballyferriter, Ireland, 1969.

The family and I packed up and headed back to Los Angeles, but I was very quickly back to France to work on *The Lady in the Car with Glasses and a Gun*, an Anatole Litvak film with Samantha Eggar, Oliver Reed and John McEnery. (facing page) Oliver Reed had a brooding intensity that I felt at any moment would pour over the top. I guess this happened to him often enough, for when I worked with him he had a "minder" with him all of the time. (St. Tropez, France, 1969.)

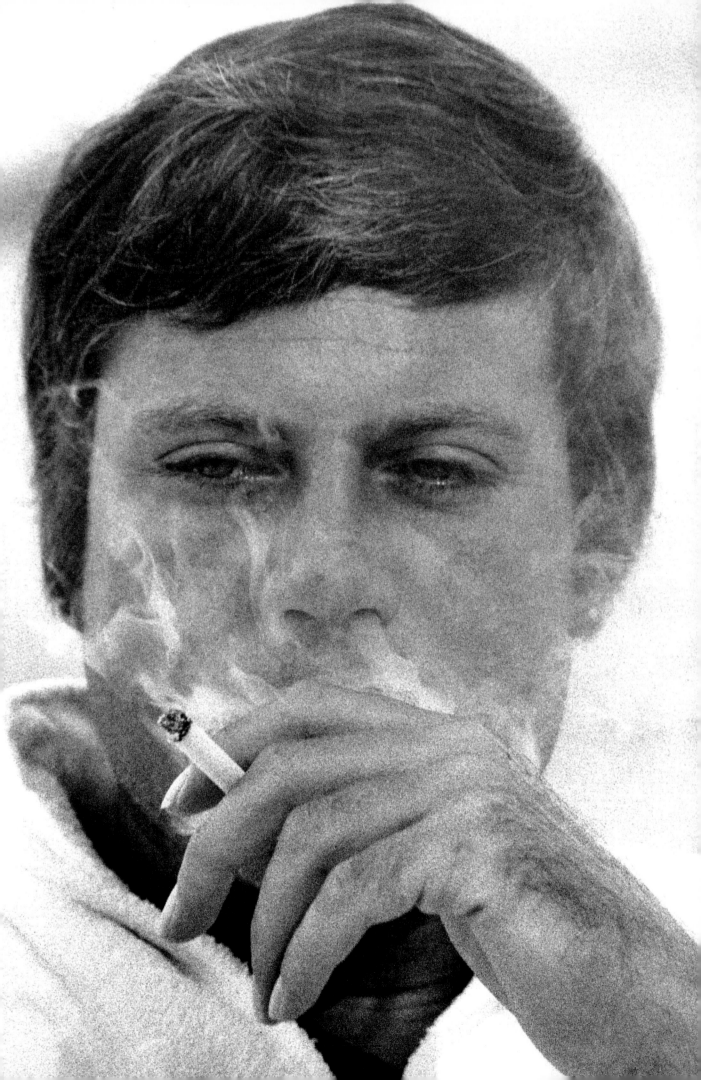

BLOW-UP, 1970

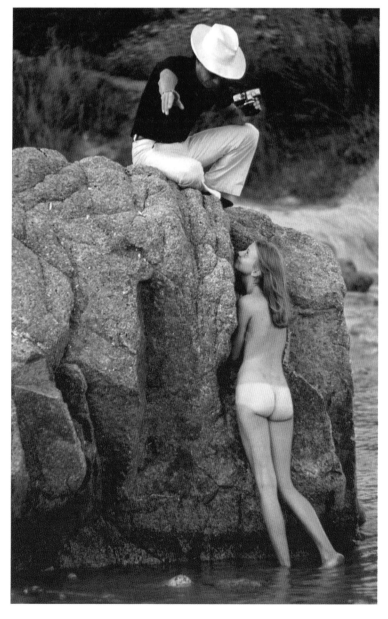

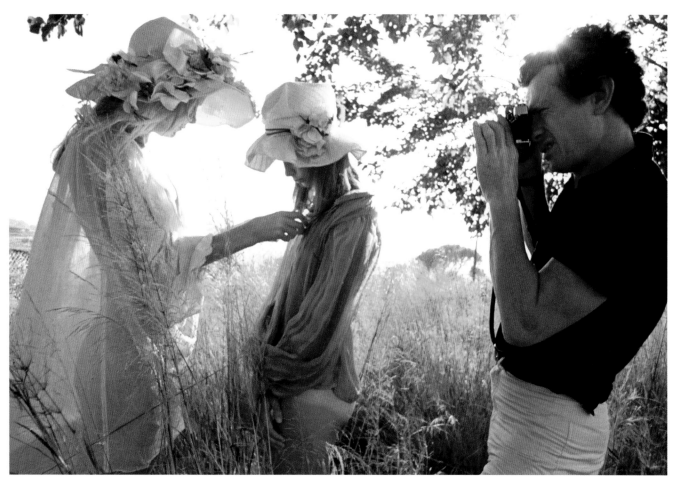

*Ewa Sinnerstad and Irja Eckerbrant pose in the late afternoon sun
for David Hamilton, 1969.*

While working on the Litvak film, we stayed with Dorothy at my favorite little hotel in Ste. Maxime, La Belle Aurore. One night we were having dinner, when David Hamilton walked in. I had known him when he was the art director of *Queen* magazine in London, and now he was famous for his books of photographs of beautiful young Swedish girls. He had a house in the old Saracen village of Ramatuelle, above St. Tropez, and these two lovely girls Irja and Ewa were in residence.

I suggested that I do a picture story on his life style, and so a few days later I drove up to his place, and followed him around for a few hours, and came away with some images of his way of life—sunshine and beautiful girls. Not too shabby, Mr. Hamilton! (Ramatuelle, France, 1969.)

February 1970 / 50 cents

McCall's

Woman of the Year / Katharine Hepburn

THE PRIVATE WOMAN

The Private Kate:
Sort of a Love Letter to
Katharine Hepburn and
Spencer Tracy
by Garson Kanin

The Death of Privacy
by Ramsey Clark

My Own Fight
with Cancer
by Marguerite Piazza

In Private Hands:
A Magnificent
10-page Needlework
Section

Last Fiction from
Edwin O'Connor

For the second time in my professional life, a magazine in New York had asked me to fly back to do a cover. This time, *Newsweek* asked me to photograph Kate Hepburn. I remember waking early, my adrenaline pumping in my New York hotel room, going over in my mind how I was going to shoot this cover. It turned out it was no problem. Behind her New York townhouse, there is a communal garden completely surrounded by the houses. The only access is through someone's house.

From the street, you would never know the large park-like gardens existed. Kate was in her usual form. I always think of her as a sergeant-major. We went into the garden and took what I thought were really nice images. When they were processed, Lee Gross, my agent, took them up to *Newsweek*, and the two of us were meeting there later in the day. While we were waiting to see the art director, I looked at about a hundred covers they had framed all over the top of the art department walls. I was thinking to myself how tacky they were, when the art director buzzed us in. The first thing he said to me is that he didn't think we had the cover, and that I would have to go back and reshoot.

Well, I knew we had good images of Kate, and I wasn't going back to reshoot. I told him this, but he said he would like to have "other things to select from." I knew what Kate's reaction to this "need for a greater selection" would be. There was nothing wrong with the pictures, so I suggested that he call her, and tell her, and I started to scrape off the piles of my color on the desk.

He screamed at me, "What are you doing?" I told him if he didn't think he had it, then he better get someone else to shoot the job. This is the only time I've ever had a set-to with an art director, though at times I would have liked to have strangled several of them for what they did to my work. Lee, who had to deal with this man in the future, was jumping in between us, as I was really angry at this joker who, I felt, couldn't recognize a good photograph if it jumped up and bit him.

The two of them did wrest the color back from me, and *Newsweek* did do a cover. Happily *McCall's* magazine came out with a beautiful cover a few months later, from the same session, and also used another shot of Kate inside. *McCall's* even made full-page newspaper ads with the cover, advertising Kate as "The Woman of the Year." So much for taste levels.

Producer Martin Schute called me to ask if I could cover some of his film in Mexico, called *Macho Callahan* with David Janssen and Jean Seberg. The photograph below was taken in Jean's room late one afternoon. Sadly, it was the last time that I ever saw her. (Cuautla, Morelos, Mexico, 1969.)

When *Macho Callahan* was finished, I called Dorothy and suggested we should go to Mexico City, and see their truly great archeological museum. Not only is the collection inside spectacular, but the architecture is as well. I spent hours there enjoying the collection. Dorothy, knowing me so well, just lets me carry on, and when she reaches her saturation point in situations like this just goes outside and relaxes in the sun.

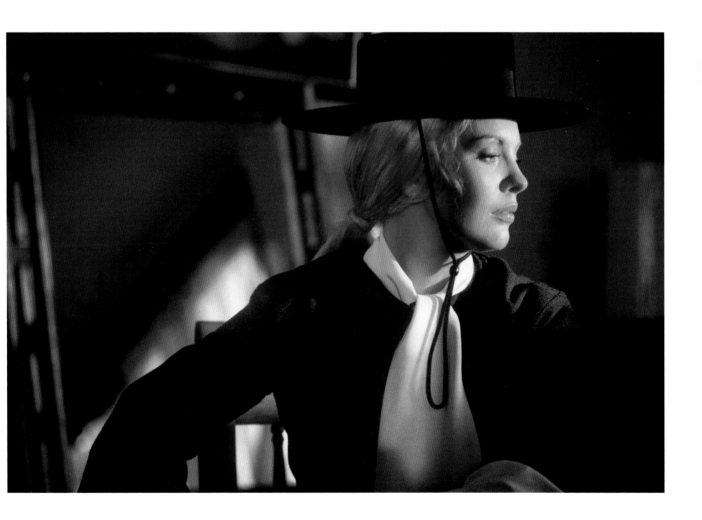

Robert Mitchum, looking like the "morning after," photographed in his agent's office above Sunset Strip. Hollywood, 1970.

(facing page) Jane Fonda poses for the cover of Show *magazine at her father's hilltop house, Beverly Hills, 1970.*

Lee called to tell me about *Murphy's War*, which was being filmed in Venezuela, starring Peter O'Toole and his wife, Sian Phillips. The story I heard was that Peter had requested the studio to put me on the film, which they didn't want to do. It went back and forth, and eventually they sent me down to Port Ordaz for a short period of time.

They were simply doing this to keep Peter happy, and didn't consider the shooting schedule, so when I arrived, there was basically nothing interesting for me to photograph on the film. It was good to see Peter and Sian again, of course, but this was the kind of assignment that was a no-winner. I tried to figure out what I could do to turn this dumb situation around to get some magazine space.

Peter and Sian told me about Angel Falls, the highest waterfall in the world, over one mile high. It would seem to be very difficult to get to, since the tepui (flat-topped mountain) that the waterfall flowed from was almost always covered in clouds. Few people even in Venezuela had ever seen it, in fact it was the rain in those clouds that creates the waterfall. The production company had an Alouette helicopter that used to fly us back and forth to the jungle location, piloted by a marvelous Frenchman named Gilbert Chomat.

Both Peter and Sian wanted to see it, and they were very enthusiastic for me to come along and photograph the adventure. We asked Gilbert if he would see if he could find out how to get there. Peter had discovered a little lodge run by "Jungle Rudy Truffino" a few weeks earlier, and he had told Peter that the Venezuelan Air Force had left a large metal barrel of aviation fuel near his place some years ago as an emergency store, and it was just sitting there. Refueling was the problem, as the distance to the lodge and then to Angel Falls was too great.

Rudy himself took hardy tourists on five-day field trips, mainly by motor launch, and then by hiking in, so while he had a rudimentary map, it was never designed for flying by helicopter. For me to be able to photograph, Gilbert had to take the entire side off the Alouette, which was a little off-putting, with the wind, prop wash and rain. When we got to the lodge, Gilbert and I went off to find this aviation fuel. I held a ladies' stocking as he pumped the fuel into the chopper. The chopper apparently had a filter, but the fuel was too full of rust to take any chances.

So with farewells to Rudy, we took off, and for a while followed the river, but with the jungle so dense we soon lost it. Exploring the Amazon by helicopter is phenomenal. The wildlife and flowering trees growing up over the top of the jungle were marvelous to see. Thinking about explorers hacking their way through the underbrush days at a time, they would have missed all of this, and this was really the way to do it.

The falls were discovered by an American bush pilot named Jimmy Angel, who flew tourists around the area in a little Piper Cub. One day, so the story goes, he flew through a mountain pass, the clouds that normally hid this tepui parted and, to everyone's surprise, there was this magnificent waterfall. When he returned, no one believed his story. So he and his wife flew back one day to see if they could find it again. When he did, he tried to land his plane on top of the tepui, but the land was so marshy the plane just sank right in. It took him and his wife several weeks to trek out from there. So it was named after him.

When I was in Venezuela, two dentists had tried some months before to repeat his feat, and they too got stuck, and had to be rescued by an airforce helicopter. I was glad that we were with probably the best-known film pilot in the business... even though flying in his bare feet was a bit unusual to see! (Venezuela, 1970.)

(top left) This beautiful flowering tree grows high above the jungle canopy.

(top right) Peter and Sian checking Jungle Rudy's map for landmarks.

(bottom) Gilbert brought the chopper down to follow the River Churun, and you can see one of the tepui in the background. We followed many of these tepui, and some of these have little waterfalls. After a good three-quarters of an hour going around these mountains, we finally see what we have been looking for—Angel Falls. There was no guarantee that it would even be visible, so we were really lucky with the weather that day.

We flew over the top of Auyan Tepui (the altimeter reading 5500 feet), saw the stone marker where Jimmy Angel's plane had landed (it had been removed for some celebration in Caracas), plus the fuselage of the dentist's plane. Gilbert looked down and saw a little ledge at the very edge of the falls, and incredibly was able to set the chopper down right there (above). One mile straight down, and Peter gingerly crawls over to the edge, but I don't think he really got that close so that he could see over, because it is more than scary with nothing to hold onto.

Sian had no stomach for that, and started collecting samples of some of the unique plants that grew at the edge of the falls (where probably no one had ever been before), just as if she were in her garden in Hampstead. (Venezuela jungle, 1970.)

Gilbert, watching the clouds, yelled to everyone to get back into the chopper. "I think we must do something!" he said. The rotors started churning over, and then my stomach, as he rolled right over the edge, and we could look straight down and see the jungle far below us.

When we were nearly back to the airport in Ste. Tomé de Guayana, the red light on the dashboard was blinking empty. When we landed, Peter got out and kissed the ground.

(below left) Peter O'Toole, Gilbert Chomat and Sian Phillips, toasting Gilbert for getting them back in one piece! A few days later, Gilbert and I went back to get some actual shots of the falls themselves. We repeated stopping at Jungle Rudy's, filtering the aviation fuel, and started heading back to the falls. Then, since it was lunch time, Gilbert, having spotted a little island in the middle of the river, sat us right down in the center of it. We were eating the sandwiches and drinking the beer we had brought along from Port Ordaz, when Gilbert leaned over, and asked if I knew what an uncut diamond looked like. He picked up this rather large milky stone, and we both looked at each other. God! Are we rich or what? We knew there were prospectors who panned for diamonds along the river, and no one could have ever reached this island with the torrential water on each side, except by helicopter, SO!

This was even a greater humidity than I had experienced in India, where even the sacred cows were dying in the streets, and paper money in your pocket turned to mush. Undaunted, with perspiration pouring out of us, we started picking up these little milky pebbles (below right), until we both had a handful. All the way to the falls, we were thinking we were now rich, and could hardly wait until we got back to show the crew that evening at dinner.

We got to the falls, and Gilbert flew right up to the top of them so I could shoot down and show the great depth. The problem was I had to use a wide-angle lens, and the rotor blades or the helicopter skids were always in the picture. Gilbert understood this, for he was the expert when it came to getting the camera in the right position, and told me he was going to turn the chopper at an angle so I could get a clear shot.

You must remember that the entire side of the chopper was gone, I'm sitting in a little metal jump seat, strapped in with the usual seat belt, and there is no support, nothing to hold onto, and he is putting the chopper on its side! "Whoa!" I yelled, as I could feel my body leaning out, and the seat belt on my waist was getting taut with my weight. "I've got nothing to hold on to, Gilbert!" He was very calm. Well, he could be, I was the one hanging out of the bloody plane. "Don't look down, only look through your viewfinder, and take the pictures," and then slowly, once again, he tilted the chopper over on its side, and I could feel the weight of my body pulling against this little belt, the metallic click of the jump seat straining, and my heart pounding a mile a minute.

I took the pictures, and then had to ask Gilbert to put the chopper down on the ground, and let me walk around for awhile. It was a very nerve-wracking experience. That evening, at dinner, we asked if any of the crew knew what an uncut diamond looked like. And yes, there was someone, and so we shoved the pebbles down the table to him. He studied them for awhile, and said, "They're nice, very high-quality crystal!" Our dreams of riches vanished in the steamy restaurant. (Port Ordaz, Venezuela, 1970.)

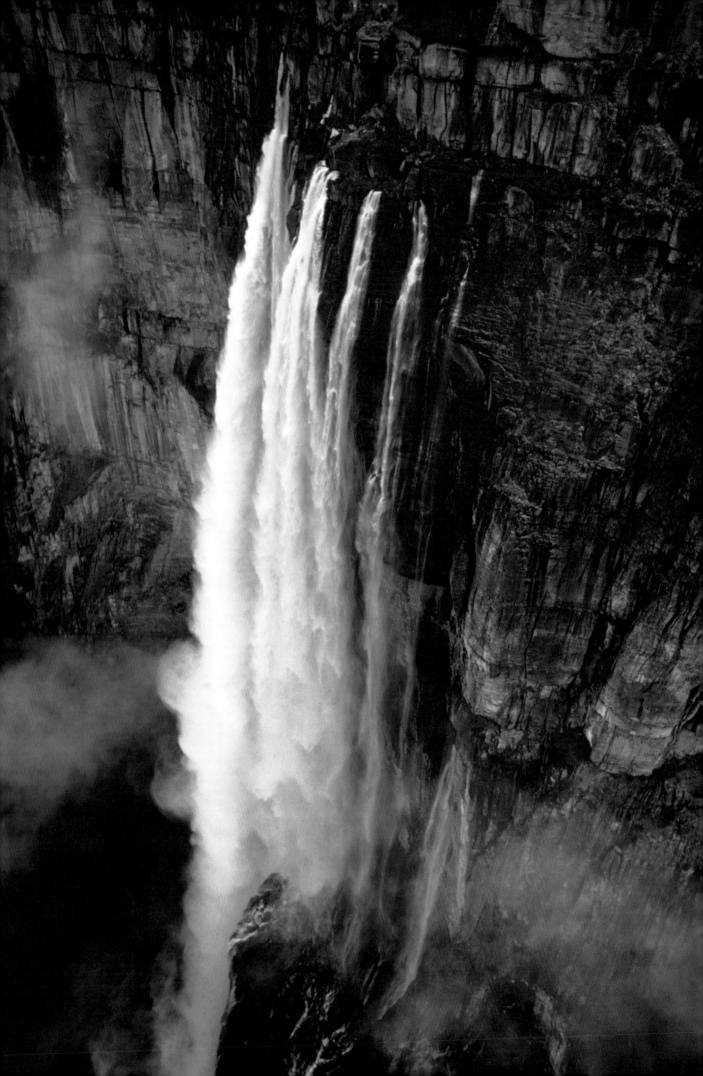

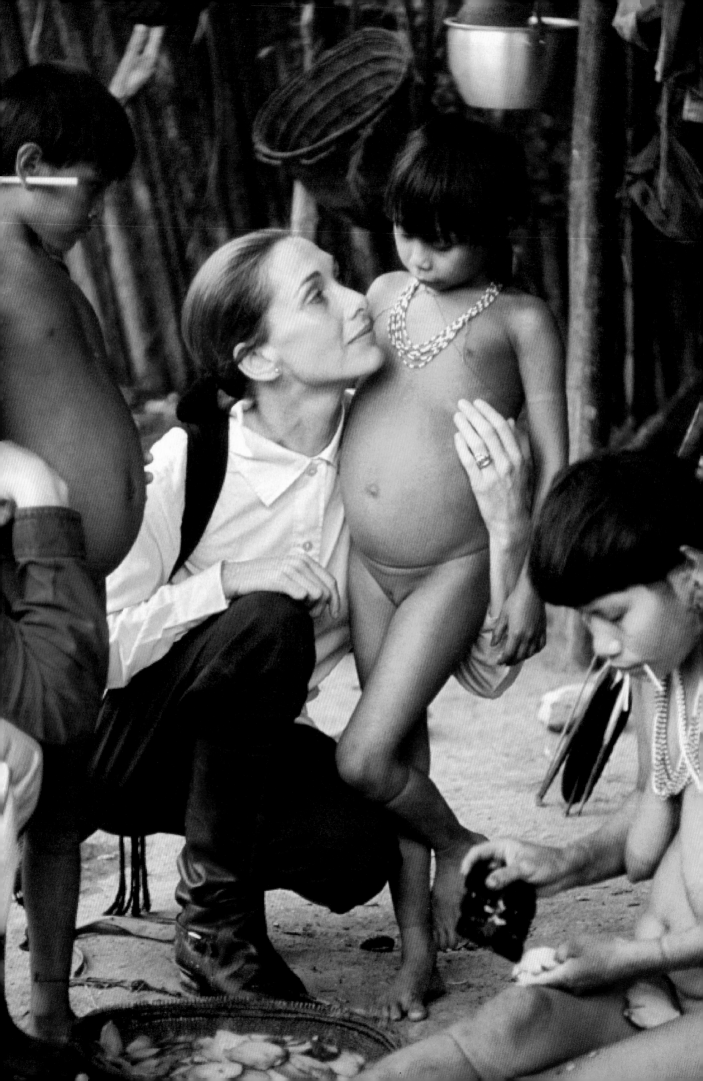

I still felt I needed something else to get space for the film, and I had my secretary call a friend in the Pacific Palisades, Dr. Johannes Wilbert, who was an expert in the Yanoama Indians. He used to tell us hair-raising stories about parachuting into one of their villages and living with them. In fact, he was the first person to be able to take their blood samples, and discover the Diego Negative gene that was proof that these Indians were actually Caucasians, and possibly one of the first, if not the first, of the peoples who came across the land bridge from Asia to the Americas.

In turn, he contacted a colleague in Venezuela, Dr. Inga Goetz, an expert on the Waika tribe, who had been studying them for ten years, author of the beautiful book *Uriji Jami: The Life and Beliefs of the Forest Waika*. When I spoke to her and told her how interested the O'Tooles were in making a visit, she agreed, as she had been planning a little trip later in the year and had already laid in fuel and provisions. She would have to get clearance from the Venezuelan government to allow us to take photographs.

A few days later, with her pilot Jorge, she flew down from Caracas in a twin engine Piper, and we joined her on the first leg of our trip. After flying some time over the jungle, we eventually landed on a small dirt airstrip, and stayed the night at a Mission Station. We were served wild pig for dinner, and it was excellent. There are Waika families at the Mission, and the children all came out in a tractor with balloons to meet us, and again when we left. They were all really lovely.

The next morning, we rode in a small motor boat up the Orinoco River for about four hours. Jorge, who was used to this trip, was alert the entire time with a rifle at the prow of the boat. I didn't want to ask, but since he never let his attention falter for a moment, all of us were watching too, for... God knows.

Peter and Sian had compiled a little list of Waika words with the help of Dr. Goetz, and were practicing saying *Shori Noje* (good friend) to everyone they met, and it seemed to work wonders. Sian was especially lovely with the children, and they were really curious about her, feeling her breasts and hair, to see if she was really like them.

When the villagers saw Peter, they pointed to him, saying something that made Dr. Goetz laugh, and she told us that they had named him Tall Mountain.

(facing page) Sian holding one of the Waika children. She and Peter watched her mother preparing the family meal. (below) O'Toole and I try one of the Waika 6-foot bows. It takes more than strength, but a technique of using your body, and the boys could send their arrows twice as far as either of us. (Orinoco River Reserve, Venezuela, 1970.)

(left) Bob and Peter ready for a night on the town.

(right) Dorothy, Peter and Sian in one of the stone niches, in the ruins of Sacsayhuaman, so finely joined that you cannot insert a knife blade. Cusco.

I had telephoned Dorothy to meet me in Caracas, and we would fly to Peru to see Machu Pichu. When Peter heard of my plans, he said, "You're not going without us!"

So the four of us flew to Lima, and frankly I had no notion of just how far a flight it was from Caracas. We were all very tired, had a bite to eat and went to bed. The rooms that were reserved in the hotel left a lot to be desired, and the next morning I went to the desk to see if I could upgrade them. I especially mentioned Peter's name, hoping to get something better.

We went out exploring the first day. The gold museum was spectacular, and one could get a faint idea of why the Conquistadors were so dazzled by the wealth of the Incas.

When we returned to the hotel that evening, there was a shoe-shine boy outside the hotel, and Peter stopped and took off his boots, giving them to the young man to be delivered to the bar, where we thought something cool would be just the thing after our tour. Peter walked into the hotel in his stockinged feet, and into a very large group of reporters.

There were just too many to deal with, so I went to talk to them and gave them all the details, and that seemed to make them happy. They took a few photographs of Peter and left.

The next day in the Lima papers, under Peter's photograph, Sian had become Gloria Sean, his wife, Dorothy was transformed into a Puerto Rican actress named Sharon Riley, and I became Peter Willoughby, an actor who was making a film with Dennis Hopper. The only paper that did get it all right was one Dorothy had spoken to, and she told them that I was the world's greatest photographer, and we did get better rooms, and Peter did get his boots back.

We flew to Cusco very early in the morning, and the altitude really hit me. I had to go to bed early that night, while they partied without any problem. The following day I was fine, but they got their just deserts. After this fantastic adventure Peter and Sian returned to London, and Dorothy and I flew back to Los Angeles. I discovered I had been assigned to photograph John Frankenheimer's film *The Horsemen* with Omar Sharif, Jack Palance and lovely Leigh Taylor-Young in Madrid. I hastly re-packed my bags, organized the film I had just shot, and headed off to Spain to start work.

(*above*) *Sian and Peter above the Machu Pichu ruins.*
(*below*) *Dorothy feeding some of the llamas. Peru, 1970*

The Horsemen was being filmed in Madrid. It was a real action film, with real Buzkashi riders from Afghanistan, supplemented with Spanish gypsies, and they could all ride like the devil. I'm told this game, played since the time of Ghengis Khan, is the roughest sporting event in the world.

The name *Buz Kashi* literally means "goat-drag" in Farsi. The championship is decided once a year in Kabul, but every little village at one time had their own games (now with the new regime, I'm not certain). The idea is to get the carcass of a dead goat into the others' goal, and there are no rules about how one gets these 120 pounds of dead weight away from the other horsemen.

I photographed the head of one of these Chapandaz, and it was crisscrossed with dozens of scars from the riding crops of the other players. They have to be very strong men to reach over from their saddle, at full gallop, and pull this carcass off the ground, or wrench it away from another player, all of the time hitting him or his horse with their leather whips.

(above) Director John Frankenheimer, with two cameras running, shouting encouragement to the riders. The camera car was going as fast as the horses could gallop as we filmed this high-speed, sometimes brutal, chase. I was really surprised at what a great rider Omar Sharif was. He could hold his own, riding at full tilt, with these experienced Buzkashi riders and the Spanish gypsies.

John told me several stories over dinner one night about the Afghan riders in Madrid. One of the stories was that they were cooking on the floor of their room with an open fire, since they apparently didn't like the food the hotel was serving. These were formidable looking men with their high-heeled boots and hats.

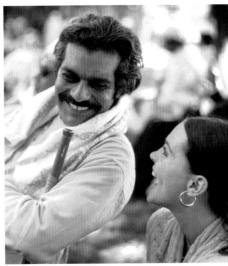

Omar Sharif and Leigh Taylor-Young. The Horsemen, Madrid, 1970.

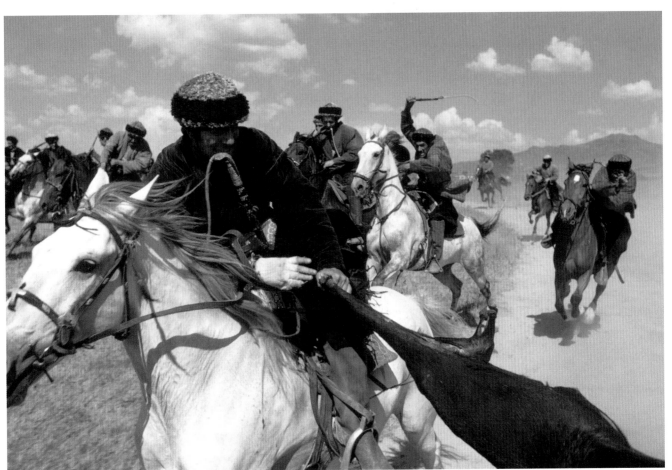

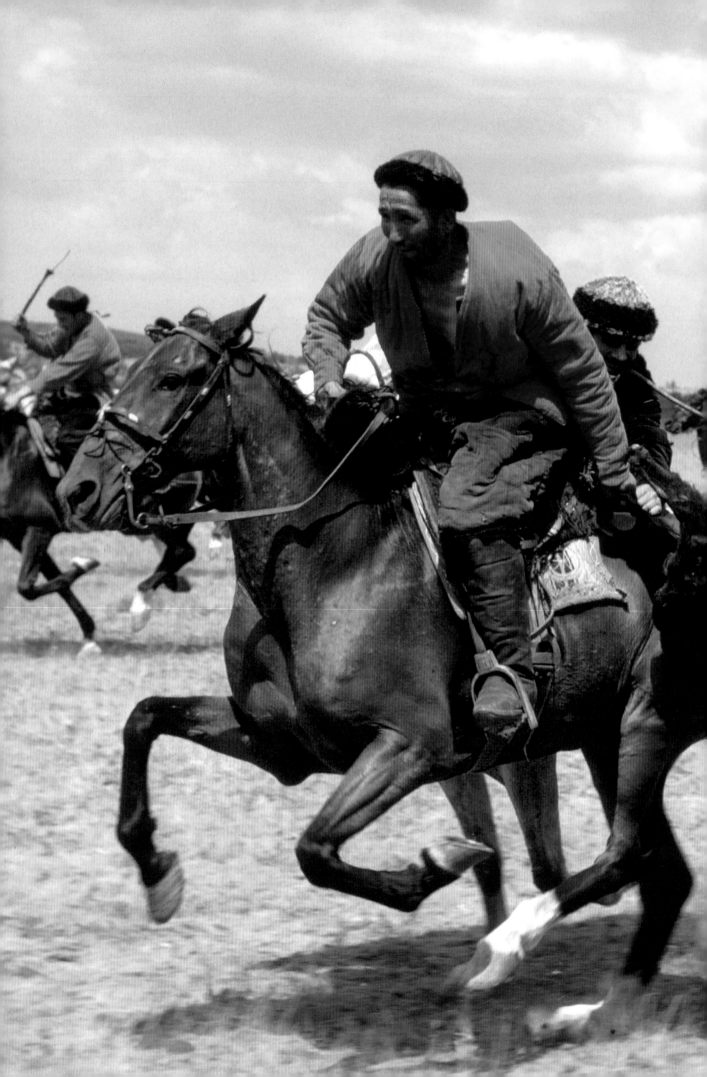

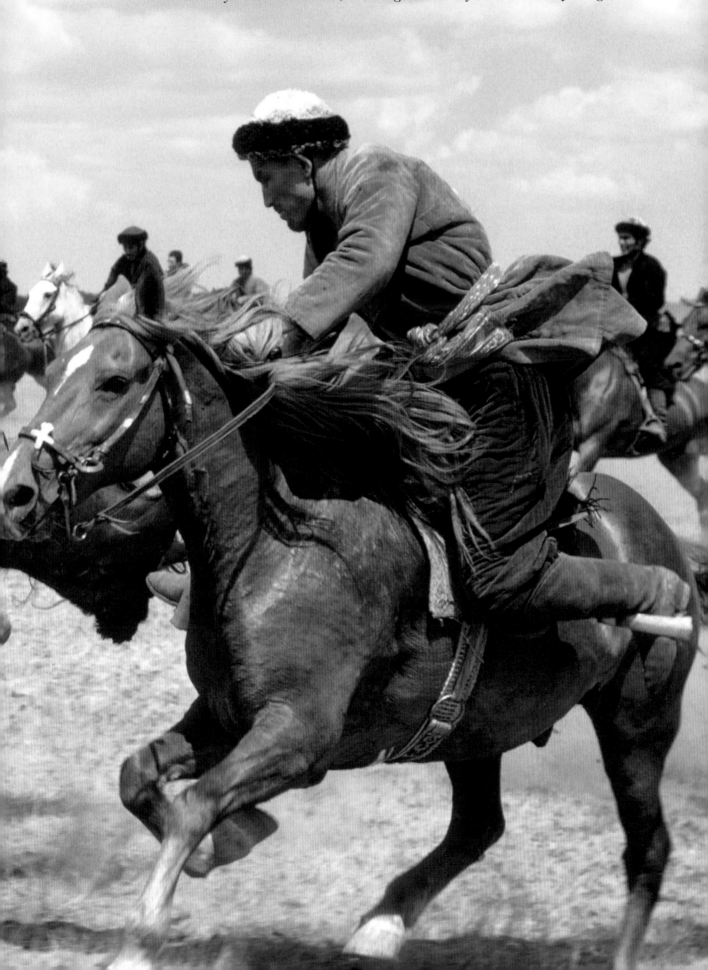

Two of the real Afghan Chapandaz, fighting it out, and just behind them you can see Omar, reaching over to try and take away the goat.

(above) Leigh Taylor-Young was lovely, and I knew I could get several covers with her. I also re-created one of the scenes from the film, that was shot before I got there, of Leigh bathing in the river. Leigh had one of the most beautiful bodies I've ever photographed. The pictures from this series are some of my favorites from the film. The Horsemen, Madrid, Spain, 1970.

(facing page) One of the assignments I did after I returned to L.A. was a TV special, "The Klowns" with Sammy Davis Jr. and Juliet Prowse. We went down to San Diego, and joined forces with the Barnum & Bailey circus, something I was never called on to photograph before. (Dorothy and I celebrated our 11th wedding anniversary.) (facing page) Sammy was such a talent, and I had great fun covering the filming. It was always a pleasure, Mr. Davis! 1970.

Donald Sutherland was a great joy to work with, seen here on the New York City location of Klute. This film also starred Jane Fonda, and was directed by gentle Alan Pakula. Donald was wonderfully mad at times. One day, Dorothy and I were walking along the street, when Donald, driving past, saw us and drove right up on the sidewalk to say hello, scaring us half to death. New York City, 1970.

Warner Brothers assigned me to photograph John Wayne in *The Cowboys*. I thought it might be interesting to cover the film as if I were Edward Curtis, or one of the frontier photographers, using their wet-plate cameras. Steve Hansen, my lab man, suggested that I use some black and white copy film he had that was high contrast and color-blind (not panchromatic as we have today). I made weeks of experiments with it, first finding out what its effective ASA rating was (it was very, very slow, at 2). This meant I had to use a tripod, but suited the character of the images I wanted to make.

I also discovered it reacted differently under the tungsten light used in the studio. For example, John Wayne's makeup became very apparent. It also had such limited latitude that it could only be used in flat light. This was a film never intended to be used to photograph with, but to copy documents. It took a bit of time to get used to it, but it was sharp, and had almost no grain.

Duke was really wonderful about posing for me. It took three sessions to finally get the image on the facing page. The daylight makeup looked like makeup when I shot the first time. We tried shooting early one morning, before putting on his makeup, and that didn't work either. Strangely, the makeup used for filming under the studio lights, used outside, was perfect.

We showed *Look* some of the first tests, and they wanted it, and so I continued throughout the film. When the time came to run it, *Look* folded. I hoped this wasn't going to be another one of those times that I had worked to get something special, and then it wasn't going to appear. Lee Gross immediately took the set over to *Life*, and happily they loved it, and used it for the cover and a big layout inside.

Meanwhile, when we were filming in Santa Fe, my comrade in arms Mel Traxel, the unit stills man, and I drove off at lunchtime with our catered box lunches to see a bit of the countryside. It was such a beautiful day, and the scenery so wonderful, we stopped along a big plain and got out to stretch our legs.

It must have been an Indian campground years before, for as we were walking I noticed a shard from an Indian pot with nice painting on it. Then there was another, and I took one of the plastic sandwich bags and started dropping in these little touchstones of another time. I would guess we probably were picking these things up for about 15 or 20 minutes when we felt drops of rain. Rain? We both looked up in amazement to see black clouds racing towards us. There had not been a cloud in the sky when we arrived, and we had been filming all morning in hot sunny weather!

It started to really come down and we had to run back to the car as it had become so heavy. Driving back to the location, I was wondering if by picking up these broken shards I had caused all of this? When we arrived, we could see the electricians and grips running around throwing canvas covers over the 10k's and the cameras. This weather had changed so rapidly, obviously no one on the set had seen it coming either. Mel and I sat sheepishly watching all of this activity from inside the car, and we weren't about to tell anyone that we might have caused this by disturbing an Indian campground!

The wind came up, and started blowing a gale, then it started snowing. Mel and I returned to the motel where the crew was staying, as this had all became too unreal. I didn't know if I should try and put these shards back or what.

The Santa Fe papers headlined the following day, "Freak Tornado Rips Santa Fe" (April 16, 1971), and the film was sidelined with this terrible weather for several days.

On the magazine cover:

LIFE **JOHN WAYNE**
Memoirs of a G-rated cowboy

MUGGING
A young mugger talks about his 1,000 'hits'

How to avoid an attacker, what to do if he moves in

George Plimpton Hunts the World's Biggest Elephant

JANUARY 28, 1972 · 50¢

(top) A portrait of the Chiricahua Apache Indian tribe that Warner Brothers brought to the film location. It was to be Chief Joseph and his tribe in their famous but ill-fated flight to Canada. The scene never appeared in the film, however. Taking this photograph became very stressful, for just as I had the tribe about ready to shoot, Tim Zinnermann, the assistant director, called for Frank DeKova to come to rehearse for a scene with John Wayne. I held on, knowing I was holding up the production. This shot with the tribe was just too good to miss. I had just tripped the shutter as Duke yelled, "Come on, Willoughby, we've got a film to make here!" Frank left, the Indians disappeared, leaving me alone on the scene, but I had the picture! Warner Brothers had dozens of the prints made up to send to the tribal leaders.

(facing page) Actor Frank DeKova, who was portraying Chief Joseph, looked marvelously like an Indian. To get this picture, the grips kindly put a scrim over him to keep the sun from being too bright for the latitude of my film. You can just see a slight highlight on the top of his hair, where he leaned back as I took the photograph.

French artist Jean Tabaud drawing a beautiful portrait of Dorothy in our home in the Pacific Palisades. 1971.

I went briefly to Arizona to work on *Junior Bonner* with director Sam Peckinpah and Steve McQueen (facing page), Robert Preston and Ida Lupino. Steve drove away from the set on his motorcycle whenever he wasn't shooting, and it became very difficult to photograph him. Even when the executives flew in from New York, expressly to shoot an ad for the film, he wasn't "available." It was just by luck that ABC liked this shot to use for their ad.

Peckinpah may be a good action director, but he was less than helpful to me, and I didn't care much for him or his cinematographer Lucian Ballard, who thought it funny when he gave a goose to some of the crew with the officer baton he affected. He only did that once to me. All in all, this is one film I could have done without, except for Bob Preston, who was always professional, and I think was one of the best actors around. (Prescott, Arizona, 1971.)

Serious drug problems were affecting our friend's young children, which made Dorothy and me very concerned for our own. These were not just random cases. Peer pressure from outside overrode good family influences. Our neighbors and friends had tragic stories. Even my secretary's son went out to Arizona to escape this problem, was blown away on a one-night LSD trip, returning home to her a vegetable who had to be led around by his little sister.

I told Dorothy we had better think of moving our children out of harm's way, but where? We made several trips to Europe, and at first we thought that Switzerland might be the place, but a move like this would obviously be very difficult. It would take us until 1973 to work out all of the details for our eventual move to Ireland.

One of the other factors was that *Life* magazine was about to be shut down, their advertising lost to television. With the loss of two of my most important outlets for the films, I could see the writing on the wall.

We started our search in Dublin, since it was close to the charming Ardmore Film Studios in Bray. Film production in Europe had increased, and being near the Dublin airport, I thought I could make a living doing a few films a year. The first morning, we had breakfast in our hotel room, and ordered the *Irish Times* to be sent up, so we could look for houses.

The headline that greeted us that morning was, "House Prices Rise By 300%." Ireland had just gotten into the EEC, and European companies were flocking to Dublin. I can only assume it was their executives that were buying up the houses and creating this incredible price increase. In any event, we saw some dilapidated houses that were more expensive than those in Brentwood or Beverly Hills.

Now we were really discouraged, since we had planned on first renting our house on Rivas Canyon to see how we fared in Ireland, and not burning our bridges. One of the estate agents told us that houses in the south were less expensive. We did see an ad that sounded interesting for a house in Cork, and since there was an airport there, I thought we should give it a shot. We found the house, and while it wasn't what we were looking for, the owner asked where we were from, and we started talking.

He mentioned that just down the road, Angela Lansbury and her husband, Peter Shaw, had bought a house, and maybe we might know them? Well, we had been over to Angela and Peter's house in Malibu several times, and had conversations about moving to Ireland, and I was very pleased to know they had already made the move. I got instructions on how to find the place, and thought I'd take a photo of it and send it to Angela (never thinking she was in residence). It would be fun to surprise her.

We drove into the large gravel entrance, and Angela came out on the front porch, and I saw her squinting to see who it was. "It's Bob and Dorothy, and we've come for a cup of tea!" I shouted, and she led us into her lovely and warm new country kitchen and poured us a very welcome glass of wine (below).

We were on the last day of our trip, and hadn't found a place to rent, and our estate agent Matt O'Sullivan was taking us to a house that I realized we had already seen. I honked my horn and we stopped and got out of our cars. As we were standing chatting he pointed across the way to a castle. "How would you like to live there?" We laughed, and then he told us that he that he knew the caretaker and would we at least like to look at it.

So off we went. Denny Murphy was there, and showed us around this fantastic big house. Now we ideally would have liked to have a place with six bedrooms, one for each of the kids, and one for Dorothy and myself, and one for Quig, who was living with us in Los Angeles and now was to join us on this new adventure. This had that and more. (facing page, top) Our first view of Coolmaine Castle, County Cork, 1972.

I will always remember walking out on the front terrace for the first time, with the breathtaking view overlooking all of Courtmacsherry Bay stretched out in front of me. That evening the sunset was incredible, every color in this late September evening was spectacular! I knew then that I had found the place we were looking for. Coolmaine Castle did have heating, and had 40 acres of land, which was partly rented out to a local farmer. The rooms were in good enough shape that we could live there while we were redecorating, so comparing the cost of the other place, and the repairs, this was by far a better buy. It had been on the market for several years, and now I had to go home to see if I could swing this. There were all sorts of problems, not the least was getting permission from the government for the land.

I was assigned to work in the Big Sur area of Northern California on a film called *Zandy's Bride*, starring Gene Hackman and lovely Liv Ullmann. I left the final packing details to Dorothy and my assistant Dale Laster, and headed up to Carmel and rented a house.

I figured I could work several weeks on the film while our household was being shipped. Our rented house in Carmel was quite special, white and pale greens everywhere, with a nice enclosed garden, and walking distance from the beach for the children. I went off each day to the location, and Dorothy and her mother did the shopping and had a nice little holiday in this charming resort town.

One day, the boys were taking our change of address cards down to the tiny post office in Carmel, when the man behind the counter noticed the Coolmaine Castle address and asked them about it. I remember the boys coming back and telling us the amazing coincidence that the postman Spears Ruskell and his brother Victor had lived in the castle years before. The odds must be stratospheric to have a coincidence like that happen in a two-man post office, and that we mailed those cards in Carmel while I was working there for the first time.

The location of the film was in a beautiful area that must have looked the same 100 years earlier. The story was about a mail-order bride (Liv) and a rough, no-nonsense frontiersman, played by Hackman. Since almost everything was filmed in one little cabin, there wasn't much for me to shoot, but it was an ideal transition before we left for foreign shores.

Our new home, Coolmaine Castle, seen from the air. Kilbrittain, County Cork, Ireland.
(facing page) Gene Hackman on the Big Sur location of Zandy's Bride, *1973.*

Director Otto Preminger, at his most imperious, rides camera boom.

The Man With the Golden Arm
1955

THE PLATINUM YEARS

There was just so much to do. The electric wiring in the house was very, very old, and the mice had enjoyed the wire covers, so replacing this was an absolute necessity, and given the size of the house, a major consideration. The electric fuse boxes were something out of the Smithsonian museum, and we had an electrical crew in the castle for eight months redoing the wiring.

They were frustrated that I wouldn't allow them to run the wires down the outside of the wall, as they did in many of the local homes. Each morning I had them come to me and we would work out the electrical problems of the day together. My experience as a photographer working with lights really came to good use. On the day these very loyal young men left, after being part of our family every day for nearly a year, we opened a bottle of champagne.

A lucky break came at just this time when Jerry Mason of Ridge Press Books in New York sold Random House on publishing *The Platinum Years*. (see above) It was beautifully designed by Al Squillace, with text by the *Life* film editor, Richard Schickel. It had very good reviews, but most importantly at the time to me, it helped pay for all of the electrical work!

Blake Edwards called me to work on *The Tamarind Seed* in London, Paris and Gstaad, Switzerland. Julie Andrews and Omar Sharif were the stars. We had all worked together and were comfortable with each other. I had an idea for an ad which Blake liked (facing page) except that Julie wouldn't have worn the robe. I figured Omar's dark arm across her pale English skin would be an eye-catcher. I had everything set up in the London studio where Blake was filming, and just as I was about to shoot the picture, he sent word that he had changed his mind. It was a great disappointment. Since I was there, I just shot Julie the way she was in her terry cloth robe. They used it as an ad, but the other way would have been far stronger. (London, 1973.)

When we were filming in Gstaad, Blake, Julie and I were driving back to their house from the location, and Blake said to Julie that if she wanted to do a nude, now would be the time while we were all there together. Julie thought a minute and said, "If I were to do it, I'd like to do it as Mary Poppins, with my umbrella, satchel, and shoes!" I assured her that if she did, I would have no problem getting it into any magazine. What a great and funny idea.

(above left) One of our very dear friends Kathleen Nolan came to Ireland as the President of the American Screen Actors Guild, and presented my book The Platinum Years, *to the President of Ireland, Cearbhail O Dalaigh. Between them is Kathleen's son, Spencer Heckenkamp, who is now well-known actor Spencer Garrett. At his left is Maurice O'Doherty, a presenter on RTE-TV. 1976.*

(above right) My book with photographs of Ireland and the early poetry that I translated from ancient Irish.

A castle in Ireland was a romantic image, and all of our romantic friends visited us at the drop of a hat. Even friends, when hearing that their friends were visiting Ireland, offered our phone number ("to be sure to go and see the Willoughbys").

This was a really good life, right next to the sea. The boys had their own small sailboat and wind surfer (David won the Courtmacsherry championship two years in a row). We were told that the wind surfing was the best in Ireland right in front of the house. On our return visits, we still see them whizzing along at heart-stopping velocity.

The children were all growing up well, playing rugby and participating in the school activities. The last we heard, Stephen still held the record for the 1500m run at his school. Christopher won several cups for his various projects. One of my favorites was his description of the ancient sea battle off Salamis.

We did cause a bit of a local flutter at first when we sent our boys to the Bandon Grammar School, which was Protestant and had been taboo in our village for the Catholic children. It was a beautiful school, run so well, and while all of the schooling in Ireland seems uniformly good, the local Catholic School looked like something out of a Dickens novel when we first arrived. Dorothy almost cried when she saw this ruin of a building she thought the kids would have to go to. After the bright sunny classrooms of the Palisades, this was a bit too much for her.

Producer Marty Poll hadn't forgotten about me, and when he was setting up the film *The Night Hawks* with Universal, he asked for me. I had never worked with Sylvester Stallone, and that, combined with cold nights and locations that were so crime-ridden that I could not put my camera bag down anywhere, made this no pleasure trip!

Don't ask the New York teamsters to let you put anything in their truck for safekeeping, even during a lunch break. They were so uncooperative and so belligerent that it has left a bad taste in my mouth to this day. This New York crew also didn't like "outsiders," and made me feel, for the first time in my life working on films anywhere in the world, as unwelcome as the clap.

I just plugged away at it, since the money was needed. Leaving the crew standing outside for hours in the snow, waiting for the actors to decide what they were going to do, was mind numbing. Shooting took me to Paris as well, and there with the French professional crews it became much easier, except of course for Stallone.

He had fired his director in New York, and took on another (for legal reasons with the Screen Directors Guild), but in effect he was directing the film. I just kept a low profile with him, but without Marty and Gladys Poll to intercede for me when I needed something special (as on the facing page), I seriously doubt I would have gotten the material that I did.

Universal Studios also asked me to put together a book of my photographs for them to use to presell the film in Europe, so this occupied all my nights, and the book was very well received. I thought this a really terrific idea as a sales tool for them to do while the film was still in production, and wondered why I had never seen it done before.

(below) Sylvester Stallone points the way for cinematographer James Contner to place the camera for the coming shot. (facing page) A potential ad for the film with the enlargement of Stallone's nemesis in the film, played by Dutch actor Rutger Hauer. (New York, 1980.)

Our finally completed kitchen, walls in place, and a lovely old pine sideboard I had discovered (with ages of paint) and a few other pieces that lent an Irish charm to the place. We found the North African birdcage in Paris.

The house was shaping up, and I had time to do eccentric things like paint our hot-press doors with a large guardian cat (facing page). I also went off with Christopher to the Skellig Islands in the west to put some final touches on my Irish poetry book, which Pan Books was going to publish.

I rented a chopper that was already going out that way for Charley Haughey, the Irish Prime Minister. (Charley, naughty boy of Irish politics, had an island of his own to which everything had to be flown in by chopper).

Ireland by air is truly breathtaking, one of the most beautiful landscapes I have ever seen, an amazing green patchwork quilt. I had even suggested to the Irish TV to have an actor read Irish poetry over the floating vision of the land from above.

(above) Our 1976 Christmas card, walking on Coolmaine Strand. Stephen, Quig, Cat, Dorothy, me, Christopher (holding Polly) and David. Jings, sitting in front, and the castle to the rear.

Over these years I did work on several films, but I could see that, living as we were so far from the major production centers, my work on future films would be winding down.

(right) Nigel Terry, who played Arthur in John Boorman's Excalibur.

(below) Dynamic Kevin Kline at Shepperton Studios, when he was filming The Pirates of Penzance in the U.K., sleeping during his break. 1982.

(facing page) Director John Landis sits amidst the blood and Kensington gore of his film An American Werewolf in London, London, 1981.

The Name of the Rose was my last film. I was only given a week to try and pull something out for *Life*, which had been resurrected as a monthly. The Director Jean-Jacques Annaud was apparently under tremendous pressure, and he could not spare me a minute, after getting his take, for me to shoot anything special with the actors.

However, at different times there were at least a dozen TV units there, from as many countries, just in the short period I was there. I could see where the time was being allotted, and it was very clear *Life* no longer had any currency, and was being replaced by TV on the film set itself. (facing page) Sean Connery and (above) F. Murray Abraham, Rome, 1986.

With Christopher married, and him and Stephen both off conquering their own worlds, and Catherine soon to be married, the house was getting too big for us. Dorothy and I also wanted to have a little place in the sun where we could put up our feet and retire.

We put the castle up for sale and proceeded to look for another place to live (above, our sitting room in Coolmaine). We had had such a great time in Ste. Maxime years before that we started our search there. It took a very long time to sell the place. We put advertisements in the journals that we thought would be the logical places, without any success.

When we were in L.A. visiting Christopher and Claire, I bought the Hollywood theatrical trade papers, and for a lark thought why not try in their Friday ads? We immediately had a response from Roy Disney and his wife, Patty. They flew over to see the place, and several months later, I handed over the key (above).

We returned to France to find our little hideaway, and on the advice of friends, went to look in Vence. It all seemed too easy after looking for weeks on the Riviera. The first house we looked at clicked with us both, and we made the arrangements to put the purchase in motion.

When I left Ireland, I thought that my photographic career was over, and I was going to retire. I put my few remaining cameras in storage and photographed nothing for over two years except for the family snaps. Then, one day, I met Dorothy's French teacher Chantal Pereon.

I felt Chantal had a special beauty coming from inside, and I had the old urge to photograph that elusive beauty that has always attracted me. So I dusted off the cameras and went over to her place to photograph her with her three children (below, Chantal with her daughter Claire. My image of a woman thinking back to when she was a young girl, and then wondering about her life to come. Vence, 1992.) This return to my camera set me in motion to pick up the threads of several other books that I had been working on, but never completed.

Life in the south of France, and especially Vence, is delightful, and our little house in the hills was just perfect for the two of us. What I didn't expect was that I would become busier than when we lived in Ireland. The Japanese published two books: *The Hollywood Special* and a book on Audrey Hepburn. Neiswand, in Germany, published four photodocument books on four of my films, and a prize-winning one on my early jazz photographs called *Jazz in L.A.*

The weather, the people, the luncheons in the sun all combined to make our move here perfect.

Dorothy and I watched with pleasure when all of the children were married. Christopher, Claire and their three girls live in Los Angeles, and he is a film and commercial editor. Stephen is a marine biologist, and his wife Torill and their two children live in Norway, where he raises salmon. David, our marine architect, lives with his wife Gina and their baby in Florida. Catherine and her husband, Rob Stott, are working and are still enjoying life in Ireland. We now have six grandchildren, and we all had a grand reunion on our 40th wedding anniversary, July 18, 1999.

妖精が逝って一年。気高く、可憐な表情が、いま甦る。

オードリー・ヘップバーン
ボブ・ウィロビー写真展

1・28 FRI. ～2・9 WED.
10:00～19:00

Audrey Hepburn

My Fair AUDREY

金 → 2月9日水 10:00～19:00　主催/PPS通信社　後援/㈱NHKサービスセンター
入場料(消費税込)/一般700円(600円) 大・高・中生500円(400円)

気高く、可憐な妖精が、いま甦る。

オードリー・ヘップバーン
ボブ・ウィロビー写真展

7月7日(木)→7月24日(日)11:00～19:00　主催/PPS通信社　後援/㈱NHKサービスセンター
神戸ハーバーランド オーガスタプラザ3F・6F

OGASTA PLAZA

Ogasta Plaza, and my Japanese agent Pacific Press, invited Dorothy and me to open their exhibition on Audrey in Kobe. It turned out to be a big success.

The reception of the Japanese was really marvelous in this modern area of Kobe with thoughtful and handsome architecture. This was just before the terrible earthquake.

(right) The opening ceremony was very formal. We were given white gloves, and gold scissors were handed to us on a silk cushion to cut the ribbon opening the exhibit.

They had laid on TV and radio interviews, and they were selling the Audrey book, so there I was signing books. I was kept busy, but we still found time for a very enjoyable trip to the ancient city of Kyoto on one of their rocket trains.

We said goodbye to some terrific people associated with the exhibit, and then headed off to Tokyo for a bit more sight-seeing. Except for the palace, I couldn't recognize anything from the time I had visited there in 1958. We flew home via Los Angeles, to see Christopher and Claire and the girls, then to David in Florida, and to Ireland to see Cat and Rob, and finally home to Vence, completing our round the world trip. (July 1994.)

PERSISTENCE OF VISION
A MAJOR PHOTOGRAPHIC RETROSPECTIVE
248 IMAGES FROM MY WORK ON FILMS.

*Producer Ken Wales, me, Robert Rehme, Film Academy President and writer-director
Frank Pierson, an old buddy from* Life *magazine days, in the ground-floor gallery.*

Opening night at the Academy of Motion Pictures Arts and Sciences was truly amazing. I was told there were 250 people at the reception. I also heard that there was a rather spectacular buffet and bar, but I never saw it. People I hadn't seen for 25 years were there. Bill Cartwright, my old film school buddy who had made me investigate so many new avenues in art (below left) with his daughter-in-law Patricia and his two sons William and Robert. Our son Christopher far right.
Dear Wallace Seawell (below center), for whom I worked as an assistant, and hadn't seen for so long, came even though he wasn't well. I was so proud for him to see this exhibit. Producer Robert Radnitz, a special friend, who had had a stroke, made the spectacular effort to come in his wheelchair (below right), seen with Robert Rehme, the president of the Academy.
I never really had a chance to talk to anyone for more than a minute. These were just happy, but fleeting moments for me, and then there was someone else shaking my hand. Neighbors and friends from the Palisades, photographer friends like Peter and Alice Gowland, Bill Claxton and his wife, Peggy Moffit, Ken Whitmore and his wife, and Bruce Talamon. It was all so terrific, my memory blurs. My former assistant Dale Laster, two of my former secretaries, Charlotte Truenfels and Phoebe Niles. It went on and on. It was a breathtaking whirlwind of an evening!

(top) Angela Lansbury and me being interviewed on TV.

(above) Kathleen Nolan, me hugging Felicia Farr and Jack Lemmon.

(top left) Producer Larry Turman and his wife, Lauree, looking at the exhibition in the upstairs gallery. (next) Jack Lemmon, Eva Marie Saint, Angela Lansbury and Jeff Hayden.

(next) Director Mark Rydell of The Cowboys.

(bottom left) Hugging composer and musical director David Raksin, who was one of the people responsible for the exhibit, and Jo Raksin.

(below) With David Raksin, producers Jeff Hayden and Larry Turman.

This is as far as this book goes. My career in film seems a time so long ago that it's as if it is another me. I feel so blessed to have Dorothy to share this exciting life with. She is everything a man could wish for in a wife—a wonderful mother to our children, and a superb cook, and the fact that she has put up with me for over forty years certainly qualifies her for sainthood. Waking up in the morning with her beside me is the best part of my day, every day. She has been, and is, my lifelong muse.

In making this book, I am especially aware that there were so many people that helped me along the way, people that supported and encouraged me, possibly not even knowing what an influence they have had. It is amazing to me how lucky I've been to have so many close friends. One of the things that I have gleaned out of all of this is that one never knows when or how a small act of kindness can influence another person's life.

We are all pilgrims on this road, and I am truly grateful to those friends (now so many long gone) whom I have never forgotten, and have learned how important it is to pass their kindness to me on to others along this journey that we are all on.

Anyone reading this book will know who some of these people were, so there is no need to make any further mention, save one: my mother, who was courageous in her life and in what she believed in, taking pleasure in the people and things she loved, imbuing in me an honest vision of what is truly beautiful. She has influenced the way I've lived and looked at the world, and I think that is why it has been a compulsion for me to make sure that I save what is beautiful. She has influenced the way I have lived and looked at the world, and I hope that is what you will see reflected in my photographs.

Vence, France, 2001.